DAWSON UK
CHARITY
BOOK

BAUDELAIRE
AND
CARICATURE

Also by Michele Hannoosh

Parody and Decadence: Laforgue's Moralités légendaires

Michele Hannoosh

BAUDELAIRE AND CARICATURE

*From the Comic
to an Art of Modernity*

The Pennsylvania State University Press
University Park, Pennsylvania

Library of Congress Cataloging-in-Publication Data

Hannoosh, Michele, 1954–
 Baudelaire and caricature : from the comic to an art of modernity
/ Michele Hannoosh.

 p. cm.
 Includes bibliographical references (p.), and index.
 ISBN 0-271-00804-0 (acid-free paper)
 1. Caricature—History. 2. Modernism (Art) 3. Baudelaire,
Charles, 1821–1867—Philosophy. I. Title.
NC1325.H36 1992
741.5'09—dc20 91-16467
 CIP

Copyright © 1992 The Pennsylvania State University
All rights reserved
Printed in the United States of America

It is the policy of The Pennsylvania State University Press to use acid-free paper for
the first printing of all clothbound books. Publications on uncoated stock satisfy
the minimum requirements of American National Standard for Information
Sciences—Permanence of Paper for Printed Library Materials, ANSI Z39.48–1984.

For Richard

οἱ δ᾽ ἤδη γναθμοῖσι γελώων ἀλλοτρίοισιν,
αἱμοφόρυκτα δὲ δὴ κρέα ἤσθιον· ὄσσε δ᾽ ἄρα σφέων
δακρύοφιν πίμπλαντο, γόον δ᾽ ὠΐετο θυμός.
—*Odyssey* 20.347–49

Ridentem ferient ruinae
—Baudelaire

Contents

Contents

Acknowledgments

In acknowledging the support of a National Endowment for the Humanities Fellowship in 1987, I must vary the customary formula slightly to say that without it this book would *certainly* not have been written. At a time when the number of university positions had fallen to a record low, the Endowment played a vital role in allowing many to pursue their research and writing through its programs for independent scholars. For this I am personally very grateful. Now when both of our National Endowments have come under attack, it surely bears repeating that much scholarly and creative work could not have been done without them. Such agencies, autonomous and independent, have an essential part to play in encouraging the intellectual and cultural life of this country.

I would like to thank the numerous friends and colleagues who read the manuscript and made suggestions for its improvement. Therese Dolan has been a source of constant help and support ever since it made its way—unsolicited—to her desk; her insights are greatly appreciated. I thank my longtime friend Joanne Paradise for her extremely valuable comments, and for giving me the benefit, over the years, of her extensive experience and her fine critical sense. William Sharpe offered the trenchant criticisms to which I have become accustomed over the course of our association, and on which I so regularly rely. Ross Chambers and Edward Kaplan deserve special thanks for their careful and sympathetic readings, and their many useful suggestions.

I am grateful to my former colleagues in the Society of Fellows in the Humanities at Columbia University, who followed the project in its early stages and provided me with a setting more conducive to study and writing than any I have known. I have profited from many museums and libraries, and thank those institutions that have provided photographs of works in their collections: the Cabinet des Estampes of the Bibliothèque Nationale (Figs. 2–5, 9, 13–15, 17–18, 22, 24, 26, 28, 31–34, 37), the Bibliothèque

d'Art et d'Archéologie of the University of Paris, the Archives Nationales, the British Library (Figs. 29–30, 35, 51), the National Art Library of Great Britain, the Witt Library of the Courtauld Institute of Art, the Royal Library, Windsor Castle (Fig. 50), the Syndics of Cambridge University Library (Figs. 41–45, 53), the libraries of the University of California at Davis and at Los Angeles, and of Columbia, Stanford, and Duke Universities (Fig. 20); the Musée des Arts Décoratifs, Paris (Figs. 58–59), the Musée des Beaux-Arts, Brussels (Fig. 52), the Board of Trustees of the Victoria and Albert Museum, London (Figs. 54–55, 57), and the Trustees of the British Museum (Figs. 1, 6–8, 10–12, 16, 19, 21, 23, 25, 27, 36, 38–40, 46–49, 56, 60). I would most especially like to thank the staff of the Department of Prints and Drawings of the British Museum, who with extraordinary efficiency and grace helped me to locate many of the works within the department's collections during my brief time there, and allowed them to be reproduced here.

Translations are my own and are strictly literal, but I have benefitted from the useful editions of Jonathan Mayne, *The Painter of Modern Life and Other Essays* and *Art in Paris*; P. E. Charvet, *Baudelaire: Selected Writings on Art and Artists*; and Edward Kaplan, *The Parisian Prowler: Le Spleen de Paris, Petits Poèmes en prose* (Athens: University of Georgia Press, 1989). I would like to acknowledge the Committee on Research of the University of California at Davis for grants allowing me to complete the necessary work in Europe. Finally, I thank my husband Richard Janko for his continual and unqualified support, help, and advice, which should go without saying, and, alas, all too often does.

List of Illustrations

Introduction

Viewed from a certain perspective, Baudelaire's three essays on caricature—
De l'essence du rire et généralement du comique dans les arts plastiques,
Quelques caricaturistes français, and *Quelques caricaturistes étrangers*—
represent a comedy worthy of their very subject. In comparison with his
other critical writings, these seem repetitious, inconsistent, incomplete and
sometimes incoherent, loosely organized, outrageously quirky in their choice
of artists and imbalanced in the attention given to them. The "essence of
laughter" alleged in the title of the first essay is developed through a
blatantly personal, even idiosyncratic theory, which derives this most con-
temporary and radical of arts from one of the oldest and most traditional
of cultural myths, the Fall of Man. Baudelaire purports to take his subject
seriously, but frequently betrays a flippant, cavalier attitude toward it, and
subjects some of the artists to a devastating sarcasm. The history of the
project was itself a comic fiasco of the highest order: at least a decade in the
making, it was revised, recast, cut, expanded, and rewritten for the benefit
of various unappreciative editors.[1] Originally conceived as a single, extended

1. Initially conceived as a history of the art, the caricature project was announced on the
back cover of his very first piece of art criticism, the *Salon de 1845*. Baudelaire drafted much
of it in 1846 but later altered it considerably in conception and content; see Pichois' chronology
in "La Date de l'essai de Baudelaire sur le rire et les caricaturistes," summarized in the Pléiade
Oeuvres complètes (1342ff.). (Unless otherwise indicated, page numbers in parentheses refer
to volume ii of this edition.) In August 1854 he submitted the work to the *Revue de Paris* and
agreed to revise the whole (*Correspondance* i, 287f.), but it was never published there. Several
months later he outlined further changes, this time in accordance with the instructions of
Victor de Mars, secretary of the *Revue des deux mondes*: "*Voici la troisième fois* que je recopie
et recommence d'un bout à l'autre cet article, enlevant, ajoutant, remaniant, et tâchant de me
conformer aux instructions de M. V. de Mars" (1343) [This is the third time I have recopied
this article and started the whole thing over again, removing, adding, recasting, and trying to
conform to the instructions of M. de Mars.] The *Revue des deux mondes* also rejected the
work. The alterations presumably did not satisfy de Mars, with whose incessant reservations
Baudelaire expressed impatience in January 1855: "En somme, j'ai plus de confiance en son

work, it was dismantled and published at different times in three separate articles; the author's high hopes of bringing them out in prestigious journals were rudely disappointed, and he had to settle for two humbler and relatively insignificant ones.[2] In a work on a comparatively limited aspect of artistic production, Baudelaire ranges freely over a wide variety of topics and artists that seem only tenuously connected with his subject. He defines a system and hierarchy but fails—or refuses—to apply the criteria with the expected theoretical rigor; the essays abound with remarks made and not carried through, opinions warmly expressed but not fully explained, examples unknown or inaccurately described. It is not too far-fetched to hold that one experiences in these essays an uncertainty and uneasiness comparable to Baudelaire's own reaction to the art of Grandville and Bruegel: a sense of organized disorder and calculated deformity, paths that lead nowhere, suggestions not pursued, strange combinations and associations of ideas, hints teasingly dropped, a *mystère* that defies clear and positive understanding.

These notorious problems have consigned the essays to relative neglect in the much-studied area of Baudelairean criticism. Some have acknowledged their importance, notably that of *De l'essence du rire*: Werner Hofmann for the development of modern art, Tobin Siebers for the fantastic, Geoffrey Harpham for the grotesque, Robert Storey for a Baudelairean psychology, Paul de Man for irony, John MacInnes for the problematics of writing, Ainslie Armstrong McLees for Baudelaire's poetic method.[3] But these merely develop one or another aspect of the comic theory, and give no sense of the aesthetic issues raised by the whole. Others have dismissed the essays as

jugement [Buloz's, director of the *Revue*] que dans celui de M. de Mars, qui ne saurait jamais prendre une résolution (une résolution!) sans des: Cependant, —il se pourrait que, —mais il faudrait voir—, il serait peut-être imprudent . . . , etc., et qui a toujours l'air de se résoudre avec indécision" (*Corr.* I, 309). [In short, I have more confidence in his judgment than in M. de Mars's, who cannot make a decision without some "however," "it is possible that," "but we will have to see," "it would perhaps be imprudent," etc., and who always seems to make up his mind indecisively.] This clearly comes from first-hand experience: de Mars's reaction to the essays on caricature.

2. *De l'essence du rire* appeared in *Le Portefeuille* (8 July 1855), the other two in *Le Présent* (1 and 15 October 1857). (These last two were reprinted in the more important review *L'Artiste* in 1858.)

3. W. Hofmann, "Baudelaire et la caricature"; T. Siebers, *The Romantic Fantastic*; G. Harpham, *On the Grotesque*; R. Storey, *Pierrots on the Stage of Desire: Nineteenth Century Artists and the Comic Pantomime*; P. de Man, "The Rhetoric of Temporality"; J. MacInnes, *The Comical as Textual Practice in Les Fleurs du mal*; A. A. McLees, *Baudelaire's "Argot Plastique": Poetic Caricature and Modernism*. See also Y. Abé, "La Nouvelle esthétique du rire: Baudelaire et Champfleury"; and C. Mauron, "Le Rire baudelairien."

incomplete and eccentric, having little relation to the larger corpus of his writings, an exception to the overall coherence of his critical work.[4] Yet this view is called into question by at least one persistent fact: Baudelaire's expressed interest in the essays and, as Pichois observes, his firm belief in their value (1345); his letters repeatedly testify to his concern for the project as a whole.[5] In fact, through their complicated and erratic history they correspond to a longer period of his career than any other single work of criticism, and come into contact with all the major concerns of his aesthetic thought. These seemingly inconsequential essays on so seemingly inconsequential an art form work out some of Baudelaire's most innovative ideas, specifically those concerning the modern aesthetic, in his late works, of the transitory, circumstantial, and contingent, with its corresponding increase in formal freedom.

In arguing for the centrality of the essays on caricature in Baudelaire's aesthetic system, I do not mean simply to locate in an earlier work the germ of subsequent ideas but, more important, to submit those ideas, and our understanding of them, to a critical reconsideration. These problematic essays explore the problematic of Baudelaire's aesthetic itself, posing and probing the questions most fundamental to it. In particular, the peculiar oxymoronic nature of *comic art*, which he treats as a contradiction in terms, represents in boldly exaggerated form, like a good caricature, the dualism of art itself, the contradiction inherent in all artistic creation, as in mankind—at once diabolical and divine, real and ideal, ugly and beautiful, temporal and enduring, inferior and superior. These essays thus bring out, more than any other, the essential humanity, or in the vast theological metaphor of *De l'essence du rire*, the "fallenness" of art—an idea with evident Romantic origins, but involving a radical realignment of values. Here it becomes the necessary (and fertile) condition of art, and art understood not as a *pis-aller* effort to regain an original perfection, but as the positing of that very perfection. The absolute exists only from the fallen, imperfect perspective of mankind; the image of oneness is born of the dualism of the comic; absolute beauty, like the category of *comique absolu*, is relative, a product of the historical and contingent. The essays thus call into question the common view of Baudelaire's system as essentially nostalgic, based on a longing for a primordial wholeness (linguistic, psychological, or metaphysical).[6] The theory of the comic undermines this notion from

4. Charvet, *Baudelaire. Selected Writings on Art and Artists*, 21.
5. He cited *De l'essence du rire* specifically as one of his best articles (*Corr.* II, 339).
6. E.g. Candace Lang, *Irony/Humour*, chap. 4.

within, employing the stock Romantic myth in order to explode the myth or, more appropriately, to affirm it *as* a myth, an entirely *human* invention like the comic, and beauty, themselves.

Like *modernité* in *Le Peintre de la vie moderne*—the transitory, fugitive, and contingent (695)—the comic is bound to the temporal and historical, to the norms of a given culture. From the essential dualism of comic art Baudelaire posits that most extreme dualistic example, a paradoxical art of modernity. Indeed, what emerges from a study of the essays on caricature constitutes a central argument of this book, treated at length in chapter 4: the important and influential theory of the modern beautiful, formulated in *Le Peintre de la vie moderne*, derives directly from the theory of the comic. These essays thus propose not only an aesthetic of caricature but also a caricatural aesthetic—dual and contradictory, grotesque, ironic, violent, farcical, fantastic, fleeting—which defines the painting of modern life, and in large part the discourse of modernity as well.[7] In language, imagery, examples, and ideas, the essay on Constantin Guys repeats and reworks the articles on the comic, which thus lay the theoretical ground for an art "of the age," representing the modern spirit. Crucial features of the idea of modernity, such as the city and its emblematic inhabitant, the urban stroller, or *flâneur*, must be reconsidered in terms of the dualism and ambiguity by which Baudelaire characterizes the comic. The modern city is the space of the comic, a kind of caricature, presenting the *flâneur*, like the laugher, with an image of his own dualism, self-ignorance, and otherness, his status as subject and object, implicated in the same urban experience he seems to control. The theory of the comic invests the idea of modernity with reciprocity, the subject's status as laugher and object of laughter, self and other, thus preventing the subjective construction and appropriation of the world so often linked with the project of modernism.

Comic art thus reflects what Walter Benjamin would later define as Baudelairean allegory, at once embodying and exposing the division and fragmentation of the modern subject, representing and revealing the terrifying and exhilarating otherness of modern experience.[8] But it proposes this as a solution too, making it the means of transcending the very alienation

7. On the specifically poetic implications of caricature's modernity, see McLees, *Baudelaire's "Argot Plastique."*

8. *Paris, Capital of the Nineteenth Century,* in *Charles Baudelaire: A Lyric Poet in the Era of High Capitalism,* esp. 170ff. On Benjamin's theory of allegory, see *The Origin of German Tragic Drama* (part 3, esp. 176f.), and Michael Jennings, *Dialectical Images: Walter Benjamin's Theory of Literary Criticism* (108ff., 170ff.)

which the dualism of the comic and the "brokenness" of allegory express. The dualism of the comic artist becomes the source of a peculiarly modern unity, the artist's capacity for *dédoublement,* that is, to be simultaneously self and other. Although, as Paul de Man argued, this *dédoublement* does not effect a synthesis of the self or unify the self,[9] it nevertheless responds to the problem raised by Benjamin. The "wholeness" of the self is created by the division in the ironic self, which transcends dualism by entering fully into it, maintaining it in the extreme, demonstrating the limitations of the self and redefining it in its relation to others, and creating the conditions by which others do the same.[10] This is the doubling of the comic artist enacted for the benefit of the audience, the self-generating and self-reflexive experience of the *flâneur* in a "communion" with the crowd. In the theory of the comic, Baudelaire's "allegorical genius," as Benjamin called it,[11] is taken a step further, offering in an image of division and fragmentation a means of overcoming these, a modern solution to the alienation of modern life itself.

The importance of the essays for the history of caricature and comic theory itself should not be underestimated. Baudelaire's theory draws upon earlier ones (the parallels are studied in chapter 1), but the quest for influences and the confident identification of sources only bring out more clearly the extent of his originality. These essays mark an important stage in the history of theories of the comic in general, and largely initiate studies of caricature in particular. The two "practical" ones provide an evaluation, unparalleled in quality and scope, of the major artists of what was by all accounts the golden age of French caricature and one of the most brilliant periods in the history of the form—the second quarter of the nineteenth century, with such artists as Daumier, Gavarni, Charlet, Grandville, and Traviès; as well as of notable caricaturists of other nationalities and periods—Hogarth, Cruikshank, Seymour, Goya, Leonardo, Pinelli, and Bruegel the Elder.[12] They offered the first vigorous and extended argument for the

9. "The Rhetoric of Temporality."

10. See G. Handwerk's concept of the "ethical" irony of Friedrich Schlegel, which not only calls into question the boundaries of the subject, but also affirms the interdependence of subjects (*Irony and Ethics in Narrative: From Schlegel to Lacan*). While Baudelaire was not overtly concerned with the notion of community onto which, in Schlegel, the subject's dependence on the Absolute is displaced, he is preoccupied with the poet's or *flâneur*'s relation to the crowd, and the reciprocity that defines it; see chapter 4.

11. *Paris, Capital of the Nineteenth Century,* in *Charles Baudelaire: A Lyric Poet in the Era of High Capitalism,* 170.

12. Although Champfleury exceeded him in range of subject and sheer number of pages, he drew freely on Baudelaire and contributed few theoretical or formal insights. His numerous

value of caricature as a serious art, worthy of study in its own right—an outlandish and bold position at a time when it was generally considered a very minor genre, as impermanent as the events it chronicled. This was not to empty caricature of its subversive qualities through a process of aestheticization, however, but to radicalize the aesthetic itself.[13] Baudelaire understood the significance of comic art as a paradigm of art in general: an insight of no small consequence in the development of modern aesthetics.

Baudelaire was a great systematizer, but understood the severe and inevitable limitations of systems, and indeed delighted in making these apparent: here he moves freely between detail and generalization, reality and abstraction, life and science, to borrow the terms of the *Exposition universelle de 1855*. The theoretical is merely an abstraction and generalization of the real, as his article on Wagner states explicitly.[14] In characteristic fashion, he describes individual works but puts his greatest effort into defining the general features of an artist's oeuvre, a method which he justifies in the same article: "n'est-il pas plus commode, pour certains esprits, de juger de la beauté d'un paysage en se plaçant sur une hauteur, qu'en parcourant successivement tous les sentiers qui le sillonnent?" (796) ["is it not easier, for certain minds, to judge the beauty of a landscape by placing themselves on a height, than by running, one by one, over all the paths that traverse it?"] But the apparent freedom of these highly personal essays should not obscure the intelligence he applies to his material, nor the basic structure he gives to it: according to his conception of an aesthetic system, he here sketches the framework (abstract, philosophical, and by necessity inadequate) that supports the infinitely fuller, more complex

books on the subject are primarily compilations of material: *Histoire de la caricature antique* (1865), *Histoire de la caricature moderne* (1865), *Histoire de la caricature au moyen âge et à la Renaissance* (1870), *Histoire de la caricature sous la République, l'Empire et la Restauration* (1874), *Histoire de la caricature sous la Réforme et la Ligue* (1880), *Le Musée secret de la caricature* (1888), *Henry Monnier* (1879), and, on pantomime, *Souvenirs des Funambules* (1859). The most sophisticated is the *Histoire de la caricature antique*, which attempts to relate the comic art of antiquity to ancient theories of the comic, notably Aristotle's *Poetics* and the fragments of the lost *Poetics II* on comedy preserved in the *Tractatus Coislinianus*, the *Politics*, and the pseudo-Aristotelian writings on physiognomy. Thomas Wright's *History of Caricature and the Grotesque in Literature and Art* (1865) is also a survey, and stops in the early nineteenth century.

13. R. Terdiman (*Discourse/Counter-Discourse: The Theory and Practice of Symbolic Resistance in Nineteenth-Century France*, 180f.) describes an effect of aestheticization in the tradition of Daumier studies as betraying the satirical force of the works.

14. "La poésie a existé, s'est affirmée la première, et elle a engendré l'étude des règles" (793) [Poetry existed and affirmed itself first, and then engendered the study of rules].

structure of the totality of examples. Only here, moreover, does he include a justification of one of the most important aspects of his own career: the activity of the theorist and critic. The comic artist analyzes and creates, knows the nature and causes of the comic and pretends not to, is characterized by self-awareness and feigns the primary condition of the comic, self-ignorance. This artist constantly and blatantly exercises the analytical faculty that Baudelaire considered a necessary component of the imagination. As we shall see, the comic artist proves what Baudelaire elsewhere maintains through the examples of Leonardo, Hogarth, Reynolds, Delacroix, Diderot, Goethe, Shakespeare, and Wagner: that the greatest artists are also theorists. Theory represents and enacts the self-consciousness and "ironic" doubling upon which comic art, indeed all art, ultimately depends.

"My book is very amusing";[15] not the least compelling aspect of these essays is that in them we come face to face with a brilliant example of Baudelaire's prose, having the rhetorical sophistication that distinguishes all his best work. His criticism is original and deeply felt, sometimes passionate, often ironic, always fascinating. His interpretations here reveal the same imagination at the expense of "objectivity" that W. Drost has noted in his criticism of painting;[16] they carry out the suggestiveness of the works on which they comment, thus meeting the critical challenge that his article on Guys formulates, justifies, and takes to unprecedented heights (712). Perhaps more important, they are replete with paradox, irony, and tongue-in-cheek humor, which here take on special significance, given the topic to which they are applied. Indeed, Baudelaire exploits his mastery of these techniques to make the essays enact the very comic processes that they describe, and frequently at the reader's expense. Putting the theory into action in this way makes the essays on the comic superb examples of the comic as well.[17] Ever confronted with the inadequacy of description to convey the effect of the comic and the visual, as Baudelaire notes frequently, the text becomes a comic work itself, like the sonnet that is the best account of a painting in the *Salon de 1846*, or the lines from "Correspondances" that best translate the overture to *Lohengrin* in the essay on Wagner.[18] Here

15. *Corr.* I, 174f.

16. "De la critique d'art baudelairienne," 82.

17. For examples of this coincidence of theory and practice in other comic theorists, notably Freud, see R. Simon, *The Labyrinth of the Comic. Theory and Practice from Fielding to Freud.*

18. *Salon de 1846* (418); *Richard Wagner et "Tannhäuser" à Paris* (784). J. P. Guillerm describes such a phenomenon as the text's "self-fetishization," making itself a work to replace the one it cannot capture ("Matières et musiques: la peinture ancienne et le texte critique à la fin du dix-neuvième siècle," 30).

the stylistic tactic runs the whole gamut of Baudelaire's *comique*, from ironic understatement to outright sensationalism, from Daumieresque satire to the powerfully murky mysteriousness of Goya's fantastic. The theorist is thus an exemplary comic artist, leading the reader toward the same self-knowledge, and the same capacity for creation, that he himself demonstrates in doing so. And this—revealing the reader's own situation—may be, as Benjamin held, the purpose of criticism and the condition for true change.[19]

19. See Jennings, *Dialectical Images: Walter Benjamin's Theory of Literary Criticism*, 37.

Baudelaire's Theory of the Comic:
De l'essence du rire

<div style="text-align: right">

1

</div>

In part 3 of *De l'essence du rire*, Baudelaire sarcastically dismisses the proponents of the traditional superiority theory of laughter, the "physiologistes du rire":

> Du reste, leur découverte·n'est pas très profonde et ne va guère loin. Le rire, disent-ils, vient de la supériorité. Je ne serais pas étonné que devant cette découverte le physiologiste se fût mis à rire en pensant à sa propre supériorité. (530)

> [Moreover their discovery is not very profound and hardly goes very far. Laughter, they say, comes from superiority. I would not be surprised if on making this discovery the physiologist himself started laughing at the thought of his own superiority.]

The example represents well his method in the essay as a whole. The highly ironic final sentence turns the superiority theory against the theorists themselves: they feel superior for having made such a remarkable discovery, but he derides them for their actual ignorance and self-delusion; and we, feeling ourselves with the author truly superior to them, laugh. The joke, in which the laugher feels superior while unknowingly the object of another's laughter, enacts the very principle of Baudelaire's theory: the comic is a mark of human dualism, a sense of superiority over the object of laughter and of inferiority relative to the absolute. But the irony necessarily leaves us uneasy

too, for we may suffer from the same self-delusion as the ludicrous *physio-logistes du rire*; the new laugher may take the place of the old. In these circumstances, the only way out is the consciousness of dualism, the ironic awareness of our simultaneous superiority and inferiority, and, as we shall see, the doubling that may ensue, the integration of the self with others.

Throughout the essays Baudelaire similarly puts the theory to work in the very process of formulating it, developing his philosophy of the comic and caricature while employing their main methods: irony and sarcasm, under-statement and extravagance, violence and insinuation, farce and wit. This metadiscursive comic commentary on the comic makes the reader at once privy to the joke and the butt of it. Moreover, it represents the main qualities of the comic at its highest level, the *absolu*: the inseparability of the creative and the theoretical, the aesthetic and the moral, and the perceived unity of a nonetheless dualistic form, "qui se présente sous une espèce *une*" (536). The reader experiences the abstraction as simultaneous with its realization, a feature, as we shall see, of the best examples of the comic: the English pantomime, which represents the quintessence of comedy, the pure comic in concentrated form (540), and the tales of Hoffmann, that "catechism of high aesthetics" (542).

Such a comic method does not merely ridicule an object, but remakes it into a new and independent creation, as Baudelaire will argue of caricature too. He relies on a standard comic technique, using clichés, commonplaces, and received traditions to produce a thoroughly novel meaning. In the example at hand, the joke about the *physiologistes* has a substantive point within the development of the argument itself, for despite his sarcasm Baudelaire will incorporate the superiority theory into his own. He ridicules a position he partially endorses, because it does not go far enough, that is, to the origins of the idea of superiority itself and the basis of his own theory: "Ainsi il fallait dire: Le rire vient de l'idée de sa propre supériorité. Idée satanique s'il en fut jamais!" (530) [Thus one should have said: laughter comes from the idea of one's own superiority. A satanic idea if ever there was one!]

Indeed, Baudelaire presents his theory of the comic via a sustained, and for some, troublingly heavy-handed, theological metaphor, the myth of the Fall. Laughter is a sign of human misery, imperfection, and weakness after the fall from grace or, as he jokingly puts it, "one of the numerous pips contained in the symbolic apple" (530). The more familiar superiority theory follows only from this primary mythical explanation: laughter comes from the sense of one's own superiority, but this is itself a manifestation of

pride, an aspect of the imperfect state of humanity after the Fall. Laughter is thus essentially ambiguous, resulting from the clash of two opposing perceptions, however unconscious: the sense of superiority over others is matched by a sense of inferiority vis-à-vis the absolute. For Baudelaire, as for Aristotle, laughter is proper to mankind, "profoundly human" (532), but precisely because it is "satanic," that is, the mark of defiance, degradation, and dualism: superior to the animals and plants, even to other human beings, inferior to the divine.

But in exploiting the theological model *à outrance*, as we shall see, he employs an essentially comic technique, making one of the oldest of myths state a radically new principle: the status of comic art, and notably caricature, as a "high" art, one especially well suited to the paradoxes and contradictions of the modern temperament. The myth is used allegorically, as a figure of speech separate from the reality it expresses and proclaiming itself as such. And allegory, that primary Baudelairean form, may be the one most apt for the representation of modern history, as Benjamin argued, and of modern beauty too.[1]

The Scope of the Comic

Je ne veux pas écrire un traité de la caricature; je veux simplement faire part au lecteur de quelques réflexions qui me sont venues souvent au sujet de ce genre singulier. Ces réflexions étaient devenues pour moi une espèce d'obsession; j'ai voulu me soulager. . . . Ceci est donc purement un article de philosophe et d'artiste. (525)

[I do not intend to write a treatise on caricature; I simply want to share with the reader some reflections that have often occurred to me about this singular genre. These reflections have become for me a kind of obsession; I wanted to get them off my chest. . . . This, then, is purely an artist's and philosopher's article.]

1. Cf. Benjamin, *The Origin of German Tragic Drama*, 165ff., and 197: "the western conception of allegory is a late manifestation which has its basis in certain very fertile cultural conflicts." See also Jennings, *Dialectical Images*, 173ff.

Blatantly contradicting the high theoretical claims of the title—*De l'essence du rire et généralement du comique dans les arts plastiques*—deflating with one stroke the swollen seriousness of its excessive length and the enormous project which it announces, the opening sentence begins the essay with a joke.[2] Such disingenuousness is only the first of many ironies; his casual, irresponsible, purposes and his limited ambitions suggest in fact the immense theoretical breadth of the enterprise. Baudelaire does not intend to write a treatise on caricature as these have hitherto been understood, that is, as a history of the form;[3] *De l'essence du rire* far surpasses this and embraces the comic in general. His position is bold and provocative: histories of caricature in relation to political, religious, and social events were the only available, and acceptable, writings on the subject. Only history could justify the study of a form that was not considered an art. The first book on French caricature indeed took such an approach: Boyer-Brun's *Histoire des caricatures de la révolte des Français* (1792), a collection of caricatures on the Revolution accompanied by a commentary on the relevant political events.[4] And the more recent two-volume *Musée de la caricature* (1838), with contributions by Nodier, Janin, Halévy, and Chasles, traced a history of caricature with respect to the major political events in France from the fourteenth century to the end of the Napoleonic era.[5]

But Baudelaire's point is also crucial to his theory, establishing the

2. Macchia (*Baudelaire critico*, 149 n. 140) likens the title to the best-known early French comic treatise, Joubert's 1597 *Traité du ris, contenant son essence, ses causes et mervelheus effais, curieusement recherchés et observés*. For the "contractual" role of titles in Baudelaire, see M. Maclean, *Narrative as Performance: the Baudelairean Experiment*, 48, 81, 96f.

3. Baudelaire had at one time conceived of the work as a history (see *Corr.* I, 145, 4 December 1847). Pichois suggests that the division of labor was effected in conjunction with Champfleury (1345), but the *Histoire de la caricature antique* and *Histoire de la caricature moderne* did not appear until 1865, and do not fulfill Baudelaire's formula. The latter work covers nineteenth-century French artists only, and fewer than Baudelaire's at that: Daumier, Traviès, and Monnier in the main text, Philipon, Pigal, Grandville, and Gavarni in appendices; the former deals with ancient examples of caricature from Egyptian and Gallo-Roman times but makes no reference to contemporary events. Champfleury's debt to Baudelaire was immense (see chap. 2).

4. The author, an ardent royalist, tried to show that caricature had been one of the most effective means (notably for a Huguenot conspiracy) of rousing the people to insurrection.

5. *Musée de la caricature, ou Recueil des caricatures les plus remarquables publiées en France depuis le XIVè siècle jusqu'à nos jours, pour servir de complément à toutes les collections de mémoires*, ed. E. Jaime. First published in serial form from 1834, this work had a certain renown: Thackeray alludes to it (although he cannot recall the title or editor) and judges it unsuccessful, the drawings meager in wit and poor in execution ("Parisian Caricatures," *Westminster Review* 32 [April 1839], repr. as "Caricatures and Lithography in Paris," *The Paris Sketchbook*, in *The Works of Thackeray* XVII, 221f.).

division between "historical" and "artistic" caricature (568). Works of the first type have a representational value and are understood with respect to exterior events; they provide a historical record, a collection of anecdotes and facts, and constitute part of the national archives; they are comparable to pages of a newspaper, short-lived and fleeting, wholly subject to the winds of time; they belong to the domain of real experience and thus interest the historian, the archaeologist, and to some extent the philosopher. Those of the second type have value in themselves alone and belong to the realm of the imagination; they contain a mysterious, enduring element making them works of art, and interest the artist. *Caricature artistique* is an oxymoronic term, for the contingency of *caricature*, "ces oeuvres fugitives, pour ainsi dire suspendues aux événements" (568) [these fleeting works, hanging on events, so to speak], contradicts the eternal quality of *artistique*. Moreover, it expresses an aesthetic paradox that constitutes the main subject of the essay and leads us to the center of Baudelaire's comic philosophy:

> Chose curieuse et vraiment digne d'attention que l'introduction de cet élément insaisissable du beau jusque dans les oeuvres destinées à représenter à l'homme sa propre laideur morale et physique! Et, chose non moins mystérieuse, ce spectacle lamentable excite en lui une hilarité immortelle et incorrigible. Voilà donc le véritable sujet de cet article. (526)

> [What a curious thing, and one truly worthy of attention, is the inclusion of this intangible element of beauty even in works meant to represent to man his own moral and physical ugliness! And, what is no less mysterious, this lamentable spectacle arouses in him an immortal and incorrigible hilarity. Here, then, is the true subject of this article.]

The traditional comic mirror sends back an image of one's own ugliness; Baudelaire's represents the ugly while incorporating the beautiful, offering an image of human vice or folly that produces irrepressible pleasure. But this phenomenon is hardly as peculiar as he pretends. Caricature represents in exaggerated and exemplary form the paradox of art itself, as so many well-known examples from his poetry attest: the hideous, enchanting vice of "Au Lecteur"; the splendid, flower-like rotting corpse in "Une Charogne"; the "ridiculous" hanged man in whom the speaker of "Un Voyage à Cythère" sees his own image; the urban mud of Paris changed to gold by

the poet's alchemy in the final line of "Epilogue," extracting beauty from evil.[6] Caricature is a *fleur du mal*.[7] The paradoxical response to an image of one's own ugliness reflects the same dualism present throughout Baudelaire's moral system: that of "l'homme désaccordé au point d'exprimer la douleur par le rire" [man so divided as to express sorrow by means of laughter],[8] or the poet of "L'Héautontimorouménos," condemned to eternal laughter. In his 1861 essay on Banville, he describes this phenomenon at work in the demoniacal character of modern art: humanity takes increasing pleasure in analyzing the satanic aspects of the human soul (168).

In the essay at hand, caricature too is the locus of modernity, notably in its subversion of academic ideals. Evoking a hypothetical "dîner d'académiciens," Baudelaire derides Academic aestheticians with brutal sarcasm for their obsession with the serious at the expense of the comic, referring to them with his most damning term for tasteless and unimaginative conservators of official values, the *professeurs jurés*:[9] "professeurs jurés de sérieux, charlatans de la gravité, cadavres pédantesques sortis des froids hypogées de l'Institut, et revenus sur la terre des vivants, comme certains fantômes avares, pour arracher quelques sous à de complaisants ministères" (526) [Distinguished Professors of seriousness, charlatans of gravity, pedantic corpses that have emerged from the cold vaults of the Institute and returned to the land of the living, like certain miserly ghosts, to extract a few pennies out of obliging ministries].[10] The serious "pedantic corpses" who ridicule Rabelais as a vulgar buffoon here become the right objects of ridicule, the

6. "Il m'a paru plaisant . . . d'extraire la beauté du Mal" (projected preface to the *Fleurs du mal*, I, 181).

7. See McLees, *Baudelaire's "Argot Plastique,"* 128.

8. *Edgar Poe, sa vie et ses ouvrages* (317).

9. The term comes from Heine's *Salon de 1831*, which Baudelaire quotes in the *Salon de 1846* (432). In the *Exposition universelle de 1855*, he characterizes the *professeur juré* as "a crazy doctrinaire of Beauty . . . closed up in the blinding fortress of his system," a "mandarin-tyrant," "a godless man who substitutes himself for God" (577f.); and in the *Notes nouvelles sur Edgar Poe*, "those sphinxes without a riddle who stand guard before the holy gates of classical Aesthetics" (319).

10. Cf. Balzac's 1830 attack on liberalism in politics, philosophy, and the arts: "ces marchands d'idées creuses . . . [qui] nous parlent de la gravité du moment, de la gravité des circonstances, de la gravité publique, et de la gravité particulière" [those merchants of hollow ideas . . . who speak to us of the gravity of the moment, the gravity of circumstances, public gravity, individual gravity] ("Complaintes satiriques sur les moeurs du temps présent," *Oeuvres diverses* I, 349). Baudelaire probably read this: it contains the same image of the modern hero as the *Salon de 1846* (494), wearing, in his black suit, a symbol of mourning (*Oeuvres diverses* I, 344). On Balzac's attack, see M. Ménard, *Balzac et le comique dans La Comédie humaine*, 68f.; and R. Chollet, *Balzac journaliste. Le Tournant de 1830*, 247ff.

true buffoons: the essay thus accomplishes this first inversion, dethroning the ruling aesthetic powers and making way for a new system of value.

But the joke has a further point: the Academic dinner recalls Stendhal's parody of a session of the Academy in *Racine et Shakespeare*, and, like it, uses the comic to propose a new aesthetic altogether. *De l'essence du rire* becomes the modern version of Stendhal's Romantic manifesto, formulating an aesthetic proper to the age: "En vérité, faut-il démontrer que rien de ce qui sort de l'homme n'est frivole aux yeux du philosophe? A coup sûr, ce sera, moins que tout autre, cet élément profond et mystérieux qu'aucune philosophie n'a jusqu'ici analysé à fond" (526) [In truth, is it necessary to demonstrate that nothing which issues from man is frivolous in the eyes of a philosopher? And least of all, certainly, that profound and mysterious element that no philosophy has up to now analyzed in depth]. Appropriately, Baudelaire slips by the reader, in a casual afterthought, the central idea of the essay: the extraordinary aesthetic importance of an art traditionally considered low, coarse, and vulgar, an art of the average person, an art which, as he later states, "amuses the Parisian population" and "satisfies the needs of public gaiety" (549), an art with an overtly social function. Studying comic art does no less than shed light on the shadowy concept of beauty, the essence of art itself—no small claim for a work meant simply to convey some modest reflections.

Le rire est satanique, il est donc profondément humain

Baudelaire introduces the fundamental principle of his theory—the satanic nature of the comic—with one of his favorite devices, the maxim, a technique consistent with the allegorical nature of the essay's theology.[11] Curiously, however, he spends the whole first paragraph reflecting not on its meaning or importance, but on its uncertain origin:

> *Le Sage ne rit qu'en tremblant.* De quelles lèvres pleines d'autorité, de quelle plume parfaitement orthodoxe est tombée cette étrange et

11. On maxims as a sign of allegory, see Benjamin, *The Origin of German Tragic Drama*, part 3, 196f. (He does not discuss Baudelaire, however.) On Baudelaire's use of the maxim in the *Le Spleen de Paris*, see J. A. Hiddleston, *Baudelaire and Le Spleen de Paris*, 39ff.

saisissante maxime? Nous vient-elle du roi philosophe de la Judée? Faut-il l'attribuer à Joseph de Maistre, ce soldat animé de l'Esprit-Saint? J'ai un vague souvenir de l'avoir lue dans un de ses livres, mais donnée comme citation, sans doute. Cette sévérité de pensée et de style va bien à la sainteté majestueuse de Bossuet; mais la tournure elliptique de la pensée et la finesse quintessenciée me porteraient plutôt à en attribuer l'honneur à Bourdaloue, l'impitoyable psychologue chrétien. Cette singulière maxime me revient sans cesse à l'esprit depuis que j'ai conçu le projet de cet article, et j'ai voulu m'en débarrasser tout d'abord. (526f.)

[*The Sage laughs not without trembling.* From what authoritative lips, from what perfectly orthodox pen, did this strange and gripping maxim fall? Does it come to us from the philosopher-king of Judea? Should we attribute it to Joseph de Maistre, that soldier moved by the Holy Spirit? I have a vague memory of having read it in one of his books, but given as a quotation, no doubt. That severity of thought and style fits well the majestic holiness of Bossuet; but the elliptical turn of thought and its refined delicacy would lead me rather to give the honor to Bourdaloue, that unrelenting Christian psychologist. This singular maxim has kept coming back into my mind ever since I first conceived the idea of this article, and I wanted to get rid of it at the outset.]

Despite the explanation suggested for his uncertainty—so much time has elapsed that he cannot remember where he first encountered the maxim—the insistent, forced uncertainty here is clearly suspect:[12] he dwells on the puzzle and delights in it, toying with four candidates and providing equally valid evidence for three of them. Indeed the maxim can be traced to none of the proposed sources, and even departs significantly from their views.[13] They discuss comedy not in Baudelaire's metaphysical terms, but simply in moral ones, as Ruff observes:[14] comedy provokes laughter, pleasure, and

12. Baudelaire frequently quotes—or misquotes—from memory, e.g. *Exposition universelle de 1855* (596) and *Salon de 1846* (419).

13. Clapton finds a parallel in Lavater, whom Baudelaire mentions in *Quelques caricaturistes français*: "Le Sage sourit souvent et rit rarement" [The Sage smiles often and laughs rarely] ("Lavater, Gall et Baudelaire," 444). Patty makes a case, now widely accepted, for Bossuet ("Baudelaire and Bossuet on Laughter").

14. *L'Esprit du mal et l'esthétique baudelairienne*, 257.

applause for what is immodest and base, the thesis motivating critics of the theater from Plato to Rousseau. One has the distinct impression that the mystery surrounding its origin serves principally to enhance the effect of the "strange and gripping maxim" itself.

So why this conspicuous *fausse route*, this long digression at the very outset, if it leads nowhere? The seriousness of the quest is undermined by the ludicrousness of the passage itself. In insisting on the theological nature of the source, Baudelaire exaggerates it to the point of comicality: "plume parfaitement orthodoxe," "soldat animé de l'Esprit-Saint," "sainteté majestueuse," "impitoyable psychologue chrétien"; in the following two paragraphs he also remarks upon "the officially Christian character of this maxim" and, with absurd understatement, "an author—a Christian, no doubt." Of the four possibilities, three are spokesmen for the most orthodox Catholicism, and one is the Bible itself. Moreover, the final sentence, expressing his need to rid himself of the haunting maxim, recalls the obsessive reflections he had wished to get off his chest in the first lines of the essay: perhaps the maxim is no more than one of those, a joke played on the reader to lead to a more important point.[15] There are instances elsewhere in his work where he not only misquotes, but does so deliberately, and then falsely proclaims his uncertainty about the attribution of the famous idea.[16] Here he goes a step further: the maxim has so many possible sources as to have none at all; the "authoritative lips" are those of the author himself.[17]

In fact, Baudelaire presents us with an "orthodox" maxim paradoxically of his own invention, invoking the dominant—Christian—comic tradition only to subject it to a radical revision. The theological basis of his own theory—the fallenness of the comic—will be of a different order altogether. His emphasizing the orthodox character of the maxim brings this out, anchoring the theory in a metaphysical and moral tradition, while distancing him from it at the same time: this is the Christian point of view, but not necessarily his own. Through the comical exaggeration and the suspect nature of the maxim, the theology is exposed from the start as a figure of

15. Cf. MacInnes, *The Comical as Textual Practice in Les Fleurs du mal*, 58.
16. Hiddleston (*Baudelaire and Le Spleen de Paris*, 50) gives as an example the misquotation of Pascal's *Pensées* in "La Solitude."
17. Baudelaire is correct—and coy—to attribute the maxim to Bourdaloue on the basis of its *tournure*, for it pastiches a remark in the *Sermon pour le premier jour de Pâques*: "on ne pèche qu'en tremblant; on n'étouffe qu'avec peine les remords de la conscience" [one sins only in trembling; one can stifle the remorse of conscience only with great effort] (Bourdaloue, *Oeuvres complètes* [1919], I, 46). The formula has connotations as theological as the idea it expresses.

speech, representing something else, a conventional language made to carry a new meaning. The joke of *Le Sage ne rit* foregrounds the metaphoricity of the theology on which the entire theory depends, exposes it, and ironically makes it the vehicle of an apologia for the very genre it most proscribes.

On this last point, the tradition is unequivocal. Bossuet's *Maximes et réflexions sur la comédie* (1694), for example, condemns comedy for its harmful effects on the spectator (arousing the passions), and laughter as the manifestation of an immodest lack of control. These represent the traditional Christian objections to comedy and have both ancient philosophical and biblical origins.[18] Plato proscribes comedy at *Republic* x.606c for inspiring a *real* weakness in the audience, corresponding to the fictional weakness at which we laugh. We take pleasure in what would normally provoke shame or distaste, and are led to behave as foolishly or crudely as what we have seen on stage.[19] Moreover, laughter betrays an overindulgence in the emotions, and in excess is forbidden to the guardians of the ideal state; nor should the gods be so represented.[20] Bossuet associates the quiet laughter of the sage with modesty, virtue, prudence, and self-possession, and the raucous laughter of the fool with recklessness, dissoluteness, and sin.[21]

In fact, Baudelaire is here more orthodox than the orthodox, taking this position even further. He compares laughter to temptation and that arch-sin, concupiscence. It has the attraction of the infernal abyss, betrays a

18. Bossuet's treatise was widely known and cited, and Baudelaire had surely read it. For the Christian tradition, cf. Bourdaloue, *Sermon pour le troisième dimanche de Pâques, sur les divertissements du monde* (*Oeuvres complètes* [1905], iii, 194ff.); and, closer to Baudelaire's own time, Lamennais, *Esquisse d'une philosophie* iii, 368ff. In his memoirs (1853), Alexandre Dumas *père* quotes from this tradition at length—Bossuet, Bourdaloue, and Rousseau—and notably its condemnation of comedy as a temptation of the devil and of Molière as his agent (*Mes Mémoires* iv, 308ff.).

19. Cf. Augustine's criticism of the theater (*Confessions* iii.2).

20. *Republic* iii, 388e–389a; *Laws* v, 732c. For Rousseau, arguing against the Aristotelian theory of catharsis, theater similarly excites the passions and reinforces prejudice; comedy elicits laughter for what should provoke indignation, and is associated with license, vice, and deception (*Lettre à M. d'Alembert sur les spectacles*, 27f., 29f., 35f.).

21. Bossuet bases his argument on St. Basil (who himself quoted *Ecclesiasticus* xxi.23): "il permet, avec Salomon, d'égayer un peu le visage par un modeste souris; mais, pour ce qui est de ces grands éclats et de ces secousses du corps, qui tiennent de la convulsion, selon lui elles ne sont pas d'un homme vertueux et qui se possède lui-même" [following Solomon, he permits enlivening the face with a modest smile; but as for those great bursts and jolts of the body, which are of the nature of convulsions, according to him they do not suit a virtuous man, one who is in possession of himself] (*Maximes et réflexions sur la comédie*, 262f.). Ironically, the convulsive laughter of the Belgians is one of the recurring annoyances recorded in the notes Baudelaire took in Belgium from 1864 to 1866 (827f., 850f., 856).

hidden evil, and expresses the doubt and uneasiness which it seems to deny: "le Sage y regarde de bien près avant de se permettre de rire, comme s'il devait lui en rester je ne sais quel malaise et quelle inquiétude" (527) [the Sage considers things very closely before permitting himself to laugh, as though there might remain with him some indefinable uneasiness and anxiety]. It stands in contradiction to wisdom; Jesus, "the Sage *par excellence*" (527), never laughed.[22] Laughter is rather the province of ignorance, weakness, and madness, incompatible with the omniscience and omnipotence of the divine. Under its influence, the human face becomes distorted, its unity split in a grinning mouth, its simplicity contorted into multiple grotesque forms.[23]

As with the maxim, however, Baudelaire here maintains an ironic distance. He calls attention to the theological position as a mere point of view, thus suggesting a relativeness inconsistent with its claim to truth and universality: "It is certain, if one wants to take the orthodox point of view, that . . ."; "From the point of view of my Christian philosopher, . . ." To the catalogue of orthodoxy that he takes almost verbatim from Philippe de Chennevières he comically adds the unequivocal heresy that the Fall may be understood literally or metaphorically, in theological or social terms: "Dans le paradis terrestre (qu'on le suppose passé ou à venir, souvenir ou prophétie, comme les théologiens ou comme les socialistes)" [In the earthly paradise (whether we imagine it as past or still to come, a memory or a prophecy, in the sense of the theologians or the socialists)]. The theology establishes the comic as a central cultural myth; it takes the first step in the essay's stated "philosophical" purpose, the reevaluation of the comic, by making this most "frivolous" phenomenon (526) a human concern of the highest order, on par with the very condition of mankind.

Indeed, through exaggerating and then ironizing the orthodoxy, Baudelaire radicalizes and revises it. The maxim goes far beyond the traditional reason for censure—excessive passion—to establish a fundamental contradiction between wisdom and laughter. The sage *cannot* laugh without

22. The legend that Jesus never laughed, although he took on human tears and suffering, is a commonplace: *aliquando flevit, sed nunquam risit* (cf. John Chrysostom, *In Matth. Homil.* vi, 6). It figures in numerous works of the period. e.g. Lamennais, *Esquisse d'une philosophie*, iii, 371; and P. Scudo, *Philosophie du rire*, 134.

23. The deformity and contortion of laughter are traditionally cited as signs of its affiliation with the satanic. Baudelaire quotes Gautier on "ce rire . . . qui déforme la créature de Dieu!" (108) [that laughter which deforms God's creature!]. Cf. Lamennais, *Esquisse d'une philosophie*, iii, 371.

trembling; in laughter something ominous is recognized and feared, as it is simultaneously flouted. More important, trembling reflects not only dread, but also culpability, the Sage's own implication in the evil: those who tremble know their own guilt, as he puts it in his review of *Les Misérables* (223). In his essay on Wagner, he describes a similar process: one who listens to *Tannhäuser* begins trembling upon hearing the Venusberg music, that reminder of "the diabolical part of man" (795). The maxim thus introduces the dualism of laughter on which the whole theory depends: the laughter's alliance with the object of laughter.

Baudelaire indeed reverses the "orthodox" story of degradation, making the product of the Fall the very means of redemption and thus affirming the salutary value of comic art: "les phénomènes engendrés par la chute deviendront les moyens du rachat" (528) [those things born of the Fall will become the means of redemption].[24] He thus converts a standard Christian argument *against* comedy—the pleasure taken in a reminder of the Fall—into an apologia for it, according to an equally central Christian doctrine: sin itself, in the Augustinian tradition, is a calling back to the path of righteousness.[25] The Pascalian "postulation vers Satan" described in *Mon Coeur mis à nu* XI (I, 682), here represented by laughter, also measures our distance from God; laughter is the voice of the "fallen angel who remembers the heavens" (323), the sign of mankind's idea of an absolute, "l'Etre absolu dont il possède la conception" (532). It may be compared to the tears of aesthetic emotion in the *Notes nouvelles sur Edgar Poe* (334), which, in Poe's own words, testify not to pleasure but to the melancholy of a nature impatient for that paradise which the object evokes. In the same essay, perversity, the love of evil for its own sake, is, like the comic, a primitive, irresistible force, which we attribute to the devil but may actually come from a clever God: "Dieu en tire souvent l'établissement de l'ordre et le châtiment des coquins;—*après s'être servi des mêmes coquins comme de complices!*" (323) [God often draws from it the establishment of order and the punishment of rogues;—after having made use of these same rogues as accomplices!][26] Evil and vice may lead to prayer, the "cri sublime" of

24. Once again, this clause is added to the Chennevières original (quoted 1347).

25. Cf. Ruff, *L'Esprit du mal et l'esthétique baudelairienne*, 257. The transformation of the "phénomène de la chute" into a "moyen du rachat" also states a favorite theme of Joseph de Maistre's: evil may have entered the world by the mistake of mankind, but it persists by the grace of Providence, as expiation and reparation (see J. Vouga, *Baudelaire et Joseph de Maistre*, 38, 210). But Baudelaire means something quite different from traditional expiation here, as we shall see.

26. Cf. the famous cry of "Mademoiselle Bistouri," with its ironically ambiguous "peut-

Tannhäuser who, in Baudelaire's words, "surfeited with enervating plea-
sures, yearns for sorrow!" (795), and from the midst of the Venusberg's
sensual delights longs for suffering and penance. Baudelaire emphasizes a
necessary coexistence: laughter requires two presences in conflict. Paradise
is not a separate, absent state to be rejoined but is posited by the imperfect
imagination itself, an absolute defined through the fallen subject: "l'Etre
absolu dont il possède la conception" (532).[27] This is the condition for
laughter, which expresses the tension between the two, the "irritation,"
infinite grandeur and infinite misery, our distance from paradise and our
conception of it (532).

As Geoffrey Harpham points out, the reversal whereby the products of
the Fall become the means of redemption ensures for Baudelaire's system
the same regenerative force that Bakhtin attributes to the authorized comedy
of Carnival, the official, circumscribed inversion of power represented by
medieval popular festivals, the systematic parody of the conventional or-
der.[28] Bakhtin had criticized Kayser's definition of the grotesque—indeed,
the Romantic notion generally—for neglecting the sense of renewal implied
by the term.[29] For Bakhtin, the grotesque testifies to the possibility of a
utopian, authentic world, where people become one with themselves, body,
soul, and mind, embracing and participating fully in the continually regen-
erating cycle of life, and where fear of some unknown Other is wholly
absent: in Carnival the existing world is accordingly destroyed and reborn
in a new form. Harpham argues that Bakhtin, in his belief that through the
grotesque we reappropriate that world, misses Baudelaire's point about the
satanic origins of laughter, and thus the impossibility of doing so.[30] As
Bakhtin never mentions Baudelaire, it may be more accurate to say, from a
slightly different angle, that he misses the regenerative possibilities of a
Romantic-based conception of the comic. Bakhtin maintains that Romantic
laughter does not have the liberating, creative character of the carnival-

être": "Seigneur, mon Dieu! . . . vous . . . qui avez peut-être mis dans mon esprit le goût de
l'horreur pour convertir mon coeur, comme la guérison au bout d'une lame" (I, 356) [Lord,
my God! . . . you . . . who perhaps put into my mind a taste for horror so as to convert my
heart, like the cure at the end of a blade].
 27. This corresponds to Lang's notion of humor, following Lyotard's concept of represen-
tation as the positing of a presence that never was, and of desire as a will to knowledge (*Irony/
Humor*, 61ff.).
 28. *On the Grotesque*, 70ff. Harpham, however, ascribes the regenerative capacity of
Baudelaire's notion of damnation to the relation between the mythical and the demonic.
 29. *Rabelais and his World*, 48.
 30. *On the Grotesque*, 72.

esque.[31] Baudelaire's theory suggests that it does, or can; and that these very qualities exist only by virtue of dualism, within a system marked by a Fall. The license of Carnival has meaning only in relation to the artificial restriction, constraint, and hierarchy of social life; similarly that of the grotesque in relation to the limited and limiting forms of thought, perception, and representation that it violates. In Baudelaire's terms, the redemption or regeneration that the grotesque brings about has meaning only in relation to that damnation of which it is a sign. As Werner Hofmann says of caricature, it follows the pattern of all revolutionary forms and activity: it binds itself to the model it is dethroning, and is sustained by the system it attacks.[32]

Yet Baudelaire's insistence that the product of the Fall is the means of redemption makes the relation between the comic and the norm, Carnival and the social order, more complex and interdependent. Comic violation may reinforce the order it momentarily upsets, but it is inspired by the order itself. The grotesque validates the dualism from which it seems to free us, but it is a product of that very dualism too. If it risks being absorbed into the order it rejects, so the order risks being overturned by the grotesque. Reinforcing the norm ensures the tension, the clash or "choc" (532) from which laughter springs, the means by which the norm is undermined. The norm guarantees its own relativity, acknowledges its tenuousness and dependence, its vulnerability to an "enemy" that is part of its own self and coexistent with it. The liberation effected by the Baudelairean *comique* is a function of the dualism that it transcends, and that *ensures* its own transcendence; indeed, as we shall see later, transcending dualism lies precisely in maintaining it. Similarly, the dominant quality of Bakhtin's carnivalesque laughter—it includes itself in what it mocks[33]—will be realized by the dualism of Baudelaire's: the laugher is always a potential object of laughter.

Baudelaire illustrates the action of the comic—and specifically caricature—in a secular myth matching the theological one, a literary example of the Fall in Bernardin de Saint-Pierre's heroine, Virginie, "une âme absolument primitive et sortant . . . des mains de la nature . . . qui symbolise parfaitement la pureté et la naïveté absolues" (528) [a soul absolutely primitive and emerging fresh from the hands of nature . . . who symbolizes

31. *Rabelais and his World*, 51.
32. *Caricature from Leonardo to Picasso*, 11. Cf. Terdiman's discussion of the problem that this involves for all counter-discursive practices, which, having violated and internalized the dominant discourse, risk being contaminated by it (*Discourse/Counter-Discourse*, 185).
33. *Rabelais and his World*, 12.

perfectly absolute purity and naiveté]. Baudelaire takes a detail of the story—Virginie's displacement from the earthly paradise of her island to Paris, where she is sent to school and very nearly married off—and embroiders it into a fable of his comic theory. Raised a child of nature, and thus knowing no evil or vice, this hypothetical Virginie arrives in the most corrupted and corrupting of civilizations, Paris: a contrast exemplified by the difference between the "pure and rich scents of the East" to which she is accustomed (529) and the putrid stink of Paris, "turbulent, overwhelming, mephitic" (528), between the sublime images of waves, mountains, and forests that fill her eyes in her native land, and the coarse and libertine images that arrest, overwhelm, and paralyze her view in the city. She has all the innocence of the mythical first woman—she is unconscious of her sex, knows God only through the manifestations of Nature, and has no experience of images and books, the traditional representatives of deception and duplicity. Baudelaire's tale reenacts the temptation and fall of mankind, as an unsubtle pun on her "fall" into civilization (528) makes clear from the start. To an unsuspecting Eve, the city holds out the fatal apple, a caricature—an image of dualism, complication, deception, and violence to trouble her simple, angelic view:

> Or, un jour, Virginie rencontre par hasard, innocemment, au Palais-Royal, aux carreaux d'un vitrier, sur une table, dans un lieu public, une caricature! une caricature bien appétissante pour nous, grosse de fiel et de rancune, comme sait les faire une civilisation perspicace et ennuyée. Supposons quelque bonne farce de boxeurs, quelque énormité britannique, pleine de sang caillé et assaisonnée de quelques monstrueux *goddam*; ou, si cela sourit davantage à votre imagination curieuse, supposons devant l'oeil de notre virginale Virginie quelque charmante et agaçante impureté, un Gavarni de ce temps-là, et des meilleurs, quelque satire insultante contre des folies royales, quelque diatribe plastique contre le Parc-aux-Cerfs, ou les précédents fangeux d'une grande favorite, ou les escapades nocturnes de la proverbiale Autrichienne. (529)[34]

34. Adhémar ("L'Education de Baudelaire faite par son père," 129) identifies the "précédents fangeux d'une grande favorite" as the image of Madame du Barry in a keg, and reproduces an example of an "escapade nocturne" from the *Essais sur la vie de Marie-Antoinette* (1789), representing *Le Premier Baiser avec le jeune commis de la guerre*. Pornographic caricatures against the queen's legendary promiscuity were exceedingly common in the decade preceding the Revolution, particularly ones dealing with her widely publicized "pro-

[Now one day, Virginie encounters by chance, innocently, in the Palais Royal district, at a glazier's window, on a table, in a public place, a caricature! a caricature ever so tempting for us, full of gall and spite, just the kind a shrewd and decadent civilization knows how to produce. Let us imagine some good boxing farce, some British enormity, full of clotted blood and seasoned with some monstrous *goddam*; or if it appeals more to your curious imagination, let us imagine before the eyes of our virginal Virginie some charming and provocative impurity, some Gavarni of the age, and one of the best, some insulting satire on the follies of the Court, some pictorial diatribe against the Parc-aux-Cerfs, or the filthy past of a great royal favorite, or the nocturnal escapades of the proverbial Austrian woman.]

But this myth of the comic is itself a kind of caricature, and the example a model of the comic. In the long, slow, suspenseful, and highly ironic first sentence leading up to Virginie's fall, in the bravado and relish with which he describes the caricatures, in the sinister, lip-smacking glee with which he invokes and gratifies the reader's "imagination curieuse," Baudelaire puts his theory to work. The spectacle of Virginie's encounter with the caricature is deliciously comical, like caricature itself, a source of amusement and laughter for us who are, with the author, fallen. The adjectives implicate us, who find the image of evil delectable, enticing, arousing—"appétissante," "assaisonnée," "charmante," "agaçahte"—as we anticipate its effect on Virginie's "esprit naïf." The comic provokes the conventional pleasure of the voyeur, and turns it against the voyeur too. *Hypocrite lecteur—mon semblable—mon frère!*: we are faced not only with the fall from innocence in general, but with our own, and the ambiguous, "satanic" pleasure that it inspires.

Yet innocence is powerless against the comic. Virginie succumbs to the fascination of the unknown, the magic of the perverse that Baudelaire elsewhere discerned in Poe (322):

Virginie a vu; maintenant elle regarde. Pourquoi? Elle regarde l'inconnu. Du reste, elle ne comprend guère ni ce que cela veut dire ni à

menades nocturnes." See H. d'Almeras, *Marie-Antoinette et les pamphlets royalistes et révolutionnaires*; L. Hunt, "The Political Psychology of Revolutionary Caricatures," 37; and A. de Baecque, *La Caricature révolutionnaire*, 188. British boxing prints such as Baudelaire describes were also common. See British Museum, *Catalogue of Prints and Drawings in the British Museum: Political and Personal Satires*, nos. 11786 and 12339.

quoi cela sert. Et pourtant, voyez-vous ce reploiement d'ailes subit, ce frémissement d'une âme qui se voile et veut se retirer? L'ange a senti que le scandale était là. Et, en vérité, je vous le dis, qu'elle ait compris ou qu'elle n'ait pas compris, il lui restera de cette impression je ne sais quel malaise, quelque chose qui ressemble à la peur. (529)

[Virginie has seen; now she looks further. Why? She gazes at the unknown. Moreover she hardly understands either what it means or what it is for. And yet, do you see that sudden folding of the wings, that shuddering of a soul who veils herself and tries to draw back? The angel has sensed that there is scandal in it. And in truth, I tell you, whether she has understood or not, this impression will leave her with some indefinable uneasiness, something that resembles fear.]

Like the Sage earlier, Virginie faces the abyss of temptation and in the ignorance of her innocence has the same reaction that he did: sudden uneasiness, fear, and trembling. But the Sage has ironic knowledge, and Virginie does not. He recognizes the threat, and in laughing he preserves in his shudder an admission of the danger, acknowledging the inseparability of laughter and trembling, superiority and inferiority, laugher and object of laughter. She feels the presence of evil, the violation of her purity of soul, and cringes to protect it, but she understands nothing and is thus defenseless.[35] Irony will become the antidote to ignorance, saving the laugher from the comic trap.

Lacking this, however, the supposedly superior reader remains squarely in the position of Virginie: "Mais, pour le moment, nous, analyste et critique, qui n'oserions certes pas affirmer que notre intelligence est supérieure à celle de Virginie, constatons la crainte et la souffrance de l'ange immaculé devant la caricature" (529f.) [But for the moment, we, the analyst and critic, who would certainly not dare affirm that our intelligence is superior to Virginie's, let us acknowledge the fear and suffering of the immaculate angel confronted with caricature]. The author's false modesty, underscored by the highly ironic "certes," not only makes fun of Virginie's lack of sophistication, but also targets his own (and our) pretension, our sense of superiority over her. He thus suggests the source of our pleasure in observing her comic sketch, but delays the explanation, keeping us in ignorance while teasing us

35. For a Lacanian reading of this passage, see MacInnes, *The Comical as Textual Practice in Les Fleurs du mal*, 69ff.

with knowledge, leaving us suspended between the two like the uneasy Virginie between innocence and *science*.

The Theory of Superiority

Although Baudelaire considers the superiority theory an inadequate explanation of laughter, he accepts it as intermediary, a symptom of the primary cause: superiority is an expression of pride, and thus of the Fall, a sign of human weakness relative to an omnipotent God. The sense of superiority is born of the loss of innocence and linked to knowledge: the fallen Virginie will laugh when she becomes more worldly-wise. But this falls short of wisdom or ironic self-knowledge, in which we recognize our own inferiority, as does the Sage. The proof lies in the extreme case, where the greatest sense of superiority coincides with the most frequent and violent laughter: the madman.

The superiority theory goes back to Plato, who at *Philebus* 48–50 defines laughter as a "mixed" emotion, a pleasure inspired by malice, that is, delighting in the misfortunes—or mere ignorance—of the weak, those not powerful enough to harm us in return. Plato locates the source of the pleasure of laughter in envy, *phthonos*.[36] The superiority theory proper was formulated by Hobbes, whose definition predominated in Baudelaire's time: "the passion of laughter is nothing else but sudden glory arising from some sudden conception of some eminency in ourselves by comparison with the infirmity of others, or with our own formerly."[37] The passion has no name but is related to pride; in *Leviathan* it is a sign of pusillanimity, characteristic of the morally weak and those of limited intelligence, who can retain their self-respect only by putting others at a disadvantage.[38] The superiority

36. *Philebus* 48b. On Plato's theory of laughter, see M. A. Grant, *The Ancient Rhetorical Theories of the Laughable*, Michael Mader, *Das Problem des Lachens und der Komödie bei Platon*, and G. McFadden, *Discovering the Comic*.

37. *Human Nature*, chap. IX, sec. 13 (*The English Works* IV, 46). Glory is defined earlier as "the passion which proceedeth from the . . . conception of our own power above the power of him that contendeth with us" (chap. IX, sec.. 1, 40).

38. "And it is incident most to them, that are conscious of the fewest abilities in themselves; who are forced to keep themselves in their own favour, by observing the imperfections of other men. And therefore much laughter at the defects of others, is a sign of pusillanimity. For of great minds, one of the proper works is to help and free others from scorn; and compare themselves only with the most able" (*Leviathan*, part I, chap. 6, *The English Works* III, 46).

theory was accepted in the eighteenth century by Marmontel, who defined the comic as a relation, an effect resulting from a comparison, advantageous for ourselves, between ourselves and the object of ridicule. For Marmontel, this structure also accommodates laughing at ourselves (or at the image of ourselves that we recognize in the object), through a doubling which makes us both judge and accused, a Baudelairean *victime* and *bourreau*.[39]

But the most direct source in the transmission of this theory to Baudelaire was Stendhal, who discusses it in *Racine et Shakespeare*, the *Histoire de la peinture en Italie*, the *Journal*, and numerous notes, and frequently quotes the passages on laughter from Hobbes's *Human Nature*.[40] Baudelaire read the *Histoire de la peinture en Italie* and, as Pommier showed, rifled it rather unscrupulously for his *Salon de 1846*.[41] There he encountered the Hobbesian conception of the comic as nurturing the pleasure of vanity and superiority.[42] In an extended discussion of laughter and the comic in *Racine et Shakespeare*, Stendhal quotes Hobbes directly: "Qu'est-ce que le rire? Hobbes répond: 'Cette convulsion physique, que tout le monde connaît, est produite par la vue imprévue de notre supériorité sur autrui.' " [What is laughter? Hobbes replies: "This physical convulsion, which everyone knows, is produced by the unforeseen view of our own superiority over another."][43] Like Baudelaire, Stendhal insists on the suddenness of laughter, its relation to pride,[44] and the "philosophical" spirit that permits the poet to understand,

39. *Encyclopédie*, s.v. *"comique."*

40. Of the Hobbesian definition, Stendhal wrote in 1812: "Voilà la lumière qui sortie d'un petit in–12° de la Bibliothèque nationale m'éclaira soudainement vers l'an 1803" [That is the light which, coming out of a little book from the Bibliothèque Nationale, enlightened me suddenly around 1803.] (*Molière, Shakespeare. La Comédie et le rire*, 329). Other writers on the comic in Baudelaire's time subscribed to the superiority theory too. Lamennais, from his ecclesiastical perspective, places it in a Christian context (*Esquisse d'une philosophie* III, 369f.). In a work of 1840, the music critic Paul Scudo, like Baudelaire, associates it with dualism, the superiority and imperfection of the laugher (*Philosophie du rire*, 133). Baudelaire later ridicules Scudo in his 1861 article on Wagner, in which he ironically pictures Scudo laughing "like a maniac, like one of those unfortunate people who, in asylums, are called *agités*" (781). Falsely feeling himself superior to Wagner, whom he considers ludicrous, Scudo becomes an object of laughter. Baudelaire probably knew this work, which has numerous points in common with his own.

41. *Dans les chemins de Baudelaire*, 290ff.

42. *Histoire de la peinture en Italie*, chap. 96 (*Stendhal, Oeuvres complètes* XXVII, 56).

43. *Racine et Shakespeare*, 29. Baudelaire never mentions this work, but surely knew it, as the "Academic dinner" episode suggests (see above, 14f.). See Macchia (*Baudelaire critico*, 150 n. 141) and Bonfantini ("Baudelaire et Stendhal," 44).

44. Cf. Baudelaire's "orgueil inconscient" (531) with Stendhal's "vanité" (*Histoire de la peinture en Italie*, in *Oeuvres complètes* XXVII, 56; *Racine et Shakespeare*, 31), like Hobbes's glory.

and thus create, the comic: "le philosophe voit le ridicule. L'art de le rendre sensible . . . forme le talent du poète comique" [the philosopher sees the ridiculous. The art of making it manifest constitutes the talent of the comic poet].[45]

But Stendhal distinguishes between true comedy, which causes a joyous laughter, and mere satire, which provokes either a bitter laughter or none at all. The former is the product of freedom and a free imagination, the latter of meanness and enslavement to an ideal model. True laughter remains dependent on vanity and superiority but also requires a certain degree of respect for the object of laughter; satire does not have this condition and thus produces only scorn.[46] This division reflects that of Baudelaire's *comique absolu* and *comique significatif*: while superiority is a factor in both, the *absolu* bears witness to a freedom, license, pleasure, and spontaneity, as opposed to the more rigid and limited *significatif*. Perhaps more important, Stendhal finds in laughter his formula for aesthetic experience, that is, the sudden, unexpected glimpse of happiness, the "vue imprévue du bonheur": true laughter involves pleasure and reflects a "quest for happiness" in both laugher and object.[47] The chapter on laughter in *Racine et Shakespeare* is thus intimately connected to the treatise on modern "Romantic" art that it seems to interrupt. Baudelaire's own project—making caricature a model for modern art—is more ambitious and comprehensive, but does likewise and derives from a similar motive, to define an art appropriate to the new spirit of the age.

Baudelaire illustrates the superiority theory with the stock example of the person who falls on the ice or trips on the curbstone.[48] This, however, he uses in a thoroughly unconventional way, to prove not the superiority, but rather the comicality and inferiority, of the laugher—his main qualification to the tradition. He appropriates the ancient argument that laughter signals a weakness[49]—it is uncontrollable, "une convulsion nerveuse, un spasme involontaire" (530)—and underlines the paradox:

> Pour prendre un des exemples les plus vulgaires de la vie, qu'y a-t-il de si réjouissant dans le spectacle d'un homme qui tombe sur la glace

45. *Molière, Shakespeare. La Comédie et le rire*, 271.

46. *Racine et Shakespeare*, 30f.

47. Ibid., 37, 41, 35.

48. Cf. ibid., 29. In Hobbes, the example is simpler: "To see another fall, is disposition to laugh" (*Human Nature*, chap. XI, sec. 21, *The English Works* IV, 53).

49. Plato, *Philebus* 48c–50a, where the source of the ridiculous is ignorance, and the source of laughter envy, both of which are vices. Laughter is thus a vice taking pleasure in another vice.

ou sur le pavé, qui trébuche au bout d'un trottoir, pour que la face de son frère en Jésus-Christ se contracte d'une façon désordonnée, pour que les muscles de son visage se mettent à jouer subitement comme une horloge à midi ou un joujou à ressorts? (530)

[To take one of the most common examples in the world, what is so delightful in the sight of a man who falls on the ice or the pavement, or who trips at the edge of a sidewalk, that the countenance of his brother in Christ should contract in such an unruly manner, and the muscles of his face suddenly begin playing like a clock at midday or a jack-in-the-box?]

The laugher here becomes an *object* of laughter, a target of the author's mockery, his grimacing face likened to a clock chiming midday or a mechanical spring toy. Indeed he becomes even more comical than the man who stumbles (about whom nothing is said). His pride makes him feel superior to the man sprawled on the ice, but humiliates him before someone truly superior, the reader: "Est-il un phénomène plus déplorable que la faiblesse se réjouissant de la faiblesse?" (530) [Is there anything more deplorable than weakness delighting in weakness?] And in a further reversal the question implicates the reader too, occupying as "deplorable" a position as the laugher here. In laughing we enter the ongoing pattern of the comic;[50] we signal both our superiority and our inferiority, demonstrating in the laughter that seizes us a loss of control as complete as that of the object.

The reflexive character of laughter is illustrated by Baudelaire's sensational example, the hero of C. R. Maturin's voluminous novel of terror, *Melmoth the Wanderer* (1820).[51] In exchange for knowledge and superhuman powers, Melmoth promises his soul, but then suffers from the contradiction between his divine capacities and his human milieu. Because he will be absolved of his promise if he persuades another to take over the pact from

50. R. Girard, "Perilous Balance: A Comic Hypothesis," 129ff.

51. For Baudelaire's interest in this work, and its importance among the French Romantics—Hugo, Balzac, Delacroix—see Ruff, *L'Esprit du mal et l'esthétique baudelairienne*, 79ff.; R. Lloyd, "Melmoth the Wanderer: the Code of Romanticism"; G. T. Clapton, "Balzac, Baudelaire and Maturin"; and Ruff's introduction to his edition of Maturin's drama, *Bertram*. Baudelaire read *Melmoth* before 1848; in 1865 he returned to it and formally proposed translating it into French to replace the original Cohen translation of 1821. One of Baudelaire's grievances against the Belgian publishers La Croix et Verboeckhoven was that they agreed to his idea but awarded the commission to another translator. He proposed it also to Michel Lévy (*Corr.* II, 461, 466f.), but to no avail.

him, he wanders the earth in search of one to save him from damnation and restore him to the relative "happiness" of humanity.[52] He preys on the most unfortunate and tries, in vain, to tempt or force them to accept the pact, even the only one who loves him, the innocent, Virginie-like Immalee. In the end, Melmoth must pay his penalty and go to his eternal damnation. Several aspects of the story are relevant to Baudelaire's theory. The hero has a terrifying, infernal laughter, sign of his demonic pact, "wild and discordant," convulsive, chilling, "satanic," "unnatural,"[53] and the traditional attributes of the devil, mockery and irony; his presence provokes involuntary shuddering and trembling.[54] His contract with the devil represents a symbolic Fall and accordingly brings him increased knowledge and power. The consequence of this is dualism—superior to mankind, inferior to the absolute, powerful but powerless to save himself, simultaneously victim and victimizer, condemned to live between two worlds and to belong to neither,[55] a kind of Byronic "half dust, half deity," a "living contradiction," his mind disproportionate to his body ("ses organes ne supportent plus sa pensée").[56] His power and knowledge are paradoxically the source of his weakness and suffering, because they remind him ever of his alienation from both heaven and earth; he thus covets the clear conscience of ignorance (534), precisely the state he originally wished to escape. The result of this discord is laughter, the "perpetual explosion of his anger and his suffering" (531).

Melmoth's laughter, like Baudelaire's, is thus at once a triumph and a defeat, a weakness taking pleasure in another weakness; in Maturin's words, a "victory over the weakness of others obtained at the expense of a greater weakness in ourselves."[57] It marks the laugher's own despair,[58] and implicates him as much as the object of his laughter: "that wild shriek of bitter and convulsive laughter that announces the object of its derision is our-

52. Baudelaire saw the connection between this story and Wagner's *Flying Dutchman* (805).
53. *Melmoth the Wanderer*, 80, 286, 412, 259, 113, 388, 413.
54. Ibid., 466.
55. The narrator of one of the novel's many stories-within-the-story remarks: "There is something very horrible in the laugh of a dying man. Hovering on the verge of both worlds, he seems to give the lie to both, and proclaim the enjoyments of one, and the hopes of another, alike an imposture" (ibid., 169).
56. Baudelaire finds a similar contradiction between the nerves and the mind in Poe's characters (*Edgar Poe, sa vie et ses oeuvres*, 317).
57. *Melmoth the Wanderer*, 412.
58. Ibid., 457f.: "And he laughed with that horrible convulsion that mingles the expression of levity with that of despair, and leaves the listener no doubt whether there is more despair in laughter, or more laughter in despair."

selves."[59] Most important, the example confirms for Baudelaire his own idea that the product of the Fall may constitute the means of redemption:

> ce rire glace et tord les entrailles. C'est un rire qui ne dort jamais, comme une maladie qui va toujours son chemin et exécute un ordre providentiel. Et ainsi le rire de Melmoth, qui est l'expression la plus haute de l'orgueil, accomplit perpétuellement sa fonction, en déchirant et en brûlant les lèvres du rieur irrémissible. (531)

> [this laughter freezes and wrings the entrails. It is a laughter which never rests, like a malady which forever goes its way and carries out a providential order. And thus the laughter of Melmoth, which is the highest expression of pride, perpetually fulfills its function, tearing and burning the lips of the unpardonable sinner.]

The "ordre providentiel" is satanic, but also quite literally providential. While illustrating the relentlessness of the disease and the irrevocability of the infection, it also contains the cure, the most providential of schemes: salvation. Melmoth's laughter attacks not only those on its path, but most of all the carrier himself. It may express the pride that made him reject the conditions of life, refuse his humanity, and sell his soul, but it also *burns his lips*, punishes him with an ever-present reminder of his sin and the intolerable position in which it has placed him. This is not only a consequence of laughter, but specifically its function. Baudelairean laughter does not ease the tension, but realizes it, objectifying in the "torn" lips of the grin the grotesque and dual condition of the laugher. It thus works against mystification, the belief in our own superiority, the illusion of self-sufficiency, and signals instead our own implication in the structure from which we feel exempt.

But although the expression of pride is also an agent of punishment, for Melmoth it does not bring salvation, as Baudelaire had suggested of laughter earlier. His ironic self-consciousness brings no relief, nor any transcendence; he is unpardonable, *irrémissible*. He serves as an exemplary scapegoat, sacrificed for the education and salvation of other laughers, notably the

59. Ibid., 423. Maturin also separates laughter from joy, as Baudelaire will in part v: "A mirth which is not gaiety is often the mask which hides the convulsed and distorted features of agony—and laughter, which never yet was the expression of rapture, has often been the only intelligible language of madness and misery. Ecstasy only smiles—despair laughs" (ibid., 464).

reader. As the "Vers pour un portrait de M. Honoré Daumier" imply, Melmoth's laughter burns his lips and fills *us* with icy dread, the trembling and self-awareness of the Sage.[60]

Knowledge, Civilization, and the Comic

In implicating the laugher's "superiority," Baudelaire revises the definition of the comic itself. If laughter derives from a sense of superiority, then the comic must lie in the one who laughs, not in the object of laughter. We may laugh at the man who falls on the ice, but he probably will not laugh at himself; the comic resides in ourselves looking on, feeling superior for not being so clumsy. "Comique" thus applies to the object but is actually an attribute of the subject, an ambiguity he playfully takes to the point of paradox: "the most comical animals are the most serious ones, such as monkeys and parrots" (532).[61] The object of laughter is most comical when ignorant relative to the one who laughs, and unaware of being so. Baudelaire here follows the Platonic tradition of defining the ridiculous in terms of self-ignorance:[62] self-ignorance in the object of laughter heightens the comicality by inspiring a greater sense of superiority in the one who laughs.

We laugh at Virginie's encounter with a licentious caricature of Marie-Antoinette because Virginie is sexually ignorant, and unconscious of being

60. "Son rire n'est pas la grimace / De Melmoth ou de Mephisto / Sous la torche de l'Alecto / Qui les brûle, mais qui nous glace." [His laughter is not the grimace / Of Melmoth or Mephisto / Under the torch of Alecto / Which burns them, but chills us to the bone.]

61. Baudelaire chooses stock examples but emphasizes a different source of comicality: since antiquity monkeys and parrots have been considered comical for their ridiculous resemblance to mankind and their mechanical imitations of human actions or speech. See Aristotle, *Topics* III.2, 117b17, where an ape is considered a parody of man, and *Hist. anim.* VIII.12, 597b27, where the parrot is the "bird with a human tongue" (*anthropoglotton*) and imitative (*mimetika*). See also W. McDermott, *The Ape in Antiquity*, 109ff., and cf. T. Wright, *A History of Caricature and Grotesque in Literature and Art*, 95ff. As a comical imitation of man, the monkey is also satanic. See Delacroix's note in his *Journal*, 880: "Les Bretons croient que le singe est l'ouvrage du diable. Celui-ci, après avoir vu l'homme, création de Dieu, croit pouvoir, à son tour, créer un être à mettre en parallèle, mais il n'arrive qu'à une créature ébauchée et hideuse, emblème de l'impuissance orgueilleuse." [Bretons believe that the monkey is the work of the devil. After having seen man, God's creation, he thinks he can in his turn create a parallel being, but he only manages a sketchy, hideous creature, an emblem of the impotence of pride.]

62. *Philebus* 48c–49a.

so. We feel superior to her in understanding and experience, but are inferior to the figure of absolute understanding, who is beyond experience. Laughter thus depends on a relation of knowledge (in the laugher) to ignorance (in the object), notably self-ignorance, but knowledge that is itself inferior to wisdom. Baudelaire accordingly arranges these terms in a circular order, where the wisdom of the Sage rejoins the innocence of the ignorant: "Signe de supériorité relativement aux bêtes, et je comprends sous cette dénomination les parias nombreux de l'intelligence, le rire est signe d'infériorité relativement aux sages, *qui par l'innocence contemplative de leur esprit se rapprochent de l'enfance*" (532, my emphasis) [A sign of superiority relative to the beasts, and I include in this category the numerous pariahs of the mind, laughter is a sign of inferiority relative to the wise, who by the contemplative innocence of their spirit come close to a childlike state].

The exception to this rule is the philosopher, one with the capacity to observe himself from without through a process of doubling, *dédoublement*. The philosopher realizes the dualism implicit in the comic by duplicating himself in the instant and observing himself and his follies as a spectator, becoming at once the object of laughter and the one who laughs. The duplication of the philosophical laugher is thus a form of laughter's dualism, an ironic awareness of superiority and inferiority. Baudelaire will return to this crucial point in the final section of the work.

The historical implications that Baudelaire draws from this knowledge-ignorance schema are in themselves highly problematic, but are revealing of his conception of the comic as a paradigm of modern history. Generalizing from individuals to humanity,[63] he attributes to advanced societies more examples of the comic, and the inferiority this involves. Like the uncivilized Virginie, primitive cultures are innocent and therefore have no comedies or caricatures.[64] As they gain in the intelligence and metaphysical knowledge that characterize civilization, they acquire the notion of their own superiority, and with it the diabolical laughter of the fallen: Virginie evolving into

63. Cf. his discussion of Chenavard's system in *L'Art philosophique*, according to which, "l'humanité est analogue à l'homme. Elle a ses âges et ses plaisirs, ses travaux, ses conceptions analogues à ces âges . . . tel art appartient à tel âge de l'humanité comme telle passion à tel âge de l'homme" (602f.) [humanity is analogous to man. It has its ages and its pleasures, its works, its conceptions analogous to those ages . . . a certain art belongs to a certain age of humanity as a certain passion does to a certain age of man]; and the *Exposition universelle de 1855* (582): "il ne faut jamais oublier que les nations, vastes êtres collectifs, sont soumises aux mêmes lois que les individus" [it must not be forgotten that nations, those vast collective beings, are subject to the same laws as individuals].

64. Cf. Scudo, *Philosophie du rire*, 129: "The savage laughs little or hardly at all."

Melmoth, as it were. Baudelaire implies an ameliorative character to the march of history—humanity moves upward ("s'élève," "s'avançant") toward the heights ("pics") of knowledge, Christianity is a "better" law than the religions of antiquity (532f.)—but matches it with a parallel increase in the knowledge of evil, and hence in the comic. Thus Christian societies necessarily have more examples of the comic than pagan antiquity.[65]

To the "contradicteurs jurés" who object that Aristophanes and Plautus disprove this historical pattern, or who cite the ancient story of the philosopher who died laughing at the sight of an ass eating figs,[66] Baudelaire responds rather lamely that, first, these cultures were essentially civilized, anyway, with an acute knowledge of evil; and second, their comedy differs from what he means by the term, and can only be recovered by an effort of the imagination and reproduced in pastiche. He takes as fetishes the grotesque figures of antiquity and Oriental cultures, serious objects of worship or symbols of power, icons of the mythic, lacking the dualism of the comic. The fact that we find them amusing or ridiculous merely confirms his idea that the comic lies in the one who laughs, especially in Christians, whose ontology of dualism places them ever in the position of Melmoth: "On en a ri après la venue de Jésus, Platon et Sénèque aidant. . . . Les idoles indiennes et chinoises ignorent qu'elles sont ridicules; c'est en nous, chrétiens, qu'est

65. Maturin too associates Christianity with the growth of a sense of superiority. Immalee learns of the superiority of humanity only after she becomes a Christian, before which time she lives in harmony with nature and invests the animals, plants, and elements with powers equal to or greater than her own (*Melmoth the Wanderer*, 477). Cf. Champfleury, *Histoire de la caricature antique*, 184f.: "Christianisme et caricature, ces deux mots semblent jurer. Quelle est la doctrine qui, rappelant l'homme à sa misère, lui montrait son humilité, lui faisait prendre en pitié grandeur, fortune, beauté, et lui criait sans cesse que son corps formé de poussière devait retourner en poussière? Et quel art dépouilla l'homme de ses vains ornements et se plut à grossir et à exagérer sa bassesse, ses vices, ses passions? La caricature, qui, à son insu, servait la doctrine chrétienne." [Christianity and caricature, these two words seem to jar. What is the doctrine that, recalling man to his misery, showed him his humble nature, made him look down on grandeur, fortune, and beauty, and incessantly cried out to him that his body formed of dust should return to dust? And what art stripped man of his vain ornaments, and delighted in magnifying and exaggerating his baseness, his vices, his passions? Caricature which, unbeknownst to it, served Christian doctrine.]

66. Baudelaire misses the crucial detail of the story: it is not a philosopher, but Philemon, the comic poet, who, seeing an ass eat the figs that had been prepared for himself, extends the joke by sending the beast his wine as well, but then chokes on his own laughter and dies. The comic poet's love of a joke does him in. The story is told in Lucian's *Macrobii*, Valerius Maximus's *Facta et dicta memorabilia* (Book IX, xii, ext. sec. 6), and Erasmus's *Adages* (I, 10, 71), and is mentioned by Rabelais (*Gargantua*, chap. 20). The story is not uncommon in works on the comic: Jean-Paul mentions it in the *Vorschule* (sec. 30, 120) and A. Garnier in his *Traité des facultés de l'âme* of 1852 (part IV, sec. xi, 229).

le comique" (533f.) [They were laughed at after the coming of Jesus, with the help of Plato and Seneca. Indian and Chinese idols are unaware that they are ridiculous; it is in ourselves, Christians, that the comic lies]. The comic thus reflects the demystification, or degradation, of the supernatural from the perspective of the viewer, a weakening of the magical power of the image;[67] the sense of inferiority is converted into superiority, adulation into laughter.

Baudelaire's explanations, however, create more problems than they resolve. He does not specify in what ways the ancient sense of the comic differs from the modern one, except for a vague observation that there is something "barbaric" about it. (This is particularly unsatisfactory in view of what follows, where using similar terms he characterizes the English *comique* as "ferocious" and the Spanish as "cruel.") His contention that the cultures of Aristophanes and Plautus were civilized, and thus subject to the comic, anyway, is more acceptable, but nevertheless contradicts his argument about the peculiarly *Christian* nature of the comic. Did medieval Christian societies have a more advanced comic sense than the spectators at Athens in the fifth century B.C.? The qualification offered in the *Exposition universelle de 1855*—that the artistic and intellectual continuity of the tradition was broken with the Middle Ages and the process begun again[68]— does not seem to apply here: he maintains explicitly that Christianity is a "better" law than the religions of antiquity.

Thus, despite the scorn heaped upon the "contradicteurs jurés," Baudelaire can answer their hypothetical objections only with one statement striking for its vagueness and another that blatantly contradicts an earlier principle. He could have easily adapted his model of the comic to accommodate the advanced comedy of pagan antiquity, for, as he acknowledges in passing, ancient comic theory and practice display most of its important aspects ("Platon et Sénèque aidant"): the association of the comic with evil, the Platonic feeling of superiority, and the contradictory place of humanity between the gods and the animals. But he does not. In fact, the discrepancies reflect his idea of civilization and culture themselves, that is, as an increase

67. See M. Melot, *L'Oeil qui rit. Le Pouvoir comique des images*, 13; and E. Kris and E. H. Gombrich, "The Principles of Caricature," 201ff.

68. "Il ne faut pas croire que les nouveaux venus héritent intégralement des anciens. . . . Il arrive souvent (comme cela est arrivé au Moyen Age) que, tout étant perdu, tout est à refaire" (582) [It should not be thought that newcomers inherit from the ancients in full. . . . It sometimes happens (as in the Middle Ages) that, all having been lost, everything is to be done again].

in evil and the consciousness of evil, the traditional legacy of the Fall: "L'humanité s'élève, et elle gagne pour le mal et l'intelligence du mal une force proportionnelle à celle qu'elle a gagnée pour le bien" (533) [Humanity rises upward, and it wins for evil and the knowledge of evil a strength proportionate to that which it has won for the good]. Civilization is in this qualified sense an essentially "Christian" concept, that is, marked by the fallen, dual, and ambiguous structure of the comic. And if, following the reversible pattern of the comic, the products of the Fall may be the means of redemption, so it is with civilization too, which thus becomes an effort to control, through law, religion, and art, the very degradation it represents: as *Mon Coeur mis à nu* XXXII maintains (I, 697), *true* civilization lies in the diminishing of the traces and consequences of original sin.[69]

With this section on civilization and the comic, Baudelaire confronts one of the most influential treatises on the comic of the age, Hugo's famous call to order of Romanticism, the *Préface de Cromwell* of 1827.[70] Hugo, too, associates the grotesque with the development of Christian dualism: the grotesque figured little in antiquity and arose only with the advent of Christianity. He does not discuss dualism as a result of the Fall, but merely as the consequence of Christianity's "truer," more comprehensive view of life, which encompasses the two extremes of creation.[71] Representation should follow the example of nature, and the artist the example of the ultimate Creator, by joining dark with light, grotesque with sublime, body with soul, animal with spiritual. This not only fulfills the objectives of a mimetic conception of art (reproducing in art the oppositions essential to nature), but also raises humanity to a knowledge of the beautiful and sublime. The grotesque thus functions as a means of contrast by which to perceive both the real (nature in its dualism) and the ideal, a term of comparison by which to gauge the beautiful.[72]

69. He attributes the same idea to Delacroix in his 1863 essay (767): humanity diminishes its natural wickedness through the products of civilization—suffering, punishment, duty, and the exercise of reason. Cf. *Les Misérables par Victor Hugo* (224).

70. Baudelaire never mentions Hugo's theory of the grotesque, despite the many allusions to him in his work; but he did know Hugo's early writings well (see Lloyd, *Baudelaire's Literary Criticism*, 159f.), and the parallels are striking.

71. "Le laid y existe à côté du beau, le difforme près du gracieux, le grotesque au revers du sublime, le mal avec le bien, l'ombre avec la lumière" [ugliness exists alongside beauty, the deformed alongside the graceful, the grotesque opposite the sublime, evil with good, shadow with light] (*Préface de Cromwell*, 191).

72. Ibid., 203. Bakhtin criticized Hugo on this point for diminishing the autonomous value of the grotesque and missing the regenerative force of the "lower stratum" (*Rabelais and his World*, 43, 126). But while this may appear to be so in the *Préface*, the novels suggest otherwise,

Hugo's essay affirms the ascendancy of the grotesque in modern art, indeed defines the modern as the union of grotesque and sublime, in contrast to the more "uniform simplicity" of the pagan era, valuing only one side of life and thus one type of beauty.[73] Like Baudelaire, he relates the ages of society to a corresponding development of the grotesque, and thus finds himself confronted with Baudelaire's same difficulty, that is, patent examples of the grotesque in ancient art (Thersites, Hephaestus, Polyphemus), and artists who discredit the theory (Aristophanes and Plautus). Hugo resolves this via the common metaphor of generation: "Ce n'est pas qu'il fût vrai de dire que la comédie et le grotesque étaient absolumment inconnus des anciens. . . . Rien ne vient sans racine; la seconde époque est toujours en germe dans la première" [Not that it would be true to say that comedy and the grotesque were absolutely unknown to the ancients. . . . Nothing grows without roots; the seed of the second epoch is always sown in the first.].[74] In antiquity the grotesque vision is "timide" and inferior, always overwhelmed by the heroic vision—and achievements—of epic and tragedy.[75]

Hugo's piece is more than a description, however; it is of course a polemic, openly arguing for the inclusion of the grotesque, ugly, and bestial into the "sublime" realm of art. In this way it bears a definite relation to Baudelaire's view of caricature, and the *beau moderne* to which it leads. But there remains a significant difference between them: Hugo wishes to join the grotesque with the sublime, as seen in nature; Baudelaire to find the sublime in the grotesque, the beautiful in the ugly, the universal in the trivial. The comic and grotesque possess their own value; they are not means of setting off the sublime. Hugo wishes to follow the example of nature, Baudelaire to find the mechanism by which nature is redeemed from within itself and becomes the source of the *surnaturel*.

as *Notre-Dame de Paris*, for example, attests. See also S. Nash, "Transfiguring Disfiguration in *L'Homme qui rit*: A Study of Hugo's Use of the Grotesque."

73. "C'est de la féconde union du type grotesque au type sublime que naît le génie moderne, . . . opposé . . . à l'uniforme simplicité du génie antique" [It is from the fertile union of the grotesque and the sublime that the modern spirit is born, . . . as opposed to . . . the uniform simplicity of the ancient spirit] (*Préface de Cromwell*, 195).

74. Ibid., 195.

75. Ibid., 198f. The modern reader is not alone in questioning such a judgment. In 1836 Musset ridiculed Hugo's definition of Romanticism as the combination of grotesque and sublime by presenting Aristophanes as the artist who best fulfills it: he can hardly be excluded from a conception of the grotesque, or the grotesque from a conception of the ancient world, if he is the finest example of it (*Lettres de Dupuis et Cotonet*, in *Oeuvres complètes en prose*, 823f.).

Baudelaire's intent becomes even clearer in his conception of what lies beyond civilization and the comic. In a remark merely tacked onto the end of a paragraph and not developed, he envisages a sequel to the Melmoth stage in the bold ambition of the pure poet, who, from within a highly civilized culture, reaches beyond the furthest boundaries of worldly pride and creates a poetry "limpid and profound like nature," from which laughter will be lacking, as in the perfect Sage (533). Pure poetry is transparent in its depth as nature is within itself, not monstrous and complicated like comic art;[76] it thus has the potential to obtain the mystical purification that Baudelaire subsequently identifies as the final goal of the development of civilization (533). It redeems humanity from the Fall by revealing and embodying the harmony of universal analogy—the real, human equivalent of the mythical unity of paradise.

And yet, for all the quasi-mysticism of this vision, Baudelaire keeps the pure poet's effort squarely within the definition of poetry (following Poe) as the human aspiration toward a higher beauty (334). The pure poet remains in the human realm of the fallen and in fact reenacts a quintessentially human myth, the satanic, Promethean challenge to the gods; but in so doing he creates a world analogous to nature, in which division is subsumed into a general harmony through universal analogy and metaphor. He transcends the legacy of the comic—knowledge, ambition, pride—precisely by carrying it further. The pure poet is compared not to the divine but to the sage, whose humanity makes him sensitive to the attractions of the comic, and whose knowledge makes him recognize the danger.[77] The movement that surpasses the comic is itself an essentially comic one, affirming unequivocally the comic nature of the absolute, the fallenness and humanity of the ideal.

The Types of the Comic

Baudelaire grounds his typology in a first distinction between joy and laughter: joy is single, but is manifested in a variety of ways, including tears;

76. MacInnes (*The Comical as Textual Practice in Les Fleurs du mal*, 50) interprets the comparison as referring to the "sourcefulness" of nature, on the one hand, and its mystery, its inscrutable depth, its veiled purpose, on the other; but "profond" suggests depth, not darkness.

77. Although MacInnes notes that pure poetry "seems tinged . . . with the shadow of hubris," he takes this as a sign of the tentativeness, the "teasing ambiguity," of Baudelaire's assertion, and sees in pure poetry still a "nostalgic longing for a narcissistically replete language" (Ibid., 50f., 81).

laughter is the expression of a dual, contradictory sentiment, which conflict produces the convulsion. But he uses this model of fallenness to affirm the humanizing implications of his theory; joy is devalued at every turn. The joyous laughter of children resembles the contented purring of a cat, the happy tail-wagging of a dog,[78] or the Romantic cliché of the flower opening into the world of nature: "Le rire des enfants est comme un épanouissement de fleur. C'est la joie de recevoir, la joie de respirer, la joie de s'ouvrir, la joie de contempler, de vivre, de grandir. C'est une joie de plante" (534) [The laughter of children is like the blossoming of a flower. It is the joy of receiving, the joy of breathing, the joy of opening up, the joy of contemplating, living, growing. It is a plant-like joy]. The ironically florid language suggests his allegiance to the complicated, satanic laughter that is his real subject—to the mark of a thoroughly human contradiction over the mindless plant-like happiness of living and growing.[79] Moreover even this joyful laughter is not wholly innocent, but betrays a modicum of ambition, the first stirrings of superiority: "ainsi qu'il convient à des bouts d'hommes, c'est-à-dire à des Satans en herbe" (535) [as it is proper to slips of men, that is, to budding Satans].[80] His sarcastic extension of the botanical metaphor again betrays his sympathy for the satanic, his delight in playing with the standard cliché, his "comical" pleasure in perversity.

A second type of laughter, which does not initially seem to fit the theory, is that caused by the grotesque; for example, fabulous creations that present no weakness, misfortune, or self-ignorance at which to laugh, but nevertheless provoke a "rire vrai, rire violent . . . une hilarité folle, excessive, et qui se traduit en des déchirements et des pâmoisons interminables" (535) [true, violent laughter . . . a mad, excessive mirth that expresses itself in interminable paroxysms and swoons]. Here Baudelaire makes the crucial separation between *comique absolu* and *comique significatif*. The *comique significatif*, or ordinary comedy of manners, is primarily an imitation, but with a creative element—the choice, order, and arrangement necessary for it to have meaning, rather than simply reproduce the confusing plurality of phenomena. It derives from one's sense of superiority over others, presents

78. Scudo uses this same example in distinguishing joy from laughter (*Philosophie du rire*, 125).

79. Likewise MacInnes (*The Comical as Textual Practice in Les Fleurs du mal*, 53), who compares Baudelaire's attitude here to his contemptuous reference to nature as "sanctified vegetables" in the famous letter to Desnoyers (*Corr. I*, 248).

80. Cf. his emphasis on the "enfant terrible" in the Charlet section of *Quelques caricaturistes français* (548).

itself as dual (its moral idea clearly spelled out and not a product of the art alone), and is grasped by reason and analysis; although it is generally easier to understand, the laughter caused by it may arise more slowly, as the rational mind takes time to decipher the meaning. The *significatif* is, as the term implies, referential and restrictive; its evident dualism defines—and limits—the sense. Its most common manifestation is satire.

The *comique absolu*, or grotesque, is primarily a creation, but with an imitative element, refashioning the preexisting forms of nature; it derives from one's sense of superiority over nature, presents itself as unified (its moral idea inseparable from the art), is grasped synthetically by intuition, and excites a spontaneous, excessive, violent laughter.[81] The impression of unity opens up the possibilities of meaning by refusing to specify a single one. Moreover, the *comique absolu* guarantees a sense of inferiority along-side superiority, preserving the ironic dualism on which self-knowledge depends. For the loss of control represented by its explosive, sudden laughter signals the presence of a force beyond our conscious comprehension, the "élément mystérieux" that cannot be rationalized or explained away. And the nature to which we feel superior is also that in which we must live. The *comique absolu* confronts us with the fantastic and surreal, worlds beyond our own and beyond ourselves, and thus weakens the possibility of self-delusion and mystification present in the *significatif*.

The Romantic origins of the *comique absolu* are manifest. As Kayser has shown, the effort to define the grotesque as an aesthetic category arose in connection with caricature in the eighteenth century and its implicit critique of neoclassical aesthetic principles, particularly in the German tradition.[82] In 1775, Wieland mounted a defense of caricature in the second dialogue of his *Unterredungen zwischen W** und den Pfarrer zu ***. The parson's argument that caricature serves no good purpose is countered by the

81. MacInnes, following de Man, concentrates on this temporal distinction to define his notion of comicality as signification by deferral; the comic is always *significatif* because, fallen, its meaning never coincides with the gesture that produces it, just as the *significatif* inspires laughter after the fact (*The Comical as Textual Practice in Les Fleurs du mal*, 52). But deferral of signification in the Baudelairean system characterizes all acts of representation; complete coincidence of meaning with gesture is not only impossible but, as we shall see, incomplete, abstract, and empty. Moreover this definition ignores the difference which Baudelaire specifies *within* the comic. He insists on the relativism of the comic almost to the point of absurdity; both types are theoretically "fallen." Using temporality as the main basis for the distinction is problematic: Baudelaire does not maintain that the *significatif cannot* provoke a sudden laughter, only that it is not impossible or forbidden (*défendu*) to laugh after the fact (536); the *absolu*, in contrast, *must* involve suddenness.

82. *The Grotesque in Art and Literature*, 30.

narrator's view that it offers a frightening picture of the ugly and vicious creature we might be (or run the risk of becoming). Wieland includes the fantastic and grotesque among his types of caricature,[83] and although he ultimately concentrates on those of the *significatif* type for their moral utility, he nevertheless suggests, through the ambiguities of the dialogue form, the high value and interest of the grotesque.

The liberating, carnivalesque quality of the grotesque was indeed emphasized in Flögel's *Geschichte des Grotesk-Komischen* (1788), the first attempt to trace the grotesque historically from its origins in antiquity, through the popular festivals, farces, kermesses, and mystery plays of the Middle Ages, to contemporary burlesques. It influenced writers on the comic from Jean-Paul to Bakhtin in our own era. Although it is primarily documentary, as Bakhtin noted,[84] Flögel defined a major principle of comic theory, the circumscribed subversion of carnival: comic representations have the function of relieving us temporarily of our habitual burdens, and thus according, within a delimited context and period, a power of which we are normally deprived. In Baudelaire this applies not merely to the social, the domain of the *significatif*, but to our relation to nature as well. Presenting itself as unified, "sous une espèce *une*," the *comique absolu* represents a fantasized human triumph over nature and time, and thus achieves a unity from within dualism, a simultaneity from within the temporal.

In his *Geschichte der komischen Litteratur* (1784) Flögel also underscored the subjective element of laughter, the disposition of the laugher—temperament, physical condition, age, emotional state, education, social standing, and the era and nation in which he lives.[85] This becomes a recurring feature of German comic theory, as P. Haberland has observed,[86] and a key point of Baudelaire's. Indeed Jean-Paul's *Vorschule der Ästhetik* (1804) clearly shifts the source of laughter from the object to the one who laughs.[87] The comic requires a certain identification between laugher and

83. *Unterredungen*, 343.

84. *Rabelais and his World*, 36.

85. *Geschichte der komischen Litteratur*, i, 245.

86. Haberland notes this subjective tendency in the minor theorists, e.g., Mendelssohn, Sulzer, Feder, and König, as well as in Möser, Flögel, Kant, and Jean-Paul (*The Development of Comic Theory in Germany during the Eighteenth Century*, 125ff.).

87. The *Vorschule* was not translated into French until 1862, and Baudelaire could not have read the German. However, its ideas were indirectly available: it was summarized in 1849 in J. Willm, *Histoire de la philosophie allemande depuis Kant jusqu'à Hegel;* Coleridge lifted whole sentences from it for his lecture "On the Distinctions of the Witty, the Droll, the Odd, and the Humorous" of 1818 (*Notes and Lectures upon Shakespeare*); Philarète Chasles was inspired

object; it results from the contradiction between the thoughts which we impute to the object and his own.[88] Attributing thoughts to another represents for Baudelaire a kind of appropriation consistent with superiority; but the identification with the object necessary for this makes the laugher an object of laughter too. This distinction will be crucial in his conception of the *flâneur* and the cosmopolitan artist in *Le Peintre de la vie moderne*.

Jean-Paul defines the comic as an absurdity, a negation of understanding; it has a liberating effect, unlike satire, which inspires gravity and moral improvement. High moral seriousness is inconsistent with the comic and disturbs the harmony of a comic work. Baudelaire implies much the same in defining the evident dualism of the *significatif* as the formal separation of art and moral idea; the problem will become more acute in the Grandville example of *Quelques caricaturistes français*, with the clash between his "philosophy" and his "art." For Jean-Paul, as for Baudelaire, the less poetic a nation or era, the more it confuses the comic with satire: France, the country of persiflage, has the least degree of the comic. Yet seriousness is also a condition of the comic: the greatest comic artists come from the clergy (Rabelais, Swift, Sterne); the most serious nations—England and Spain—produce the most comedies and have the highest comic spirit; the most highly developed comic faculty arises in the sadness of old age.[89] Baudelaire will develop this into the paradox of the comic artist, who uses knowledge to create an impression of ignorance, and creates the spontaneous, explosive *comique absolu* from the "science" of its laws of operation.

Baudelaire also appropriates for the comic crucial aspects of the Romantic sublime, thus collapsing the distinction between them: not only the suddenness and singleness of the sublime,[90] but more important, the recognition of a higher power, in awe, on which it depends. Jean-Paul's concept of humor (the inversion of the sublime) similarly reflects the inferiority of all things

by it for the article "humour" in the *Dictionnaire de la conversation et de la lecture* (1836). Baudelaire read Jean-Paul's literary works, notably Chasles's translation of *Titan* (see *Edgar Poe, sa vie et ses oeuvres*, 318; and *Marceline Desbordes-Valmore*, 148). For the history of the *Vorschule* in France, see C. Pichois, *L'Image de Jean-Paul Richter dans les lettres françaises*, 305–48.

88. "so dass also das Komische, wie das Erhabene, nie im Objekte wohnt, sondern im Subjekte" ["Thus the comic, like the sublime, never resides in the object, but rather in the subject"] (*Vorschule*, 110). For Jean-Paul, laughing at oneself requires a temporal delay in which one becomes a different self, attributing to the earlier self one's new thoughts (ibid., 113). Cf. Scudo, *La Philosophie du rire*, 41, 46f.

89. Jean-Paul, *Vorschule*, 117f.

90. See Joshua Reynolds, *Discourses on Art*, 65: "The sublime impresses the mind at once with one great idea; it is a single blow."

relative to the infinite and their equality before it: "it lowers the great, but
. . . to place it side by side with the small, and raises the small, but . . . to
place it side by side with the great, and thus to annihilate both, for
everything is equal and nothing before the Infinite."[91] Like the sublime of
Kant or Schiller, humor involves an understanding of human limitation and
ignorance relative to an unattainable ideal;[92] its laughter contains a measure
of pain. Baudelaire's grotesque pushes this inversion to its limits, making
the ideal a product of the comic itself.

In *De l'essence du rire* Baudelaire insists on the fallen nature of both
types of comic by restating the point in the final lines of the section: "J'ai
dit comique absolu; il faut toutefois prendre garde. Au point de vue de
l'absolu définitif, il n'y a plus que la joie. Le comique ne peut être absolu
que relativement à l'humanité déchue, et c'est ainsi que je l'entends" (536)
[I said the absolute comic; yet we must take care. From the point of view of
the definitive absolute, there is only joy. The comic can only be absolute
relative to fallen humanity, and it is in this sense that I understand it]. The
comique absolu cannot be removed from the satanic and the sense of
superiority, as some have done.[93] He considers this sufficiently important to
state it yet again in the conclusion to the essay as a whole, even at the
acknowledged risk of redundancy: "je ferai remarquer une dernière fois
qu'on retrouve l'idée dominante de supériorité dans le comique absolu
comme dans le comique significatif, ainsi que je l'ai, trop longuement peut-
être, expliqué" (543) [I will point out one last time that the dominant idea
of superiority is found in both the absolute comic and the significant comic,
as I have explained, at perhaps too great a length, already]. Laughter caused
by the *absolu* is close to innocence and joy, for like them it has something
profound, axiomatic, and primitive about it (535), and thus has a higher
place in the comic hierarchy. (This leads him to say later, for example, that
Hoffmann's *comique absolu* inspires in the reader the "joy" of his own
superiority, a comic *approaching* the purity of joy.) Unlike joy, the *comique
absolu* cannot be single and unified, for it belongs to the comic, and thus by

91. "Er erniedrigt das Grosse, aber . . . um ihm das Kleine, und erhöhet das Kleine, aber
. . . um ihm das Grosse an die Seite zu setzen, und so beide zu vernichten, weil vor der
Unendlichkeit alles gleich ist und nichts" (Jean-Paul, *Vorschule*, 125).

92. For Kant, however, this reveals to the imagination its higher, "supersensible" destiny
(*Critique of Judgment*, sec. 26). See P. Carrive, "Le Sublime dans l'esthétique de Kant," 82ff.,
and T. Weiskel, *The Romantic Sublime*, 39ff. For the availability of German idealist philosophy
in France in Baudelaire's time, as well as works about it, see N. Accaputo, *L'Estetica di
Baudelaire e le sue fonti germaniche*, 111ff.

93. E.g. Mauron, "Le Rire baudelairien," 59.

definition is marked by dualism and contradiction, but it comes across as such, with no separation between the art and the moral ideas it suggests. Such a unity ensures a plurality of meanings, a suggestive openness, unlike the clearly divisible, one-to-one structure of the *significatif*.[94] Baudelaire compares it on this point to nature (536), a view consistent with the system of the *Salon de 1846*: nature is fallen, and thus characterized by infinite variety, but presents itself as harmonious and unified. The artist of the *comique absolu* is a model of the ideal artist, a creator like the divine one, who with a similarly "diabolical" act, created the world of nature.[95]

In fact, the language of this section likens the *comique absolu* to the revelatory *poésie pure* described earlier. Pure poetry resembles the wisdom and innocence of the Sage and, like them, approaches the joy of the child, just as, here, the grotesque conveys a deep-seated truth (the profound, axiomatic, and primitive aspect) and approaches innocence and joy. Pure poetry embodies relative unity and approaches the clarity and depth of nature *revealed*, just as the grotesque, "se rapprochant . . . de la nature, se présente sous une espèce *une*, et qui veut être saisie par intuition" (536) [coming close . . . to nature, presents itself as unified, something to be grasped by intuition]. The *comique absolu* may fulfill Baudelaire's notion of an ideal art. Emphasizing the relative nature of the *comique absolu* serves not to devalue it according to its distance from the "definitive absolute," but rather to revise the sense of "absolute" itself. The *comique absolu* belongs squarely within the domain of mankind, a human absolute more powerful than the unified absolute it posits, joy. As we shall see, the artistic product of the fallen world is indeed superior to the ideal beauty of paradise, which, in the simile of *Le Peintre de la vie moderne*, risks being "abstraite et indéfinissable, comme celle de l'unique femme avant le premier péché" (695) [abstract and nondescript, like that of the only woman before the first sin].[96]

94. McLees argues for the "polyvalence" of caricature, but in different terms (*Baudelaire's "Argot Plastique,"* 43f.).

95. Baudelaire elsewhere describes the Fall in terms of self-division and self-multiplication. Cf. the ambiguous query of *Mon Coeur mis à nu* xx (I, 688f.): "Qu'est-ce que la chute? Si c'est l'unité devenue dualité, c'est Dieu qui a chuté. . . . En d'autres termes, la création ne serait-elle pas la chute de Dieu?" [What is the Fall? If it is unity become dualism, then it is God who fell. . . . In other words, would creation not be the Fall of God?"]; and also *Victor Hugo* (137): "Comment le père *un* a-t-il pu engendrer la dualité et s'est-il enfin métamorphosé en une population innombrable de nombres?" [How could the Father, one and undivided, engender dualism, and how did he metamorphose into an innumerable multitude?]

96. See chap. 4.

Examples and Exempla

In the *Exposition universelle de 1855*, Baudelaire acknowledges his taste for classifying and comparing the art of different nations:

> Il est peu d'occupations aussi intéressantes, aussi attachantes, aussi pleines de surprises et de révélations pour un critique, pour un rêveur dont l'esprit est tourné à la généralisation aussi bien qu'à l'étude des détails, et . . . à l'idée d'ordre et d'hiérarchie universelle, que la comparaison des nations et de leurs produits respectifs. (575)

> [There are few occupations so interesting, so engaging, so full of surprises and revelations for a critic, or for a dreamer whose mind is given to generalization as well as to the study of details and . . . the idea of a universal order and hierarchy, as the comparison of nations and their respective products.]

In the final section of *De l'essence du rire*, he indeed ranks the art of France, England, Germany, Italy, and Spain according to his categories of the comic—*significatif* and *absolu*—and illustrates them with specific examples. He qualifies the division by distinguishing levels within each category: the *comique significatif* taken to a further degree becomes *comique féroce*; and a lesser degree of *comique absolu* is *comique innocent*.[97] *Significatif-féroce-innocent-absolu* constitutes the basic structure of classification for both the brief survey in this essay and the detailed studies in the two subsequent ones. But he also acknowledges the multiple other possibilities based on different criteria, or combinations from the different categories, which the artists of the two subsequent essays will bear out. In fact, true to the dual and "impure" nature of the comic, the best examples of the *absolu* will be those which contain elements of the *significatif*.

The rationalist and materialist French spirit, and the utilitarian purposes

97. Baudelaire claims to have borrowed the term *comique innocent* from Hoffmann. Hoffmann describes a "reine Scherz" in the passage from chapter 3 of *Die Prinzessin Brambilla* (*Sämtliche Werke* III, 813) alluded to in *Quelques caricaturistes étrangers* (571). There "reine" has the sense of "pure," the comic in and for itself, and applies to both Italian and German forms. In the translation that Baudelaire read, Toussenel renders the kindliness and good-naturedness of the German variety as "l'innocence de la plaisanterie" (*La Princesse Brambilla, Contes*, 79).

of its art, consign that country to the *significatif*, of which Molière is the
finest example. In his later essay on Gautier, Baudelaire describes the typical
Frenchman's response to art as analytic and successive, rather than synthetic
and comprehensive, one of the main distinctions, as we recall, between
significatif and *absolu*.[98] He denies the French even the higher form of this
inferior comic, the *féroce*, on the basis that the French character shrinks
from anything excessive, absolute, or profound. Even French grotesque fails
to reach the *comique absolu*: Rabelais, whom he rightly calls the French
master of the grotesque (537), always retains something useful and reason-
able, making his art symbolic and referential, with the transparency of a
moral fable. This is a satirical Rabelais, having a specific target and lacking
the imaginative openness of the *absolu*. French humor is pointed only,
without the freedom and exuberance, the "prodigious poetic good humor"
(537), of the grotesque. Only the farcical interludes of Molière's *Malade
imaginaire* and *Bourgeois Gentilhomme*, and the carnival figures of Callot
reach the exalted level of *comique absolu*; in *Quelques caricaturistes étran-
gers*, however, Baudelaire calls the French Callot an essentially Italian artist,
thus stripping France, with evident delight, of one of its two claims to comic
glory. He finds the French spirit typified rather in the tales of his bête noire,
Voltaire, whose comedy derives solely from the idea of superiority over
others and is thus *significatif*: explicitly dual, limited in sense, and lacking
the mystery, fantastic, or absurdity that would guarantee in the laugher a
sense of inferiority coexistent with superiority.[99]

Further up the hierarchy, one encounters England as a country of *comique
féroce*; Italy ("joyous, noisy, carefree") represents the *comique innocent*,
that first level of the *absolu*; and Germany the *comique absolu*, marked by
seriousness, depth, and excess. Spain falls between the two, its grotesque
fantasies marked by cruelty and a somber quality. Baudelaire had already

98. *Théophile Gautier* (124): "Il sent ou plutôt il juge successivement, analytiquement.
D'autres peuples . . . sentent tout de suite, tout à la fois, synthétiquement." [He feels, or rather
he judges, in succession, analytically. Other people . . . feel right away, all at once, synthetically.]
Cf. *Salon de 1859* (616).

99. Baudelaire's main complaint against Voltaire elsewhere was indeed his positivistic
refusal of mystery, an attitude antithetical both to art and to the *comique artistique*, which
must contain "un élément *mystérieux*, durable, éternel" (526, my emphasis). See his 1861
Victor Hugo (134), in which "Voltaire did not see any mystery in anything," and *Mon Coeur
mis à nu* XVIII (I, 688): "Voltaire . . . hated mystery." The epithets applied to him confirm this:
"l'anti-poète, le roi des badauds, le prince des superficiels, l'anti-artiste, le prédicateur des
concierges" (I, 687) [the anti-poet, the king of gawkers, the prince of superficial people, the
anti-artist, the preacher of the concierge].

warned that the categories are not fixed, however; just as Molière, the best example of French *significatif*, also produces that nation's rare sample of *comique absolu*, so other artists may transcend, momentarily or definitively, their national characteristics. The first of his two examples follows this pattern: the English pantomime, whose *comique* goes beyond the normally English moralizing *féroce* and attains the explosive exuberance of the *absolu*.

The English Pantomime

Baudelaire's choice of the English pantomime is especially apt, a caricatural version of an august precedent: it provides the *mot d'ordre* for modern art that the famous English performances of Shakespeare in Paris did for Romanticism in 1827–28. He reveals its special significance only after having described the show and acknowledged the blandness of his narrative relative to it:

> Avec une plume tout cela est pâle et glacé. Comment la plume pourrait-elle rivaliser avec la pantomime? La pantomime est l'épura-tion de la comédie; c'en est la quintessence; c'est l'élément comique pur, dégagé et concentré. (540)

> [With a pen all this is pale and frozen. How could the pen compete with pantomime? Pantomime is the refinement, the quintessence of comedy; it is the comic element pure, detached, and concentrated.]

Pantomime represents a kind of pure comedy, the comic abstracted and brought to life, a perfect illustration of the comic in its highest form. It has the farcical exaggeration, hyperbole, and license of the *comique absolu* ("monstrueuse farce," "vertige de l'hyperbole," "emportement," 539f.), and is characterized by the violence that marks absolute laughter (535).[100] Unlike the discursive, colorless, frozen writing that seeks to reproduce it, the unreality of the pantomime paradoxically ensures an immediacy, color,

100. The line between violence and the comic may be drawn at the point of the harmful and injurious, as theorists from Plato to Freud have maintained. As Siebers notes, comic art does violence to its object but cloaks its brutality in apparently harmless forms (*The Romantic Fantastic*, 81ff.). For Baudelaire, violence marks the point where the *comique absolu* joins the ideal of Romanticism: Delacroix is characterized by the same violence and suddenness as the *absolu* (754).

and life. Reality is thus a product of the grotesque and caricatural; anything less leads to the numbness and pallor of death. As the concentration of the comic, the pantomime reflects this perfectly, an abstraction having the most wide-reaching, all-encompassing effects, the primordial reality of the *absolu*. "Quand il riait, son rire faisait trembler la salle; ce rire ressemblait à un joyeux tonnerre" (538) [When he laughed, his laughter made the theater quake; that laughter was like a joyous thunderclap]: with Pierrot's laughter the whole earth shakes.

Baudelaire's description centers on the boisterous English Clown, who represents in every respect the excess, jubilance, violence, and absurdity of the *comique absolu*:

> D'abord, le Pierrot n'était pas ce personnage pâle comme la lune, mystérieux comme le silence, souple et muet comme le serpent, droit et long comme une potence, cet homme artificiel, mû par des ressorts singuliers, auquel nous avait accoutumés le regrettable Deburau. (538)[101]

> [First of all, the Pierrot was not that character as pale as the moon, mysterious as silence, supple and silent as the serpent, straight and long as the gibbet, that artificial man, moved by such peculiar springs, to which the lamented Deburau had accustomed us.]

If Deburau is associated with an idealized, ethereal realm—pale, silent, lunar, artificial—the English Pierrot, in contrast, has the grossness and materiality of life: garish color, raucous noise, earthy obscenity and appetite. This ideal *comique* is located squarely within the domain of the fallen, even the bestial. He is short, fat, and stocky, wearing a beribboned costume that Baudelaire likens to the feathers of a bird or the fur of an angora cat.[102]

101. Deburau died in June 1846. In the *Salon de 1846*, Baudelaire calls him "the true Pierrot of our time, the Pierrot of modern history" (451).

102. MacInnes (*The Comical as Textual Practice in Les Fleurs du mal*, 45f.) sees the beribboned Pierrot as a living thyrsus and thus a mode of writing. The same detail of Clown's costume leads R. Storey (*Pierrots on the Stage of Desire: Nineteenth-Century Artists and the Comic Pantomime*, 101ff.) to compare him to Samuel Cramer, with his androgynous fantasies: Clown is a "sexually ambiguous victim." But anxiety about sexuality is embodied in the plot and characters of pantomime in general, not only in this one (nor only in Baudelaire's eyes); centers usually on Harlequin (whose power derives from the magic bat given him by the protective maternal fairy) and on the conventional "transvestite" roles, e.g. the woman washing her doorstep here, who is played by a man. On this subject see D. Mayer, "The Sexuality of Pantomime," and *Harlequin in his Element*, 320f.

On his floured cheeks, he had smeared two large patches of red, and for his lips had drawn two wide bands of carmine, giving him an ear-to-ear grin, the same sign of satanic laughter worn by the villains of melodrama mentioned earlier (531), the torn lips of Melmoth here caricatured in grease paint. He is outrageous, exuberant, and slapstick, roaring in like a storm, falling down flat like a sack of potatoes ("arrivait comme la tempête, tombait comme un ballot," 538), with a cavernous, thunderous laugh marking him even more clearly with the diabolical sign of Melmoth. He has Pierrot's legendary insouciance and moral indifference and the same rapacious nature, which he manifests with considerably more vulgarity and gusto: "Seulement, là où Deburau eût trempé le bout du doigt pour le lécher, il y plongeait les deux poings et les deux pieds" (539) [Only where Deburau would have gently dipped the tip of his finger in to lick it, he plunged in both his hands and feet]. He has an indefatigable spirit of survival and an insatiable, bawdy sexuality, and is an incurable thief. Seeing a woman washing down her doorstep, he robs her of the contents of her pockets and tries to stuff the lot into his own—sponge, mop, basin, and the water itself. His declaration of love is a hilariously obscene display, which Baudelaire evokes with comically understated discretion by likening it to the "phanerogamous habits of the monkeys, in the famous cage at the Jardin des Plantes" (539).[103] Pierrot's indecent antics are even funnier for relating him, following an old rule of comedy, to that most comical of animals, the monkey. But the outrageous comedy of the scene derives from the image of dualism it presents: the woman washing her doorstep is played by a tellingly tall, skinny man whose prudish shrieks clash with his obvious extra-dramatic masculinity. Pierrot is at once cocksure seducer and ignorant dupe, unwittingly undermining the very image he so boisterously attempts to project. Baudelaire calls it a "frenzy" of laughter, an "ivresse," both terrible and irresistible (539)—like temptation itself, as fascinating and terrifying as the caricature was to Virginie.

In another scene, Pierrot's capacity to bounce back from misfortune is put to the ultimate test and reaffirmed, thanks to his habit of thievery:

Pour je ne sais quel méfait, Pierrot devait être finalement guillotiné. Pourquoi la guillotine au lieu de la pendaison, en pays anglais? . . .

103. The immodesty of monkeys is a commonplace. Cf. Champfleury, *Histoire de la caricature moderne* (196), who describes Traviès' creation Mayeux as showing "guère plus de pudeur dans le langage que le singe dans ses actes publics" [hardly more modesty in his language than the monkey in his public acts]. The Palais des Singes opened in 1837.

Je l'ignore; sans doute pour amener ce qu'on va voir. L'instrument funèbre était donc là dressé sur des planches françaises, fort étonnées de cette romantique nouveauté. Après avoir lutté et beuglé comme un boeuf qui flaire l'abattoir, Pierrot subissait enfin son destin. La tête se détachait du cou, une grosse tête blanche et rouge, et roulait avec bruit devant le trou du souffleur, montrant le disque saignant du cou, la vertèbre scindée, et tous les détails d'une viande de boucherie récemment taillée pour l'étalage. Mais voilà que, subitement, le torse raccourci, mû par la monomanie irrésistible du vol, se dressait, escamotait victorieusement sa propre tête comme un jambon ou une bouteille de vin, et, bien plus avisé que le grand saint Denis, la fourrait dans sa poche! (539)

[For some misdeed or other, Pierrot, in the end, had to be guillotined. Why the guillotine rather than hanging, on English territory? I do not know; no doubt to bring about what we will see in a moment. So the instrument of death was there, mounted on the French boards, which were highly surprised at this romantic novelty. After having struggled and bellowed like an ox that scents the slaughter-house, Pierrot finally suffered his fate. The head came away from the neck, a great head white and red, and rolled noisily up to the prompter's box, showing the bleeding disk of the neck, the split vertebrae, and all the details of a piece of butcher's meat just dressed for the display window. But then, suddenly, the truncated torso, moved by its irresistible mania for theft, rose up, triumphantly filched its own head like a ham or a bottle of wine, and, far more shrewd than the great Saint Denis, stuffed it into his pocket!]

Baudelaire calls attention to precisely those features that illustrate the comique absolu: the astonishing "romantic novelty" of the guillotine, rather than the traditionally English gibbet; the anthropomorphization of the stage; Pierrot's excessive bellowing, and the noisy rolling of his enormous, self-propelled head across the stage. The detailed, playfully gruesome anatomical description is in the best Rabelaisian tradition.[104] He comically extends the earlier simile of the steer awaiting slaughter by comparing the severed head to a piece of butcher's meat, one of Clown's traditional prizes. And the definition of the absolu as the superiority of mankind over nature is fulfilled

104. Cf. Friar John's beheading of Picrochole's archer in Gargantua, chap. 44.

in the retrieval of the head (now compared to the proverbially comical ham) by Pierrot's headless, but no less willfully determined, torso. Magically taking on their own life, the head and torso defy the limitations of nature and the finality of death, spontaneously regenerating themselves, an image of the limitless creative power of the *absolu*. Indeed, the scene too undergoes just such a comic regeneration, in parody: Pierrot, for obvious reasons, must take greater care than the legendary bishop of Paris, and prudently stuffs the head into his pocket before it can be snatched away. That he is motivated by his typical mania for theft, and treats the head like any other booty (as in the scene with the woman and the bucket of water), makes his actions all the funnier: the fantastic rejoins the real, indeed the all-too-predictable. Pierrot outwits nature with his rascal's nature, *comique absolu* at its best.[105]

Baudelaire finds the most exemplary illustration of *comique absolu* not in the rollicking, knockabout scenes of the show, but rather in the opening one, the "transformation scene," in which the characters are turned into Harlequin, Clown, Colombine, et al., by the fairy's magic: "Une des choses les plus remarquables comme comique absolu, et pour ainsi dire, comme métaphysique du comique absolu, était certainement le début de cette belle pièce, un prologue plein d'une haute esthétique" (540) [One of the most remarkable things, for the absolute comic and, so to speak, the metaphysics of the absolute comic, was certainly the beginning of this beautiful play, a prologue full of high aesthetics]. Baudelaire specifies "métaphysique": the prologue is a reflection on *comique absolu* itself, and enacts the very process by which this affects the spectator. Standing quietly before the audience, the characters are suddenly animated by the wave of the fairy's magic wand:

> Aussitôt le vertige est entré, le vertige circule dans l'air; on respire le vertige; c'est le vertige qui remplit les poumons et renouvelle le sang dans le ventricule.
>
> Qu'est-ce que ce vertige? C'est le comique absolu; il s'est emparé de chaque être. (540)

> [Suddenly a giddiness has entered, giddiness moves through the air; it is this giddiness that fills the lungs and renews the blood in the

105. Stierle suggests that Baudelaire's description aims to reproduce the comic in language and translate the achievement of the pantomime itself, in which the simultaneity of *comique absolu* is conveyed by a succession of scenes in time ("Baudelaires 'Tableaux parisiens' und die Tradition des *tableau de Paris*," 313). (The English translation of this article is an abridged version, lacking the pages on the pantomime.)

veins. What is this giddiness? It is the absolute comic; it has taken hold of each one of them.]

The fairy's gesture is a "magic breath" that instills in them the spirit of the vertiginous *comique absolu*, transforms them, and admits them into a new realm of existence (540). It is the *comique absolu* that destroys the dramatic illusion and turns them blatantly into actors, forcing the spectator to acknowledge the dualism from within the powerful, unified experience of the *absolu*: prior to the fairy's action they resemble the ordinary people in the audience. But then they come to life, making windmills, leapfrogging, somersaulting, kicking, punching, slapping, running, jumping, dancing, all the while issuing great peals of laughter. Baudelaire treats the *comique absolu* as an irresistible and omnipotent force, a "vertige," a "délire," a fate controlling their every action, like a tempest moving windmills. But he also insists on the carefree good will, almost joy, with which it fills them: "Tous leurs gestes, tous leurs cris, toutes leurs mines disent: La fée l'a voulu, la destinée nous précipite, je ne m'en afflige pas; allons! courons! lançons-nous!" (541) [All their gestures, all their cries, all their expressions say: the fairy has willed it, destiny hurries us on, it doesn't worry me. Let's go! Come, let's get started!] The characters are completely under its spell, but do not seem to mind (540); their bursts of laughter are full of contentment (540); the exchange of punches, slaps, and kicks, likened to a battery of artillery fire, is nevertheless "without rancor" (541). They fearlessly prepare for the disasters and tumult that await them, look forward to them with enthusiasm, thus reflecting the good humor necessary to the *absolu* (537). The violent gaiety of the pantomime approaches innocence and joy, like the *comique absolu* generally. In his essay on Banville (1861), Baudelaire attributes to this type of excessive, carnivalesque humor a cathartic function, emptying satire of its bitterness and converting aggression to innocent gaiety: "l'excès en détruira l'amertume, et la satire . . . se déchargera de toute sa haine dans une explosion de gaieté, innocente à force d'être carnavalesque" (167) [the excess will destroy the bitterness of it, and the satire will discharge all its hatred in an explosion of gaiety, innocent by dint of being carnivalesque].

 With this explosion of *comique absolu*, the work enters the fantastic: "Et ils s'élancent à travers l'oeuvre fantastique, qui, à proprement parler, ne commence que là, c'est-à-dire sur la frontière du merveilleux" (541) [And they go off into the fantastic work, which, to be precise, only begins at that point, on the frontier of the marvelous]. By the power of the *comique absolu*,

players and audience cross the Melmothian boundary between real and imaginary, and enter the rarefied regions of the *merveilleux*. Baudelaire will explore the intimate relation between the *absolu* and the fantastic in his section on Hoffmann, and will develop it in those on Daumier, Goya, and Bruegel, but makes it clear already here: the *comique absolu* gives them superhuman powers, makes possible the fantastic antics to follow, and transforms a rationally ordered plot into a rough-and-tumble series of magic acts, metamorphoses, and resuscitations. The comic, proper to mankind, that mark of human inferiority, leads to the superhuman and the supernatural.

The relation of the pantomime as Baudelaire describes it here to the one enacted in his prose poem, "Une Mort héroïque" (1863) is important; it clarifies both his understanding of the comic and the poem itself. The Clown Fancioulle bears a strong resemblance to the English Pierrot. Pantomime is his specialty: "[il] excellait surtout dans les rôles muets ou peu chargés de paroles, qui sont souvent les principaux dans ces drames féeriques dont l'objet est de représenter symboliquement le mystère de la vie" (I, 321) [he excelled especially in silent roles, or those with few words, which are often the principal ones in those magical dramas whose object is to represent symbolically the mystery of life]. He shares Pierrot's agility of body and facial expression, coming and going, laughing, crying, writhing and twisting: "Ce bouffon allait, venait, riait, pleurait, se convulsait" (I, 321). Pierrot's excess ("emportement"), "hyperbole" (539), and monstrously farcical deeds (540) are matched by Fancioulle's "extravagantes bouffonneries" (I, 321). The "vertige" of the *comique absolu*, which fills the English clowns and makes them oblivious to the destiny that awaits them (540), corresponds to the intoxication of Art that fills Fancioulle and blinds him to the terrors of the abyss, the proximity of death that lies in store (I, 321). The clowns feel happy contentment (540), Fancioulle a kind of joy (I, 321); he is in paradise (I, 321), they enter into the new realm of the fantastic and *merveilleux* (541). Finally, both inspire the same reaction in the audience: Pierrot provokes a frenzy of laughter, at once terrible and irresistible, and Fancioulle causes "explosions of joy and admiration," with which the audience gives itself over to the intoxicating pleasures of his performance (I, 322).

The situation of "Une Mort héroïque," the motivation for Fancioulle's performance, is that the clown, a favorite of the Prince, is "fatally attracted" to the serious business of a conspiracy against his master. Fancioulle and his partners are arrested and destined to die; however, rumors of a pardon

arise when the Prince announces a performance to be attended by the conspirators, at which Fancioulle will play one of his best roles. The pantomime takes place, and Fancioulle surpasses himself; but suddenly a child, instructed by the Prince, issues a long, piercing whistle of disapproval, interrupting the performance and tearing both the actor and his audience from the marvelous intoxication of his art. Fancioulle stops short, totters, and falls dead on the stage; that night, his co-conspirators are put to death.

This is a complex poem that has been discussed repeatedly.[106] But seen in the light of Baudelaire's comic theory, the poem suggests another sense, rather different from those proposed hitherto; and conversely, it qualifies the nature and function of the comic as Baudelaire presents them in *De l'essence du rire*. What has not been sufficiently taken into account in all the ironies of this poem is the *problem* with Fancioulle's art: not its tragic inability to sustain the false illusion it represents and to resist the reality of death, but its failure to fulfill the very conditions of comic art itself. This is hidden under a heavy, almost oppressive, layer of sentimentality that, like the art itself, deceives and bewitches the reader:

> Fancioulle me prouvait, d'une manière péremptoire, irréfutable, que l'ivresse de l'Art est plus apte que tout autre à voiler les terreurs du gouffre; que le génie peut jouer la comédie au bord de la tombe avec une joie qui l'empêche de voir la tombe, perdu, comme il est, dans un paradis excluant toute idée de tombe et de destruction. (I, 321)

> [Fancioulle proved to me, in a peremptory, irrefutable, way, that the intoxication of Art is more apt than any other to veil the terrors of the abyss; that genius can play-act at the brink of the tomb with a joy that prevents it from seeing the tomb, lost as it is in a paradise that excludes any idea of the tomb and destruction.]

To take the statement as positive is to put ourselves in the position of the audience within the poem, mistaking the Prince's sadistic manipulation for

106. J. Starobinski, *Portrait de l'artiste en saltimbanque*, 86ff; L. Bersani, *Baudelaire and Freud*, 132f; V. Rubin, "Two Prose Poems by Baudelaire: 'Le Vieux Saltimbanque' and 'Une Mort héroïque' "; J. Hiddleston, *Baudelaire and Le Spleen de Paris*, 15ff; R. Chambers, "L'Art sublime du comédien ou le regardant regardé"; M. Maclean, *Narrative as Performance: the Baudelairean Experiment*, 49ff; McLees, *Baudelaire's "Argot Plastique,"* 105. P. Schofer (' "Une Mort héroïque': Baudelaire's Social Theater of Cruelty," 51), arguing that the guillotine is everywhere implicit in the poem, implies a further link between the two texts.

a charitable act of clemency. It is to fall victim to the sentimentalism of Fancioulle himself. The clichés, rather, signal the irony: Fancioulle's comedy destroys the dualism of comic art and fails to accomplish its purpose, that is, reminding mankind of its inferiority relative to an omnipotent absolute, death. Comic art by definition is meant to present an image of mortality (and thus redemption), and this is *precisely* what Fancioulle's does not do. Instead, it inspires an intoxicating and dangerous oblivion that hides the abyss, a joy that keeps him from seeing his mortality, a paradise that excludes these very ideas but in which he is, significantly, *perdu*. Baudelaire uses a word heavy with theological connotations of damnation to suggest, under cover of praise, the flaw in Fancioulle's art.[107] The problem lies not in the conventional Romantic division between the sublimity of art and the intrusive, disillusioning forces of reality, but in Fancioulle's failure to maintain that very dualism that is the *sine qua non* condition of comic art and, as we shall see later, of art in general.

This is supported by the effect of the art on the audience: a total "domination," an intoxication ("enivré"), a pleasure ("volupté") to which they abandon themselves and forget about death and suffering: "Personne ne rêva plus de mort, de deuil, ni de supplices. Chacun s'abandonna, sans inquiétude, aux voluptés multipliées que donne la vue d'un chef-d'oeuvre d'art vivant" (i, 322) [No one dreamt any longer of death, nor mourning, nor torment. Each abandoned himself without a worry to the multifarious pleasures that the sight of a masterpiece of living art provides]. Once again, the metaphorical language makes the point: the sublime art of Fancioulle behaves like the most pernicious of vices, bringing the artist and his audience into total submission and captivity, an *art satanique* par excellence. It is in fact as fatal an attraction for them as the conspiracy itself first was to Fancioulle: "pour les personnes vouées par état au comique, les choses sérieuses ont de *fatales attractions*" (i, 319) [for people destined by trade to the comic, serious things have a fatal attraction]. He and the audience are as taken in by his comedy as he was earlier by the serious idea of rebellion, which the narrator presented as a rather bizarre but true law at the beginning. The attraction of art is potentially the most fatal of all ("*plus apte que tout autre* à voiler les terreurs du gouffre"). Unlike the English

107. Burton (*Baudelaire in 1859*, 181) remarks that in Fancioulle there is no gap between work and artist, vision and execution, but takes this as a positive statement of the Baudelairean poetic ideal. Cf. McLees, *Baudelaire's "Argot Plastique,"* 110. Hiddleston (*Baudelaire and Le Spleen de Paris*, 18) notes the "charlatanism" of Fancioulle, his veiling of the abyss being illusory.

pantomime, Fancioulle's encourages an identification but not a sense of distance and dualism.

The one who does not submit is actually he who masterminds it all, the cruel and despotic Prince, an artist of a different kind, as the narrator had casually suggested at the outset:

> Amoureux passionné des beaux-arts, excellent connaisseur d'ailleurs, il était vraiment insatiable de voluptés. . . . véritable artiste lui-même . . . le grand malheur de ce Prince fut qu'il n'eut jamais un théâtre assez vaste pour son génie. Il y a de jeunes Nérons qui étouffent dans des limites trop étroites. (I, 320)

> [Passionate lover of the fine arts, excellent connaisseur, he was truly insatiable of delights. . . . himself a veritable artist . . . the great misfortune of this Prince was that he never had a theater vast enough for his genius. There are young Neros who stifle within limits too narrow.]

The Prince is an artist like Nero, coldly using his kingdom as his stage and his subjects as unwitting players; in this he is paradoxically superior to Fancioulle because he retains even in intoxication the calculating power of his art. He is "lui-même enivré" but his "ivresse" is not all-consuming; he maintains an ironic consciousness and thus gives the order to the page.

Fancioulle, for all his artistry, does not preserve his hold on reality, and thus his awakening coincides with his death. He does not sustain the *dédoublement* necessary of the true comic artist, the capacity to be at once himself and another, the ability to know his own duality while playing a comic character whose essence it is *not* to know this, the creatively simultaneous superiority and inferiority that surpass the limitations of dualism. He does not have the self-irony of the English Clown, who deftly transforms one role into another and thus defeats death, seizing his severed head and creating from this a new role altogether. Fancioulle becomes his role, and the step is fatal. He falls victim to the illusion of his own art, the illusion of unity: here, as in "Le Joueur généreux," the devil's most powerful strategy is to make us think that he does not exist.[108]

108. For Chambers, the illusory nature of his art leaves the *comédien* ever at the mercy of a brutal awakening, the piercing whistle of the reality of the human condition ("L'Art sublime du comédien," 199, 250f.). But the essays on caricature suggest that in true art such an "awakening" does not take place: by *dédoublement* the artist is simultaneously self and other, distinct from his role but consciously creating the illusion of being one with it.

But Baudelaire does not abandon the reader there: there exists an alternative to the deceptive sublimity of Fancioulle and the tyrannical, cynical artistry of the Prince. The latter is not the only one who does not wholly submit; the poem offers us the narrator who witnesses the event and recounts it.[109] But this conventional topos is more subtle than is first apparent. He is the only one who sees the aura around Fancioulle's head as he acts, "auréole . . . où se mêlaient . . . les rayons de l'Art et la gloire du Martyre" (I, 321) [an aura . . . in which were mingled . . . the rays of Art and the glory of Martyrdom]. Fancioulle himself is not a true martyr because this requires self-awareness, the joy of sacrificing oneself;[110] only the narrator sees him as such, and demonstrates the knowledge of dualism proper to the artist. From his perspective alone Fancioulle becomes a martyr to the aesthetic cause, a victim offered up as an example of the falsity of a nondualistic attitude to art. His is accordingly the "clairvoyant eye" (I, 322) that perceives the Prince's composure beneath his enthusiastic applause and exposes it in the poem.

He also describes the aesthetic emotion that he currently feels in *remembering* the incident and re-creating it in the poem, that is, his melodramatically trembling pen and tearful eyes: "Ma plume tremble, et des larmes d'une émotion toujours présente me montent aux yeux pendant que je cherche à vous décrire cette inoubliable soirée" (I, 321) [My pen shakes, and tears from an emotion still present to me come into my eyes as I seek to describe that unforgettable evening]. But the excessive sentimentality signals the irony: the existence of the poem proves that, unlike the case of Fancioulle, these signs of passion were mastered by the narrator's will, a *volupté transformée en connaissance*, a pleasure transformed into knowledge, to use Baudelaire's famous formula for artistic expression. The narrator's comment, quoted earlier, of what Fancioulle proved to him is thus ironic: Fancioulle proved that the intoxication of art, more than any other, can hide the terrors of death, but in so doing proved that he was not a true comic artist. Comic art at its best reminds us of our inferiority and

109. On the role of the narrator as teller and audience, see Maclean, *Narrative as Performance*, 50f.
110. Cf. *Mon Coeur mis à nu* XII: "Pour que le sacrifice soit parfait, il faut qu'il y ait assentiment et joie de la part de la victime. Donner du chloroforme à un condamné à mort serait une impiété, car ce serait lui enlever la conscience de sa grandeur comme victime et lui supprimer les chances de gagner le Paradis" (I, 683). [For the sacrifice to be perfect, there must be assent and joy on the victim's part. Giving chloroform to a man condemned to death would be an impiety, for that would be to remove from him the consciousness of his grandeur as a victim and to destroy his chances of reaching Paradise.]

mortality, of the dualism *necessary* to art, and thus of our potential for transcendence.

For the audience too the intoxicating spectacle of Fancioulle's performance is fatal: "Les gentilshommes coupables avaient joui pour la dernière fois du spectacle de la comédie. Dans la même nuit ils furent effacés de la vie" (I, 323) [The guilty gentlemen had for the last time enjoyed the spectacle of comedy. That night they were stricken from this life]. We are told in the closing lines that no future mimes ever reached the excellence of Fancioulle, nor enjoyed his same favor. Baudelaire italicizes this, the final word, and thus underlines its ironic ambiguity: Fancioulle's popularity with the public, and the special, ill-fated station that he enjoyed at the Prince's court. The Prince accorded Fancioulle the ultimate "favor" of giving him *une mort héroïque*, making him a victim in sacrifice.

In terms of *De l'essence du rire*, Fancioulle's story illustrates the importance of dualism in the *comique absolu*. The English pantomime does not run the same risk, for the *comique absolu* makes the clowns larger than life, transforms them from images of the ordinary people in the audience into hyperbolic, caricatural figures, and foregrounds the dualism rather than repressing it. Fancioulle's history explains why E. T. A. Hoffmann may provide an even clearer example of *comique absolu*, for his involves a constant mixture of *significatif* and *absolu*, moral meaning and the fantastic. Significantly, Hoffmann is also Baudelaire's prime example for the *dédoublement* of the comic artist who, like Fancioulle, creates a perfect character; like the Prince, retains his distance on it; and, like the ironic narrator, understands precisely that true comic art will not hide the grave but keep it ever present to our minds.

The source of Baudelaire's pantomime has the same acknowledged uncertainty as *Le Sage ne rit*, placing the example in the same shadowy region as the mysterious and exemplary maxim. He raises the question straightaway in his introductory paragraph, with an intriguing mélange of precision and vagueness:

> Je garderai longtemps le souvenir de la première pantomime anglaise que j'aie vu jouer. C'était au théâtre des Variétés, il y a quelques années. Peu de gens s'en souviendront sans doute, car bien peu ont paru goûter ce genre de divertissement, et ces pauvres mimes anglais reçurent chez nous un triste accueil. Le public français n'aime guère être dépaysé. Il n'a pas le goût très cosmopolite, et les déplacements d'horizon lui troublent la vue. Pour mon compte, je fus excessivement

frappé de cette manière de comprendre le comique. On disait, et c'étaient les indulgents, pour expliquer l'insuccès, que c'étaient des artistes vulgaires et médiocres, des doublures; mais ce n'était pas là la question. Ils étaient Anglais, c'est là l'important. (538)

[For a long time I will remember the first English pantomime that I saw played. It was at the Théâtre des Variétés, a few years ago. Few people will remember it, no doubt, for very few appeared to appreciate this type of entertainment, and those poor English mimes received from us a sorry welcome. The French public does not like to be taken out of its element. It does not have very cosmopolitan tastes, and changes of horizon disturb its vision. For my part, I was exceedingly struck by this way of understanding the comic. To explain their lack of success, it was said (and this by the indulgent ones) that these were second-rate mediocre artists, understudies; but that was not the point. They were English, that was the important thing.]

With such indeterminacy, the identity of the pantomime has remained unknown. On the evidence of newspaper reports, J. Mayne tentatively identified it as *Arlequin, pantomime en trois actes et onze tableaux*, performed at the Variétés from 4 August to 13 September 1842.[111] Clown was played by Tom Matthews,[112] whose "rich semi-hoarse roaring voice"[113] would have created the thunderous laughter by which Baudelaire makes Clown an emblem of the *comique absolu*. Reviews note the difference between the ebullient, incorrigible, coarsely comical Clown and the delicate, judicious, *rusé* French Pierrot, and describe an episode where the decapitated Clown's larceny and gluttony move him to steal his own head and stuff it into his pocket.[114] Contrary to Baudelaire's claims, however, it had tremendous success and received excellent reviews in the press: Clown's performance is a dramatic event, the show sends the Parisian audience into transports of gaiety and laughter, its popularity exceeds all expectation, and

111. *The Painter of Modern Life*, 159f.
112. See M. Willson Disher, *Clowns and Pantomimes*, 156; *Dictionary of National Biography* xxxvii, 70f. Matthews was the greatest successor to Joseph Grimaldi, who had brought the role of Clown to prominence and made the harlequinade the most important part of the pantomime.
113. Cf. H. Byron, "Pantomimical," *The Theatre* (1 January 1879), 409.
114. See *Le Corsaire* (6 August 1842); and Gautier's article in *La Presse* (14 August 1842).

so on.[115] Moreover, the beheading takes place during a tooth-pulling session, where Harlequin cuts off Clown's head in order to extract the tooth more easily, as Gautier describes it and a contemporary illustration confirms.[116]

In this case the government's strictly pursued policy of theater censorship, so regrettable a source of bureaucratic red tape for managers at the time, actually had a favorable consequence: the script of *Arlequin*, translated into French and submitted to the Ministry of the Interior on 2 August 1842, remains in the files to this day,[117] and matches Baudelaire's description on most counts. Clown is the servant of Pantaloon, Harlequin's father, who rivals his son for the love of Colombine; the harlequinade consists of the efforts of Clown and Pantaloon to capture Colombine from Harlequin and steal his magic bat (which would restore Pantaloon to youth). The show contains Baudelaire's prologue, in which the conventional good fairy dedicates herself to the lovers' cause and changes the characters into the traditional ones of pantomime, instills in them the spirit of comedy, and sends them off into the mad and magical world of the harlequinade. It includes the scene of the woman washing down her doorstep and indignantly rebuffing Clown's overt and coarse advances. It features the violence, the *fantastique*, the creative metamorphosis of the real, the protean movement of meaning between real and surreal, and the irresistibly hilarious comedy by which Baudelaire defines the *absolu*: Pantaloon is cut in two, Harlequin stuffed head-first into a bottle, Clown beaten up and chased from the stage, two characters plummeted through windows to the street below; Clown's clarinet becomes a syringe squirting water over Pantaloon, a stolen hundred-pound note turns punningly into a hundred-pound weight, a pilfered jewel box contains the dubious treasure of a group of screaming children, a pie eagerly delved into yields up two live pigeons that promptly take flight; inanimate objects move on their own, or change their size and shape; bodies dismembered or cut in half are once again made whole. In the decapitation scene, Harlequin, disguised as a dentist, removes Clown's head instead of his aching tooth, but Pantaloon picks it up off the floor and it is securely glued back onto his torso.[118]

115. Cf. Lois Hamrick, "The Role of Gautier in the Art Criticism of Baudelaire" (cited 1349). See *La Tribune dramatique* (7 August 1842), *Le Corsaire* (6 August 1842), *La Presse* (8 and 14 August 1842), and *Le Charivari* (6 August 1842).

116. See Maurisset's illustration in *Le Charivari*, 22 August 1842.

117. Archives Nationales F[18] 788. *Arlequin* was the first English pantomime performed in France for several years and one of only two given at the Variétés between 1841 and 1847 (Archives Nationales F[18] 1 34, *Enregistrement des ouvrages dramatiques 1841–47*).

118. Dismemberment, decapitation, and the refixing of the head are in the best tradition of

The guillotine, to which Baudelaire calls particular attention, remains conspicuously absent, however. On the one hand, the tooth-pulling scene may have been later altered to appeal to the French audience; directors frequently varied the performance, usually by substituting episodes from other pantomimes,[119] and press reports indicate that this show was changed from time to time during its five-week run.[120] On the other hand, the guillotine episode reflects specific qualities of Baudelaire's notion of the comic: English *comique absolu* triumphs over the most seemingly irreversible—and quintessentially French—means of execution, the subject of countless English caricatures, the guillotine; the ludicrously fantastic wins out over the rational, and the most theatrical of public spectacles becomes the mere set for a more extraordinary act.[121] This burlesque treatment of the origins of the French republic carries out a revolution of its own, in the victory of the life-giving absurd over death. Pierrot becomes the artist of the *comique absolu*, transforming his decapitation into a new source of vitality, a new comic role, making the *morcellement* of the subject the matter of ongoing creation and metamorphosis. He enacts the return of the comic artist from the depths of seeming defeat, the power of the comic to carry humanity beyond the limitations of rationality and the finality of death. Accordingly, it is the comic that restores Pierrot to life, or gives him an afterlife, in the parody of Saint Denis: one more incredible antic, the "phénomène de la chute" literally become the "moyen du rachat."

Further, the guillotine heightens the nationalistic tension that Baudelaire's comic ranking establishes: "ces pauvres mimes anglais reçurent chez nous un triste accueil. . . . On disait . . . que c'étaient des artistes vulgaires et médiocres, des doublures; mais ce n'était pas là la question. Ils étaient

the grotesque: cf. Rabelais, *Pantagruel*, chap. 30, where Epistemon, beheaded by a dragon, has his head refitted by Panurge. They were also common features of nineteenth-century English pantomime. In the "Dissection of Harlequin" scene, originally from *Harlequin and the Swans* (1813) but reused frequently, Grimaldi was chopped up, nailed limb by limb to a wall, and then brought back to life (see D. Mayer, "The Pantomime Olio and other Pantomime Variants," 26). Maurice Sand (*Masques et bouffons*, 288f.) mentions one of Deburau's masterpieces, Charles Charton's *Les Epreuves* (1833), a pantomime "dans le genre anglais": Pierrot has his head cut off and glued on again by Harlequin, who demands a fee; Pierrot refuses to pay because it is not properly attached.

119. Mayer, "The Pantomime Olio and other Pantomime Variants," 23.

120. *Le Corsaire*, for example, reports changes (24 August 1842) and cuts (2 September 1842) in the performance. *La Tribune dramatique* (7 August 1842) mentions cuts and improved trick machinery.

121. For the English obsession with the guillotine and its "rationalism," see R. Paulson, "The Severed Head: The Impact of French Revolutionary Caricatures on England," 58ff.

Anglais, c'est là l'important," (538). Indeed although *Arlequin* was a critical success, it received one highly unfavorable review, significantly in the official *Moniteur universel*, and for the very reason that Baudelaire cites here—the Frenchman's hostility to all things English: "une pantomime mêlée de chants *anglais* (c'est tout dire), de dialogues anglais, de soufflets anglais, de coups de pied anglais . . . tout est anglais . . . ce qui fait que cela est assez peu divertissant pour nous." [a pantomime mixed with *English* songs (that says it all), English dialogue, English slaps, English kicks . . . everything English, which means that it is hardly entertaining for us at all].[122] The writer charges that it is twice as long as it should be, lacking in taste, good sense, and direction, and replete with crude acts of buffoonery "peut-être très gracieux pour John Bull, mais fort peu agréables pour nous" [perhaps very graceful for John Bull, but extremely disagreeable for us]. The *Moniteur*'s chauvinistic attitude, however untypical of reactions to the performance in general, gave Baudelaire the occasion to introduce one of his favorite themes, the provincialism of the French mind. This is a recurrent complaint in his work, as in the essay on Wagner and the *Salon de 1859*, where it is again responsible for chasing imaginative English artists from French soil.[123] Baudelaire generalizes the *Moniteur*'s nationalism in order to foreground the "uncosmopolitan" quality of his compatriots, and thus to introduce the primary quality of the comic artist:[124] "Le public français n'aime guère être dépaysé. Il n'a pas le goût très cosmopolite, et les déplacements d'horizon lui troublent la vue" (538). Only those able to escape the confines of their own culture, era, and values, only those capable of *dédoublement*, can appreciate the extraordinary comedy and the aesthetic value of the pantomime. The rationalist French mind is thus the least "philosophical" as this was defined earlier; it lacks the power to escape its own limitations and observe itself from without (532)—precisely the characteristic of the next

122. *Moniteur universel*, 14 August 1842.

123. "Représentants enthousiastes de l'imagination et des facultés les plus précieuses de l'âme, fûtes-vous donc si mal reçus la première fois [1855], et nous jugez-vous indignes de vous comprendre?" (609f.) [You enthusiastic representatives of the imagination and of the most precious faculties of the soul, were you then so badly received the first time, and do you deem us unworthy of understanding you?]

124. Cf. the poor reception of the English troupe's show the following year, *La Fée de Lismore*, which played for five days in June: "the most perfect platitude that can be imagined" (*Journal des théâtres*, 15 June 1843); "The welcome they received is not likely to flatter them much" (*Le Corsaire*, 12 June 1843). Most papers ignored the performances altogether, and only *La Tribune dramatique* (18 June 1843) reported that the clowns "were welcomed back with pleasure." Baudelaire may have conveniently conflated the two seasons.

example, Hoffmann. By contrast the *Moniteur's* reviewer represents perfectly the attitude of the *professeurs jurés de sérieux*; that caricature (or pantomime) does not have the value of high art. He writes: "ce qu'il y a de plus singulier, c'est de savoir que de semblables parades se jouent dans leur patrie à côté des chefs d'oeuvre de Shakespeare. . . . chez nous le *Boeuf enragé* ne va pas encore de pair avec *Britannicus*, et Deburau n'est pas le camarade de Ligier." [what is most peculiar is that such burlesque shows are played in their country alongside the masterpieces of Shakespeare. . . . In our country the *Le Boeuf enragé* is not yet the equal of *Britannicus*, and Deburau is not in the company of Ligier].[125]

Although the specific identity of the pantomime matters less than Baudelaire's interpretation and use of it, the fact remains that he considered this *Arlequin* unique in the genre and a perfect example of the *comique absolu*, indeed, the model from which he drew his notion of this. Violence, hyperbole, transformation, spontaneity, freedom, a gaiety approaching innocence and joy, an ongoing, self-generating creation—Baudelaire makes these features of the English pantomime those of the comic in its highest form. If, as MacInnes points out, the writer's fears about the inadequacy of his narrative—"pale" and "frozen"—ally him with the French, rather than English, variety, Deburau's lunar pallor,[126] they do not seem to have been realized. The enormity of the task that threatened to reduce him to a silence as total as Deburau's instead inspired him to a prose as lively and enchanting as its subject; a prose to match the pantomime, a prose of *comique absolu*, rapid and richly colored, ironic, grotesque, and theatrical, that, despite his statement to the contrary, can indeed "compete with pantomime" (540) and enact the very process that it despairs of ever describing.

E. T. A. Hoffmann

The section on Hoffmann brings out some of the most important aspects of Baudelaire's comic theory: the close relation between the comic and the fantastic, the impression of unity in an art by nature dual, and the doubling of the comic artist as the realization, and transcendence, of dualism. Hoffmann holds the place of honor because of the complexity and comprehensiveness of his *comique*, which spans the whole range from French *significatif* to the "mad" and "frothy" Italian *innocent*, to the deep German

125. The great tragedian (1796–1872).
126. MacInnes, *The Comical as Textual Practice in Les Fleurs du mal*, 45.

absolu. Both of the examples chosen—*Die Königsbraut* and *Die Prinzessin Brambilla*—illustrate this richness and versatility, which Baudelaire presents not as a mixture, but as a perfect harmony of different kinds in one same work, and having a single purpose.[127] The supernatural and grotesque carry in themselves a clear moral message.

In discussing *Daucus Carota, ou La Fiancée du roi (Die Königsbraut)*, Baudelaire greatly simplifies the story (which, in the manner typical of Hoffmann, has several turns of plot) so as to bring this message out. The evil gnome Daucus Carota, parading as King of the Carrots, succeeds in persuading a village girl to become his queen. Dazzled and bewitched by the splendors that the gnome places before her eyes, she does not perceive the actual misery that awaits her. Her magician-father does, however, and to restore her to her senses shows her "the underside of all these splendors" (541): while the troop of carrots sleeps soundly, he lifts the flap of the tent for her to see, revealing the soldiers wallowing in the slime, those glorious heroes snoring in a foul marsh. Baudelaire draws attention to the moral of the story, the importance of distinguishing dream from reality and keeping them in proper balance. This is also a main source of the comic here, not only because of the discrepancy between dream and reality, military pomp and stinking bog, the daytime grandeur of the carrot troop in their red suits and green-plumed hats, and their nighttime squalor as they snore on their filthy, smelly beds, but also because the fantastic ends up neatly rejoining the real: the carrot-soldiers lie in the "earthy mire" that is the natural abode of carrots. In moral terms, this comical reversal likewise restores the young girl, with her dreams of grandeur, to the reality of her humble situation, and the reader, equally caught up in the surreality of the story, to the more familiar and banal world of realist narrative.

Baudelaire's description suggests another aspect of this *comique*, however, based on the buoyancy and play of the English pantomime.[128] Comparing the troop of carrots to a "régiment anglais" on the basis of their reddish

127. Baudelaire read both stories in Toussenel's translation of 1830. He also read *Le Pot d'or*, the *Kreisleriana* (trans. Loève-Veimars, 1830), *Le Chien Berganza* (trans. Egmont, 1836), and *Maître Puce (Pérégrinus Tyss)*, as well as Loève-Veimars' *Vie d'Hoffmann* (1833). See R. Lloyd, *Baudelaire et Hoffmann. Affinités et influences* (10ff.) and I. Köhler, *Baudelaire et Hoffmann*, 6.

128. Hoffmann himself referred to pantomime admiringly as "the primary spectacle of all, [which] expresses so many profound sentiments without the help of words" (quoted in Pommier, "Baudelaire et Hoffmann," 470).

color draws attention clearly to the parallel.[129] Baudelaire insists on their tricks and showmanship, as with the earlier English clowns:

> Tous ces petits personnages . . . exécutent des cabrioles et des voltiges merveilleuses sur de petits chevaux. Tout cela se meut avec une agilité surprenante. Ils sont d'autant plus adroits et il leur est d'autant plus facile de retomber sur la tête qu'elle est plus grosse et plus lourde que le reste du corps, comme les soldats en moelle de sureau qui ont un peu de plomb dans leur shako. (541)

> [All these little little figures . . . perform marvelous tricks and capers on little horses. It all is carried out with surprising agility. They are all the more adroit, and it is all the easier for them to fall on their heads, because these are larger and heavier than the rest of their bodies, like toy soldiers made of elder-pith which have a bit of lead in their shakos.]

The carrots are caricatures, although in a diminutive, rather than exaggerated, sense—spirited *petits personnages* like Cruikshank's in *Quelques caricaturistes étrangers* (566), little toy soldiers upon toy horses. They possess enormous, heavy heads disproportionate to their bodies, in the manner of caricatures generally, and have the same exuberant agility as the English clowns. But here Baudelaire brings out the function of the *significatif* within the *absolu*. Hoffmann's stories convey a moral message through their most grotesque aspects: "Ses conceptions comiques les plus supra-naturelles, les plus fugitives, et qui ressemblent souvent à des visions de l'ivresse, ont un sens moral très visible" (542) [His most supernatural and fleeting comic conceptions, which often resemble the visions of intoxication, have a very conspicuous moral sense]. Indeed the very best artists of the grotesque—Poe, Maturin, Balzac, Hoffmann, Goya, and Daumier—integrate *significatif* and *absolu*, make the grotesque carry a moral within itself, and paradoxically create a "fantastique pur, moulé sur nature" [a pure fantastic, molded from nature],[130] a dual art having an effect of unity, the perfect realization of the *comique absolu*.

129. In Hoffmann's story the carrots are not red, but rather a yellowish-orange. See Köhler (*Baudelaire et Hoffmann*, 55 n. 111).
130. *Edgar Allan Poe, sa vie et ses ouvrages* (277).

Baudelaire finds the most striking example of this in *Die Prinzessin Brambilla*, where the moral is contained within the grotesque and fantastic themselves: "c'est à croire qu'on a affaire à un physiologiste ou à un médecin de fous des plus profonds, et qui s'amuserait à revêtir cette profonde science de formes poétiques, comme un savant qui parlerait par apologues et paraboles" (542) [it is as though one were dealing with the most profound physiologist or alienist, who amused himself by clothing this deep science in poetic forms, like a scholar who spoke in fables and parables]. But unlike the transparent fable of Rabelais, in which the art *serves* to express a particular message, Hoffmann's makes the moral spring from the art. This is a fable that expresses the inexpressible, the extravagant visions of the fantastic and grotesque that cannot be rationalized. And such poetry conveys "science," the fantastic reveals the "physiology" of the imagination, the mythical bodies forth and clarifies the real. The fantastic drawn from the real, and the real from the surreal, this *comique absolu* represents the paradox that will define the art of modernity.

In particular, Baudelaire cites the "chronic dualism" (542) of Giglio Fava in *Die Prinzessin Brambilla*, the contradiction within him between dream and reality, intention and action.[131] Giglio is a lowly actor in love with the beautiful Princess Brambilla, herself betrothed to Cornelio Chiapperi, prince of Assyria. A dreamer dissatisfied with his condition, Giglio imagines himself the characters that, as an actor, he is supposed merely to represent, and interprets his experience according to his wishes for it. The story takes place during Carnival, thus allowing a free play of disguise and mistaken identity—real, fantastic, and psychological. Giglio's inner division is objectified in the structure of character doubles and doubling, consistent with the Carnival context:

> Ce personnage *un* change de temps en temps de personnalité, et, sous le nom de Giglio Fava, il se déclare l'ennemi du prince assyrien Cornelio Chiapperi; et quand il est prince assyrien, il déverse le plus profond et le plus royal mépris sur son rival auprès de la princesse, sur un misérable histrion qui s'appelle, à ce qu'on dit, Giglio Fava. (542)

> [This single character changes personality from time to time and, under the name of Giglio Fava, he declares himself the enemy of the

131. Baudelaire takes Giglio's malady from the "chronic dualism" of chapter 7 which, although applied to the prince, is also an allegory of Giglio's mind, ever discontent with his situation.

Assyrian prince Cornelio Chiapperi; and when he is the Assyrian
prince, he heaps the most profound and regal scorn on his rival for
the Princess's favor, a wretched actor whose name, they say, is Giglio
Fava.]

In this episode, Giglio dresses in a costume identical to Cornelio Chiapperi's
and imagines himself the prince; upon seeing the real prince, he thus takes
him for a disguised Giglio.[132] The fantastic metamorphoses and magical
duplication provide an allegory of the divided self; this fantastic is also a
parable of the real. Giglio sees before him an identical self who hides the
Princess Brambilla from his view, an image of the self-annihilation his self-
ignorance brings about: "c'est la faute de mon moi si je ne vois plus la
princesse . . . ; je ne puis voir à travers mon moi, et ce maudit moi m'attaque
avec des armes dangereuses" [it's the fault of my own self that I no longer
see the princess . . . ; I cannot see through my self, and this cursed self
attacks me with dangerous weapons] (La Princesse Brambilla, 111).

The Italian ciarlatano Celionati illustrates Giglio's condition with a tale
of Siamese twins, two princes joined together who complement one another
emotionally, and whose dispositions never agree. Baudelaire discusses this
same problem in more practical terms in his 1859 review of Asselineau's
volume of stories, La Double Vie: the common condition of the homo
duplex, "toujours double, action et intention, rêve et réalité; toujours l'un
nuisant à l'autre, l'un usurpant la part de l'autre" (87) [always dual, action
and intention, dream and reality; one always harming the other, one
usurping the other's share]. The main symptom of chronic dualism is inner
discord, from the failure to understand oneself; Giglio will overcome it,
become a true actor, and attain happiness with the seamstress Giacinta only
when he gains self-knowledge.

This occurs in all four main characters precisely through the agency of
the comic. Looking at themselves in a magical mirror-pool, they experience
the liberating vertige of seeing their own image inverted, and begin to laugh
(La Princesse Brambilla, 234)—not with a villainous cackle, but with the
triumphant laughter of inner joy (ibid., 99). "Ceux-là ont compris la vérité
de la vie . . . qui se sont reconnus, . . . et qui ont ri" (ibid., 235) [The ones
who have understood the truth of life . . . are those who have recognized
themselves, . . . and laughed]: the agent of transformation from self-

132. La Princesse Brambilla, in Contes, trans. Toussenel, 186. References in the text are to
this edition unless otherwise indicated.

ignorance to self-knowledge, and further, to knowledge beyond the self, is the *comic* mirror, the world's images turned upside down, which resolves dualism into a harmony, the divided self into a double self, a self with the capacity to see itself as other. Self-knowledge here consists in the recognition of oneself as an object of the comic. The characters know the same *vertige* as the English clowns, the *comique absolu*. It comes from a caricatural vision contrary to reason and is the best method of inspiring reason:[133] they return to their proper roles, the Princess is united with Cornelio Chiapperi, and Giglio with Giacinta.[134]

Moreover, it is finally revealed that the whole operation was an act of theatrical direction planned and staged by the impresario Celionati himself. His comic theater, in which he makes himself a player, serves the same function as the magical mirror-pool in which the characters recognize themselves and laugh. Carnival, the intersection of comic theater and life, the introduction of theater into life, provides the context for showing the importance of comic theater *to* life: the distorting mirror by which one comes to recognize oneself as other, at once subject and object. It thus reflects Baudelaire's own view of comic art, revealing to humanity its dual condition and providing some means of transcending it through self-knowledge—exploiting, like Celionati, the creative potential of dualism through *dédoublement*.

The Paradox of the Comic Artist

The dualism that constitutes Giglio's *comique* contains the solution to the problem as well, *dédoublement* and the paradox of the comic artist:

> je ferai remarquer . . . que cependant, relativement à cette loi d'ignorance, il faut faire une exception pour les hommes qui ont fait métier de développer en eux le sentiment du comique et de le tirer

133. In Hoffmann's story, the tyrannical philosophers specifically forbid the characters from looking into the mirror-pool. See T. Todorov, *Introduction à la littérature fantastique*, 128.

134. De Man sees this as a further mystification, the characters playing an even more artificial and clichéd role, that of the happy couple ("The Rhetoric of Temporality," 218). But their self-knowledge consists precisely in recognizing their mystification, the dualism—or fragmentation—at the basis of the "unity" of the self.

d'eux-mêmes pour le divertissement de leurs semblables, lequel phé-nomène rentre dans la classe de tous les phénomènes artistiques qui dénotent dans l'être humain l'existence d'une dualité permanente, la puissance d'être à la fois soi et un autre.

. . . Les artistes créent le comique; ayant étudié et rassemblé les éléments du comique, ils savent que tel être est comique, et qu'il ne l'est qu'à condition d'ignorer sa nature; de même que, par une loi inverse, l'artiste n'est artiste qu'à la condition d'être double et de n'ignorer aucun phénomène de sa double nature. (543)

[I will point out . . . , however, that concerning this law of ignorance, an exception must be made for those men who have made it their profession to develop in themselves the sense of the comic and to draw it out for the amusement of their fellows, a phenomenon belonging to the class of all artistic phenomena that betoken in a human being the existence of a permanent dualism, the power to be at once oneself and another.

. . . Artists create the comic; having studied and brought together the elements of the comic, they know that such and such a being is comic, and that it is so only on the condition of being unaware of its own nature; just as, following an inverse law, the artist is an artist only on condition of being dual and not unaware of any aspect of his dual nature.]

This is the tradition of the actor from Diderot's *Paradoxe sur le comédien*, who communicates emotion by having none, and by knowing how to produce the illusion of it. *Artiste comique* is in Baudelaire's scheme a paradox: the artist is defined by self-knowledge, the comic by self-ignorance. If, as an artist, one must live with the Melmothian knowledge of dualism, one can also, through creating the illusion of ignorance, make others laugh, and bring them to an understanding of theirs. Baudelaire presents this as an exception to the comic, but in fact it is made possible through the distinctive feature of the comic itself: dualism. The comic artist recognizes his dual nature and exploits it, making himself appear one way while he knows himself to be another: "quand Hoffmann engendre le comique absolu, il est bien vrai qu'il le sait; mais il sait aussi que l'essence de ce comique est de paraître s'ignorer lui-même et de développer chez le spectateur, ou plutôt chez le lecteur, la joie de sa propre supériorité et la joie de la supériorité de

l'homme sur la nature" (543) [when Hoffmann engenders the absolute comic, it is certainly true that he knows it; but he also knows that the essence of this comic is to appear to be unaware of oneself and to develop in the spectator, or rather in the reader, the joy of his own superiority and the joy of human superiority over nature]. He takes advantage of the artist's peculiar capacity for *dédoublement*, the power to step back from oneself and survey the phenomena of the self, the power to be at once oneself and another.

In *Die Prinzessin Brambilla*, Reinhold defines chronic dualism in similar terms, as a state in which the self separates from itself and personal identity decomposes.[135] But chronic dualism is an involuntary condition, a "malady" in which the personality *must* split in two, *cannot* hold onto itself; it results from a lack of control. Baudelaire's *dédoublement*, on the other hand, is deliberate, a product of extreme control, an ironic strategy by one who has self-knowledge to bring the self-ignorant to it also. (Indeed, he elsewhere associates the comic artist with perfect health.)[136] The clearest example of the comic artist in this sense is the comic actor, who, in the terms of Rousseau's critique, possesses the art of dissembling ("se contrefaire"), suppressing the *être* to live in the *paraître*.[137] Like Diderot's *comédien*, he can only succeed in appearing self-ignorant if he actually has knowledge, in making others laugh if he knows the rules and "elements" of the comic. Accordingly the actor is, in Diderot's words, the one who laughs but never cries,[138] the very obverse of Christ who, in the tradition cited by Baudelaire earlier, cried but never laughed.

But Baudelaire's insistence on dualism brings out the actor's own involvement in the comedy. The comic artist is thus both ironic and ridiculous. In *Die Prinzessin Brambilla*, this is superbly represented by Hoffmann's *ciarlatano*, who masterminds the whole, confusing show, the play of dualism, illusion, and disguise (including his own), and the comic experience of a world turned upside down, to lead the other characters to self-knowledge. Through the theater of Carnival, in which he himself has a part, he creates the comic mirror in which they come to recognize themselves.[139]

135. *Die Prinzessin Brambilla* (*Sämtliche Werke* III, 894): "jene seltsame Narrheit, in der das eigene Ich sich mit sich selbst entzweit, worüber denn die eigne Persönlichkeit sich nicht mehr festhalten kann." Cf. *La Princesse Brambilla* (*Contes*, 215).
136. *Les Martyrs ridicules par Léon Cladel* (187).
137. *Lettre à M. d'Alembert sur les spectacles*, 106.
138. *Paradoxe sur le comédien*, in *Oeuvres esthétiques*, 349.
139. On specularity in Baudelaire and its relation to theatricality, see B. Delmay and M. Lori, *Baudelaire. Dallo Specchio alla scena: uno stadio ripetitivo*.

Thus the dualism of the comic artist is transformed from a Melmothian punishment, and a source of damnation, to the *power* ("puissance") to be oneself and another, later described as the privilege of the poet in "Les Foules" and the convalescent's gift in *Le Peintre de la vie moderne*. The artist escapes the limitations of dualism precisely by exploiting it, using knowledge to create an art that depends on the illusion of ignorance. This is done not in order to feel superior to others and control them, but as a means by which to bring them to self-awareness, to a knowledge of their dualism too. The ironic act is linked not only to the perception of the self as other, but also to the recognition of others in the definition of the self.[140] In the theological and Romantic terms used earlier in the essay, the comic artist accomplishes a self-sacrifice for the benefit of fallen humanity, takes over the pact from Melmoth.[141] If Rousseau's artist annihilates himself and makes himself a plaything of the audience,[142] this self-degradation is in Baudelaire's scheme salutary. What for Rousseau constitutes a kind of prostitution, a self-abasement before those who buy the privilege,[143] is for Baudelaire a means of converting the *phénomène de la chute* into a *moyen de rachat*, the "holy prostitution" by which the *flâneur* of "Les Foules" escapes the limits of the self by giving himself to the crowd.

Like the Christian sacrifice, this one is grotesque, "comical," its victim a caricatural object of laughter; it accordingly achieves the same conversion.[144] Baudelaire's comic artist suffers the knowledge of his own dualism and uses

140. Cf. Handwerk's concept of ethical irony as a move outward toward others (*Irony and Ethics in Narrative*, 41ff.).

141. Self-awareness is necessary for it to be a true sacrifice, as Baudelaire indicates elsewhere (I, 683). Cf. the essays on Poe, where he again evokes his model of the comic here, Hoffmann: "ce talent bouffon, ironique et ultra-grotesque . . . [une] des âmes vouées à l'autel, *sacrées*, pour ainsi dire, et qui doivent marcher à la mort et à la gloire à travers un sacrifice permanent d'elles-mêmes" (250) [that clownlike talent, ironic and ultra-grotesque . . . one of these souls destined for the altar, consecrated, so to speak, and who must march to death and glory through a permanent sacrifice of themselves].

142. *Lettre à M. d'Alembert sur les spectacles*, 108.

143. Ibid., 106: "Qu'est-ce que la profession du Comédien? Un métier par lequel il se donne en représentation pour de l'argent, se soumet à l'ignominie et aux affronts qu'on achète le droit de lui faire, et met publiquement sa personne en vente. J'adjure tout homme sincère de dire s'il ne sent pas au fond de son âme qu'il y a dans ce trafic de soi-même quelque chose de servile et de bas." [What is the profession of the actor? A profession in which he puts himself on display for money, submits to ignominy and to the affronts that one buys the right to shower on him, and publicly puts his person on sale. I beseech every sincere man to say whether he does not feel in the depths of his soul that in this traffic of oneself there is something servile and lowly.]

144. Cf. Vouga, *Baudelaire et Joseph de Maistre*, 214ff.; P. Pachet, "Baudelaire et le sacrifice."

it for the amusement and education of others, revealing to them their own ugliness, bringing the self-ignorant to a knowledge of their dualism, developing their sense of superiority over the comic character and their inferiority before the greater power of the artist who created it. An artist like Poe is thus a "caricature" or "farceur" (321), playing the fool in order to represent the vices and ignorance of mankind, "un Ilote qui veut faire rougir son maître" (321) [a helot who wants to make his master blush]. *Dédoublement* turns the self's dualism outward, converts it into a creative capacity to escape the limits of the self through interaction with others, to redefine the self in terms of the variety of forms and beings outside it. And the knowledge of dualism that comic art entails prevents the artist from believing in his own glory and becoming a victim of dualism, falling into the trap of the *physiologistes du rire*.[145] Such self-knowledge marks the human, and modern, equivalent of the mythical unity.[146] If only "poésie pure" can free us from our situation, as Baudelaire implied earlier, the comic can have a similar effect, paradoxically by maintaining the very dualism and contradiction that constitute the problem. Only through fallen and imperfect Nature can we define and know the beyond; through the real, the ideal; through contradiction and paradox, harmony.

Baudelaire's remarks also suggest a subtle justification of the essay itself, which ironically rejoins the casual obsession-soothing of its opening lines. By his essentially paradoxical nature, and the doubling it necessitates, the comic artist constantly exercises a *critical* faculty, being fully aware of the conditions and components of the comic, including that fundamental one, unawareness. The theoretical enterprise, treated so cavalierly at the start, here becomes a crucial task of the artist. "Having studied and brought together the elements of the comic": the most "knowledgeable," self-conscious, and self-sacrificing of artists, who recognizes the world beyond the self, is the one who is also a theorist.

In his discussion of the irony implicit in *comique absolu*, Paul de Man argues, against Starobinski, that for Baudelaire irony does not imply a reconciliation between self and world, a recovery of self within the world, a therapy for the self. Irony may lead to self-knowledge, but this does not equal wholeness; the divided self remains divided.[147] For de Man, the ironic

145. Nor can this enlightenment constitute an unqualified superiority: one must recognize one's inferiority too, and thus one's dependence on others.

146. In his notes on *Les Liaisons dangereuses* (1856–57), Baudelaire remarks that "evil aware of itself is less frightful, and closer to the cure, than evil unaware of itself" (68).

147. "The Rhetoric of Temporality," 214ff.

subject reasserts the radical difference that separates itself from the world, and fiction from reality. This is indeed consistent with Baudelaire's theory of the comic: *dédoublement* does not "unify" the self, but asserts its division and multiplicity. But de Man misses the point that, for Baudelaire, exploiting and asserting a self-conscious dualism define the "unified" self in a fallen world. De Man's example of *Die Prinzessin Brambilla* points up the problem. If the idyllic harmony of the ending introduces a new mystification, this does not contradict the demystified, ironic subject that the experience of the comic has produced: as in the case of Celionati, irony consists in playing a role and recognizing it as such, seeing oneself as an object and creator of the comic at the same time.[148] The comic artist is at once self-conscious and self-ignorant, creator and character, *dédoublé* and *dualiste*. Clearly, irony does not lead to synthesis or a stable recovered unity, nor is this, in the Baudelairean scheme, its purpose; but as the recognition and realization of dualism it may, like *dédoublement*, open the boundaries of the self, becoming the means by which others reach the same level of understanding and adopt the same course of action. Transcending dualism consists in maintaining it, realizing the variety of the self and, as Gary Handwerk suggests of irony generally, the self's—every self's—dependence on others:[149] such is the function of the artist.

It is significant that Baudelaire does not posit the possibility of a future when poetry itself would no longer be necessary; the future holds in store only the pure *poet*, who reenacts the myth of mankind's ambitious leap beyond the bounds of human pride and creates a language of universal analogy and *correspondances*. C. Lang argues that his dualistic irony (as opposed to his pluralistic "humor") implies a nostalgia for a prelapsarian golden age of innocence, purity, truth, and unity, when "things were beautiful in themselves and did not need the embellishment of language."[150] But this is plainly incorrect: Baudelaire understands beauty solely in human terms; it shares the dualism of mankind and has no meaning in paradise, as the sterile, ungraspable beauty of "l'unique femme avant le premier péché"

148. And if the discovery of irony leads only to the end of the story, the drying up of the source of invention, this does not undermine the "harmony" achieved; it rather marks the limits of illusion and representation. The story, and comic art generally, are born of conflict, discord, difference, dualism, and disorder; once these are exposed, the invention necessarily ceases. Self-knowledge is the source of comic art, but also its end, in both senses: the purpose which it strives to achieve and the point at which it is no longer necessary.

149. *Irony and Ethics in Narrative*, 16.

150. *Irony/Humor*, 109.

attests, or the senseless experience of "joy" as opposed to the *comique absolu*. Even the supposedly uncorrupted, naive beauty of the past in "J'aime le souvenir de ces époques nues" exists only from a corrupted, fallen perspective, that is, the "souvenir" and "hommage" of the poem. The ideal must be posited by the dualistic, self-reflexive subject as an object of desire and aspiration, and, as such, unattainable; absolute beauty, as Baudelaire will state explicitly in *Le Peintre de la vie moderne*, does not exist in itself. We may posit a mythical past free of temporality, self-consciousness, and laughter, but it exists only as a human creation; Baudelaire's notion of beauty precludes the concept (and the very desire) of ever "returning" to such. His pure poet escapes the extreme dualism of laughter but remains a poet, committed to the dualism of art and the differentiation of language.

Quelques caricaturistes français

2

De l'essence du rire defines the essence or nature of the comic, a philosophy or ontology of the comic comparable to a philosophy of beauty. It provides the theoretical structure in which the artists of the subsequent practical essays will be placed, but is not openly concerned with formal matters. This is understandable to the extent that most of the examples used in it do not come from caricature or the plastic arts at all. *Quelques caricaturistes français* and *Quelques caricaturistes étrangers* bring out the formal elements of the comic more clearly. As a prelude to the next two chapters, it may be useful to survey these, and to relate them to the theory.

On a formal level caricature clearly embodies the dualism by which Baudelaire defines the comic.[1] The comic is a sign of superiority and inferiority, at once *plaie* and *couteau, victime* and *bourreau*; caricature likewise presents both the victim and the means by which it is deformed (exaggeration, simplification, inversion, etc.). Distorting the subject while maintaining a likeness sufficient to ensure recognition, caricature both preserves and alters it in one same image.[2] We thus follow the caricatural—

1. Cf. W. Hofmann, "Baudelaire et la caricature," 40.
2. The idea that caricature preserves the very form that it violates derives from the concept of exaggeration and is prominent in twentieth-century theory, but rarely mentioned in the nineteenth century. See, however, L. de Cormenin, "De la caricature" (*La Liberté*, 10 February 1850): "Elle conserve la ligne pure qu'elle force et qu'elle outre et son procédé comme celui du téléscope grossit et montre l'objet comme à travers une lentille extensive" [It preserves the pure line that it strains and exaggerates, and its procedure, like that of the telescope, is to enlarge the object and show it through a distorting lens].

and interpretative—process from start to finish; the deformations locate the subject's characteristic traits, or those to which the commentary is directed. The likeness to a non-deformed original communicates the identity of the object; the deformation distances the viewer from this, signals the presence of a symbolic intent (notably a comic one), and locates the flaw or trait being satirized. We see the victim before and after, free of aggression and subjected to it, as well as the means of victimization itself. This double reference is perceptible even in grotesque forms (although these appear unified);[3] primarily a creation, the grotesque nevertheless has, in Baudelaire's definition, a necessary imitative element.

The specific formal features of Baudelaire's *comique* are conventional Aristotelian ones: incongruity and disproportion.[4] This may be between tone or manner and subject, between a character and its environment, between a character and the audience, and so on. In his 1861 preface to Cladel's *Martyrs ridicules*, Baudelaire regrets that others do not capitalize on this most fundamental of laws: "La disproportion du ton avec le sujet . . . est un moyen de comique dont la puissance saute à l'oeil; je suis même étonné qu'il ne soit pas employé plus souvent par les peintres de moeurs et les écrivains satiriques" (185) [Disproportion between tone and subject . . . is a comic technique whose power is obvious; I am even surprised that it is not used more often by painters of manners and satirical writers].[5] Like the comic artist, Cladel is an analyst of evil who does not shrink from presenting humanity with an image of its own ugliness: "il ouvre la plaie pour la mieux montrer, la referme, en pince les lèvres livides, et en fait jaillir un sang jaune et pâle" (184) [he opens the wound to show it better, closes it again, squeezes its livid sides together and makes a pale, yellowish blood flow from it]. The antithesis of the title, to which Baudelaire calls attention, expresses the contradictory nature of the comic; a deformation of Chateaubriand's *Martyrs*, it presents the protagonists as parodic martyrs who sacrifice themselves to a base cause—not to God, but to vice, egoism, foolishness, and debauchery. He attributes the comic quality of the work to the exaggeration of the characters and to the clash of tone and subject, the "artistic solemnity" used to recount comical events (184).

3. On the importance of the double perception for the interpretation of caricature, see W. Hofmann, *Caricature from Leonardo to Picasso*, 11ff. Cf. Harpham, *On the Grotesque*, 127.

4. On Aristotle's notion of the comic, see R. Janko, *Aristotle on Comedy: Towards a Reconstruction of Poetics II*.

5. This preface is especially relevant to his ideas on the comic because he read the novel in manuscript and suggested revisions, which Cladel apparently followed (1165).

The same principles apply in the visual arts.[6] In the *Salon de 1859* he warns against the dangers of treating certain subjects inappropriately, thus producing a comic effect: "Si l'anecdote asiatique n'est pas traitée d'une manière asiatique, funeste, sanglante, elle suscitera toujours le comique" (641) [If the Asiatic anecdote is not treated in an Asiatic, fatal, bloody way, it will always evoke the comic]. He criticizes Gérôme's "Ave Cesar imperator" for depicting a Caesar who resembles an obese wine merchant or butcher (640), a caricature inconsistent with the innate nobility of one accustomed to having the world at his command. Anachronism and the jarring incongruity of diction and content yield the comic too, as when the trivial, quotidian aspects of modern life are depicted *à l'antique*; this creates "une caricature à l'inverse" (639). Daumier's *Histoire ancienne*, lowering the heroes and heroines of antiquity, provides the clearest example of the disjunction of subject and manner: "tous . . . nous apparaissent dans une laideur bouffonne qui rappelle ces vieilles carcasses d'acteurs tragiques prenant une prise de tabac dans les coulisses" (556) [they all . . . appear to us with a farcical ugliness that recalls those old wrecks of tragic actors taking snuff in the wings]. Baudelaire makes the comparison enact the process of vulgarization, not only in the discrepancy between the grandeur of the tragic actors and the weakness in which they are caught—taking snuff in the wings—but also in the familiar and pejorative term used to describe them, "vieilles carcasses."

More important, however, Baudelaire ascribes to caricature a certain freedom, expansivity, and abandon: Hogarth at times has this "aisance" and "abandon" (565), Leonardo does not (570). The lowest level of the comic—the French *significatif*—has the least degree of it, and conversely, the greatest degree of reasonableness; the *absolu* accordingly has the greatest, the "prodigious poetic good humor" that Baudelaire deems necessary for the true grotesque in *De l'essence du rire* (537). It accounts for the *fureur* of Italian comic art (570), the exuberance and violence of the English pantomime, the prolific metamorphoses of Pierrot, and the abundant verve (566) of Cruikshank. It is opposed to mental concentration and firmness of will (571), a *vaporisation* (1, 676) and *multiplication* (1, 649) on the other side of *centralisation* (1, 676). The comic resists containment and tends ever

6. The tradition goes back to antiquity (see the opening lines of Horace's *Ars poetica*, cited in the Conclusion, note 3). In the eighteenth century, Francis Grose attributed the ludicrous in painting to incompatibility (*An Essay on Comic Painting*, 14f., in *Rules for Drawing Caricaturas*).

toward the surpassing of boundaries. But, as always in Baudelaire's use of these terms, the opposites attract and, for there to be art, must go together: *ironie* controls and thus permits the pleasurable heightened awareness of *surnaturalisme*; without centralization, multiplication is aimless, futile, and destructive; the pleasure of *volupté* is lost without *connaissance*; *concentration* prevents dissolution; will orders the chaotic creations of fantasy and permits them to be appreciated. This tension offsets the dangers of unlimited freedom (119) and ensures art as opposed to mere passion, enthusiasm, or inspiration.

Indeed, here lies one of the most paradoxical of comic laws, the necessity of the inferior *significatif* to the *absolu*. The explosive, intoxicating, and vertiginous Italian *comique* can best be produced only through the diametrically opposed recuperative qualities of the French: "c'est un artiste français, c'est Callot, qui, par la concentration d'esprit et la fermeté de la volonté propres à notre pays, a donné à ce genre de comique sa plus belle expression" (571) [it's a French artist, Callot, who, by the concentration of mind and the firmness of will proper to our own country, has given this type of comic its finest expression]. Art requires concentration, centralization, and will, to make intelligible and memorable the enthusiastic, expansive, self-generating experience of the imagination. In the artist of genius, such as Delacroix (746) or Wagner (807), a *volonté formidable* is the companion of a *passion immense*. In *Fusées* Baudelaire makes the point through an oxymoron: *concentration productive* (I, 649). The closest example to pure *comique absolu* is the English pantomime, and even there he sees the art (the actors' talent for hyperbole) conferring a sense of reality on fantasy (540). Like the creative imagination, which contains in itself a critical sense and faculty of judgment, the true *comique absolu* preserves an element of the *significatif*, thus ensuring the expressivity of the art, its capacity to suggest meanings to the observer.

The importance of the freedom and abandon of the comic can perhaps best be appreciated by a figure conspicuously absent from these essays, Decamps. Baudelaire frequently discusses the comic spirit of this artist, who contributed regularly to *La Caricature* and *Le Charivari* during their height, but distinguishes it from caricature.[7] In the *Salon de 1846*, he attributes to him "croquis . . . amusants et profondément plaisants . . . un dessin d'homme d'esprit, *presque de caricaturiste*; car il possédait je ne sais quelle

7. Other critics of the time comment on Decamps's humor too, e.g. Charles Blanc (*Histoire des peintres* III), who notes the ironic and mocking side of his work.

bonne humeur ou fantaisie moqueuse, qui s'attaquait parfaitement aux ironies de la nature" (448, my emphasis) [sketches amusing and profoundly comical . . . the drawing of a witty man, almost a caricaturist; for he possessed some particular good humor or mocking fancy that was a perfect match for the ironies of nature]. Decamps has the requisite good humor that Baudelaire finds exemplified in the pantomime, and, later, in Daumier; he has the caricaturist's ability to convey character by just a few lines; his works bear a fascinating strangeness and produce a sudden impression on the viewer (449), both qualities of *comique absolu*. Like Goya and Hoffmann, he renders nature in its fantastic and real aspects, in its "most sudden and unexpected guises" (362), in works marked by irony and the surreal: "nous retrouvons donc enfin cette ironie, ce fantastique, j'allais presque dire ce comique" (362) [we find, then, that irony, that fantastic, I was almost going to say that comic]. But comic art is not an art of the *presque*, and it is *presque* that dominates these assessments. This is, rather, a form of history or genre painting, which communicates its essential seriousness through its ironic alliance with the comic, just the other side of the generic divide from Daumier; and one step equally away, in the other direction, from the painter to whom Baudelaire also compares Decamps, Delacroix. In contrast, the comic is an art of excess, hyperbole, and license, as the language of the *absolu* makes clear.

Baudelaire follows an Aristotelian model and places caricature at the opposite end of the spectrum from classical sculpture, both transformations of reality: relative to a *tableau de moeurs*, caricature is a representation *traduit en laid*, vulgarized, trivialized, "uglified," while ancient statuary is *traduit en beau*, idealized, ennobled, stylized (684). In the representation of personality, caricature is the counterweight to portraiture. Daumier's *portraits-charges* of political personalities accordingly exaggerate, accentuate, and distort, but simultaneously preserve a likeness: "tout en chargeant et en exagérant les traits originaux, il est si sincèrement resté dans la nature, que ces morceaux peuvent servir de modèle à tous les portraitistes" (552) [while exaggerating and caricaturing the original traits, he stayed so frankly within nature that these specimens could serve as a model to all portraitists]. The methods of portraiture set out in the *Salon de 1846*—idealization and generalization (456)—have the same function as exaggeration and distortion in caricature, expressing the artist's conception of the character of the subject:[8] "Toutes les pauvretés de l'esprit, tous les ridicules, toutes les

8. For Wright, all art in a sense began as caricature: "In fact, art itself, in its earliest forms,

manies de l'intelligence, tous les vices du coeur se lisent et se font clairement
sur ces visages animalisés; et en même temps, tout est dessiné et accentué
largement" (552) [Every meanness of spirit, every absurdity, every quirk of
the intellect, every vice of the heart can be read and seen clearly on these
animalized faces; and at the same time, everything is broadly drawn and
accented]. The exaggeration, like idealization, constitutes the conceptual
aspect of caricature, by which the viewer interprets the distortion.[9]

The close affinity of caricature to portraiture is formulated early on, but
explicitly in eighteenth-century theory.[10] In his *Rules for Drawing Carica-
turas* (1788), F. Grose defines caricature as the exaggeration of physical or
moral traits, and places it on a continuum with character drawing: "The
sculptors of ancient Greece seem to have diligently observed the forms and
proportions constituting the European ideas of beauty; . . . a slight deviation
from them, by the predominancy of any feature, constitutes what is called
Character and serves to discriminate the owner thereof, and to fix the idea
of identity. This deviation or peculiarity, aggravated, forms *Caricatura*."[11]
Caricature is thus a kind of type-portraiture, where deviation is necessary
for the depiction of character; caricature merely exaggerates the deviation.
The student must first master the human form, and only then may alter the
proportions and distances of the lines; conversely, portrait painters can
learn much about the portrayal of character by studying caricature.[12]

Hogarth, too, had defined caricature with respect to type-portraiture in
his 1743 engraving "Characters and Caricaturas." *Caricatura* is the exces-

is caricature; for it is only by that exaggeration of features which belongs to caricature, that
unskilful draughtsmen could make themselves understood" (*A History of Caricature and
Grotesque in Literature and Art*, 2).

 9. S. Worth ("Seeing Metaphor as Caricature") likens the interpretation of caricature to
that of metaphor, for both express something as it is not, and depend on conceptual knowledge.
But Baudelaire here implies that the conceptual plays a role in the interpretation of all images,
all art forms, as his constant emphasis on symbolic language (be it the hieroglyphs of nature,
or the *argot plastique* of Philipon's pear) confirms. Art (like reality itself) communicates
through signs—hieroglyphs, symbols, images, emblems—which must translate and communi-
cate the artist's reading of reality, not reproduce reality itself. Interpretation is always, in
Baudelaire's scheme, conceptual.

 10. See F. Baldinucci, *Vocabolario toscano dell'arte del disegno* (1681): "Painters and
sculptors say caricaturing for a way of making portraits that are as like as possible to the
portrayed person as a whole, but in a playful and sometimes humorous fashion, exaggerate or
enlarge disproportionately peculiarities of the portrayed features, so that in general they appear
to be faithful, but in details they are changed" (quoted in Rhode Island School of Design,
Caricature and its Role in Graphic Satire, 6).

 11. *Rules for Drawing Caricaturas*, 5.

 12. Ibid., 4ff., 11.

sive exaggeration of an individual's facial features, while *character* depicts the naturally ugly and portrays types. In the *Anecdotes*, caricature belongs to the grotesque, character painting falls between the sublime and the grotesque and resembles stage comedy.[13] Comedy in fact holds the higher place, for while fulfilling the criterion of public utility (entertainment and improvement of the mind), it involves greater difficulties of execution. Hogarth follows Fielding's famous distinction in the 1742 preface to *Joseph Andrews* between comedy and burlesque: comedy expresses human affectations, while burlesque depicts people with exaggerated features or in a monstrous attitude. Fielding makes his point via a contradiction in terms: Hogarth is a comic history painter.[14]

Indeed, Hogarth's aesthetic treatise, *The Analysis of Beauty* (1753) has certain affinities with Baudelaire's comic theory.[15] In his discussion of the ridiculous, he concentrates on the formal qualities of pictorial humor: the joining of opposite ideas, the juxtaposition of incompatible excesses, inelegance of figure, the use of straight lines and plain curves (rather than the famous serpentine line that he associates with beauty) to express movement or living figures.[16] Like Baudelaire, he uses the example of the Italian theater—the exaggerated agility, uncouth attitudes, and rapid movements of Harlequin, Scaramouche, Pierrot, and Polichinelle.[17] His aesthetic overall has some themes in common with Baudelaire's: a fierce opposition to manner (Baudelaire's *style*) and to copying, and an insistence on fitness (the proper application of form to content and sense), contour, variety, and movement, a "wanton kind of chase" for the eye; perhaps most important, the essential satanism of beauty and the caricatural connotations of the

13. *Anecdotes*, ed. J. B. Nichols, 8f. Hogarth associated caricature with aristocratic amateurs, for whom it was, in the 1730s and 1740s, a fashionable pastime. See R. Godfrey's introduction to the Victoria and Albert Museum exhibition catalogue, *English Caricature 1620 to the Present*, 14.

14. On the relations between Hogarth and Fielding, see P. J. de Voogd, *Henry Fielding and William Hogarth: the Correspondences of the Arts*; R. Cowley, *Hogarth's Marriage à la mode*, 20ff; L. Gowing, *Hogarth*, 60.

15. Baudelaire was aware of Hogarth's criticism, which he mentions in his defense of artist-critics in the essay on Wagner (793). *The Analysis of Beauty* was well known and widely available. It had been translated into French: *Analyse de la beauté, précédée de la vie de ce peintre et suivie d'une notice chronologique, historique et critique de tous ses ouvrages de peinture et de gravure*, trans. H. Janson, Paris, 2 vols., 1805. Diderot attacked it in his *Salon de 1765* and also borrowed from it (without acknowledgment) Hogarth's examples of the theory of fitness in chapter 1 (cf. *Salons* II, 114ff.). See J. Burke, ed., *The Analysis of Beauty*, lix, and "A Classical Aspect of Hogarth's Theory of Art," 152.

16. *The Analysis of Beauty*, 48ff.

17. Ibid., 183, 158.

serpentine line. Hogarth's punning illustration of the serpentine line on the title page of the *Analysis* carries an epigraph from *Paradise Lost*; its beauty is the same that lured the eye of Eve.[18] Beauty is, as Baudelaire also implies, comic, caricatural, and fallen.

Quelques caricaturistes français and *Quelques caricaturistes étrangers* follow the national patterns established in *De l'essence du rire*, and disrupt them at the same time. Nearly all the examples of French caricature fall within the *significatif* category, but it is important to keep in mind the high value nevertheless placed on Daumier. The *significatif* may accommodate inferior comic artists more easily, but does not necessarily imply inferior comic art. It had been defined in terms of imitation, superiority over others, evident duality, and reasonableness or the avoidance of excess, and these accordingly predominate in Baudelaire's treatment of the French. All the artists discussed, with the exception of Grandville and possibly Jacque, are *primarily* imitative and thus *significatif*, imitation combined with a certain creative faculty (535). The degree and type of imitation vary and determine the artist's rank in Baudelaire's hierarchy of value. Thus Daumier is placed squarely in the *significatif* for his love of nature and his reliance on observation, but in the critical vocabulary of the *absolu* (e.g. "fantastique," "monstruosités," "effrayants," "grotesques," "sinistres," "bouffons," 554): his "faculté créatrice" plays a dominant part in the imitation. Charlet, on the other hand, ranks low on the scale, for his works reveal no creativity in either form or idea, and even his imitation is perverted by excessive stylization and *chic* (548); of his works Baudelaire admits only the one that, in accordance with the criteria of the *significatif*, has realistic and credible characters. An artist like Pigal lies somewhere in the middle, having little imagination, and being unpretentiously and competently imitative.

On the second major feature of the *significatif*, superiority over others, the French caricaturists display relative consistency, excepting once again Grandville and Jacque. Charlet uses this in the worst manner, cultivating a sense of superiority in his public in order to ingratiate himself with them and reinforce their prejudices; Gavarni, too, flatters his viewers, but with a cynicism that implicates them. Daumier relies on superiority, but his *bonhomie* tempers this and subsumes it in a more charitable humor; superiority

18. See W. J. T. Mitchell, "Metamorphoses of the Vortex," 132, and R. Paulson, *Representations of Revolution*, 130. On the caricatural nature of Hogarth's character painting and conception of beauty, see F. Antal, *Hogarth and his Place in European Art*, 129ff.; and R. Costa de Beauregard, "Eccentricity and Hogarth's Ogee Line." Hogarth himself, however, associated the ridiculous with the plain, rather than serpentine, line.

is countered by a certain kindness, a sense of fellowship with the caricatured object.

The third quality of the *significatif*, duality, plagues Gavarni (the *littérateur* versus the artist, the caption versus the art, 559), Grandville (the philosopher and man of letters versus the artist, 558), and Charlet (the idea versus the art, 548), but not, for example, Daumier or Jacque, in whose works the idea springs clearly and immediately ("d'emblée," 556, 563) from the art. And the avoidance of excess associated with the *significatif* characterizes all the French artists to some degree: even Daumier, to whom Baudelaire applies the vocabulary of excess proper to the *absolu*, stops short of certain satirical subjects he considers too violent to be truly comical (556f.). Perhaps only the great political caricatures from the early years of the July Monarchy knew no restraint: a "fantastic epic," a "vast series of historical buffooneries," "un tohu-bohu, un capharnaüm, une prodigieuse comédie satanique, tantôt bouffonne, tantôt sanglante" (549) [a chaotic confusion and disorder, a prodigious satanic comedy, now farcical, now bloody], a passion suppressed by the censorship laws of 1835.

In the range of recent artists it covers, the close attention given specific works, and the analysis of each artist's *comique*, *Quelques caricaturistes français* breaks radically new ground. Few articles before it treat caricature as an art in itself. Thackeray's "Parisian Caricatures" of 1839, covering some of the same material, is the first of its kind.[19] The only article to have the range of Baudelaire's, although in considerably less detail, appeared in *La Liberté* in 1850 by the journalist Louis de Cormenin.[20] None but Baudelaire's gives the French caricaturists of the period the attention they deserve as the collective masters of this genre. Articles on individuals appear primarily as reviews and obituaries, with no detailed discussion of individ-

19. Reprinted as "Caricatures and Lithography in Paris," in *The Paris Sketchbook*. Baudelaire was aware of Thackeray's art criticism, as he reveals in *Le Peintre de la vie moderne* (688): "M. Thackeray who, as everyone knows, is very interested in matters of art . . . one day spoke about M. G. in a little London review." The article briefly mentions Grandville, Monnier, Raffet, Charlet, H. Vernet, the Devérias, Roqueplan, and Decamps, the portfolios of Aubert, and the restrictions on the press and caricature during the Empire and Restoration. Like Baudelaire's, it discusses Philipon's war against the government in *La Caricature* and *Le Charivari*, the *poire* trial, the September laws (which "murdered" political caricature), the move to *caricature de moeurs*, and the creation of Robert Macaire.

20. "De la caricature," 10 February 1850. Cormenin cites many of the same artists, but values them differently: Grandville and Gavarni head the list, the one showing the animality of mankind, the other exposing the secret vices of everyday life. Daumier follows as more brutal and straightforward, then Monnier, "the informer of porters, gossips, and petty bourgeois," and Traviès, Bertall, and Cham for their verve and spirit.

ual images. Pigal, Trimolet, Traviès, and Jacque are wholly neglected; there is little on Carle Vernet, Daumier, or Gavarni; most mentions of Monnier have to do with his theatrical performances; Charlet and Grandville seem exceptions, but Baudelaire takes a radically different position toward them. Perhaps most important, although Baudelaire hierarchizes the four types of *comique*, the variety and quality of caricature covered by this essay nevertheless suggest the extraordinary potential of the *significatif*. It thus offers powerful supporting evidence for the otherwise unjustified (and seemingly half-hearted) assertion in *De l'essence du rire* that the *significatif* can stand with the *absolu*, despite the delay between it and the laughter it inspires: "cela n'arguë pas contre sa valeur; c'est une question de rapidité d'analyse" (536) [that does not argue against its value; it is a question of the rapidity of the analysis].

Vernet, Pigal, and Charlet

Carle Vernet

The section on Carle Vernet that opens *Quelques caricaturistes français* seems to contradict the purposes of the project as a whole: Baudelaire insists on the historical, rather than caricatural, value of the artist's work. One can certainly argue for the historical aspect of caricatures; but one does not, in a work on Vernet as a caricaturist, argue that his are not really caricatures, but rather true images of contemporary reality. Indeed, Baudelaire announces the paradox from the start: "Son oeuvre est un monde, une petite *Comédie humaine*; car les images triviales, les croquis de la foule et de la rue, les caricatures, sont souvent le miroir le plus fidèle de la vie" (544) [His work is a whole world, a little *Comédie humaine*; for trifling images, sketches of the crowd and the street, caricatures, are often the most faithful mirror of life]. Vernet's caricatures provide a historically authentic image, despite the artificiality they acquire over time.

Vernet was well known for his comic portraits of English visitors to Paris after the Peace, and especially his caricatures of the *Incroyables*, the elegant, extravagantly dressed royalist youth at the time of the Directoire, and their female counterparts, the *Merveilleuses* (Fig. 1). Here they are offered as a historical reality, caricatural only from our later point of view: "Chacun

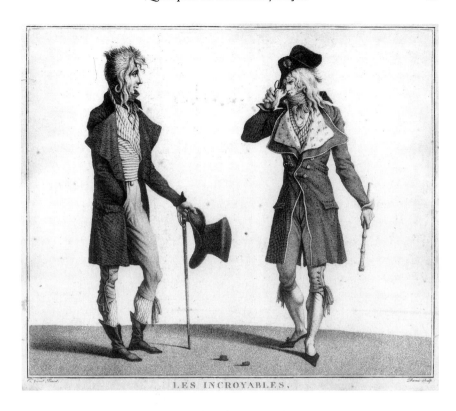

LES INCROYABLES,

Fig. 1. Carle Vernet. *Les Incroyables* (photo: British Museum)

était roide, droit, . . . avec son frac étriqué, ses bottes à revers et ses cheveux pleurant sur le front" (544) [Everyone was stiff, erect . . . with his narrow frock coat, his riding boots, and his locks running down over his brow]. They reflect the ideals of the age, an aesthetic of the sculptural and stylized: "Telle était la mode, tel était l'être humain: les hommes ressemblaient aux peintures; le monde s'était moulé dans l'art . . . chaque citoyen avait l'air d'une *académie* qui aurait passé chez le fripier" (544) [Such was the fashion, such were human beings: men looked like paintings; the world had molded itself on art . . . each citizen looked like an academic nude that had passed by the secondhand clothing shop.].[21] The joke comparing the Revolutionary

21. Champfleury singles out this remark in discussing the comic images of the period, but attributes the phenomenon to the artists' inability to escape the classical Academic principles in which they had been trained (*Histoire de la caricature sous la République, l'Empire et la Restauration*, 281).

citoyen to a painter's nude in period dress makes the point, that is, the comicality, from our perspective, of another era's aesthetic: further proof of his theory, in *De l'essence du rire*, that the comic lies in the one who laughs, not in the object of laughter. In *Le Peintre de la vie moderne* he makes the same point àpropos of some fashion plates of the Revolutionary period published by Pierre de La Mésangère,[22] in which the figures physically reflect the moral and aesthetic values of the time, and which at a later date would provoke laughter: "L'homme finit par ressembler à ce qu'il voudrait être" (684) [Man ends up looking like what he would like to be]. The resemblance of the two passages is not surprising, for many of La Mésangère's plates (engraved by Bacquoy) were done from drawings of Carle Vernet's (Fig. 2).

In fact, this tension between the historical and caricatural is crucial, as it brings out the close relation between the two that will come to prominence in the essay on Guys: the caricatural nature of the painting of modern life. Here the significance of the two metaphors applied to Vernet's work—the *Comédie humaine* and the mirror—becomes apparent. His caricatures constitute a pictorial novel of manners, to which Baudelaire applies the same metaphor in his article on Gautier: the *roman de moeurs* is a mirror in which the crowd takes pleasure in seeing itself (119f.).[23] As this makes clear, and as Baudelaire's habitual emphasis on the imagination would imply, the mirror metaphor need not express praise: the *roman de moeurs* is more often "flat," "useless," a "vulgar" genre (120). Later in *Quelques caricaturistes français* he applies it to Monnier in its most negative sense: his works merely reflect the world, rather than interpret and translate it. Likewise photography, in the *Salon de 1859*, is a mirror in which society narcissistically gazes at itself, fascinated by its own trivial image (617).

But the allusion to *La Comédie humaine* ensures the positive connotations of the metaphor here, as a comparison with the essay on Gautier again confirms: Balzac produced something admirable from the relatively trivial materials of the genre by infusing into it vitality, passion, color, will, genius (120). Vernet does not have the same stature but might be considered a Balzac in miniature (a "little" *Comédie humaine*). The real equivalents in the art of caricature to Balzac in the *roman de moeurs* are Daumier and Gavarni, who, as Baudelaire remarks later in this essay (560) and again in *Le Peintre de la vie moderne* (687), complement the *Comédie humaine*. But

22. Probably the *Journal des dames et des modes*.
23. The mirror is of course a standard image for the *roman de moeurs* and the realist novel. See Stendhal, *Le Rouge et le Noir*, Part II, chap. 19.

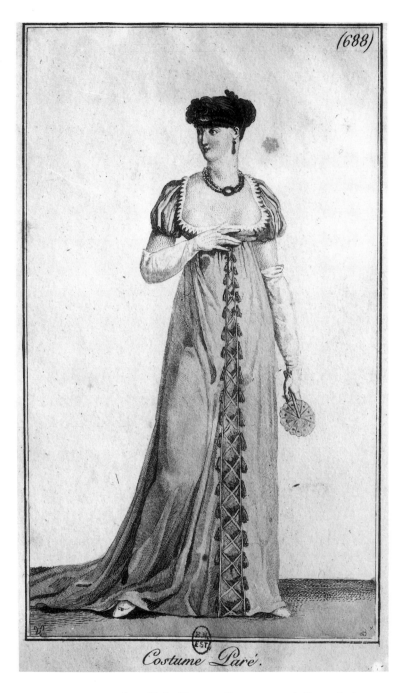

(688)

Costume Paré.

FIG. 2. Bacquoy, after Carle Vernet. *Costume paré, Journal des dames et des modes* 17, 1806 (photo: Bibliothèque Nationale)

Vernet displays the same spirit: in literary terms, such artists are not poets, but novelists and *moralistes*—observers and analysts of society, but inventive and visionary ones, like Balzac, portraying civilization in bold relief, ennobling the trivial, and attaining the general and universal through the particular which is the material of the novel. Balzac's mirror is as truthful an image of the society it depicts as Vernet's caricatural mirror is of his. And Balzac is specifically a caricaturist, as the pictorial metaphors suggest: he can only achieve his historical portrait, a "true" mirror image, by high relief, bold outline, deep color, sharp contrast of light and shade, contorted and convulsed forms rendering his vision of the world. His characters are exaggerated, hyperbolic, caricatural, as a succession of "plus" makes clear: "tous les acteurs de sa *Comédie* sont plus âpres à la vie, plus actifs et rusés dans la lutte, plus patients dans le malheur, plus goulus dans la jouissance, plus angéliques dans le dévouement, que la comédie du vrai monde ne nous les montre" (120) [all the actors of his *Comédie* are more eager for life, more active and shrewd in the struggle, more patient in misfortune, more greedy in their pleasures, more angelic in their devotion, than any the comedy of the real world shows us]. Vernet stands to realism much as Balzac does, presenting not an undigested copy but a carefully drawn, distorted image in which society may recognize and understand itself, its follies, its ideals. The historical veracity of his images, like the painting of modern life, derives from the comic and caricatural.

Vernet has a talent for rendering pose, gesture, and expression that Baudelaire will later attribute to Daumier: "Les poses, les gestes ont un accent véridique; les têtes et les physionomies sont d'un style que beaucoup d'entre nous peuvent vérifier en pensant aux gens qui fréquentaient le salon paternel" (544) [The poses, the gestures, have the mark of truth; the heads and facial features are of a style that many of us can verify if we think of the people who frequented the salons of our fathers].[24] But he lacks a distinguishing quality of the comic, *liberté*. Daumier's sure draftsmanship, in contrast, is "abundant," "effortless," creating a truth of movement suited to the mobility of the subject: "un art léger, fugace, qui a contre lui la mobilité même de la vie" (556) [a light and fleeting art, pitted against the

24. This rather quaint remark may be accurate. As J. Ziegler has shown, Baudelaire's father, chief of the Administrative Services of the Senate and an artist himself, was in close contact with many late eighteenth-century artists and sculptors, and possibly Carle Vernet ("François Baudelaire, peintre et amateur d'art," 124 n. 19). J. Adhémar demonstrates that Baudelaire's first dwelling contained numerous eighteenth-century *gravures galantes* ("L'Education artistique de Baudelaire faite par son père," 126).

very mobility of life]. On the other hand, Baudelaire appreciates the tension established between the fixity of Vernet's figures and the violence of the passions they represent. In the sole example cited, a *maison de jeu* (Fig. 3),[25] he brings out this contrast in terms of the moral atmosphere of gambling: gamblers young and old, passionate and daring, or calculating and intense, joyous and despairing, *filles* avidly following the turns of fortune; a moral climate rendered in physical forms by means of an art whose "hardness" and "dryness" express the ambiguity of a subject of such apparent fervor and emotion, the simultaneous violence and restrained concentration of gambling.

But the image may play a further role in linking caricature to an art of modernity. Baudelaire's use of the gambler as a figure of the modern hero was first remarked upon by Benjamin relative to the poem "Le Jeu," so peculiarly placed within the *Tableaux parisiens*.[26] Benjamin describes a lithograph allegedly by Senefelder, in terms strikingly similar to Baudelaire's here:

> There is a lithograph by Senefelder which represents a gambling club. . . . Each man is dominated by an emotion: one shows unrestrained joy; another, distrust of his partner; a third, dull despair; a fourth evinces belligerence; another is getting ready to depart from the world. All these modes of conduct share a concealed characteristic: the figures presented show us how the mechanism to which the participants in a game of chance entrust themselves seizes them body and soul, so that even in their private sphere, and no matter how agitated they may be, they are capable only of a reflex action.[27]

In their automatic, mechanical actions, the repetitive movement of betting that takes precedence over their emotions (however violent these may be),

25. *Le Trente-un ou la maison de prêt sur nantissement*, engraved by Darcis from a drawing by Guérain.

26. W. Benjamin, "On Some Motifs in Baudelaire," in *Charles Baudelaire*, 134ff.

27. Ibid., 135. Cf. Baudelaire: "il y a là des joies et des désespoirs violents; de jeunes joueurs fougueux et brûlant la chance; des joueurs froids, sérieux et tenaces; des vieillards qui ont perdu leurs rares cheveux au vent furieux des anciens équinoxes" (545) [It is a scene of violent joy and despair; of fiery young gamblers risking their luck; of cold, serious, and tenacious gamblers; of old men who have lost their hair in the gales of long-departed equinoxes]. Benjamin may in fact be remembering Baudelaire's text; he quotes other passages from *Quelques caricaturistes français* in his notes on Daumier for the *Passagenwerk* (*Gesammelte Schriften* v, 2, 901).

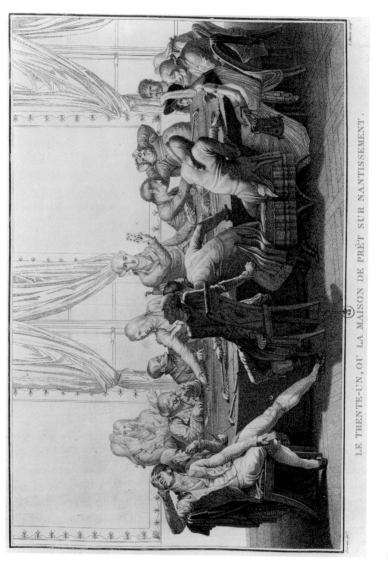

LE TRENTE-UN, OU LA MAISON DE PRÊT SUR NANTISSEMENT.

FIG. 3. Darcis, after Guérain. *Le Trente-un, ou la maison de prêt sur nantissement* (photo: Bibliothèque Nationale)

the gamblers represent the modern heroes of the crowd, conscious of their submission to (and complicity with) chance, their alienation from experience, and their subjection to the repetitive movement of time. Baudelaire's insistence on the stiffness and artificiality of Vernet's figures, and on the hardness, dryness, and seriousness of the *maison de jeu* image, supports this view: Vernet's figures are prototypes of the modern hero, at once passionate and mechanical, a *flâneur* within the anonymity of the crowd.

The few articles written about Vernet in Baudelaire's time give due place to his comedy. In 1837 A. Jal notes his taste for puns and jokes, and calls attention to the satirical wit of his social caricatures, in which man's follies, eccentricities, and manias are truthfully rendered.[28] Vernet's comic side likewise occupies a large part of Charles Blanc's study of 1854: his mocking spirit, the pantomimical movement of his figures, his talent for capturing the oddities and eccentricities of mankind.[29] He too notes the realism and veracity paradoxically communicated by the caricatures, which he attributes to Vernet's understanding of the comic possibilities of attitude and gesture: "ses figures paraissent avoir vécu réellement, avoir été prises sur le fait, en flagrant délit de ridicule, au moment où elles passaient dans la rue" [his figures appear to have actually lived, and been caught in the act, *in flagrante delicto* of absurdity, at the moment they passed in the street].[30] But Baudelaire develops this paradox to the full, bringing out the crucial link between caricature and the art of modernity that will inform the essay on Guys.

Pigal

For Baudelaire, Pigal provides the transition between the eighteenth-century Vernet and the more modern Charlet. The positive connotations of this, however, are harshly undermined by the irony of the section as a whole, and by the negative modernity of Charlet which Pigal prepares. The line from Vernet through Pigal to Charlet moves from the stilted and strange toward the familiar, from Vernet's "hardness" and "dryness" (545), through Pigal's gentleness ("douceur," "bonhomie"), to Charlet's cloying *gentillesse*, which borders on panegyric (547); from Vernet's truthfulness of character (544), to Pigal's truth, however common ("vérités vulgaires," 545), to a flattery that leaves truth behind—"rarely a truth," "a cajolery addressed to the

28. *L'Artiste* xiii, 1837, 186.
29. *Histoire des peintres* iii, 6, 8, 14.
30. Ibid., 7.

privileged caste" (547). The "progress" represents a decline toward an *ironic* conception of modernity, the false and facile variety of Charlet's, which the true modernity of Daumier will explode.

Although by Baudelaire's time Pigal was seen principally as the reflection of a past era, he had earlier enjoyed a certain popularity, for which Gautier, who considered him mediocre, found no justification.[31] During the heyday of caricature in the early 1830s, *Le Charivari* hailed him as "the honorary painter of the people," the artist who best rendered the *peuple parisien*,[32] and it is this aspect which Baudelaire brings out: "Les scènes populaires de Pigal sont bonnes . . . presque toujours des hommes du peuple, des dictons populaires, des ivrognes, des scènes de ménage, et particulièrement une prédilection involontaire pour les types vieux" (545) [Pigal's popular scenes are good . . . almost always men of the people, popular sayings, drunkards, family scenes, and especially an involuntary predilection for elderly types]. The comedy is gentle, "innocent," lacking the licentiousness of Biard's comic genre scenes (545).[33] There is, to be sure, a sentimental innocence to Pigal's sensuality, as in the bourgeois couple's response to the Farnese Hercules in *Quel gaillard*, or the young girls competing for a glimpse of the nude bathers in *A mon tour*, in contrast to the rampant eroticism of contemporary popular prints, such as Achille Devéria's (Figs. 4–6). But this borders on the bathetic, a cuteness that dated rapidly. Indeed, irony permeates Baudelaire's supposedly favorable assessment. His description of Pigal is as even and dispassionate as the art he wishes to characterize, with terms of moderation dominating: Pigal is a "moderate" caricaturist (545), an "essentially reasonable" one (546), whose compositions have a "good" and "just" feel to them (545). He has no lively originality and little imagination, and instead follows the modest, simple, commonsense procedure of recounting what he observes. Even this fails to produce the violent reaction that copying does: in Baudelaire's system, *raconter* includes a certain aesthetic distance and choice, although it ranks lower than "interpret" or "translate."

Moderation and reasonableness are, as we have seen, inconsistent with the comic, which depends, rather, on exaggeration, expansivity, freedom, violence, exuberance, and excess. This is *significatif* at its most harmless and, as the rhetoric suggests, its least interesting: "Presque tout le mérite de

31. *La Presse*, 17 March 1837. Champfleury included Pigal in an appendix to the *Histoire de la caricature moderne*, where he compares him to the popular novelist Paul de Kock for representing the old French comic spirit of the charming "gros mot" (282).
32. *Le Charivari* 75 (14 February 1833).
33. Cf. *Salon de 1859* (641): "les polissonneries . . . des Biard du dix-huitième siècle."

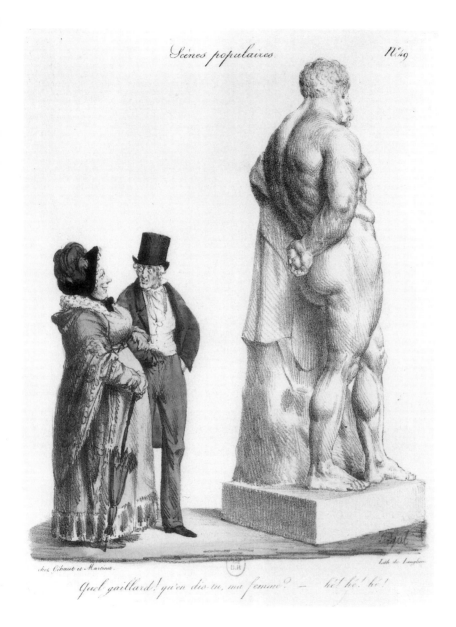

FIG. 4. Pigal. *Quel gaillard! qu'en dis-tu ma femme?—hé hé hé* (photo: Biblio-thèque Nationale)

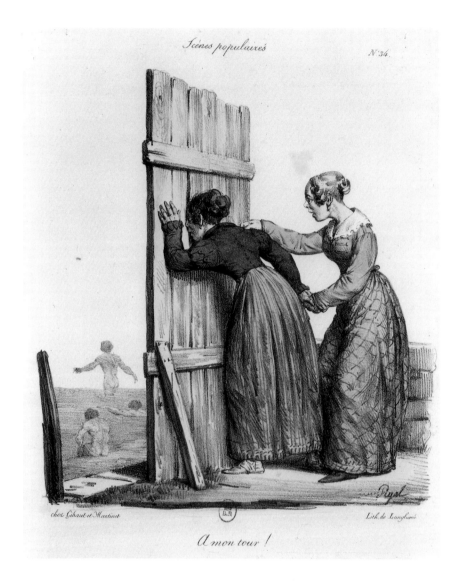

A mon tour !

Fig. 5. Pigal. *A mon tour* (photo: Bibliothèque Nationale)

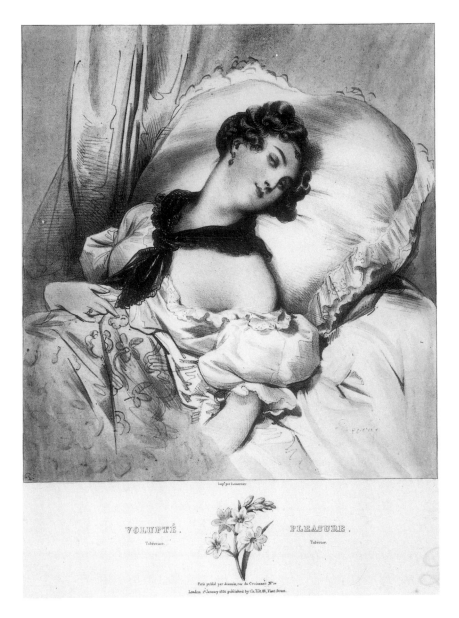

VOLUPTÉ. PLEASURE.
Tubéreuse. Tuberose.

FIG. 6. Achille Devéria. *Volupté* (photo: British Museum)

Pigal se résume donc dans une habitude d'observation sûre, une bonne mémoire et une certitude suffisante d'exécution; peu ou pas d'imagination, mais du bon sens" (546) [Almost the whole of Pigal's merit can be summed up as a habit of sound observation, a good memory, and an adequate sureness of execution; little or no imagination, but some good sense]. Baudelaire's language is, at best, noncommittal, and, at worst, condescending, paying and retracting the compliment in the same breath, mocking the *significatif* through an outrageous understatement and feigned even-temperedness—a placidity that brutally conveys the mediocrity of Pigal and of the French comic ideal overall.

Charlet

The section on Charlet is second in length only to the one on Daumier that immediately follows it. This comparison is significant, for the exceedingly high praise which Baudelaire gives the latter is matched only by his wholehearted contempt for the former. Indeed, he viciously attacks Charlet and, in a savage final paragraph, dismisses him with utter disdain:

> En résumé: fabricant de niaiseries nationales, commerçant patenté de proverbes politiques, idole qui n'a pas, en somme, la vie plus dure que toute autre idole, il connaîtra prochainement la force de l'oubli, et il ira, avec le *grand* peintre et le *grand* poète, ses cousins germains en ignorance et en sottise, dormir dans le panier de l'indifférence, comme ce papier inutilement profané qui n'est plus bon qu'à faire du papier neuf. (549)

> [To sum up: a manufacturer of nationalistic nonsense, a licensed dealer in political proverbs, an idol who, in short, is no more enduring than any other idol, he will soon know the full force of oblivion, and along with the *great* painter and the *great* poet, his first cousins in ignorance and foolishness, he will be laid to rest in the wastebasket of indifference, like this paper that I have needlessly profaned and that is now good for nothing more than pulping.]

The rhetoric is blatantly, defiantly exaggerated, with its heavy alliteration and its unsubtle metaphor: Baudelaire ends his discussion of Charlet by crumpling him up and throwing him scornfully into the rubbish. The paper containing so many insults, so much profanation, has itself been profaned,

simply by the worthlessness of its subject. But Baudelaire specifies "uselessly," thus raising the crucial question: why waste the paper if there is no need to do so? He remarks that, had he followed his better judgment, he would not have included Charlet, an artist so lacking in comic qualities, in the article at all (548f.): why, then, spend three pages on him, thus giving him the second most prominent place in it? He maintains that he would have been accused of "grave omissions," but this excuse fails to persuade, for there are numerous "oublis" for which he is willing to brave criticism. Why did he devote so much attention to an artist whose work he clearly despised and whom he did not even consider a caricaturist?

To begin with, it is important to note that Baudelaire criticizes Charlet in exactly the same terms and on exactly the same grounds that he does that bête noire of his *Salon de 1846*, Horace Vernet. Charlet's draftsmanship is characterized by *chic*, the same "modern monstrosity" that dominates Vernet's (468, 470). The term referred originally to painting without a model, but by Baudelaire's time was used pejoratively; he associates it with the traditional, conventional, and unimaginative, and compares it to the exercise of a writing master who can draw a flourish with his eyes closed (468). This may seem inconsistent with his normal call for drawing from memory, away from the model, but is not: the "absence de modèle et de nature" (468) that characterizes *chic* represents an *abuse* of memory, "plutôt une mémoire de la main qu'une mémoire du cerveau" [rather a memory of the hand than of the brain]. *Chic* denotes the memory of formulas, as in Charlet's monotonous "circles and ovals," or his images of children, "always plump and fresh like rosy apples" (547f.); memory is a function of the imagination, the "profound memory for characters and forms" (468) that marks the artistry of Daumier and Delacroix. In the *Salon de 1846* he criticizes the *ingristes* (although not Ingres himself) for the same type of convention: "ces ovales de têtes exagérés . . . conventions et habitudes du pinceau qui ressemblent passablement à du chic" (461) [these exaggerated ovals of heads . . . conventions and habits of the brush that rather resemble *chic*].

Baudelaire condemns both Charlet and Horace Vernet for their nationalistic ideology and their consequent appeal to the chauvinistic French. Charlet's "niaiseries nationales" (549) correspond to Vernet's "sottises nationales" (471); neither has the special gift of the true—and specifically modern—artist, cosmopolitanism (546, 470; cf. 576), the capacity to feel and experience an alien culture. He associates the works of both with the frivolity and sentimentality of vaudeville (469, 547f.), and accuses them of

pandering to the public, particularly with their military subjects; both in
fact did famous images of the *soldat laboureur*, the Napoleonic veteran
returned to the countryside to work the land, an immensely popular theme
during the late Restoration and the July Monarchy.[34] Reproduced in numer-
ous formats—novels, vaudeville, lithographs, etc.—this image represented
the saccharine patriotism and sentimental republicanism that Baudelaire
most despised. Charlet is thus a fawning courtier whom he sarcastically
depicts as following the bourgeois dictum, "In the arts, what matters is to
please" (547); even more brutally he describes Vernet's works as "a brisk
and frequent masturbation, an excitation of the French skin" (470). Charlet
represents the perversion of the comic artist, and Vernet a parody of *Le Sage
qui rit*, fleeing anything great as another would evil, approaching his Molière
"only in trembling" ("il n'aborde même son Molière qu'en tremblant,"
469). He predicts that both will fall into oblivion along with the platitudes
they express (469, 549). Charlet is an artist of circumstance in the worst,
that is, nonuniversal sense (546); Vernet similarly shuns the sublime, the
great, and the abstract for the anecdotal and episodic (469f.); and both are
compared to that model of the bad poet, Béranger (470, 546). Charlet holds
the unenviable place in *Quelques caricaturistes français* that Vernet does in
the *Salon de 1846*: they represent the worst in contemporary art and taste,
the antithesis in every respect of Baudelaire's aesthetic, and provide a
negative backdrop against which to define this clearly.

Indeed, here lies the real reason for the attention accorded Charlet: he
contrasts radically with Baudelaire's exemplar of the comic artist, Daumier.
The verbal echoes are too numerous to miss; the diatribe against the false
caricaturist is a panegyric in praise of the authentic one, and Charlet a
parodic version of Daumier. Baudelaire develops the contrast on nearly
every point, starting with the first sentence of each passage. He begins the
Charlet one tentatively, uneasily, at a loss ("embarrassé") as to how to
express what he knows will be an unpopular view (546), but launches into
the Daumier section with confident sureness and relish, pleased to assert his
views on so worthy a subject: "Je veux parler maintenant de l'un des
hommes les plus importants, je ne dirai pas seulement de la caricature, mais
encore de l'art moderne" (549) [I now want to speak about one of the most
important men, not only in caricature, but in the whole of modern art]. He
acknowledges Charlet's great reputation, the "glory" of France (546), and

34. See Nina Athanassoglou-Kallmyer, "Sad Cincinnatus: *Le Soldat laboureur* as an Image
of the Napoleonic Veteran after the Empire."

laments Daumier's lack of reputation, despite the prodigious daily output that so amuses the Parisian public: "Le bourgeois, l'homme d'affaires, le gamin, la femme, rient et passent souvent, les ingrats! sans regarder le nom" (549) [The bourgeois, the businessman, the street urchin, women, all laugh and pass by, the ingrates, often without looking at the name]. If, for some, Charlet's absence from the Institute is as scandalous as Molière's from the Académie française (546), here the comparison is discredited altogether: "Quant au moral, Daumier a quelques rapports avec Molière. Comme lui, il va droit au but. L'idée se dégage d'emblée. On regarde, on a compris" (556) [As for the moral aspect, Daumier has some affinities with Molière. Like him, he goes right to the point. The idea emerges at once. You look and you understand immediately]. Daumier thus is *truly* like Molière, in the best sense, the Molière who could represent the *comique absolu* from within the domain of the *significatif* in *De l'essence du rire*.

Charlet is a small mind (546), Daumier a great artist (552f., 556), one of the rare few named in the *Salon de 1859* as capable of conversing with a philosopher or a poet (611). Charlet flatters (547), Daumier brings out the ridiculous and the sinister, even in what he loves (554f.). Charlet's drawing consists of stylized *chic* (548), Daumier's is never *chic* (556). His compositions always display a harmony of idea and art (556), Charlet's rarely do so (548). Charlet is "très artificiel" (548), Daumier is rooted in honesty and decency (556). Charlet's art has a narrow, exclusive focus, the soldier (547), whereas Daumier has "scattered his talent in a thousand different places" (554). Daumier's figures are always firm on their feet ("bien d'aplomb," 556), Charlet carelessly does not bother to make them so (548). His draftsmanship is characterized by negligence (548), like that of the much-berated art student, the *rapin*, Daumier's by certitude (556), like that of the great masters. Charlet takes the sentiments that he portrays from vaudeville (548), Daumier from his intimate knowledge of the subject (555), even when this comes from vaudeville, as with Robert Macaire. Charlet enjoys immense popularity but is destined ultimately to indifference and oblivion (549), Daumier enjoys less recognition but will endure as one of the most important figures not only of caricature but of modern art as a whole (549). Charlet is not worth even the paper that the section is written on (549), Daumier deserves an entire study of his own (549).

Despite these elaborate and close parallels, Baudelaire never mentions Daumier in this section, but contrasts Charlet explicitly, rather, with Goya: the art of both attacks monks and friars, but for different purposes. Flatterer and *courtisan*, Charlet presents the hated jesuitical priest, the *calotin*, not to

expose his moral ugliness (547), but to cater to the anticlerical prejudices of his own *soldat-laboureur*, popular-republican public; he produces an artless "Voltairean sermon" (547). Goya, on the other hand, depicts their ugliness, filth ("crasse"), and debauchery ("crapule") in an art which renders them beautiful. He thus represents the true caricaturist who creates beauty in ugliness, through the power of an art "purifying like fire" (547).[35] Goya exhibits the creative and transformative power of the artist, Charlet the compromising "servilité" of the fawning courtier.

A rhetoric of negativity dominates this section, reflecting the failure of Charlet's art: he produces *inverse* caricature, trying to make the subject interesting and pleasing rather than laughable. In an indictment saturated with irony and sarcasm, Baudelaire takes as his prime examples Charlet's treatment of the soldier and the gamin: "Il n'y a de beau, de bon, de noble, d'aimable, de spirituel, que le soldat. Les quelques milliards d'animalcules qui broutent cette planète n'ont été créés par Dieu et doués d'organes et de sens, que pour contempler le soldat et les dessins de Charlet dans toute leur gloire. Charlet affirme que le tourlourou et le grenadier sont la cause finale de la création" (547) [There is nothing beautiful, good, noble, kind, or witty except the soldier. The few billion animalculae that graze on this planet were created by God and endowed with organs and senses only to contemplate the soldier, and Charlet's drawings, in all their glory. Charlet asserts that the foot soldier and the grenadier are the final cause of creation]. Even their uncouth blunders are so presented as to make them endearing: "Cela sent les vaudevilles où les paysans font les *pataqu'est-ce* les plus touchants et les plus spirituels" (547) [That smacks of those vaudevilles where the peasants commit the most touching and witty malapropisms]. The comparison is barbed, vilifying Charlet's artistry by associating it with the simplicities and vulgarity of vaudeville, as opposed to the violence and *fantastique* of the English pantomime. And his famous children are merely

35. Throughout his career, Baudelaire considers this a mark of great art, which, from the *Salon de 1846* to the 1859 article on Gautier, purifies the impure and converts the horrible into the beautiful: "le génie sanctifie toutes choses, et si ces sujets [libertins] étaient traités avec le soin et le recueillement nécessaires, ils ne seraient point souillés par cette obscénité révoltante" (*Salon de 1846*, 443) [genius sanctifies everything, and if these libertine subjects were treated with the necessary care and reflection, they would not be sullied by that revolting obscenity]; "C'est un des privilèges prodigieux de l'Art que l'horrible, artistement exprimé, devienne beauté, et que la *douleur* rythmée et cadencée remplisse l'esprit d'une *joie* calme" (*Théophile Gautier*, 123) [One of the prodigious privileges of Art is that the horrible, expressed in an artistic way, becomes beauty, and that sorrow, given cadence and rhythm, fills the mind with a calm joy].

miniature versions of his soldiers, caricatures of an already ridiculous
model: "ces chers petits anges qui feront de si jolis soldats, qui aiment tant
les vieux militaires, et qui jouent à la guerre avec des sabres de bois" (547)
[those dear litle angels that will make such pretty soldiers, who are so fond
of old veterans, and who play at war with wooden sabers] (Figs. 7 and 8).
 Baudelaire wryly attributes Charlet's *gentillesse* to a pure heart, an
innocence ironically equal to that of his rosy-cheeked children, but his real
meaning is plain: Charlet's cowardice, the courtier's commitment to flatter-
ing his patrons. A pun best conveys the consequences of Charlet's grovelling
relation to his public:

> C'est un homme très artificiel qui s'est mis à imiter les idées du
> temps. Il a décalqué l'opinion, il a découpé son intelligence sur la
> mode. Le public était vraiment son *patron*. (548)

> [He is an artificial man who set about imitating the ideas of the time.
> He made a tracing of public opinion, he tailored his intelligence to fit
> the fashion. The public was truly his *patron*.]

Patron not only makes Charlet subservient to his master—that is, the
"esclave" of earlier—but also, in conjunction with "découper," trivializes
his creative activity as the mere cutting out of patterns.[36] Instead of imagi-
nation, Charlet has an intelligence formed on the paper model of public
opinion. *Patron* has negative connotations in Baudelaire's sarcastic treat-
ment of tragedy and historical landscape painting in the *Salon de 1846*: "la
tragédie consiste à découper certains patrons éternels, qui sont l'amour, la
haine, l'amour filial, . . . et, suspendus à des fils, à les faire marcher, saluer,
s'asseoir et parler" (480) [tragedy consists in cutting out certain eternal
patterns—love, hate, filial devotion—and, suspending them from strings,
making them walk, bow, sit down and speak]; "un bon paysage tragique
. . . est un arrangement de patrons d'arbres, de fontaines, de tombeaux. . . .
Les chiens sont taillés sur un certain patron de chien historique" (481) [a
good tragic landscape . . . is an arrangement of paper-model trees, foun-
tains, tombs. . . . The dogs are modelled on a certain paper pattern of

36. Cf. *Les Martyrs ridicules par Léon Cladel* (184): "[la jeunesse] découpe sa vie sur le
patron de certains romans, comme les filles entretenues s'appliquaient, il y a vingt ans, à
ressembler aux images de Gavarni" [youth models itself on the pattern of certain novels, as
kept women worked hard, twenty years ago, to look like the images of Gavarni].

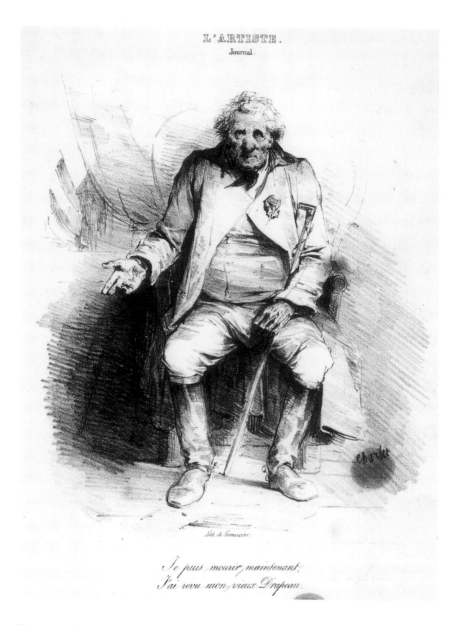

Lith. de Lemercier.

Je puis mourir maintenant,
J'ai revu mon vieux Drapeau.

FIG. 7. Charlet. *Je puis mourir maintenant. J'ai revu mon vieux drapeau*, 1830
(photo: British Museum)

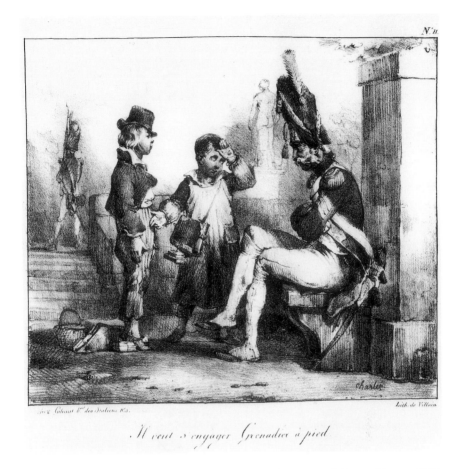

FIG. 8. Charlet. *Il veut s'engager grenadier à pied. Croquis lithographiques,* 1823 (photo: British Museum)

historical dog]. *Décalquer* has the same sense, which he later opposes to the more creative "traduire" (557).[37] Tracing a model and cutting out patterns already set by public taste—in this way does Charlet understand creation.

Baudelaire begrudgingly acknowledges two respectable efforts. The first, *Voilà peut-être comme nous serons dimanche!*, pictures a band of brigands

37. *Décalquer* sometimes has positive connotations, but in such cases the object traced (a dream, 89, or the artist's personal nature, 247) is itself a product of the imagination. For Baudelaire's use of the metaphor of translation, see my article "Painting as Translation in Baudelaire's Art Criticism."

eating near an oak tree from which dangles a hanged man (Fig. 9).
Baudelaire does not analyze the picture, but his description focuses on
the comical contrast between the brigands and the dead man (or the future
image of themselves that they see in him), and also on the irony of the
corpse itself, "taking the air," "sniffing the dew," and hanging in the
ridiculous attitude of a ballet dancer with his toes lined up and pointing
downward: "prend le frais de haut et respire la rosée, . . . les pointes des
pieds correctement alignées comme celles d'un danseur" (548). But Baude-
laire undermines his "praise" of the work at every turn. He patronizingly
remarks not the artist's talent but only his good intentions; there are few
sketches like this one to make up for the others, and even it suffers from
inadequate draftsmanship and falls short when compared to Villon's verses
on the same theme. More important, the difference between Charlet's image
and Baudelaire's own approach to the subject in "Un Voyage à Cythère" is
striking: the "ridiculous" hanged man in which the speaker of the poem
sees a hideous and grotesque image of himself—the flesh rotting, the
intestines hanging out, the corpse castrated by birds of prey—is comedy of
another sort, which leads him from the illusions of the first stanzas through
the truth of the middle ones, to the understanding, and finally the prayer, of
the end. Charlet's image has none of the spectacular, grotesque horror of
Baudelaire's, and none of the terrible irony by which this gradually imposes
itself upon the naively Romantic and unsuspecting speaker. While both may
fulfill the purpose of caricature—presenting in a work of beauty the image
of moral and physical ugliness—the poem does so with the power of the
absolu; Charlet's wit, in comparison, strikes one as shallow and facile, the
brigand's remark a far distance from the speaker's self-recognition in
the hanging, disemboweled, and castrated corpse of the poem.

Baudelaire also cites Charlet's series, *Costumes de la Garde Impériale* of
1819–20 (Fig. 10), which exhibits some of the positive formal qualities
noted in other artists: "un caractère réel," that is, proper pose, gesture, and
attitude, as in Carle Vernet (548); careful draftsmanship, and figures placed
firmly and surely ("d'aplomb"), as in Daumier (556). He distinguishes this
early Charlet, whom he later calls "the noble historian of the old veterans,"
from the later one, the tavern wit, "le bel eprit de l'estaminet" (764), and
blames the decline on the laziness that comes with the vanity and self-
assurance of fame: "Alors Charlet était jeune, il ne se croyait pas un grand
homme, et sa popularité ne le dispensait pas de dessiner ses figures correcte-
ment" (548) [Charlet was young then, he did not consider himself a great
man, and his popularity did not dispense him from drawing his figures

Fig. 9. Charlet. *Voilà peut-être comme nous serons dimanche. Album lithographique*, 1832 (photo: British Museum)

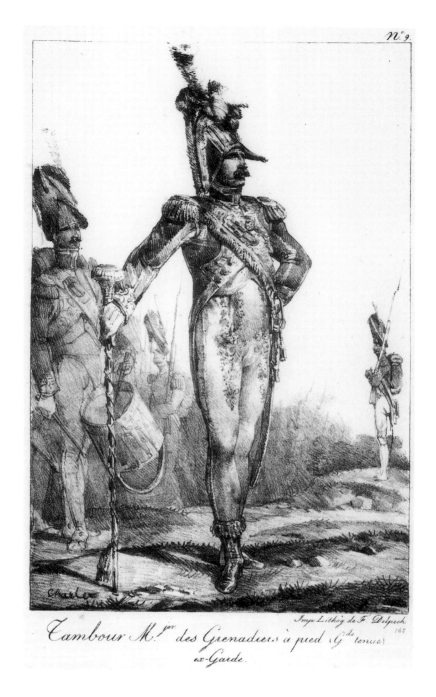

FIG. 10. Charlet. *Tambour-major des grenadiers à pied. Costumes de la Garde Impériale*, 1819–20 (photo: British Museum)

correctly]. Charlet subsequently lost the consciousness of dualism on which comic art depends.

Baudelaire's passionate dislike of Charlet is extraordinary at a time when he was being everywhere extolled as an artist of the first rank (particularly after his death in 1845). As early as 1830, Balzac hailed him as the Homer of the Bonapartists, a painter, poet, and historian of precisely those figures that Baudelaire later deplored—soldiers, and children who enjoy talking to them: "Qui peut oublier ces scènes fraîches et gracieuses, ces naïvetés surprenantes qui séduisent même un célibataire récalcitrant." [Who can forget these fresh and graceful scenes, these astonishing simplicities that delight even a recalcitrant bachelor].[38] Janin, one of Baudelaire's *bêtes noires,* eulogized in 1846: "qui a jamais douté de votre esprit, de votre bonne grâce, de votre noble coeur, de vos actives sympathies pour ce qui est la gloire, l'amour, la liberté? qui même doutait de votre bon sens, mon maître? Ses amis le pleurent et le pleureront toujours; le peuple sait et redira son nom." [who ever doubted your wit, your good grace, your noble heart, your lively feelings for glory, love, freedom? who even doubted your good sense, my master? His friends will weep for him and will do so forever; the people know his name and will long repeat it].[39] In a long essay in the *Revue contemporaine* (31 January and 15 February 1854), Charlet's biographer La Combe calls him a great painter, an excellent draftsman, an ingenious moralist, a profound philosopher and writer who produced a comedy worthy of Molière, and whose stature will increase over time—all points that Baudelaire attempts to discredit. Only Champfleury later departs from the trend and adopts Baudelaire's judgment in a direct allusion to *Quelques caricaturistes français*: "il est un écrivain qui, sans crainte de froisser l'opinion, a singulièrement dédoré les rayons de cette couronne" [there is one writer who, without fearing to offend public opinion, has singularly removed the glitter from this crown].[40]

But the most interesting essay, with respect to Baudelaire's, came from the pen of the artist he most revered, Eugène Delacroix, in 1862. The article is laudatory, taking a position contrary to Baudelaire's on nearly every point. Indeed, there are compelling reasons for thinking that Delacroix wrote it in response to his.

Quelques caricaturistes français appeared in *Le Présent* on 1 October

38. *La Mode,* 2 October 1830, in *Oeuvres diverses* II, 144.
39. *L'Artiste* v (4 January 1846).
40. *Histoire de la caricature sous la République, l'Empire et la Restauration,* 352.

1857. Eleven days later, Charlet's biographer La Combe wrote to Baudelaire to protest its severity, and quoted in support of his own view a letter from Delacroix:

> M. Eugène Delacroix m'écrivait il y a quelques mois: "Je regarde Charlet comme un des plus grands artistes de tous les temps et presque tous ses dessins sont des chefs d'oeuvre. J'aurais voulu moi-même écrire une notice sur lui pour dire à tous ce que je vous dis ici. J'en ai été empêché, ne connaissant pas tout son oeuvre et ayant eu peu de relations avec sa personne. Votre livre, Monsieur, contribuera à lui donner le rang qui lui est assigné dans la postérité."[41]

> [M. Eugène Delacroix wrote to me a few months ago: "I consider Charlet one of the greatest artists of all time and nearly all his drawings are masterpieces. I would myself have liked to write an essay on him to say to all what I tell you here. I was prevented from doing so, not knowing his whole oeuvre and having had little contact with him personally. Your book, monsieur, will help give him the place that is destined for him in posterity.]

Sometime in November, Delacroix began to enter notes into his journal for the article that would only appear four years later.[42] The sequence of events may be fortuitous; neither the *Correspondance* nor the *Journal* ever mentions Baudelaire's essay. But the coincidence is striking, and, if significant, would explain the notorious and otherwise unattested reprimand that Baudelaire describes in his 1863 essay on Delacroix:

> Il avait des faiblesses étonnantes pour Decamps, aujourd'hui bien tombé . . . De même pour Charlet. Il m'a fait venir une fois chez lui, exprès pour me *tancer*, d'une façon véhémente, à propos d'un article irrespectueux que j'avais commis à l'endroit de cet enfant gâté du chauvinisme. En vain essayai-je de lui expliquer que ce n'était pas le Charlet des premiers temps que je blâmais, mais le Charlet de la

41. *Lettres à Baudelaire*, 202. La Combe's letter indicates that as late as a few months prior to that date, Delacroix still had no plans to write an article on Charlet, although he had at one time thought of doing so.

42. The notes begin at the entry for 29 October but were probably written in November, for on the 28th of that month he records the first sentence (*Journal*, 700). The article appeared in the *Revue des deux mondes*, xxxvii (1 January 1862) (referred to in the text as *RDM*).

décadence; non pas le noble historien des grognards, mais le bel esprit de l'estaminet. Je n'ai jamais pu me faire pardonner. (764)

[He had an astonishing weakness for Decamps, much out of favor today. . . . Likewise for Charlet. He once summoned me to him for the express purpose of lecturing me vehemently about a disrespectful article that I had been guilty of writing on that spoiled child of chauvinism. In vain did I try to explain to him that it was not the early Charlet that I was blaming, but the Charlet of the decadence; not the noble historian of the old veterans, but the tavern wit. I never managed to be forgiven.

Je n'ai jamais pu me faire pardonner: this is the only place, in any of his writings, where Baudelaire acknowledges, however good-humoredly, Delacroix's reserve toward him. While Delacroix had always kept his distance from Baudelaire, his displeasure with the Charlet section of *Quelques caricaturistes français* may have exacerbated this irrevocably. If Baudelaire had invented the story to suggest his close relations with Delacroix, as Moss has proposed, he could surely have come up with an example less detrimental to himself.[43]

Indeed, Delacroix's article and the preparatory notes which he made for it in the *Journal* address many of the issues raised by Baudelaire's. He employs a negative rhetoric, as though to correct the misconceptions of another. The journal notes begin as though in answer to an unfavorable judgment: "Le mérite de Charlet. *Heureusement, je n'ai pas été le seul à*

43. *Baudelaire et Delacroix*, 24n., 210f. Moss challenges the story on the grounds that by 1857 Delacroix had not taken an interest in Baudelaire for years, and suggests rather that Baudelaire may have transformed the protests of La Combe, Charlet's biographer, into Delacroix's. This is unlikely: Delacroix elsewhere chided Ernest Chesneau, however politely, for not giving enough space to Charlet in his *Peinture française au dix-neuvième siècle* of 1862 (see Delacroix, *Correspondance* IV, 316ff.). And while he carefully distanced himself from Baudelaire as the years passed, he continued to read his works, at least up to 1861, as his letters attest (see *Lettres à Charles Baudelaire*, 113ff.). The *Journal* indicates that he read Baudelaire's translations of Poe in 1856 and thought carefully about the introductory essay (*Journal*, 573f.). He would definitely have known of *Quelques caricaturistes français*, from either *L'Artiste* (which he read regularly), *Le Présent*, or the outraged La Combe, with whom he corresponded about it. Despite Baudelaire's sometimes dubious credibility, and Delacroix's reserve toward him, their relations were far closer than we tend to think. The parallels between Delacroix's ideas, as expressed in the *Journal*, and Baudelaire's own, are extraordinarily frequent and close; and Baudelaire's essay on Delacroix contains insights that only one well acquainted with him could know.

m'en apercevoir . . . L'ouvrage de M. de La Combe" (*Journal*, 682, my emphasis) [Charlet's merit. Fortunately I have not been the only one to notice it . . . The work of M. de La Combe]. He is at pains to debunk the myth (which Baudelaire develops to excess) that Charlet benefited from official favor, enjoyed the acclaim of the public, or catered to its taste:

> Le public ne s'est pas engoué de Charlet comme de tant d'artistes médiocres qu'il adopte à cause de leur conformité avec son propre goût. Sa mort n'a pas été déplorée dans vingt journaux, on n'a point souscrit pour lui élever un tombeau ou une statue. Ses admirateurs ignorent dans quel coin reposent ses restes. . . . Il ne fut l'objet d'aucune faveur du gouvernement. (*Journal*, 685)

> [The public did not become infatuated with Charlet as it does with so many mediocre artists that it adopts because they conform to its own taste. His death was not mourned in twenty newspapers, and no one started a subscription to place a monument on his grave or to erect a statue for him. His admirers do not know where his remains are. . . . He was the object of no favor by the government.]

In direct contrast to Baudelaire, Delacroix maintains that Charlet's draftsmanship is not at all academic (*Journal*, 687), and compares his early manner to that of the great masters (*RDM*, 237). He argues for the variety of Charlet's figures, a "vaste comédie humaine"—"he never repeated the same head or attire" (*RDM*, 236f.)—unlike Baudelaire, who repeatedly complains of his monotony. Delacroix had a superb eye for form and was in a position to judge; moreover, he did not share Baudelaire's ideological aversion to Charlet. He surely regarded him as an influence on his own manner, one who would have reminded him of his acknowledged early master, Géricault.[44] And Baudelaire's mocking comments on the *rondeur* of Charlet's forms ("Toujours ronds et frais," "toujours des ronds et des ovales," 547f.) would have affronted his own expressed interest in "le dessin par les boules."[45] Delacroix's criticism of the public may have in fact been

44. P. Gaudibert ("Delacroix et le romantisme révolutionnaire," 13 n. 1) argues for the influence of Charlet's 1830 lithograph "The Allocation (the 28th of July)" on Delacroix's "The 28th of July: Liberty Leading the People." Cf. M. Marrinan, *Painting Politics for Louis-Philippe: Art and Ideology in Nineteenth-Century Orleanist France 1830–1848*, 73f.

45. *Journal*, 184.

damning criticism of Baudelaire's eye as well: Charlet is appreciated only by artists (*RDM*, 241).

Baudelaire concentrates on the artificiality and falsity of Charlet's work, with its stale, set types and its vaudeville emotions. Delacroix insists on his unique characters and his intimate knowledge of his subjects (as Baudelaire says of Daumier): "il s'était attablé avec eux, il avait surpris dans leurs confidences et sur leur visage tout ce qu'il lui fallait pour donner la vie à son dessin" (*RDM*, 240) [he had sat down with them, he had caught in their confidences and on their faces all he needed to give life to his drawing]. These types possess the quality of great art: they remain in the memory (*Journal*, 688), in direct contrast to Baudelaire's assertion that Charlet will deservedly fall into total oblivion. Delacroix dissociates Charlet from the sentimentalism and excessive *gentillesse* that Baudelaire makes his characteristic trait: "il peint l'homme non pas comme une école sentimentale voudrait qu'il fût, mais comme il est fait, avec ses ridicules et même ses vices" (*Journal*, 683) [he portrays man not as a sentimental school would like, but as he is, with his absurdities and even his vices]. This disputes Baudelaire's mocking depiction of Charlet's thought: "montrer au naturel les vices du soldat, ah! quelle cruauté!" (547) [show as they are the vices of the soldier, ah! what cruelty!] His is hardly the cloying, sugary comedy attributed to him by Baudelaire, but rather a Rabelaisian *esprit gaulois* (*Journal*, 685). Delacroix boldly places himself among those whom Baudelaire had condescendingly pictured as indignant over Charlet's rejection by the Institute: "Je voudrais qu'on plaçat leurs bustes [Charlet's and Géricault's] . . . dans le vestibule au moins de ces académies qui se sont passé, quand ils vivaient, de se les associer" (*Journal*, 683) [I would like that their busts (Charlet's and Géricault's) be placed . . . in the vestibules, at least, of those academies that declined to have anything to do with them while they lived.] He defends Charlet's sincerity and wholly removes him from the atmosphere of the salon (*RDM*, 241). The *Journal* adds, in the same language of the "reprimand" cited by Baudelaire, that for such people Charlet was "only" a caricaturist, an "artiste d'estaminet" (*Journal*, 684); Baudelaire could not have taken this term from the published version, for it does not appear there. Some form of the reprimand surely took place.

The force of Baudelaire's views, however, may have obliged even Delacroix to acknowledge Charlet's concern for pleasing his public, and to recognize the superiority of the early work, notably the *Costumes de la garde impériale*:"alors qu'il s'inquiétait peut-être moins de plaire que d'exprimer fortement ses idées" [when he was perhaps less concerned with pleasing the

public than with expressing his ideas forcefully]. The later work, in contrast, betrays a more rapid and virtuosic execution bordering on *coquetterie* (*RDM*, 237). Charlet thus betrays what Delacroix identifies as the classic French flaw, undifferentiation, compositional egalitarianism, the neglect of proper hierarchy—the result of which is a superabundance of tiresome details, a lack of order by which to read the painting, confusing for the eye and exhausting for the imagination:

> Les moindres détails, les plus insignifiants, sont aussi étudiés, présentés sans aucun sacrifice ni souci du mauvais effet de cette conscience maladroite. On ne trouve point en général dans la peinture française de ces heureuses négligences dont le mérite est d'attirer l'intérêt sur les parties qui méritent de le fixer. . . . Cet art de prendre en tout ce qui en est la fleur, de ne point fatiguer le lecteur par des détails oiseux, . . . de ne faire voir que l'essentiel est la qualité qui nous charme et dont l'absence gâte pour nous des ouvrages pleins de choses, mais dont l'ordonnance confuse et surtout l'abondance indiscrète émoussent l'imagination qui ne sait où s'arrêter. (*Journal*, 687f.)

> [The least detail, however insignificant, is carefully studied and presented without any sacrifice, without concern for the bad effect that this awkward conscientiousness will produce. In general, one does not find in French painting those happy oversights whose merit is to attract attention to the parts which deserve to hold it. . . . This art of taking the best in everything, not tiring the reader with idle details, . . . and showing only the essential, is the quality that delights us and whose absence spoils for us those works full of objects, but whose confused organization and undifferentiated abundance blunt the imagination, which does not know where to pause.]

The influence of these aesthetic values is everywhere apparent in Baudelaire's criticism, particularly in his critique of landscape, photography, and realism, in which the indiscriminate rendering of details overwhelms the viewer. But Delacroix, addressing Baudelaire's dominant theme of falsehood and deceit, maintains that despite their *coquetterie* Charlet's works retain a definite *franchise* (*RDM*, 238). And in answer to Baudelaire's contention of increasing negligence resulting in vulgar *crayonnage*, he holds that Charlet's

composition remains incisive nonetheless, with nothing hasty or neglectful about it (*RDM*, 238).

But the most striking difference between the two articles surely lies in the humility with which Delacroix, the acknowledged master, and by then a member of the Institute, begins and ends, evoking his inability to do justice to Charlet's work and to bring him the recognition he deserves:

> Je voudrais à ma faible voix plus de force et d'autorité pour entretenir dignement le public français de quelques admirables contemporains qui font sa gloire . . .
>
> Celui qui écrit ces lignes . . . aurait désiré présenter une analyse de quelques-unes de ces merveilles du génie de Charlet. . . . Il a été effrayé de son impuissance et de la difficulté d'une tâche si ingrate (*RDM*, 234, 242)
>
> [I wish my feeble voice had more strength and authority to discuss as they deserve some admirable contemporaries who are the glory of the French public . . .
>
> The one who writes these lines . . . would have liked to present an analysis of some of the wonders of Charlet's genius. . . . He was frightened by his own inadequacy, and by the difficulty of such an ungrateful task]

More subtly eloquent an indictment of Baudelaire's opening *embarras* for precisely the opposite reason could hardly be found.

Daumier

At the center of this essay on the *significatif* French, Daumier paradoxically embodies some of the primary characteristics of the *absolu*. Baudelaire attributes to him a unity of impression in an art by nature dual and contradictory, a harmony of fantastic and real, and an expressive power that surpasses all the artists discussed, with the sole exception of Goya later. Indeed, this section illustrates, more than any other, the violence and furor of the *comique absolu*, and its revolutionary power to bring about a new

art altogether. To this end, it incorporates a long digression on the carica-tural "fever" (549) induced by the 1830 revolution: the role of caricature in opposing the policies of Louis-Philippe's government, especially its increas-ingly repressive laws against freedom of speech and freedom of the press. Baudelaire pictures himself turning the pages of Philipon's weekly, *La Caricature,* and seeing the events of the July Monarchy's early years reap-pear before his eyes: "C'est véritablement une oeuvre curieuse à contempler aujourd'hui que cette vaste série de bouffonneries historiques qu'on appelait la *Caricature* . . . tous ces épisodes des premiers temps du gouvernement reparaissent à chaque instant" (549f.) [That vast series of historical buf-fooneries which was called *La Caricature* is truly a work curious to contemplate today . . . all those episodes of the early years of the government reappear at each moment]. None of the six caricatures described in this context, usually taken to be Daumier's, has been identified; in fact they are not by Daumier at all.[46]

Freedom of the press, including political caricature, was one of the fundamental issues of the 1830 revolution. It was suspended by one of the five Ordinances of 25 July which provoked the insurgency two days later and brought down the Restoration government of Charles X; the abolition of censorship consequently became a provision of the revised charter in August, under the new centrist government of Louis-Philippe. Over the following five years, however, censorship laws were once again adopted and increasingly strengthened so as to suppress the frequent journalistic attacks against the government, especially in the republican papers. Editors were personally responsible for defamatory publications against the king, as Philipon's numerous prison sentences attested; a stamp tax was placed on caricatures; newspaper and pamphlet hawkers needed authorization. The Fieschi affair—the unsuccessful assassination attempt on the king in July 1835—prompted the adoption of the repressive September laws, requiring a prohibitively high *cautionnement* deposit to be paid by each newspaper (one-third of which had to be put up personally by the owner), against

46. Commentators have assumed that the six unknown plates were never published (e.g. T. J. Clark, *The Absolute Bourgeois,* 143), or that Baudelaire, who in a note here confesses to no longer having the prints in front of him, merely remembered them badly (e.g., Crépet, in Baudelaire, *Curiosités esthétiques,* 504f.). He may indeed have seen unpublished works, for he knew Daumier well and for a time lived near his studio on the Ile Saint-Louis, but he speaks of them as though they *were* published, specifically in *La Caricature.* Daumier was acquainted with the famous *Club des hachischins,* which met from 1845 to 1847 in the Hôtel Pimodan. Escholier (*Daumier et son monde,* 70) suggests that one of the figures in Daumier's *Les Fumeurs de Hadchichs* closely resembles Baudelaire.

which fines could be held.[47] Any criticism of the king, direct or indirect, any attack on the principle or form of the government established in 1830, any report of libel and slander trials, any support for legitimists or republicans, any opinion in favor of the fall of the constitutional monarchy, any institution of subscriptions (or announcement thereof) to pay for fines, and any publication of prints, drawings, engravings, or lithographs without prior approval by the Minister of the Interior counted as crimes against the national security, punishable by fines and imprisonment.[48] The September laws effectively extinguished political caricature and transformed it into *caricature de moeurs*. Philipon's weekly *La Caricature*, the organ of the greatest opposition, ceased publication altogether and, as Bechtel observes, there is virtually no reference to French politics in his daily, *Le Charivari*, after 18 August 1835 until the 1848 revolution.[49]

Baudelaire is aware of this evolution, and to illustrate it uses Daumier's *Robert Macaire* series on the unscrupulous wheelings and dealings of a swindler and multitalented opportunist in a time of rampant financial speculation (Fig. 11). It is significant, however, that he does not present the emergence of social caricature as a *pis-aller*, but as a distinct effort to create something new in the face of changing attitudes:

> *Robert Macaire* fut l'inauguration décisive de la caricature de moeurs. La grande guerre politique s'était un peu calmée. L'opiniâtreté des poursuites, l'attitude du gouvernement qui s'était affermi, et une certaine lassitude naturelle à l'esprit humain avaient jeté beaucoup d'eau sur tout ce feu. Il fallait trouver du nouveau. Le pamphlet fit place à la comédie. La *Satire Ménippée* céda le terrain à Molière, et la grande épopée de Robert Macaire, racontée par Daumier d'une manière *flambante*, succéda aux colères révolutionnaires et aux dessins allusionnels. La caricature, dès lors, prit une allure nouvelle, elle ne fut plus spécialement politique. Elle fut la satire générale des citoyens. Elle entra dans le domaine du roman. (555)

[Robert Macaire was the decisive starting point for caricature of manners. The great political war had calmed down a bit. The

47. For a weekly like *La Caricature*, 50,000 ff; for a daily like *Le Charivari*, 100,000 ff.
48. *Bulletin des lois du royaume de France*, IXᵉ série, 1ᵉʳᵉ partie, 247ff.
49. Bechtel (*Freedom of the Press: Philipon vs. Louis-Philippe*, 40). See his introduction in general for a history of the press laws; and also Robert Justin Goldstein, *Censorship of Political Caricature in Nineteenth-Century France*, chap. 4.

FIG. 11. Daumier. *Robert Macaire agent d'affaires*, 1836 (photo: British Museum)

stubborn persistence of legal prosecution, the hardening of the gov-
ernment's attitude, and a certain lassitude natural to the human spirit
had thrown a lot of water on all that fire. Something new had to be
found. The political pamphlet gave way to comedy. Menippean satire
surrendered the field to Molière, and the great epic of Robert
Macaire, recounted by Daumier in a *dazzling* way, succeeded the
rages of revolution and directly allusive drawings. Caricature thence-
forth took on a new character, and was no longer specifically
political. It became the general satire of the people. It entered the
realm of the novel.]

Baudelaire underlines *flambante*, and thus calls attention to the pun, indi-
cating the brilliance of Daumier's creation and extending the earlier meta-
phor: the political fire quelled by the waters of censorship and human
lassitude passes into this superb social example, itself no less fiery—or
politically inflammatory. In likening the movement from historical to social
caricature to the attested development of literary forms—from political
pamphlet to social comedy, Menippean satire to Molière, revolutionary epic
to the novel—Baudelaire draws caricature into the realm of modern art. The
political *comédie satanique* (549) becomes a *comédie humaine*, and Dau-
mier the equivalent of Balzac (560). Indeed, while Baudelaire greatly ad-
mired the political works of the early 1830s, caricature may best fulfill his
definition—representing to mankind its moral and physical ugliness in a
work of beauty and power—when it extends its domain to the social and
approaches the novel: that mirror which sends back to the crowd an image—
exaggerated, deepened, heightened, highlighted, revealing—of itself (119f.).
Caricature after 1835 is less distinctly political, but more than political—
"la satire générale des citoyens," a critique of the values, practices, and
beliefs of a nation.[50] With social caricature, as with the realist novel, the
implication of the viewer or reader is assured; Macaire is everywhere, part
of the reality of each and of all.[51] And this new epic fulfills the prescription
of the Balzacian modern painter in the *Salons* of 1845 and 1846, wresting
from contemporary life its epic side (407, 493). Caricature, like the realist
novel, is nothing less than the art of the nineteenth century.
 Baudelaire's history of the opposition press movement is sketchy but

50. For the role of *Le Charivari* as a locus of cultural resistance, see Terdiman, *Discourse/
Counter-Discourse*, 160ff.
51. See Terdiman on the importance of the recurring character for this effect (ibid., 169).

relatively accurate. It is remarkable for its time, since only Thackeray, writing for an English paper, produced a comparable one (see note 19). Baudelaire mentions the unrelenting war waged against the government by *La Caricature* from 1830 to 1835; the institution of its monthly supplement, *L'Association mensuelle* (August 1832) to raise money for its frequent penalties; the confiscation of the impressions of Daumier's *Rue Transnonain* in 1834, and the progressive hardening of the government's attitude. He recounts the story of the famous pear, Philipon's stock symbol of Louis-Philippe, and the trial at which, for his own defense, he drew a series of four sketches demonstrating the progressive deformation of the king's head into a pear.[52] With characteristic impertinence, Philipon had attempted to show that resemblance to the king alone was not grounds for condemning a sketch.[53] Baudelaire takes the impertinence further by citing an equally defamatory parallel, the head of Apollo gradually transformed into that of a frog. This example from Lavater's *Art de connaître les hommes par la physionomie* was well known and cited frequently in the period;[54] Grandville did a version of it in his *Têtes humaines et d'animaux comparées*. But Baudelaire uses it to suggest the full status of caricature as an art. He describes the process by which the visual pun takes hold and one image

52. The trial took place in November 1831 (*La Caricature*, 26 January 1832).

53. Gombrich (*Art and Illusion*, 344), followed by Wechsler (*A Human Comedy*, 71), maintains that "poire" already meant "fathead" in contemporary slang, and thus functions as a pun. But this usage seems to postdate the Philipon episode (G. Esnault, *Dictionnaire historique des argots*, traces it to this). Baudelaire makes no allusion to it. A pear-shaped head would be ridiculous anyway. Hofmann (*Caricature from Leonardo to Picasso*, 95) reproduces an earlier example in Isabey's 1827 drawing of the archaeologist and collector Alexandre de Sommerard. See Döhmer, "Louis-Philippe als Birne," 251.

54. E.g. *Le Charivari*, 9 April 1833: "la charge d'Apollon, faite très ressemblante au moyen d'une grenouille" [the caricature of Apollo, made very like by means of a frog]; and 17 April 1835: "Lavater a bien pu calculer d'instinct, lorsqu'il a fait voir combien peu de transitions deviennent nécessaires pour conduire un profil de grenouille au profil magnifique de l'Apollon de Belvédère, qui est, dit-on, le beau idéal" [Lavater was able to calculate instinctively, when he showed how few transitions are necessary to transform the profile of a frog into the magnificent profile of the Apollo Belvedere, which is, they say, the ideal of beauty]. Cf. Lavater, *L'Art de connaître les hommes par la physionomie* IX, plates 527–29 (6f.): "la transition d'une tête de grenouille à celle d'Apollon . . . [qui] semble presqu'impossible, sans un effort inouïe . . . s'offre et se développe en quelque sorte ici d'elle-même, et qui plus est, d'une manière si frappante que nous sommes moins surpris de l'effet comme très-extraordinaire, que comme très-naturel" [the transition of a frog's head into Apollo's . . . which seems almost impossible without an unheard of effort, . . . here presents itself and develops in a way of itself, and what is more, in so striking a manner that we are less surprised by how extraordinary, than by how very natural, the effect is]. Baudelaire mentions Lavater frequently (*Choix de maximes consolantes sur l'amour*, I, 547; *Victor Hugo*, 133; *Salon de 1846*, 456; *Exposition universelle de 1855*, 587).

becomes a symbol of another, to which it is related only by a certain—comical—formal resemblance:

> Le symbole avait été trouvé par une analogie complaisante. Le symbole dès lors suffisait. Avec cette espèce d'argot plastique, on était le maître de dire et de faire comprendre au peuple tout ce qu'on voulait. (550)

> [The symbol had been found through an obliging analogy. From then on the symbol was enough. With this type of pictorial slang, one could say and make the people understand anything one wanted.]

This visual language of symbols, however, is not just any language, but *argot*, unintelligible to those outside the group for which it was intended.[55] The pear is part of a caricatural jargon or code, protecting the authors from prosecution but communicating its message easily to a select audience, the republican opposition. It is a kind of parodic hieroglyphic language, with special meaning for the initiated—here, ironically, the people; the caricaturist thus uses the same methods as the ultimate artist, creator of the "hieroglyphic dictionary" of Nature (59).[56]

In introducing the subject, Baudelaire follows a similar practice, creating a verbal *argot* by packing his description with comically significant double-entendres: "Cette fantastique épopée est dominée, couronnée par la pyramidale et olympienne *Poire* de processive mémoire" (549) [This fantastic epic is dominated, crowned by the pyramidal and olympian Pear, of litigious fame]. *Couronnée* and *olympienne* point ironically to the king, and specifically his head, which the pear caricatures; *pyramidale* is a multiple pun, not only suggesting the monumentality of the image and the shape of the pear-head, but also containing homonymically the Latin root of *poire*, *pira*, in the manner of a popular etymology. Baudelaire thus places the reader in the position of the "peuple," and himself in the position of Philipon's caricaturists with their *argot plastique*, both laughing at the ignorant, ridiculous authorities and their supporters, who are here all the more contemptible for sharing the patriotic sentimentalism of Charlet: "hurleurs patriotes," howling patriots.

The five caricatures by which Baudelaire illustrates the opposition's war

55. McLees (*Baudelaire's "Argot Plastique,"* 148) notes its subversive quality.
56. *Puisque réalisme il y a:* "ce monde-ci, —dictionnaire hiéroglyphique" (59).

against the government represent the violence and ferocity, the *bouffonnerie sanglante*, of the *comique absolu*. This is the decapitation of Pierrot without Pierrot's one-upmanship, however: in each, the conventional figure of Liberty is violated, strangled, tortured, or condemned to death. Only the continuous and abundant production of caricatures kept alive the values so brutally and fatally repressed; Liberty murdered was reborn on page after page, day after day. In one example, she sleeps soundly, her traditional revolutionary phrygian bonnet atop her head; a man, seen only from behind, but easily identified by his pear-shaped head topped by a wave of hair and flanked by large whiskers, approaches stealthily with the intention of violating her. Baudelaire pushes the satire further by remarking that "he has the burly shoulders of a market-seller or a fat landlord," thus alluding to the *roi bourgeois*, and implicating the bourgeoisie itself in the crime (Figs. 12 and 13).[57] Another, Traviès's *Une Exécution sous Louis XI* (*La Caricature* 180, 17 April 1834, Fig. 14), pictures Louis-Philippe as Louis XI ordering Liberty's execution, as the recognizable ministers of the *juste milieu*—Thiers, Guizot, Argout, Persil, Talleyrand, Soult, Keratry, et al.— look on, their grotesque and monstrous faces like Carnival masks, impish, grimacing, contorted, at once ridiculous and sinister.[58] This image renders the abstraction concrete by a chilling suggestion of the violence of the government against the people: the fortress in the background (Plessis-les-Tours, the favorite residence of Louis XI) alludes to the controversial *forts détachés* meant to protect Paris from the Holy Alliance, but commonly seen instead to protect the king from an insurgent Parisian population;[59] the

57. Cf. Grandville's famous *Naissance du juste-milieu, après un enfantement pénible de la Liberté* (*La Caricature* 66 [2 February 1832], see Fig. 12), a parody of Devéria's *Naissance d'Henri IV* (1827), picturing Liberty asleep, coiffed with her phrygian bonnet; Louis-Philippe, with his pear-shaped head, tuft of hair, and enormous sideburns is seen from behind, and holds the newborn *juste-milieu* up to the ministers. A parody of Guérin's 1817 *Clytemnestre* by Casati (*La Caricature* 168 [23 January 1834]) shows a pear-headed Louis-Philippe/Aegisthus pushing a guard/Clytemnestra toward the bed of a sleeping lady Liberty (see Fig. 13).

58. Following J. Mayne's tentative identification (*The Painter of Modern Life*, 173), this has previously been taken to be Decamps' *Arrêt de la cour prévôtale* (*La Caricature* 13 [27 January 1831]), where "Françoise Liberté" is condemned for her part in the July revolt. But this represents her in contemporary surroundings, whereas Baudelaire specifies a "Gothic tribunal: a great gallery of contemporary portraits in period dress" (551). The Traviès is consistent with Baudelaire's footnote: "Je n'ai plus les pièces sous les yeux, il se pourrait que l'une de ces dernières fût de Traviès" (551) [I no longer have the works before my eyes, it is possible that one of the latter was by Traviès].

59. Opponents of the fourteen fortifications charged that they would be used to quell uprisings within the city, and that in the hands of an enemy they would ensure the destruction of Paris. They were a frequent topic in the press in the early 1830s. Heine discusses them in his 1833 *Salon* (106–17).

FIG. 12. Grandville. *Naissance du juste-milieu après un enfantement pénible de la Liberté. La Caricature* 66, 1832 (photo: British Museum)

Fig. 13. Casati. *Parodie du tableau de la Clytemnestre. La Caricature* 168, 1834 (photo: Bibliothèque Nationale)

La Caricature (Journal) N°180

UNE EXÉCUTION SOUS LOUIS ONZE.

Fig. 14. Traviès. *Une Exécution sous Louis XI. La Caricature* 180, 1834 (photo: Bibliothèque Nationale)

indication of the Sainte-Pélagie prison in the foreground reminds the viewer of the fate of those who resisted the repression, including Daumier and Philipon of *La Caricature*. In all the examples, torture, suffocation, stabbing, throat-cutting, murder, and rape occur repeatedly as images of the government's violence against the values won by the 1830 revolution—freedom, the republic, the constitution (Figs. 15–18).[60]

The most compelling and problematic example, however, comes not from 1830 but from a revolution closer to Baudelaire's own time and heart, 1848.[61] It was inspired by the Rouen riots of 27–28 April (following the elections on the twenty-third), in which an angry crowd clashed with the *garde nationale* and was fired upon. Baudelaire describes a judge leaning avidly over a corpse riddled with holes, running his claw-like nails down it and sneering, in an allusion to the stereotypical wily nature of the Normans, "Ah! le Normand! il fait la mort pour ne pas répondre à la justice!" [Ah! the Norman! he's playing dead so as to avoid having to answer to justice!] Ridiculous bourgeois officials all decked out, well crimped, tightly laced, bloated with pride, their mustaches curled, stand pompously in the background; among them bourgeois dandies ready to put down the riot with a bouquet of violets in the buttonhole of their jackets (551). The magistrate is indeed Franck-Carré, as Crépet first hypothesized: his appointment as head of the enquiry was bitterly contested in the republican press. *La Commune de Paris* expressed outrage at the decision, and the Parisian *Société républi-*

60. Baudelaire's other examples are even less discreet. Othello's line to Desdemona, "Avez-vous fait vos prières ce soir, Madame?" sets the tone for another murder, as Louis-Philippe suffocates a struggling, resistant Liberty. (Cf. Chassériau's lithograph so entitled, from his 1844 *Othello* series, which Baudelaire mentions in the *Salon de 1845*.) In another a young Liberty is surrounded by Louis-Philippe's ministers and enticed into a house of ill-repute, where the familiar attributes of the king—sideburns and tuft of hair—betray his presence; in another she is taken into a torture chamber where bare-armed athletes, all recognizable ministers, await her avidly with instruments of torture. *La Caricature* has no plates fitting these descriptions precisely, but contains a number on the same themes, as Crépet first noted (*Curiosités esthétiques*, 505). Cf. Ferogio's *Imitation libre d'un tableau du Titien*, a parody of Titian's *Crowning of Thorns* (*La Caricature* 169 [30 January 1834]), in which Freedom of the Press is tortured by ministers, judges, and Louis-Philippe; she is stifled by the king and his ministers in Grandville's *Descente dans les ateliers de la Liberté de la Presse* (*L'Association mensuelle*, November 1833); in Casati's parody of Prud'hon's *La Vengeance et la justice divine poursuivant le crime*, Louis-Philippe/Crime has stabbed Republican France and left her to die (*La Caricature* 170 [2 February 1834]); her throat is cut in *Barbe-bleue, blanche, et rouge* by Grandville and Julien (?) (*La Caricature* 127 [11 April 1833]) (see Figs. 15–18).

61. The work has not been identified. No caricature matching Baudelaire's description is listed in the Ministry of the Interior's *Registre du dépôt des estampes, gravures et lithographies* for 1848, but the indications there are frequently too brief or general to provide adequate information.

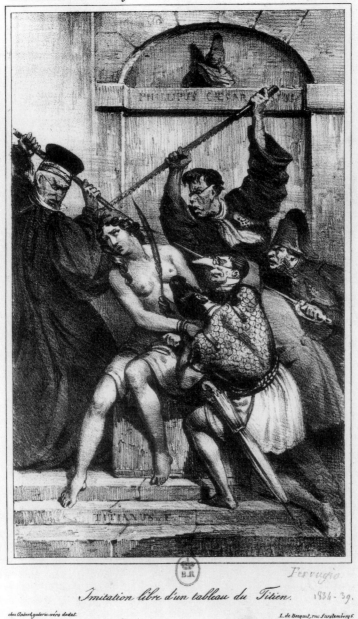

Imitation libre d'un tableau du Titien. 1834-39.

FIG. 15. Ferogio. *Imitation libre d'un tableau du Titien. La Caricature* 169, 1834 (photo: Bibliothèque Nationale)

Fig. 16. Grandville. *Descente dans les ateliers de la Liberté de la presse*, 1833 (photo: British Museum)

Fig. 17. Casati. *Parodie d'un tableau de Prud'hon. La Caricature* 170, 1834 (photo: Bibliothèque Nationale)

caine centrale issued a statement comparing him to Richelieu's ruthless henchman, the magistrate Laubardemont: "Here comes the royal Court, Louis-Philippe's judges, throwing themselves like hyenas on the debris of the massacre and filling the dungeons with 250 republicans. At the head of these Inquisitors is Franck-Carré, that abominable attorney-general of the Peers' Court, that Laubardemont who furiously demanded the head of the insurgents in May 1839."[62] Baudelaire compares the magistrate to a shark, if not a hyena, but the sense is the same: a justice transformed into bloodthirstiness

62. An allusion to the uprising led by Barbès and Blanqui, 12 May 1839. Quoted in H. Bouteiller, *Histoire des milices bourgeoises et de la Garde Nationale de Rouen*, 153. Baudelaire elsewhere mentions Franck-Carré with high irony (I, 710).

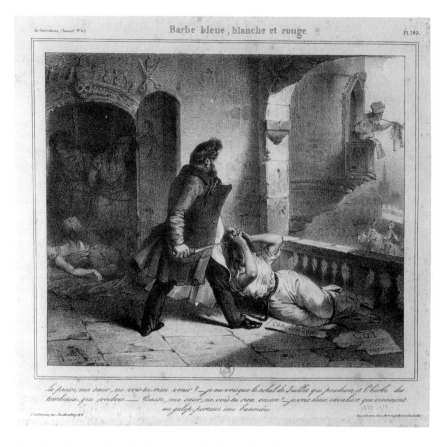

FIG. 18. Grandville et Julien (?). *Barbe bleue, blanche et rouge. La Caricature* 127,
1833 (photo: Bibliothèque Nationale)

and lust for revenge, a system feeding on the dead bodies of revolutionaries,
consolidating its power from the ruins of civil strife. His description
suggests, as Biermann points out, the ambiguity of Baudelaire's own histor-
ical position, belonging to the class of the magistrate but standing on the
side of the victim.[63] In this case, however, ambiguity does not indicate
ambivalence. Baudelaire directs his sarcasm clearly against the self-satisfied

63. K. Biermann, *Literarisch-politische Avantgarde in Frankreich 1830–1870*, 176. Clark
(*The Absolute Bourgeois*, 143) notes a different ambiguity: Baudelaire's identification with
both the bourgeois dandies in the background whose pose he adopted before and after 1848,
and the corpse itself. But Baudelaire never identified with bourgeois dandies, particularly of
the ludicrously curled and decked-out type described here.

"bigwigs" (as the familiar "gros bonnets" attests), the ridiculous "dandys bourgeois," figures of comical self-ignorance puffed with pride, and equally the grotesquely villainous, man-eating magistrate; his sympathy lies with the corpse. On the other hand, as we shall see, it is significant that he describes no living insurgents in the picture; he confers heroic status upon the revolutionaries only in death.

Baudelaire's marked sympathy for the opposition in these passages does not merely lend support to that quintessentially oppositional form, caricature; more important, the comic ideal it expresses sheds light on his politics, notably his confusing attitude toward the 1848 revolution. The generally accepted opinion of his political development traces a line from a position of relative detachment around 1845, with nonetheless a faith in socialist moral and aesthetic doctrines,[64] to active engagement as a contributor to two socialist journals and a participant on the barricades for the overthrow of the July Monarchy and the reinstatement of the republic in 1848 (especially during the violent June days), and finally to a diametrically opposed position of reaction after the 1851 coup d'état and his reading of Joseph de Maistre that same year.[65] Ruff holds that Baudelaire actually retained a certain republican feeling throughout his life, despite his change of attitude.[66] Clark also affirms Baudelaire's continued interest in revolutionary politics,[67] but offers two reasons for his post-1851 reaction. The first has to do with the moralizing fervor of the socialists, a quality that ironically links them with the bourgeois and the "grande hérésie moderne" that it espouses, didacticism. The second has a more pragmatic basis, Baudelaire's opposition to an *illusory* fervor, "promising everything and offering no single concrete proposal"; this would account for his turning against the February revolution itself as early as August 1848 in his letter to Proudhon, and perhaps even earlier.[68] For Clark, Baudelaire maintained his support for the people but turned against the republic of February and opposed himself to any premature uprising without a coherent program right up until 1851. After this period, and the famous "depoliticization"

64. Cf. Kelley, *Baudelaire: Salon de 1846*, 15f.

65. Pichois explains this by the "mystical" and "utopian" nature of his socialism; its practical application had to be profoundly disappointing (1554). And socialist doctrines, with their emphasis on the power of freedom to overcome evil, contradicted Baudelaire's increasing belief in the power of original sin in human affairs ("Baudelaire en 1847," 137).

66. "La Pensée politique et sociale de Baudelaire," 72.

67. *The Absolute Bourgeois*, 142. He cites as evidence the 1862 letter to Sainte-Beuve (*Corr.* ii, 220) and the May 1859 one to Nadar (*Corr.* i, 578).

68. *The Absolute Bourgeois*, 164, 166.

resulting from the December coup d'état, he "covers his traces,"[69] adopts a pose, with his revolutionary feeling revealing itself only as an echo in select pieces, notably the city poems, and in particular the 1865 prose poem, "Assommons les pauvres!"

The Daumier section of *Quelques caricaturistes français* encapsulates the problems of defining and explaining Baudelaire's attitude. It was written after his own revolutionary fervor had passed, and twice substantially revised after he had become disillusioned with the revolution and socialism, yet it describes 1830, the age of "great political fervor" (551), with warmth and admiration. Indeed, through its confrontation of the two insurrections it goes far in clarifying his position.

It is significant that Baudelaire says nothing about the 1830 revolution itself, but reserves his praise for its images, products of a bygone belle époque of genuine revolutionary feeling. In contrast, he finds only the one caricature from 1848 to rival them: "car tous les plaidoyers politiques étalés aux carreaux, lors de la grande élection présidentielle, n'offraient que des choses pâles aux prix des produits de l'époque dont je viens de parler" (551) [for all the political appeals displayed in the shop windows, at the time of the big presidential election, offered only pale little things in comparison with the products of the period I have just spoken of].[70] The coincidence of his esteem for the revolution and the quality of its images is hardly fortuitous. For Baudelaire, the golden age that caricature enjoyed in 1830 was due to the authenticity of its inspiration; the poverty of images in 1848 reflects his conception of that revolution as flawed from the start, and thus incapable of provoking the same quality of representation. Clark is right to separate Baudelaire's feelings toward the 1848 revolution from his feelings toward revolution in general, but this should be regarded from the opposite perspective: while Clark concludes that Baudelaire's disappointment with 1848 bears not on revolution overall but on an ill-conceived one, the essay (and the future course of his thought) suggests, rather, that his

69. Ibid., 142.

70. Baudelaire was not alone in this opinion. The correspondent for the *Illustrated London News* remarked upon the same phenomenon in the column of 6 May 1848: "But the most singular consequence of the Revolution is that it has completely destroyed the talent for caricature for which the French were so remarkable, and in which . . . they were not only unequalled but unapproachable. Some thousands of caricatures have appeared during the last two months, and yet I would defy any man to find a single one possessing point or wit, or of tolerable execution. How the men who in the first years of Louis Philippe's reign literally flayed him, day after day, in the *Charivari* and *Caricature* in a terrible and yet witty manner—how *they* must pity their wretched successors."

sympathy with 1830 bears not on revolution in general but on an authentic one only.

But in what does the difference between the two revolutions, as represented in their images, consist? The answer may be found in the language used to describe them. Baudelaire insists on the explosive, passionate *fureur* of 1830: a war fierce ("acharnée") and furious, full of blood, passion, and fire, with an astonishing ferocity and cohesion ("on y mettait un acharnement et un ensemble merveilleux"), and the utter lack of this in 1848: "Depuis la révolution de février, je n'ai vu qu'une seule caricature dont la férocité me rappelât le temps des grandes fureurs politiques" (551) [Since the February revolution, I have seen only a single caricature whose ferocity reminded me of those days of great political passions]. In 1830, a fantastic epic, a wild tumult ("un tohu-bohu, un capharnaüm), a satanic comedy (549); in 1848 only "choses pâles" (551). The same opposition distinguishes the explosive English pantomime from the "pale" French variety, the violent English Clown from the graceful Deburau, the experience of the show from its description, *absolu* from *significatif*.

Moreover, the ferocity of 1830—aesthetic and political—included a sense of commitment to a cause higher than itself, a subordination of the part to the whole, a sacrifice of the individual to a collective effort: "on y mettait un acharnement et un ensemble merveilleux" (550). It displayed a spirit, solidarity, passion, and conscientiousness ("un sérieux et une conscience remarquables," 551) that countered the normally chaotic and short-lived frenzy of revolution and kept the effort going for years. The revolution of 1830 thus demonstrated the qualities of an enduring work of art. The ferocity of 1848, in contrast, lacked a guiding belief, a doctrine, and substituted for it only the empty clichés of revolutionary enthusiasts.[71]

This parallel between the political and the aesthetic, and the critique of republicanism which it expresses, is established well before the disappointment of 1848, in the *Salon de 1846*. The famous "crosser un républicain" episode in chapter 17 (forerunner to "Assommons les pauvres"), perversely celebrating the brutal subjection of a republican insurgent by a *gardien du sommeil public*, a Jupiterian deliverer of justice, provides a sardonic allegory

71. Cf. Baudelaire's comments on Montjau in his 1849 letter to Ancelle: "Vous savez que ce jeune homme passe pour avoir un talent merveilleux. C'est un aigle démocratique. Il m'a fait pitié! Il faisait l'enthousiaste et le révolutionnaire" (*Corr.* I, 157) [You know that this young man is thought to be a marvelous talent. He is a shining star of the democrats. I felt sorry for him! He played the enthusiast and the revolutionary].

of the Salon-reviewer's fantasies for the art world.[72] The passage is highly ironic toward *all* parties to the conflict, including the narrator. It points up the brutality of the guard; the sadistic fantasy of the *flâneur*-speaker-*salonnier* with his conventional aesthetic tastes—"roses," "parfums," "Watteau," "Raphaël," "Vénus," "Apollon"—and his violent, exaggerated prejudices; and the utter failure of the republican to offer any effective resistance, any alternative program.[73] Baudelaire uses the most outrageous, unspeakable secret wishes of a class, and allies himself ironically ("Have you ever . . . felt the same joy that I have?") with a group he despises—the keepers of public order—to bring out the negative side of republicanism, the egoistic glorification of the self at the expense of the whole.

This is precisely the source of his admiration for the images of 1830, and the reason he turns against the insurgency in 1848. The *Salon de 1846* passage suggests that the republican has in fact played into the hands of the enemy, fulfilled not his historical role, but only his stereotypical one: "Il ne veut plus travailler . . . aux roses et aux parfums publics; il veut être libre, l'ignorant, et il est incapable de fonder un atelier de fleurs et de parfumeries nouvelles" (490) [He no longer wants to work on roses and perfumes for the public; he wants to be free, the ignoramus, and he is incapable of founding a workshop for new flowers and perfumes]. The republican, in politics and in art, has taken the egoistic route of the bourgeoisie and betrayed the collectivity upon which effective social and aesthetic order depends. No longer united by common principles under the guidance of a chief or artistic master, emancipated workers, rather, struggle against one another for power; the leader is divorced from them and his ideas weakened, perverted, and rendered wholly ineffective for the distance. The *Salon de 1846* deplores the era of "emancipated workers" (491), the "republicans of

72. Dolf Oehler (*Pariser Bilder*, 120f.) reads the section ironically, but wrongly sees this as inverting the meaning. The speaker may represent the bourgeois public ironically, but he does not side with the *ouvrier émancipé*. The aesthetic points that the anecdote is used to support are at the center of the *Salon* itself and of Baudelaire's thought in general: *naïveté*, genius, aesthetic hierarchy, order and choice, unity of conception, originality, Delacroix and Ingres, as opposed to imitation, *poncif*, convention, cacophony, aesthetic anarchy, *tohu-bohu*, exhausting freedom, mediocrity. See the critique of Oehler by H. Stenzel (*Der historische Ort Baudelaires*, 114f.), who sees in Baudelaire's mockery of the republicans a rejection of egalitarian socialist theories; G. Van Slyke ("Dans l'intertexte de Baudelaire et de Proudhon," 75), who concentrates on Baudelaire's reservations, both in 1848 and afterward, about the effectiveness of the insurrection in resolving sociopolitical conflict; and Drost, "Baudelaire between Marx, Sade and Satan," 43ff.

73. Drost finds a similarly all-encompassing irony in "Assommons les pauvres!" ("Baudelaire between Marx, Sade and Satan," 44f.).

art" who produce a chaotic mass of triviality, mediocrity, convention, and *poncif*, who represent clichés as empty and potentially pernicious as those spoken by the narrator, and who are devoted to "une liberté épuisante et stérile, . . . anarchique qui glorifie l'individu, quelque faible qu'il soit, au détriment des associations, c'est-à-dire des écoles" (492) [an exhausting and sterile freedom . . . an anarchic freedom that glorifies the individual, however weak, to the detriment of groups, i.e. schools], themselves devoted to a unified vision.[74]

The 1846 passage is a stinging indictment, on the metaphorical level, of the republican effort, a diagnosis of its inefficacy, and an uncannily accurate prediction of 1848. For Baudelaire true revolution—pictorial or political—can only take place through association, solidarity, collectivity, organizations, in which everyone has a role under a guiding principle: a unity or harmony that depends upon variety, a kind of workers' association.[75] Here he sees only "division," "splintering," "disorder," a division unredeemed by comic *dédoublement*, the willing submission of self to a larger cause beyond the self. The allusion to *Notre-Dame de Paris* ends this section of the *Salon* with a coup of stunning irony: "et, comme il a été démontré dans un chapitre fameux d'un roman romantique, que le livre a tué le monument, on peut dire que pour le présent c'est le peintre qui a tué la peinture" (492) [and just as it has been shown in a famous chapter of a Romantic novel that the book has killed the monument, so we can say that for the time being it is the painter who has killed painting]. *Ceci tuera cela*: Hugo's famous chapter carries the ferocious revolutionary message of the novel, fulfilled at every stage in it, and by the novel itself—the written chronicle both replacing and preserving the chronicle in stone that is the cathedral. Here, however, the comparison is grotesque, inverted, parodic, and used to precisely the opposite effect. If "it is the painter who has killed painting," then the unstated equivalent, which the metaphor sustained throughout the *Salon*'s chapter forces every reader to add, expresses the miserable failure of the revolution because of the republicans: "it is the republican who has killed the revolution." Later examples support and extend the view of the *Salon*

74. Kelley too notes Baudelaire's emphasis on aesthetic hierarchy and order even during his early stage of belief in the social value of art (*Salon de 1846*, 13ff.). I. Bugliani sees the passage as Baudelaire's indictment of Proudhon and acceptance of Fourierist doctrine ("Baudelaire tra Fourier e Proudhon," 593); but see Stenzel's refutation (*Der historische Ort Baudelaires*, 112f.).

75. For Bugliani this is a medieval conception ("Baudelaire tra Fourier e Proudhon," 643). Cf. Stenzel (*Der historische Ort Baudelaires*, 114f.) on its relation to a Fourierist utopia.

de 1846, such as the undifferentiated "riot" of details that destroys aesthetic
harmony and intelligibility, and privileges triviality in *Le Peintre de la vie
moderne* (698f.). The tragedy of the 1848 revolution is that it confirmed for
Baudelaire the caricature of the materialist, egoistic republican incapable, in
the 1846 passage, of producing a splendid art; 1830 had submitted its
passion to a higher ideal, a unified vision, and produced from its chaotic
exuberance, its "tohu-bohu," a collective political and imaginative struggle,
a veritable "epic" (549).

Baudelaire never regained any significant republican enthusiasm after
1848;[76] the break between republicanism and the goals of revolution was
definitive. This in no way discredits his *engagement* on the barricades,
however; he opposed equally fiercely the bourgeois forces of order, which
he distrusted in his early years and later despised. But far from maintaining
a commitment to the people,[77] he comes to equate republican egalitarianism
with bourgeois democracy, and the people with the middle class. As Van
Slyke remarks, he associates republicanism with naive social utopianism
and a materialism that locates progress in technological, rather than moral,
achievement, thus banishing the very concept on which proper social pro-
gress, the raising of mankind above its lower instincts, would depend—a
higher ideal, a guiding force, God.[78] The worker becomes no less a materi-
alist than the bourgeois; universal suffrage did not carry through the ideas
of the revolution, but rather sanctioned its defeat.[79]

In artistic terms, too, the *école bourgeoise* and the *école socialiste* commit
the same error, as he makes clear in *Les Drames et les romans honnêtes*:
they make art simply a vehicle of propaganda (41). Even his most overtly

76. Cf. Pichois and Ziegler, *Baudelaire*, 285; and W. Drost, "Baudelaire between Marx,
Sade and Satan," 51. The evidence of the letters offered by Clark is weak: the "old fund of
revolutionary spirit" mentioned in the letter to Sainte-Beuve (*Corr.* II, 220) is placed in the
ambiguous context of a question and applied to the reform of the Academy; the curiosity and
passion for politics mentioned in the letter to Nadar (*Corr.* I, 578f.) come across as remarkably
dispassionate, the detached, philosophical observer predicting the course of events with the
certainty of one who has seen it all before.

77. Pace Clark, *The Absolute Bourgeois*, 165, 177.

78. "Dans l'intertexte de Baudelaire et de Proudhon," 73. Cf. *Mon Coeur mis à nu* V (I,
679), where Baudelaire attributes the frenzy of 1848 to a "plaisir *naturel* de la démolition";
and links the people and to the bourgeoisie by their "amour naturel du crime."

79. Van Slyke cites, in support of this view, the overwhelming ratification given the coup
d'état by the people ("Dans l'intertexte de Baudelaire et de Proudhon," 71). Note the mocking
reference to universal suffrage, responsible for the glorious reputation of Charlet earlier: "il est
bien douloureux d'avoir maille à partir avec le suffrage universel" (546) [it is truly painful to
have a bone to pick with universal suffrage].

"republican" work—the 1851 preface to Pierre Dupont's *Chants et chansons*—maintains the distinction between "true" republicanism and "false." Baudelaire praises Dupont not for singing about the people, but for his love of virtue, humanity, and the republic, and implies that his songs remained pure almost in spite of the uprising: "La Révolution de Février activa cette floraison impatiente et augmenta les vibrations de la corde populaire; tous les malheurs et toutes les espérances de la Révolution firent écho dans la poésie de Pierre Dupont. Cependant la muse pastorale ne perdit pas ses droits, et à mesure qu'on avance dans son oeuvre, on voit toujours, on entend toujours . . . bruire doucement et reluire la fraîche source primitive qui filtre des hautes neiges" (31f.) [The February revolution accelerated this impatient flowering and increased the vibrations of the popular string; all the misfortunes and all the hopes of the revolution echoed in the poetry of Pierre Dupont. However, the pastoral muse did not lose its claim on him, and as one proceeds through his work one always sees, one always hears the gentle plashing of the original clear spring that trickles down from snows on high]. He makes the same qualification in his 1861 article on Dupont: "Par grand bonheur, l'activité révolutionnaire, qui emportait à cette époque presque tous les esprits, n'avait pas absolument détourné le sien de sa voix *naturelle*" (173) [Fortunately his revolutionary activity, which at that time carried away almost everyone, had not completely turned his away from its natural voice].

The *fureur* at the source of Baudelaire's admiration for 1830 and its images returns us to the comic ideal of *De l'essence du rire:* the violence of the *comique absolu* illustrated by the English pantomime. Although French caricature, including Daumier's, is primarily *significatif*, those products of the opposition years approach the *absolu*. *Fureur* and its cognates occur four times (550ff.), and with *feu* (549), *férocité* (551), and *fièvre* (549) recall the *emportement* and hyperbole of the pantomime and the *fureur* of the Italian carnival (570). Baudelaire repeatedly refers to the caricatures as "bouffonneries" (549f.), thus recalling the primary quality of the Italian *comique innocent* (571). *Grotesque* and *fantastique*, both features of the *absolu*, figure here too, in "fantastique épopée" and the "costumes grotesques" of the political personalities (549). The "comédie satanique" exposes the vices and absurdities of the government, or in the terms of *De l'essence du rire*, its own moral ugliness. This is caricature at its best: the *significatif* necessary to an overt political message made to function, in its outrageousness, spiritedness, and courage, like the *absolu*, the historical given the status of legend, a true *épopée*. Baudelaire seems to admire

revolution most when it thus becomes myth, or art: hence the heroism of the *dead* insurgent in the caricature from 1848. This is a politics marked more by romanticism than pragmatism.[80]

Daumier reenters the essay only now as a central player in the "permanent skirmishing" (552) of the period. Baudelaire places him in the *comique significatif* because of his love of nature and the real (557), but also insists on the coherence and integrity of his art, where the comic is inseparable from the rest, "involuntary, so to speak" (556), and the idea arises directly, naturally, and immediately from the art itself—all qualities of the *absolu*.[81] Further, Baudelaire proclaims the captions unnecessary, and in this way emphasizes the self-sufficiency of Daumier's works, like the studies of Boudin in the *Salon de 1859*, in which, with the caption hidden, one can still guess the season, the time, the strength and direction of the wind (666); and likewise the music of Wagner, which is intelligible even for those who do not know the libretto (*Richard Wagner et Tannhäuser à Paris*, 797). "L'idée se dégage d'emblée" (556) [the idea emerges directly]: this recalls his remarks on the painting of Delacroix, which projects its idea at a distance, producing an impression even at a distance too great for the subject to be understood.[82] The picture alone communicates its meaning without the intermediary of another language.[83] The normally conspicuous duality of the *significatif* is here tempered by the perfect harmony between idea and expression: Daumier's *significatif* borders on the *absolu*.

Daumier indeed has the oxymoronic quality later associated with Goya, the paradox of the *comique absolu*: Baudelaire calls attention to the seriousness of his humor, and also the fantastic nature of the reality that he presents. If the famous *Rue Transnonain* of 1834 (Fig. 19) represents the

80. *Pace* T. J. Clark, *The Absolute Bourgeois*, 165.

81. The "so to speak" is important: "involontaire" indicates only an apparent lack of will. Cf. the *Salon de 1846*: the poetic effect must not be sought after in a painting, but must derive from the painting itself, as though unknown to the artist (474).

82. *Exposition universelle de 1855*, 595.

83. Daumier himself is quoted as having believed in the all-importance of the image: "La légende est bien inutile. Si mon dessin ne vous dit rien, c'est qu'il est mauvais; la légende ne le rendra pas meilleur" [The caption is completely useless. If my drawing says nothing to you, it is because it is bad; the caption will not make it better] (Searle and Bornemann, *La Caricature: Art et manifeste du XVIè siècle à nos jours*, 154). But cf. W. Hofmann on Daumier's formal ambiguities and the importance of the title and subtitle in interpreting the image ("Ambiguity in Daumier," 363); on the importance of the captions, see Terdiman, *Discourse/Counter-Discourse*, 180ff., and K. Herding, "Die Kritik der Moderne im Gewand der Antike: Daumiers *Histoire ancienne*," 129. (For a French translation of this article, see *Gazette des Beaux-Arts*, ser. 6, 113 [January 1989], 29–44.)

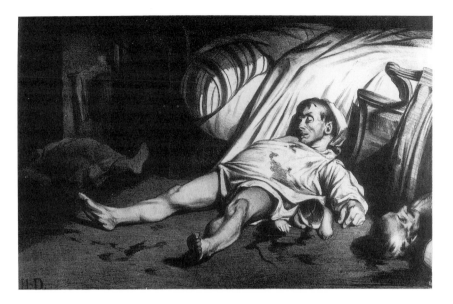

Fɪɢ. 19. Daumier. *Rue Transnonain*, 1834 (photo: British Museum)

awesome horror of a reality at once "triviale et terrible" (552), Baudelaire's description brings out the relation between the two, the terrible and the trivial, the fantastic and the real: the grotesque image of the murdered worker exposed in his semi-nudity to the gaze of all and lying obscenely on the floor with his legs and arms spread out, in a pose that A. Stoll has likened to the dead Christ in Rubens's *Lamentation of Christ*;[84] the irony of the death that, by his own, he causes—his body crushes that of his small child; the cheap, "banal," furnishings in contrast to the brutality and violence to which they bore witness; the atmosphere of poverty, misery, coldness, silence, and death. Far from removing the image from the realities of social struggle, the aestheticization represented by the *comique absolu* here ensures its historical significance.[85] The image represents caricature at its best in the Baudelairean scheme, the trivial raised to the level of "high

84. "Die Barbarei der Moderne. Zur ästhetischen Figuration des Grauens durch Goya und Daumier," in *Die Ruckkehr der Barbaren: Europäer und "Wilde" in der Karikaturen Honoré Daumiers*, 43.
85. Terdiman argues that aestheticization is an ideological move to neutralize Daumier's satire and distance his work from the radical social and political messages it conveys (*Discourse/Counter-Discourse*, 180f.). The reverse is true for Baudelaire, however: the force of *Rue Transnonain* comes from the fact that it surpasses caricature in the ordinary sense.

art," the point where caricature touches on history, and on history painting: "ce n'est pas précisément de la caricature, c'est de l'histoire" (552).

And history need not involve the representation of a political event: the evolution of caricature from political to social is not a degradation, for non-political caricature may carry a powerful political message. *Le Choléra-Morbus*, from *La Némésis médicale,*[86] on the cholera epidemic, shows a deserted, desolate public square burning in the heat and glare of a relentless sun in an ironically splendid sky (554) (Fig. 20).[87] Baudelaire insists on the

Fig. 20. Daumier. *Le Choléra-Morbus. Némésis médicale,* 1840 (photo: Duke University Library)

86. A book in two volumes by Antoine Fabre written as a satire against the Faculté de Médecine, for which Daumier did twenty-nine engravings (1840).

87. A. Fairlie ("Aspects of Expression in Baudelaire's Art Criticism," 196) likens this to the ironical sky of *Une Charogne* and *Le Cygne.*

unbearable brilliance more than any other aspect of the picture. Indeed a vast expanse of bright white occupies the whole middle ground, broken only by images of misery and death: the skinny dog roaming aimlessly, his tail between his legs, drooling and sniffing the parched pavement; a stretcher being carried off; in the background, a hearse pulled by nags in precisely the same pose as the dog, and parallel to it; and a large corpse lying on the cobblestones in the center foreground. Baudelaire implies the irony, even the complicity, of the harsh sunshine by juxtaposing its "ardeur" with the ominous, stark, black shadows it causes the figures to throw; a woman passerby shields her nose and mouth from the stench of putrefaction; the nags pulling the hearse are black blots, deathly shadows of the dog.

Through Baudelaire's political metaphors, this "social" caricature contains the revolutionary vision of *Rue Transnonain*: the ironical sky is that of "les grands fléaux et les grands remue-ménage politiques" [great scourges and political upheavals], the deserted square is "plus désolée qu'une place populeuse dont l'émeute a fait une solitude" (554) [more desolate than a populous square that a riot has swept clean], and one has the same impression of silence, harshness, and death. The corpse slumped on the cobbles—a young man in shirt-sleeves and vest, a man of the people—could as easily be a dead insurgent, a victim from the barricades. It comes closer to Baudelaire's description of the image from 1848 than any other of the period.[88]

In *Le Dernier Bain* (1840), too, social caricature is linked to the representation of history, but a history now defined as modernity. The image depicts a suicide's desperate plunge into the river, as a placid bourgeois fishes in peaceful unawareness on the opposite bank (Fig. 21). The one gives himself over ("se livre") only to the innocent pleasures of fishing, the other to the hands of death, less terrible only than the misery of his life. Baudelaire calls attention to the decisiveness of the figure—arms folded over his chest, an enormous paving stone hanging by a cord round his neck—and brings the point home with characteristic sarcasm: "Ce n'est pas un suicide de poète qui veut être repêché et faire parler de lui" (553) [This is no poet's suicide who might want to be fished out and get himself talked about.]. Even before his jump, he has lost his look of living, breathing humanity: he

88. Baudelaire's example of the political force of social caricature is apt: cholera and revolution had been linked since the 1832 epidemic, which coincided with the uprising against the government at General Lamarque's funeral. In 1840, the insurgency of 1839 was still recent.

FIG. 21. Daumier. *Le Dernier Bain,* 1840 (photo:
British Museum)

is compared to a statue about to topple from its pedestal. But the joke is
ironic, for indeed there will be no monument to his existence after the
plunge, nothing to ensure that he will be (like the vain poet) remembered
and "talked about." This desolate figure, in his pitiful frock coat with its
"grimacing" folds, and his sickly tie twisted like a snake ("tortillée comme
un serpent"), wears the same black suit, and is described in the same
language, as the modern hero at the end of the *Salon de 1846*: his thin black
shoulders, and "these grimacing folds, which play like serpents around
mortified flesh" ("ces plis *grimaçants*, et jouant comme des *serpents* autour
d'une chair mortifiée," 494, my emphasis). Suicide is likewise a "modern"

passion and subject in the same section of the *Salon*, part of the heroism of modern life. The modern hero is a caricatural figure by Daumier.[89]

This is a history marked specifically by victimization (which will pass to the women in the essay on Guys). The bourgeois's indifference in *Le Dernier Bain* becomes a conspiracy with death itself, in the 1840 *A la santé des pratiques: association en commandite pour l'exploitation de l'humanité* (Fig. 22), as the stereotypically bourgeois *association en commandite*—the joint stock company, a Macaire, July Monarchy specialty—here takes on a blacker hue; the relentless sun of *Le Choléra-Morbus* becomes the oppressive, leaden sun here, and the same hearse reappears in the background. On the outskirts of the city, at the café of the "Bons Vivants," a man dressed in black (Baudelaire says an undertaker or a doctor) and a skeleton toast their new agreement: the former has proposed a quack remedy, a scheme of "quick and radical cure—infallible method!" on which to make a million. This is a business venture of the most sinister kind, a joint stock company for these "bons vivants" making profit from the death of others. The hearse in the background suggests both the source of their plan—the misery and desperation of the ill—and its success, as though representing the first unfortunate victim of their "cure."

Les Philanthropes du jour (1844) pictures a similar pact between the middle class and death, this time a result not of its profit motive, but of its pretended enlightenment. In a prison yard, a silly, gullible do-gooder in suit and top hat exclaims to two repugnant and brutish convicts—"Ainsi donc mon ami, à vingt-deux ans vous aviez déjà tué trois hommes. . . . [Q]uelle puissante organisation!" [So, my friend, at twenty-two you had already killed three men . . . what a powerful constitution!] (Fig. 23). The image targets the naiveté of social formulas: the ludicrous philanthropist blames society for the criminals' outrages because it did not direct their "puissante organisation" properly.[90] Baudelaire broadens—and to some extent softens—the satire to mock, rather, the specious absurdities that the philanthropist's sophisticated academic theories can produce (he is "très docte," a "savant"), and that lead him to admire the "powerful constitution," however perverted, that committed such abominable crimes. He transforms the image

89. On Daumier's Robert Macaire as a modern "antihero," see McLees, *Baudelaire's "Argot Plastique,"* 39f.

90. Drost relates this mockery of social utopian schemes to that of "Assommons les pauvres!" ("Baudelaire between Marx, Sade and Satan," 39f.).

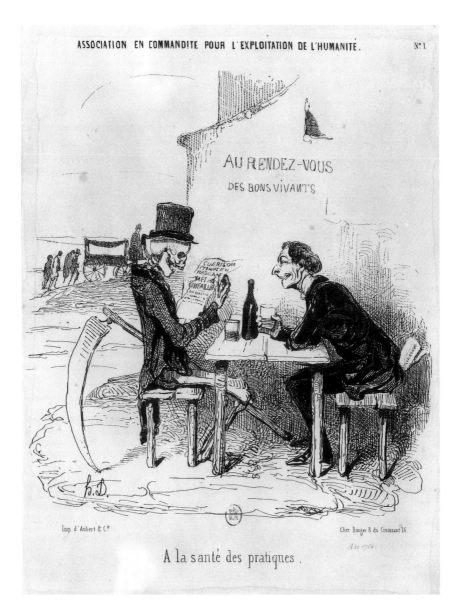

FIG. 22. Daumier. *A la santé des pratiques: association en commandite pour l'exploitation de l'humanité,* 1840 (photo: Bibliothèque Nationale)

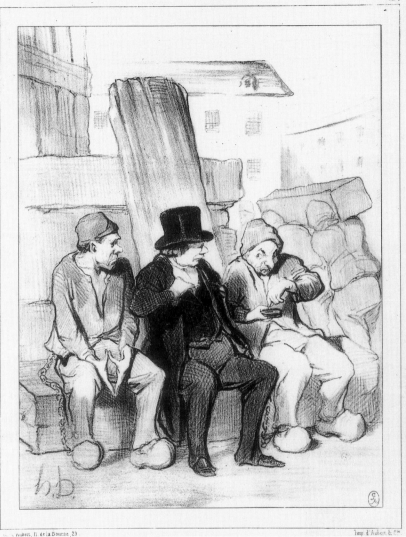

FIG. 23. Daumier.—*Ainsi donc, mon ami, à vingt deux ans vous aviez déjà tué trois hommes . . . quelle puissante organisation, et combien la société est coupable de ne l'avoir mieux dirigée! . . .—Ah! voui, monsieur! . . . la gendarmerie a eu bien des torts à mon égard . . . sans elle je ne serais pas ici!* [So, my friend, at twenty-three you had already killed three men. What a powerful constitution you have, and how guilty society is for not directing it properly!—Oh yes sir! The police behaved really badly toward me! Without them I wouldn't be here!] *Les Philanthropes du jour,* 1844 (photo: British Museum)

into a comment on bourgeois self-delusion, the self-ignorance that marks the object of laughter.

If caricature stands in opposition to the neoclassical ideal, Daumier's presents this overtly and makes it an issue in contemporary aesthetics. Baudelaire presents *Histoire ancienne*, Daumier's travesties of legendary themes, as a critique of *la fausse antiquité* and the persistence of classical clichés in contemporary art, "the best paraphrase of the famous line: *Who will deliver us from the Greeks and the Romans?*" (Fig. 24). Presenting the heroes of antiquity parodically, with a farcical ugliness, ridicules the "école néo-grecque," which Baudelaire himself attacks in *L'Ecole païenne* (46f.), the *Salon de 1859* (637), and the 1861 *Pierre Dupont* (169). The artists of this school (Gérôme being the finest example) do the very opposite: they try to elevate banal modern life by dressing it *à l'antique*, and thus produce inverse caricature (639), or worse still, pastiche (47). Baudelaire's ridicule has the political implications that Herding has argued of Daumier's series itself, satirizing the state's appropriation of classical antiquity as a means to establish its own glory, dressing modern life *à l'antique*.[91] Baudelaire implies that the result is precisely the opposite of the establishment's intent; it produces a caricature of its own, inverted, ludicrous, a pastiche, lacking the dualistic self-awareness of the comic.

Baudelaire also discusses Daumier's depiction of the modern city and its main citizen, the bourgeois:

> Feuilletez son oeuvre, et vous verrez défiler devant vos yeux, dans sa réalité fantastique et saisissante, tout ce qu'une grande ville contient de vivantes monstruosités. Tout ce qu'elle renferme de trésors effrayants, grotesques, sinistres et bouffons, Daumier le connaît. Le cadavre vivant et affamé, le cadavre gras et repu, les misères ridicules du ménage, toutes les sottises, tous les orgueils, tous les enthousiasmes, tous les désespoirs du bourgeois, rien n'y manque. Nul comme celui-là n'a connu et aimé (à la manière des artistes) le bourgeois, ce dernier vestige du Moyen Age, cette ruine gothique qui a la vie si dure, ce type à la fois si banal et si excentrique. Daumier a vécu intimement avec lui, il l'a épié le jour et la nuit, il a appris les mystères de son alcôve, il s'est lié avec sa femme et ses enfants, il sait la forme de son nez et la construction de sa tête, il sait quel esprit fait vivre la maison du haut en bas. (554f.)

91. See Herding, "Die Kritik der Moderne im Gewand der Antike: Daumiers *Histoire ancienne*."

FIG. 24. Daumier. *Le Beau Narcisse. Histoire ancienne*, 1841 (photo: Bibliothèque Nationale)

[Look through his work, and you will see parade before your eyes, in their fantastic and gripping reality, all that a great city contains of living monstrosities. All the frightening, grotesque, sinister, and farcical treasures that it holds, Daumier knows them all. The living, starved corpse, the fat, well-fed corpse, the ridiculous troubles of married life, every stupidity, every example of pride, every enthusiasm, every source of despair in the bourgeois' life, nothing is missing. No one better than he has known and loved (in the manner of artists) the bourgeois, that last vestige of the Middle Ages, that Gothic ruin that dies hard, that type at once banal and eccentric. Daumier has lived intimately with him, he has spied on him day and night, he has learned the secrets of his bedroom, he has become acquainted with his wife and children, he knows the shape of his nose and the structure of his head, he knows the spirit that animates his household from top to bottom.]

Baudelaire's comical treatment of the bourgeois translates Daumier's own, with the same good humor that he interprets in the pictures. As we shall see, this passage on Daumier's urban vision is important, for it again bears a close resemblance to the famous final chapter of the *Salon de 1846* on the heroism of modern life, and points ahead to the urban aesthetic formulated apropos of Guys in *Le Peintre de la vie moderne*. The "cadavres" here recall the *Salon*'s treatment of the modern public as "an immense cortège of undertakers" (494); the monstrosities of the big city portrayed by Daumier resemble the "thousands of floating existences that haunt the underworld of a great city"; the *merveilleux* there associated with the poetry of modern life returns in the "fantastic and gripping reality" of Daumier's Paris; the primacy of Balzac's *Comédie humaine* over the *Iliad* on which the *Salon* closes parallels the movement of caricature here away from historical epic toward the novel. More generally, Baudelaire's language—"effrayants, grotesques, sinistres et bouffons"—once again moves Daumier toward the *comique absolu*, the harmony of real and surreal, the oxymoronic "réalité fantastique" of the city and the eccentric banality of the bourgeois. His art becomes the counterpart, on the side of the real, to that of Hoffmann and Goya in the fantastic, the former a perfect blend of *significatif* and *absolu*, the latter at once transcendent and natural (570).

The comic art of Daumier thus exemplifies modern history painting and represents the modern hero. In matters of technique, too, this caricature rejoins "high art": Daumier ranks with Delacroix and in some areas even

surpasses him.[92] First, he has an extraordinary draftsmanship, sure, confident, and bold, like that of the great masters: "Il dessine comme les grands maîtres" (556). The heroic printer depicted in the splendid 1834 *Liberté de la Presse* (Fig. 25) is constructed "comme les figures des grands maîtres" (553). His figures are always true of movement (556), a quality of the superior artist in the *Salon de 1846*: "La grande qualité du dessin des artistes suprêmes est la vérité du mouvement" (435). His work gives the impression of improvisation ("lâché," "légèreté," 553), but an "improvisation *suivie*" (556), having a method, finished (553), like the "perfect sketch" of Guys later on (700). It combines the suppleness of an artist's line with the exactitude of a physiognomical drawing by Lavater. It puts solidity and *certitude* in the service of an art by definition light and fleeting, "pitted against the very mobility of life" (556); the central figure of *Liberté de la*

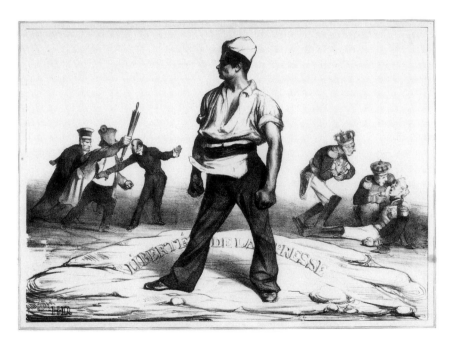

FIG. 25. Daumier. *Liberté de la presse. Ne vous y frottez pas!* 1834 (photo: British Museum)

92. In the *Salon de 1845*, Baudelaire allows that Daumier draws better than Delacroix (356).

148 Baudelaire and Caricature

Presse is squarely and firmly planted on his large feet (553). Daumier's satirical caricatures of political personalities, the *portraits-charges*, have animalized faces expressing the character trait being ridiculed, but preserve a likeness sufficient to ensure recognition, as in the grotesque, ape-like features of Dupin aîné, the redoubtable president of the Chamber of Deputies (Fig. 26): a blend of exaggeration and verisimilitude, which, as we have seen, Baudelaire counsels for portraiture in general. Daumier understands the law of portraiture, that a human figure is harmonious within itself; in Lavater's terms, "tel nez, tel front, tel oeil, tel pied, telle main" (556) [the right nose, the right brow, the right eye, the right foot, the right hand].[93]

A second, related feature of Daumier's technical superiority is his talent for observation and his memory, which together allow him to produce a work that is credible, recognizable, intelligible, and at the same time a personal interpretation of the subject. His "mémoire merveilleuse et quasi divine" (556) ensures the "mnémotechnie du beau" (455) that defines true art in the *Salon de 1846*, the "art mnémonique" of *Le Peintre de la vie moderne*; and his "talent d'observation . . . sûr" (556) allows him to grasp the character of the subject, like the best draftsmen in the same 1846 passage (456). His superb memory is compared with Delacroix's in the *Salon de 1846* (468), and later with that of Constantin Guys (698), before whom the live model confounds, rather than assists, the creative process. Daumier's talent for observation leads him to the extraordinarily intimate knowledge of his subject described in the section on the bourgeois, much like the intimate knowledge of his subject (432) that marks the art of Delacroix.

Third, Daumier's black-and-white drawings present the effect of color naturally, just as they communicate ideas (557). This places him among the masters ("C'est le signe d'un art supérieur"); relates him to the foremost colorist of the time, Delacroix; and directly recalls the hypothetical modern painter at the end of the *Salon de 1846*: "Les grands coloristes savent faire de la couleur avec un habit noir, une cravate blanche et un fond gris" (495) [Great colorists can create color with a black frock coat, a white cravat, and a gray background.]. Daumier thus meets one of the great challenges of modern art itself.

In all, Daumier provides a perfect model for Baudelaire's comic artist, turning a trivial, ludicrous, popular form into an "art sérieux," making

93. Baudelaire cites the same passage of Lavater's in the context of portraiture in the *Salon de 1846* (456).

FIG. 26. Daumier. *Dupin aîné*, 1832 (photo: Bibliothèque Nationale)

caricature a high art. "C'est un *grand* caricaturiste" (556): he underlines
the adjective as though to signal the oxymoron and the suggestion of *grand
art* which it contains. Daumier's art fulfills the purposes of caricature as set
out in *De l'essence du rire* and contains, in addition, the rancorless humor
of the pantomime: in his "Vers pour un portrait de M. Honoré Daumier"
(1865), Baudelaire cites the kindness and good humor that inform even the
most critical pieces, not a Melmothian grimace, but a "broad, honest
laughter." These caricatures are marked by "honnêteté" and "bonhomie";
he refuses to treat subjects that he judges too indelicate, however rich in
satirical possibilities (556f.). They depict evil and its consequences, teach us
to laugh at these and at ourselves, and thus inspire the same *dédoublement*
which the comic artist effects in creating them.[94]

 Baudelaire's article was by far the most significant to be published on
Daumier for many years. Champfleury devoted nearly two-thirds of his
Histoire de la caricature moderne to him, but this is historical and descrip-
tive, lacking the analysis and breadth of Baudelaire's essay. Moreover, he
relies heavily on Baudelaire's observations, as numerous parallels of lan-
guage and theme, as well as direct quotations, attest.[95] In 1839, Thackeray
devoted most of his article on French caricature to the figure of Robert
Macaire, the unscrupulous opportunism that he represents, and the com-
mentary that his satire makes on French society. But Thackeray does not
neglect the artistry, ingenuity, and variety of the works, "the admirable way

 94. Daumier is also the model of *caricature artistique* which, as *De l'essence du rire* states,
interests above all the artist (526): "artists alone have understood how much seriousness there
is in it" (549).
 95. Cf. Champfleury, "une guerre acharnée de la démocratie contre la royauté" (4) [a
furious war of democracy against the monarchy], and Baudelaire, "cette guerre acharnée contre
le gouvernement, et particulièrement contre le roi" (549) [this furious war against the
government, and especially against the king]; Champfleury, "Dans cette Revue curieuse de *la
Caricature*, les premières années du règne de Louis-Philippe sont tracées minute par minute"
(26) [In this curious paper, *La Caricature*, the early years of Louis-Philippe's reign are traced
minute by minute], and Baudelaire, "tous ces épisodes des premiers temps du gouvernement
de 1830 reparaissent à chaque instant" (550) [all the episodes of the early reign of the 1830
government reappear at each moment]. Even Champfleury's definition of caricature recalls
Baudelaire's: "L'homme s'irrite de trouver sans cesse sa figure réfléchie par un miroir où
n'apparaîssent que ses difformités morales" (xii) [Man becomes irritated seeing his face
incessantly reflected in a mirror in which only his moral deformity appears]; cf. Baudelaire's
"représenter à l'homme sa propre laideur morale et physique" (526). Champfleury quotes
Baudelaire frequently in this work (198, 227f.), and later in his *Histoire de la caricature sous
la République, la Restauration et l'Empire*. As Stamm notes (*Gavarni and the Critics*, 66),
Champfleury follows Baudelaire on the independence of Daumier's art from the caption, the
description of the *Rue Transnonain*, the accuracy of his rendering of anatomy, and the
impression of color in a black-and-white lithograph.

in which each fresh character is conceived, the grotesque appropriateness of Robert's every successive attitude and gesticulation, and the variety of Bertrand's postures of invariable repose, the exquisite fitness of all the other characters." Like Baudelaire, he remarks upon the perfect, natural conception behind so apparently careless a *dessin*: "The figures are very carelessly drawn; but, if the reader can understand us, *all the attitudes and limbs are perfectly conceived*, and wonderfully natural and various."[96] Daumier's conception of the subject and his ability to create an effect adequate to convey it make him superior to the man who was to Thackeray what Daumier was to Baudelaire, Cruikshank: "George Cruikshank . . . does not know the art of 'effect' so well as Monsieur Daumier . . . who, though he executes very carelessly, knows very well what he would express, indicates perfectly the attitude and identity of his figure, and is quite aware, beforehand, of the effect which he intends to produce."[97]

But Baudelaire's insistence on the grotesque, monstrous, and sinister has no equivalent until perhaps the 1890 essay of Henry James, which describes Daumier's grotesqueness, the "abnormal blackness" of the images, and the "strange, ugly, extravagant . . . vigour," bordering on brutality, with which he caricatured public life.[98] Only an article in *La Tribune des peuples* (17 September 1849) came close to defining the energy, vigor, strength, intelligence, and grandeur that Baudelaire interprets and so forcefully conveys: "Et qu'on ne lui demande pas la grâce du contour, l'aménité de la ligne, la rondeur de la forme à ce crayon âpre comme un scalpel, brutal comme un coup de poing; la précision de la pose, l'énergie concise du geste, le *heurt* du trait, la haine du détail, l'intelligence de l'intention, voilà ce qui caractérise cet historiographe implacable qui lance aux vents de l'Europe la portraiture du bourgeois croqué tout vif sur les feuilles estampillées de cette griffe léonine *H.D.*" [Don't ask for graceful contours, smooth lines, or roundness of form from this pencil sharp as a scalpel, brutal as a fisticuff; precision of pose, concise energy of gesture, abrupt and bold strokes, hatred of detail, an intelligence of intention, this is what characterizes this implacable historiographer, who hurls to the four winds of Europe the portrait of the bourgeois sketched from life, on pages stamped with this leonine signature *H.D.*].

96. "Caricatures and Lithography in Paris" (*The Works of Thackeray* xvii, 246).
97. Ibid., 246.
98. "Daumier, Caricaturist," in *The Painter's Eye. Notes and Essays on the Pictorial Arts*, 235, 232.

Monnier, Grandville, and Gavarni

Monnier

"He is just the opposite of the man of whom we have just spoken" (557):
Monnier is thus the antithesis not only of Daumier but of comic art in
general. With these words, Baudelaire condemns him to as unenviably low
a position on the comic ladder as the other, unacknowledged counterweight
to Daumier, Charlet. But his treatment of the two differs significantly: if
Charlet was a clever flatterer who willingly conformed to the prejudices of
his public, Monnier is less deceitful, and equally less intelligent, depicting
the bourgeois precisely because therein lies the true nature of his talent ("un
talent essentiellement bourgeois," 557). Baudelaire's contempt is less viru-
lent for so naively mediocre a mind, but he cannot forgo some cutting
sarcasm, making Monnier the butt of countless jokes and turning him into
the kind of fatuous, self-absorbed, and self-satisfied bourgeois he depicted
in his works (Figs. 27 and 28). In one jibe he attributes Monnier's popularity
to his versatility, his triple career as an actor, writer, and caricaturist: "il
remplissait trois fonctions à la fois, comme Jules César" [he filled three
positions at once, like Julius Caesar]. With another he sarcastically imagines
the tedium of Monnier's task, and ridicules his plodding method of studying
the bourgeois as a model for his character, Prudhomme: "Combien de tasses
de café a dû avaler Henri Monnier, combien de parties de dominos, pour
arriver à ce prodigieux résultat, je l'ignore" (557) [How many cups of coffee
Henri Monnier must have swallowed, how many games of dominoes he
must have played to arrive at this prodigious result, I shall never know].[99]
This contrasts markedly with Daumier's intimate relations with his bour-
geois, described in warmly sympathetic terms. Daumier comes to know his
subject by sure and skillful observation, and then creates his character; in
contrast, the author of the 1841 *Physiologie du bourgeois*, showing his
subject about his daily business in relentless detail—at the café, reading the
papers, and playing dominoes—simply watches, studies, and transfers him
onto the paper. Daumier creates many types, characters conceived "en
grand"; Monnier's sole type, "ce type monstrueusement vrai," is not a type

99. Baudelaire notes the "pedantry" of domino players in the *Exposition universelle de
1855* (591). One has only to think of Charles Bovary's "passion" for dominoes, which he plays
with Homais in Flaubert's *Madame Bovary* (part II, chap. 4).

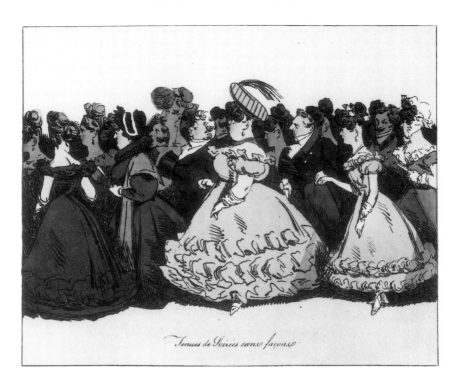

FIG. 27. Monnier. *Tenues de soirées sans façons. Récréations* (photo: British Museum)

at all, but only a copy from life. In the context of Baudelaire's comic vocabulary, this "monstrueusement" is highly ironic: not the monstrous reality of Daumier, but the all too monstrously, abominably true portrait of the bourgeois.

According to this standard, Monnier fails on a number of points. First, like Charlet, he is an artist of *le chic*, but "after nature." The contradiction in terms (*chic* normally implies the absence of a model or nature[100]) expresses the irony: Monnier turns even a living model into a conventional recipe, makes a copy into a cliché. The result is coldness and hardness, "froid" and its cognates appearing here three times.

100. Cf. Baudelaire's definition in the *Salon de 1846* (468).

FIG. 28. Monnier. *Prud-homme* (photo: Biblio-thèque Nationale)

Second, Monnier is an artist of details, a quality that Baudelaire every-where considers inconsistent with great art.[101] He does not grasp the *ensemble* of his subject, as do Daumier (556), Delacroix (433, 596), Guys (698f.), and the master of detail used properly, that is, offset by bold outline to ensure the perspective of the whole—Balzac (120). Although close study of the model is necessary, this should serve the purposes of generalization and exaggeration of those qualities that best express its character. Monnier, however, makes the mistake most antithetical to art: "Après l'avoir étudié, il l'a traduit; je me trompe, il l'a décalqué" (557) [After having studied him,

101. E.g. *Salon de 1846*: "le sublime doit fuir les détails" (457) [the sublime should flee details].

he translated him; no, I am mistaken, he traced him onto the paper]. The correction is significant: translation, as Baudelaire understood it from Delacroix,[102] would have too many associations with imagination and artistic creation to convey his view of Monnier; "décalquer" lacks any sense of creative interpretation or transformation. Baudelaire maintains repeatedly in his criticism that copying does not equal composition or creation.[103] Monnier has a mirror in place of an imagination, but not the mirror of the visionary Balzac, held up to the face of Paris (120), not the "poetic mirror of the English spirit" (609), not even the faithful mirror of life produced by Carle Vernet (544), which translates the character and ideals of those it pictures; rather "a mirror that does not think and contents itself with reflecting the passers-by" (558). He resembles the photographer of the *Salon de 1859*, who permits the public to contemplate, like Narcissus, its trivial image on the metal plate (617). Like photography, Monnier's art nourishes the illusions and fantasies of a class; it promotes the bourgeois ideal of having art reflect our own image of ourselves, rather than the comic ideal of revealing something unrecognized about ourselves. It is not only narcissism but mystification, the bourgeois's apotheosis, his transformation into a hero, his desires presented as universal reality and truth. And the consequences are boredom and ultimately silence: "quand tout Monsieur Prudhomme a été dit, Henri Monnier n'avait plus rien à dire" [when the whole of Monsieur Prudhomme had been said, Henri Monnier had nothing left to say].

Third, for all their detail and precision, Monnier's works leave an impression not of clarity but of vagueness (558); they do not transmit clearly to the observer the artist's vision, as do Daumier's, which do not even need their caption, or, later, Guys's ("sharply," "always clear," 698). Baudelaire utters only one word of praise—for the *Scènes populaires* (1830)—but this, too, with heavy irony: "Plusieurs de ses *Scènes populaires* sont certainement agréables; autrement il faudrait nier le charme cruel et surprenant du daguerréotype" (557f.) [Many of his *Scènes populaires* are certainly pleasing; otherwise one would have to deny the cruel and surprising charm of the daguerreotype]. But as the *Salon de 1859* so brutally maintains, photography is an industry, not an art at all—a bourgeois parody of the real thing;[104] the "charme cruel et surprenant" here is that of reality itself, rather than the artist's vision, reality observed but unread, uninterpreted, and untranslated.

102. Cf. Delacroix, *Journal*, 619f.
103. E.g. *Salon de 1859* (624f., 661), *L'Oeuvre et la vie d'Eugène Delacroix* (747).
104. *Salon de 1859* (616f.).

An anecdote recounted by Champfleury about an exchange between Baudelaire and Monnier at the Hôtel Pimodan reinforces and complements these assertions.[105] Baudelaire allegedly characterized Monnier's works as dictionaries, "sténographies bourgeoises," lacking composition and idealization. Stenography is the scriptorial equivalent of the daguerreotype of *Quelques caricaturistes français*, with the added connotation of a conventional sign. And the metaphor of the dictionary, missing from *Quelques caricaturistes français*, completes the picture. Not only are Monnier's works a mere compilation of bourgeois customs, manners, speech, dress, and prejudices; but they are so precisely because he has copied the dictionary of life rather than follow Delacroix's prescription (quoted repeatedly by Baudelaire) for the dictionary of nature, selecting from its many entries to compose his "poem."[106] Monnier has produced not a poem, not a portrait, but only another dictionary, a meaningless and tiresome list of words. Through the ideology of realism, Champfleury attempts to salvage Monnier's reputation from Baudelaire's devastating critique: this *décalcage*—copying what he sees—is justified by the exactitude of his vision and his ability to reproduce it.[107] But for Baudelaire, precision and verisimilitude will not compensate for the lack of imagination, the faculty by which reality is apprehended and interpreted, "seen," even before it is translated onto the canvas or plate.

Most critics, however, took Monnier's work as a critique of the bourgeoisie. Balzac, for example, compares him to Hogarth and Callot,[108] and insists on his irony: "Monnier, c'est l'ironie, l'ironie anglaise, bien calculée, froide, mais perçante comme l'acier du poignard. . . . Il s'adresse donc à tous les hommes assez forts et assez puissants pour voir plus loin que ne voient les autres, pour mépriser les autres, pour n'être jamais bourgeois" [Monnier is irony, English irony, calculating, cold, but piercing like the blade of a

105. *La Vie parisienne*, 10 September 1864; reprinted with slight variations in *Histoire de la caricature moderne*, 243f. Baudelaire lived at the Hôtel Pimodan from May 1843 to July 1845. Champfleury places the meeting around 1849, but this is probably erroneous.

106. Cf. *Salon de 1846* (433), *Salon de 1859* (624), *L'Oeuvre et la vie d'Eugène Delacroix* (747). Baudelaire adapted the metaphor from Delacroix (*pace* L. Horner, *Baudelaire, critique de Delacroix*, 152). See Delacroix, *Oeuvres littéraires*, I, 58: "Les formes du modèle, que ce soit un arbre ou un homme, ne sont que le dictionnaire où l'artiste va retremper ses impressions fugitives ou plutôt leur donner une sorte de confirmation" [The forms of the model, be it a tree or a man, are only the dictionary where the artist goes to strengthen his fugitive impressions, or rather to give them a kind of confirmation].

107. *Histoire de la caricature moderne*, 260.

108. *Oeuvres diverses* II, 144 (1830).

dagger. . . . He speaks to all men strong and powerful enough to see further than others do, to scorn others, and never to be bourgeois].[109] A. Jal takes Prudhomme as a critique of the contemporary social and political order: "cette espèce d'hommes vulgaires et prétentieux qui n'était que ridicule au temps de Molière, mais qui devint dangereuse, lorsque la famille de M. Jourdain tint le pouvoir, non pour élever la nation vers cet idéal qu'elle n'apercevait pas, mais pour l'abaisser à ses petites vues et à ses grands besoins de confortable" [that type of vulgar, pretentious man who was only ridiculous in Molière's time, but who became dangerous when the members of M. Jourdain's family held power, not to raise the nation toward that ideal which it did not perceive, but to lower it to their own petty views and their great need for comfort].[110] Only Gautier sees Monnier's bourgeois as a portrait drawn from reality and reflecting the character of the artist himself: "C'est une espèce de portrait à outrance où la physionomie . . . prend un air étrange de l'excès même de sa réalité. . . . Monnier n'a rien exagéré; . . . on se demande quelquefois s'il n'est pas un bourgeois lui-même." [It is a kind of exaggerated portrait whose expression takes on a strange look from its very excess of reality. . . . Monnier exaggerated nothing; . . . one wonders sometimes whether he is not a bourgeois himself].[111] Gautier uses the same metaphors as Baudelaire: the daguerreotype and the stenographer, as opposed to the portraitist Balzac, who takes his models from reality but gives them character.[112] The daguerreotype lacks color and *touche*;[113] the works are not caricatures, but casts molded from nature. But Gautier sees in Prudhomme Monnier's vengeance against bourgeois stupidity, the sole instance where the artist actually practiced the exaggeration, choice, and composition that art requires.

Baudelaire's refusal to interpret Prudhomme ironically responds directly to this. He turns him into a "mirror," and Monnier into the reflected image, a bourgeois (and caricatural) Narcissus observing, like the public of photography, "sa triviale image sur le métal." Monnier's popularity with the bourgeoisie testifies, for Baudelaire, to the uncritical infatuation of a class with itself, its narcissistic self-love, its comical self-ignorance. Along with his public, he becomes a character, and caricature, from Daumier's *Histoire ancienne* (see Fig. 24, page 145).

109. Ibid., ii, 538 (1832).
110. *Souvenirs d'un homme de lettres*, 564f. Cf. *Nouveaux Tableaux de Paris au XIXᵉ siècle* (1834).
111. *La Presse*, 8 July 1849.
112. Article of 15 January 1849 (*Histoire de l'art dramatique en France* vi, 38).
113. *La Presse*, 20 February 1855 (*Portraits contemporains*, 35f.).

Grandville

Il y a des gens superficiels que Grandville divertit; quant à moi, il m'effraye. Car c'est à l'artiste malheureusement que je m'intéresse et non à ses dessins. Quand j'entre dans l'oeuvre de Grandville, j'éprouve un certain malaise, comme dans un appartement où le désordre serait systématiquement organisé, où des corniches saugrenues s'appuieraient sur le plancher, où les tableaux se présenteraient déformés par des procédés d'opticien, où les objets se blesseraient obliquement par les angles, où les meubles se tiendraient les pieds en l'air, et où les tiroirs s'enfonceraient au lieu de sortir. (558f.)

[There are superficial people whom Grandville amuses; as for me, I find him terrifying. For unfortunately it is the artist who interests me and not his drawings. When I step into the work of Grandville, I feel a certain uneasiness, as though I have entered an apartment in which the disorder were systematically organized, where the absurd cornices propped themselves against the floor, the pictures looked deformed as through an optician's glass, the objects hit one another obliquely by the angles, the furniture stood with its legs in the air, and the drawers slid inward instead of out.]

Baudelaire's reaction to Grandville is the most curious of all, and perhaps the most revealing of his conception of the comic. One might expect this artist, with his bizarre, grotesque, highly imaginative and inventive creations, to fulfill, more than any other, the criteria of the *comique absolu*. His art is rich in the fantastic, hallucinatory, and analogical; he produced a *danse macabre* (*Voyage pour l'éternité*), a form of the grotesque that Baudelaire used and, in the *Salon de 1859*, wished to see more frequently revived (652); he depicted animals in the daily situations of human life (*Les Métamorphoses du jour*), translated musical notation into visual images, and rendered in visual forms the absurd logic of dreams. In *Un Autre Monde* (1844),[114] he created a phantasmagorical vision of what Walter

114. Baudelaire mistakenly calls this *Le Monde à l'envers*, thus substituting the generic name for Grandville's actual title: *le monde à l'envers* drawings, which reversed the position of humans and animals, were common in medieval art and afterward, and, as Melot notes, were an archetype of the *dessin d'humour* (*L'Oeil qui rit. Le Pouvoir comique des images*, 156). Wright cites numerous examples (*A History of Caricature and Grotesque in Literature and Art*, 88ff.).

Benjamin described as the commodification of the universe: Saturn's ring becomes an iron balcony for fashionable people to take the air, the progress of a comet across the sky becomes a lady in fashionable evening dress parading across the floor of a gaslit ballroom, Venus the evening star becomes a glittering jewel adorning the hair of a stylish nineteenth-century human Venus on her balcony (Figs. 29 and 30).[115] Objects take on life, living things become objects, and a visual synecdoche and metonymy translate the fetishes of a culture: an ophicleide is a monstrous, squatting beast, a twirling ballerina is a spinning spool of thread, an audience is all eyes or clapping hands, people are reduced to items of fashionable clothing.[116]

Grandville's is a topsy-turvy world organized according to common laws of the absurd: fish catch men on their lines, a man is walked by his dog, vegetables and flowers plot a revolution, women adopt the habits and dress of men, puns are translated visually. Baudelaire points out his interest in

FIG. 29. Grandville. *Le Pont des planètes. Un Autre Monde,* 1844 (photo: British Library)

115. *Le Pont des planètes, Pérégrinations d'une comète, L'Etoile du soir (Un Autre Monde).* Cf. W. Benjamin, *Paris, Capital of the Nineteenth Century,* in *Charles Baudelaire: A Lyric Poet in the Era of High Capitalism,* 165.

116. Cf. *Plusieurs dilettanti ont les oreilles déchirées, Le Concert à la vapeur, Apocalypse du ballet, Vénus à l'opéra, A quoi bon du reste la personne? . . .* (all from *Un Autre Monde*).

FIG. 30. Grandville. *Pérégrinations d'une comète. Un Autre Monde*, 1844 (photo: British Library)

analogy and his method of turning the rational, orderly world of nature into a hallucinatory, apocalyptic one. And while such a vision satirizes contemporary issues and institutions—socialist theories, scientific knowledge, capitalism, Romanticism, the Academy, female emancipation, the commodity fetish of bourgeois society[117]—Baudelaire implies its affinity with the *comique absolu*, the perceived superiority of mankind over nature: "Cet homme, avec un courage surhumain, a passé sa vie à refaire la création. Il la prenait dans ses mains, la tordait, la rarrangeait, l'expliquait, la commentait" (558) [This man, with superhuman courage, spent his life remaking creation. He took it in his hands, twisted it, rearranged it, explained it, commented on it]. Grandville's "superhuman courage" is thus satanic, remaking creation according to his interpretation, close to the ideal of Hoffmann.

But as the passage cited above suggests, Baudelaire denies Grandville a place in the *absolu*, and has grave reservations about the quality of his art. Grandville's absurd merely frightens, leaving the observer confused and uneasy. Baudelaire thus finds himself in the uncomfortable position of Virginie gazing at her first, fatal caricature in *De l'essence du rire*, with the same fear and uneasiness: *"je ne sais quel malaise,* quelque chose qui ressemble à la *peur"* (529, my emphasis). This attitude is puzzling: why, having proved his skill in analyzing the grotesque and categorically stated his preference for it, does he revert to being a novice "ange immaculé" (530) in front of Grandville's bizarre creations? Even more curiously, why are the very same qualities—the fantastic, bizarre, monstrous, terrifying, and grotesque, the dream-visions and nightmares, the animalized faces, or as he later puts it in the section on Goya, "toutes les débauches du rêve, toutes les hyperboles de l'hallucination" (568) [every debauchery of dreams, every hyperbole of hallucinations]—so exhilarating and admirable in that artist, yet so disturbing and dissatisfying in Grandville? Why does the "commotion vive" (568) felt before Goya's works constitute aesthetic pleasure, but only a "malaise" before Grandville's?

The unstated parallel with Goya is instructive. Although Baudelaire employs similar terms for both, he attributes to Goya, as we shall see, an essential quality lacking in Grandville: the harmony of fantastic and real,

117. On the satirical and parodic aspects of *Un Autre Monde*, see P. Kaenel, "Le Buffon de l'humanité: la zoologie politique de J.-J. Grandville"; S. Appelbaum, *Bizarreries and Fantasies of Grandville*; and W. Spies, "Der verzweifelte Systematiker: Hinweis auf Grandvilles Beschäftigung mit der reproduzierten Welt."

transcendent and natural, diabolical and human (570), which produces an oxymoronic art of "monstrueux vraisemblable" and "absurde possible" (569f.), a dualistic art that defies analysis and communicates its meaning through the art itself. This is the counterpart, in the domain of the *absolu*, to Daumier in the *significatif*. Hoffmann's work has the same combination of clear moral meaning in the fantastic (542). Grandville, in contrast, tries to represent the principle of analogy but fails, never managing to make his art express his idea, or conversely, to embody his idea in his art. He is plagued by the chronic dualism of Giglio, the contradictory impulses of the philosopher and the artist, the literary and the pictorial, specific, "intended" meaning and suggestiveness.

Baudelaire's critique of Grandville's dualism centers on his "analogical" and "allegorical" manner: "Grandville a roulé pendant une grande partie de son existence sur l'idée générale de l'Analogie. . . . Mais il ne savait pas en tirer des conséquences justes; il cahotait comme une locomotive déraillée" (558) [For a great part of his life, Grandville worked on the general idea of Analogy. . . . But he did not know how to draw the right consequences from it; he bumped along like a derailed locomotive]. His methodical organization, his philosophical treatment of the absurd, prevents the impression of unity on which the true absurd, the *absolu*, depends. His effort to express ideas through his art is constantly thwarted by the disjunction between his "literary" mind and his artistic *métier* (558). In this he resembles the artists of *L'Art philosophique*, who borrow the goals of another art for their own—heretics who create a "false genre" (604), "a pictorial art that pretends to replace the book" (598): Grandville too has "un esprit maladivement littéraire, toujours en quête de moyens bâtards pour faire entrer sa pensée dans le domaine des arts plastiques" (558) [a morbidly literary mind, always searching for bastard means of introducing his thought into the domain of the plastic arts]. Baudelaire treats this literary effort as a kind of self-interference, a refusal to let the art speak for itself, resulting from "stubborn habits" and an "obstinate will" (559): Grandville has the will necessary to the artist, but applies it to a purpose alien to the art itself. In contrast, Daumier's comedy is *seemingly* involuntary, "pour ainsi dire, involontaire," as though the idea escapes from him (556). The Virginie-like malaise of the speaker comes, as in her case, from the perception of dualism, and the unintelligibility this produces ("elle ne comprend guère ni ce que cela veut dire ni à quoi cela sert," 529). Nor can Baudelaire comprehend Grandville, in whom the clash of idea and art permits neither the one nor the other to emerge unscathed: "il a fini par tomber dans le

vide, n'étant tout à fait ni philosophe ni artiste" (558) [he ended up falling between the two, being neither wholly a philosopher nor wholly an artist].

Interestingly, it is precisely this dualism that Benjamin cites in taking Grandville as a model of the allegorical—or, as he increasingly termed it, modern—artist, both reflecting and exposing, like Baudelaire himself, the commodity myths and fetishes of nineteenth-century French culture. In the unfinished *Passagenwerk*, or "Arcades Project," Grandville would have figured prominently as an artist of the kind of Baudelairean modernity that Benjamin sought in the commodity culture of Second Empire Paris, in which specialty items and *nouveautés* are raised to the level of poetic objects.[118] Benjamin's insight was to understand the crucial implications of Baudelaire's point for the experience of modernity, for the dividedness of allegory he saw precisely as a product of the world's division and fragmentation, a symptom and result of modern alienation. Perhaps more important, this dualism or "brokenness"—in Baudelaire's terms, the irreconcilability and non-reciprocity of idea and art in Grandville—calls into question the mythic appearance of the world, nature, and history. For Benjamin, allegory both speaks and reveals the fragmentation behind the alleged order and causal evolution of history; it represents and exposes the brutal separation of humanity from the world of nature; it embodies and uncovers the chaos behind the logic of the universe, the arbitrary nature of the systems humanity has constructed. Grandville's allegorical art, like Baudelaire's, expresses the fragmentation, commodification, and dehumanization of experience in capitalist culture, and thus demystifies it, "reveals its nature."[119] It reflects and reveals the myths constructed by bourgeois capitalism, the illusion of organic harmony in the world of modern technology and merchandise:

The enthronement of the commodity and the splendor of the distractions which surround it, this is the secret subject of Grandville's art. . . . Under his pen the whole of Nature is transformed into specialty items. He presents it in the same spirit in which advertisements — a word which comes into use at precisely this time—begin to present their articles. . . . The universal exhibitions construct a universe of

118. On the place of Grandville in the *Passagenwerk*, see Susan Buck-Morss, *The Dialectics of Seeing: Walter Benjamin and the Arcades Project*, 152ff.

119. *Paris, Capital of the Nineteenth Century*, in *Charles Baudelaire: A Lyric Poet in the Era of High Capitalism*, 166. In his notes for the *Passagenwerk*, Benjamin describes Grandville's art as the modern equivalent of allegory, "breaking open" the unity of nature (*Gesammelte Schriften* v, 267).

commodities. Grandville's fantasies transfer commodity character to the universe. They modernize it.[120]

Like the allegories of the Baudelairean metropolis, Grandville's expose the phantasmagoria of bourgeois urban life, the kaleidoscopic vision by which the commodity is transfigured into the organic, or even into the sacred, the "pantheism" and mystical intoxication by which Baudelaire himself characterized the experience of the modern city (I, 651). Grandville's is a world of proliferating, self-generating commodities metamorphosing one into another, commodities that multiply to fill every earthly and heavenly space. Bourgeois capitalism projects itself onto the universe and raises itself to the level of the universal, proclaiming its cosmic significance and claiming universal authority. For Benjamin, Grandville's allegory, like Baudelaire's, exposes the fetishized character of commodities and the illusion it creates, and illuminates the myths that both define contemporary experience and also prevent access to a genuine experience. It reveals the mechanization and death to which we are unknowingly subjected behind a veil of organicism and life.

Yet Baudelaire's misgivings about the separateness of Grandville's dualism have a further, crucial dimension: "il a fini par tomber dans le vide, n'étant tout à fait ni philosophe ni artiste." The allegorical disjunction he perceived in Grandville may not only have commented on bourgeois history, as Benjamin later maintained, but may also have been a *victim* of it, marking the pressure of modern capitalist culture upon the individual, the subject's collapse and annihilation under the weight of commodified experience, the vengeful power of the mythic. Indeed, despite his defense of Grandville's "brokenness," Benjamin himself seems to have recognized this and acknowledged, if not endorsed, the force and implications of Baudelaire's critique. The first version of Benjamin's essay contained this stark, unexplained remark, echoing Baudelaire's "il est tombé dans le vide": "He ended in madness." Benjamin omitted this in the French version written four years later, in 1939, but its implications could not be so easily erased.[121] The commodification of the universe, which allegory both effects and exposes, could yet overwhelm the allegorist too. The ambiguities of Benjamin's own

120. *Paris, Capital of the Nineteenth Century,* in *Charles Baudelaire: A Lyric Poet in the Era of High Capitalism,* 165f. Cf. Spies, "Der verzweifelte Systematiker: Hinweis auf Grandvilles Beschäftigung mit der reproduzierten Welt."
121. Cf. *Gesammelte Schriften* v, 51 and 65.

view of history as both negative and positive,[122] and his suicide in the face of capture by the Nazis, suggest that he recognized fully the perils, to the individual, of a demystified, allegorical history, history laid bare in the fortuitousness of its events, revealing the terrible power of the mythic, which allegory unveils but might not succeed in banishing.[123] The dualism of allegory may yet be as unbearable and dangerous in the existential domain as Baudelaire argues for the aesthetic one.

Baudelaire did recognize the importance of what he jokingly called Grandville's "mad side," the dream images, but not without ambivalence:

> Avant de mourir, il appliquait sa volonté, toujours opiniâtre, à noter sous une forme plastique la succession des rêves et des cauchemars, avec la précision d'un sténographe qui écrit le discours d'un orateur. L'artiste-Grandville voulait, oui, il voulait que le crayon expliquât la loi d'association des idées. (559)

> [Before his death, he applied his will, ever obstinate, to noting the sequence of dreams and nightmares in visual form, with the precision of a stenographer who takes down the speech of an orator. Grandville the artist wanted, yes, he really wanted his pencil to explain the law of association of ideas.]

Here we find the same interfering *volonté* imposing a particular sense upon a complex and potentially suggestive art, limiting the richness of meaning characteristic of the *absolu*. While Baudelaire criticizes other "hallucinatory" works for their renunciation of will,[124] Grandville's display too much. His mocking insistence on this suggests the dangers of this approach, the

122. M. Jennings, *Dialectical Images*, 38.

123. On 26 September 1940, at the age of forty-eight, still at work on the "Arcades Project" with Grandville and Baudelaire at its center, Benjamin committed suicide at the Spanish border, his attempt to escape the Nazis thwarted by the lack of an exit visa. Of his own identification with the allegorical artist there can be no doubt: he conceived of the *Passagenwerk* as montage (*Gesammelte Schriften* v, 574; cf. 1073). And Adorno criticized him for the same disconnectedness and brokenness that Baudelaire had Grandville—an accumulation of discontinuous thematic fragments not placed in dialectical relation, without mediation, linked by juxtaposition and montage (ibid., v, 1127ff.).

124. He thus criticizes Janin's *Gâteau des Rois*, in which "les idées se succédaient à la hâte, filaient avec la rapidité du son, s'appuyant au hasard sur des rapports infiniment ténus" (24) [the ideas followed upon one another hurriedly, flew off with the rapidity of sound, relying at random on infinitely tenuous relations].

point at which will predominates over imagination, runs counter to it, and condemns the work to inharmonious dualism.

Moreover, while the stenographic simile suggests the hated aesthetic of copying—Grandville transcribing the messages of a real artist, an unknown power, the "orateur"—Baudelaire suggests, despite his irony, the idea of interpretation: the art explains as it transcribes. Perhaps his ambivalence stems from the ambiguity in Grandville himself: Grandville creates a comic art, but often without being aware of it (559), that is, he lacks the quality of the greatest comic artists—the knowledge and deliberate feigning of ignorance that characterize *dédoublement*. Grandville produces the comic in spite of his will, not by means of it. If Baudelaire's praise is elsewhere underhanded, here we have the reverse, a mockery that nevertheless pays tribute to Grandville's genius. His criticism calls attention to the extraordinary potential of Grandville's comedy, a comedy ever escaping, though not free of, the will's effort to contain it, to direct narrowly, and thus to stifle, the freedom on which the *comique absolu* depends.

The works alluded to are the *Deux Rêves*, done, as Baudelaire specifies, just before the artist's death.[125] They obey the self-generating, metamorphic quality of the *comique absolu*, each image progressively transforming itself according to various laws of association—linguistic, formal, iconographical, psychological. Deliberately leaving the interpretation open, Grandville's commentary explains the first, *Crime et expiation*, as the stages of the nightmare of a man obsessed with committing a crime, or of a murderer pursued by remorse (Fig. 31). The victim clubbed by the criminal in the upper left is at once a human being and a tree pulled up violently by its roots. The image is based on the scene of the crime, which takes place in a dark wood, and also (as the commentary states) on a pun on the expression "il a fait suer un chêne," indicating its violence. The victim also resembles a demon, complete with tail—a projection of the criminal's conception. The cross marking the crime becomes a fountain, then the weapon (here a dagger), and the scales of justice, all circling round a central multitude of hands outstretched: like the victim's during the crime, now the criminal's supplicate too. One of the scales becomes an eye that grows to enormous proportions, the eye of conscience, guilt, and remorse, pursuing the fleeing criminal downward to where a crumbling column plunges him into the

125. Grandville died on 17 March 1847: in July, *Le Magasin pittoresque* published the two drawings, with the artist's commentary (xv, 27 [July 1847]). See Philippe Roberts-Jones, *Beyond Time and Place*, 61.

FIG. 31. Grandville. *Crime et expiation. Deux Rêves*, 1847 (photo: Bibliothèque Nationale)

sea—the hero toppled from his pedestal of righteousness and honor. There the eye takes the form of a huge fish ready to devour him, but the cross, now having the luminous whiteness of the eyeball, reappears before his outstretched hands. It again becomes a fountain and flows with the tears of repentance, which bathe and purify the dreamer/sinner. Thus he is saved from the self-destruction of guilt by the transformation of guilt into remorse. The metamorphosing images reflect the criminal's inability to grasp and control his own act. Once committed, it takes on its own life, quite literally becoming an image not only of revenge, but also of fantasized mercy—the fall a means of redemption.

In the second, *Une Promenade dans le ciel* (Fig. 32), the crescent moon becomes a mushroom, an umbelliferous flower, a parasol, a bat or an osprey with piercing eyes, a set of bellows, a pair of hearts pierced by an arrow, a bobbin wound with a tangled thread, a cart pulled by horses, and a constellation of stars, restoring the dreamer to the point of departure, the night sky. Each image is transformed into another, ever escaping the dreamer's grasp. In his commentary, Grandville specifies the dreamer as a young girl (the parasol, the bobbin, the bathetic image of the two hearts) whose waking moments have been confused to produce the particular images: a visit to the shops (the parasol), a walk in the country (the mushroom, the flower), and a fine summer evening (the crescent moon, the bat). The picture follows the same arc-like movement as *Crime et expiation*, progressing similarly through terror to hope: from the tranquillity and innocence of the first three images, to the threatening image of the bat/osprey with its terrifying gaze and the beams of light coming from its eyes, to the gentle sentimentality of the hearts, and finally the constellation.[126] These two works belong among Grandville's most original, as he himself understood; well before the experiments of surrealism, they expressed the peculiar and amusing logic of dreams, the moral sense of absurdity, the phantasmic reality of the grotesque, and thus discovered a new art, "l'art de ces déformations et réformations des signes, l'art de ces transitions se succédant toujours parallèlement à un sens moral" [the art of the deformation and reformation of images, the art of transitions that succeed one another and run parallel to a moral sense].[127] It is to them that Baudelaire will return in his discussion of Bruegel (573), with its radical and uncharac-

126. For psychoanalytic interpretations of these images, see Laure Garcin, *J.J. Grandville. Révolutionnaire et précurseur de l'art du mouvement*, 38ff.

127. From Grandville's own commentary, *Magasin pittoresque* xv, 27 [July 1847].

FIG. 32. Grandville. *Une Promenade dans le ciel. Deux Rêves,* 1847
(photo: Bibliothèque Nationale)

teristic concession to the role of unconscious forces in the creation of a work of art.

Grandville was very highly regarded in the period following his death in 1847; Baudelaire's assessment is harsh relative to contemporary ones. As early as 1830 Balzac praised the wit and philosophical depth of the *Voyage pour l'éternité*.[128] Grandville's love of detail is for most critics an effort to endow his fantastic visions with reality, and his philosophical side secondary to his artistic purposes.[129] Interestingly, Charles Blanc illustrates Grandville's use of analogy with an anecdote of the artist translating into visual images the ideas suggested by a piece of music: "il traduisait sur le papier des idées que lui suggérait la mélodie, . . . puis s'égarant peu à peu dans sa propre pensée, oubliant ce qui l'entourait, il paraissait se plonger dans une méditation solitaire; il rêvait et machinalement sa plume donnait une forme à ses rêves" [he translated onto the paper ideas which the melody suggested to him, . . . then, wandering off little by little into his own thoughts, forgetting what surrounded him, he seemed to sink into solitary meditation; he began to dream, and his pen mechanically gave a shape to his dreams].[130] This provides a striking parallel for the scenario in the essay on Wagner, in which Baudelaire pictures himself listening to the overture to *Lohengrin* and translating it by quoting verses from "Correspondances":

> M'est-il permis à moi-même de raconter, de rendre avec des paroles la traduction inévitable que mon imagination fit du même morceau, lorsque je l'entendis pour la première fois, les yeux fermés, et que je me sentis pour ainsi dire enlevé de terre? . . . car ce qui serait vraiment surprenant, c'est que le son *ne pût pas* suggérer la couleur, que les couleurs *ne pussent pas* donner l'idée d'une mélodie, et que le son et la couleur fussent impropres à traduire des idées; les choses

128. *Oeuvres diverses* II, 10.

129. See Julien Lemer, *La Presse littéraire* 69 (21 August 1853). Lemer also signals Grandville's vital role in the caricatural attack on the government from 1830 to 1835. Indeed his works were among the most vigorously contentious to be published in Philipon's two journals, equalled only by Daumier's; even taking into account Baudelaire's broader conception of caricature, it is remarkable that he wholly neglects this side of Grandville's production. (On the harassment of Grandville by the police, represented in *Oh! les vilains mouches*, see Clive Getty, "Grandville: Opposition Caricature and Political Harassment.") Alexandre Dumas devotes a chapter of his memoirs to Grandville in 1853, and later an article in *L'Artiste*. Like Baudelaire, he describes Grandville's method as remaking the world, seeing and revealing the hidden side of things (*Mes Mémoires* V, 72–77; cf. *L'Artiste*, December 1854).

130. *La Presse littéraire*, 30 October 1853. This served as the introduction to the 1853 volume of *Les Métamorphoses du jour*.

s'étant toujours exprimées par une analogie réciproque, depuis le jour où Dieu a proféré le monde comme une complexe et indivisible totalité. (784)

[May I now myself describe, or convey in words, the inevitable translation that my imagination did of the same piece when I heard it for the first time, my eyes closed, feeling, so to speak, carried away from the earth? . . . for what would be truly surprising would be that sound *could not* suggest color, that color *could not* evoke the idea of a melody, and that sound and color were unsuitable for translating ideas; seeing that things have always expressed themselves through reciprocal analogies, ever since the day when God created the world as a complex and indivisible totality.]

Grandville's interest in the Fourierist concept of analogy matched Baudelaire's own; the hieroglyphs and rebuses of his analogical, allegorical method reflect the "forest of symbols," the "correspondences" of Baudelaire's poem. But Grandville's analogy, in Baudelaire's view, remains ever separate from the ideas it should translate; it lacks the reciprocity of the "analogie réciproque" provoked here, the relative unity of the dualistic *comique absolu*, the harmony of art and moral idea, the reflexive nature of the artist's doubling. Such reciprocity is crucial to Baudelaire's notion of comic dualism, as we have seen, and to the discontinuous and fragmentary experience of modernity too.

 Only Gautier and Champfleury reveal a distinct lack of enthusiasm for Grandville. Gautier's obituary (*La Presse*, 24 March 1847) surely influenced Baudelaire, for it directly anticipates many of the points made in *Quelques caricaturistes français*. Like Baudelaire, he concentrates on the discrepancy between Grandville's literary and artistic ambitions: "Il a voulu faire parler au crayon le langage de la plume" [He wanted to make the pencil speak the language of the pen].[131] He remarks the laborious quality of Grandville's *bizarrerie*, the overly obvious, painful effort noted also by Baudelaire. But the two accounts differ markedly: Baudelaire understood the psychological interest of Grandville's work, his extraordinary "mad side," and the comic potential of this, which Gautier completely ignores. Gautier seems merely not to understand; Baudelaire is confused but intrigued, recognizing the

131. Repr. in *Portraits contemporains*, 231f.

extent of Grandville's ambitions and vision, but also his ultimate failure to realize them.

Champfleury, following Baudelaire, criticizes Grandville for a double fatigue for the eye and the mind, unintelligibility, fastidiousness, and a misguided effort to combine the fantastic with a moral idea.[132] But he invokes many of Baudelaire's arguments only to arrive at the opposite conclusion: a preference for the early works over the late ones. For Champfleury, *Crime et expiation*, which Baudelaire admires, is so confusing a work that the artist had to employ means outside his art—a page of written explanation—to ensure that it would be understood. Baudelaire, who harbored reservations about Champfleury's judgment, would have certainly appreciated the irony.

Gavarni

Whereas Grandville's work demonstrates for Baudelaire an unresolved conflict between his literary ambitions and artistic talent, Gavarni's is more clearly and uniformly literary. The resulting dualism thus produces no malaise or fear. It fits comfortably into Baudelaire's definition of the *comique significatif*: it is easily understood by most people, its principal value is historical rather than artistic, and it is patently dual, the image separate from the caption, the art from the moral, pictorial from literary. Unlike Daumier, Gavarni needs the caption, without which the work is "powerless" and fails to communicate the sense.

Gavarni's literary quality consists in a rhetorical manipulation of the observer: he "touches on things," "leaves one to guess" (559). In contrast to the frankness and directness (559) of Daumier, this art teases and flirts, using all the oblique, hypocritical, devious methods of the sensualist *littérateur*: reticence, insinuation, subtlety, flattery, discretion, dissimulation. "Il flatte souvent au lieu de mordre; il ne blâme pas, il encourage. . . . Grâce à l'hypocrisie charmante de sa pensée et la puissante tactique des demi-mots, il ose tout" (559) [He often flatters instead of biting; . . . he does not blame, he encourages. Thanks to the charming hypocrisy of his thought and the powerful tactic of innuendo, he dares all]. The "tactic" is indeed a battle-plan of seduction—Baudelaire sees him as a Marivaux, a Paul de Kock, the

132. *Histoire de la caricature moderne*, 289, 291.

modern version of an eighteenth-century cynic "slightly tinged with corruption," out to seduce his reader through a calculated, enticing reticence.[133]

However, Baudelaire's emphasis on Gavarni's cynicism suggests that this is a technique by which he entraps and mocks his public, not, as with Charlet, simply a way of currying favor. His reticence is at once flattery and "lure"; the flattery becomes a form of caricature, confronting the public with its vanity.[134] The viewer is caught in the coil of these intricate captions ("entortillées"). Gavarni exploits his hypocrisy, the better to charm and then implicate his audience; Charlet abdicates his integrity in order to win popularity. Even Gavarni's candid moments are tinged with such deception and cunning, like the seduction of a femme fatale that makes the victim a partner in crime: "quand sa pensée cynique se dévoile franchement, elle endosse un vêtement grâcieux, elle caresse les préjugés et fait du monde son complice" (559) [when his cynical thought unveils itself frankly, it dons a graceful dress, it caresses prejudice and makes the world its accomplice]. Gavarni is a demonic figure, a master of subterfuge and *libertinage*, corrupting the observer and taking pleasure in doing so. It is a contemporary equivalent of a Gavarni image that lures Virginie into the realm of the fallen in *De l'essence du rire*, "un Gavarni de ce temps-là" (529). And significantly, such beguilement takes its cue from the "victim": it responds to the viewer's desire, coaxes it out, exposes its depravity and corruption. This portrayal of the comic artist as a femme fatale prepares the relation between woman and the painter of modern life in the essay of that title: both represent and lay bare the fantasies of the "seduced," the viewing public.

Baudelaire's example from the *Baliverneries parisiennes* of 1846–47 (Fig. 33) represents not only Gavarni's delightful depravity—the cynical girl scornfully telling a young hopeful that she has just finished with his father—but also his way of enticing and ensnaring the viewer: "Ces coquins-là sont si jolis que la jeunesse aurait fatalement envie de les imiter" (560) [Those rascals are so pretty that young people will inevitably want to imitate them]. The caricatural image becomes a model, charming us into adopting the comical perversion it presents—a cynicism less like Marivaux's than that of Valmont or the marquise de Merteuil.[135] The haughty strength of the girl in

133. The comparison to Paul de Kock is hardly complimentary, as Baudelaire elsewhere dismisses him as a pretentious popular novelist who mistakes the shock of antithesis for real thought. Cf. the essay on *Madame Bovary* (79), *Salon de 1859* (677), and *Lettres d'un atrabilaire* (I, 781).

134. On the formal relation of flattery to caricature, see Françoise Meltzer, *Salome and the Dance of Writing*, 202f.

135. Cf. Baudelaire's notes on *Les Liaisons dangereuses*, begun in 1856 (66–75).

Chez Aubert & C^{ie} Pl. de la Bourse 29

Imp. d'Aubert & C^{ie}

F<small>IG</small>. 33. Gavarni. *Quartier Bréda: Ma bonne dame charitable. Baliverneries parisiennes*, 1846 (photo: Bibliothèque Nationale)

this example, foregrounded like the figure itself, is captivating and imposing, and thus places the viewer in the comical position of the young man. Indeed, Gavarni's art generally relies on insinuation and innuendo, which attract us and leave us ultimately the victim. We regard a scene from behind, from the other side of a curtain or door; we have a part in the sensuality and the hypocrisy, which the picture itself, by its charm, prevents us from relinquishing (Fig. 34). It represents especially well the implication of the laugher (here the viewer) by which Baudelaire defines the comic.

But the "imitability" of Gavarni's characters, however successful at seducing the viewer, condemns him to the pure historical: "Gavarni [a créé] la Lorette; et quelques-unes de ces filles se sont perfectionnées en se l'assimilant, comme la jeunesse du quartier Latin avait subi l'influence de ses *étudiants*, comme beaucoup de gens s'efforcent de ressembler aux gravures de mode" (560) [Gavarni created the Lorette; and some of these real girls have perfected themselves by assimilating this image, as the youth of the Latin Quarter succumbed to the influence of his students, or as many people try to look like fashion plates].[136] This contemporary artist is thus as dated as Carle Vernet, but worse, for Vernet captured the "pretension to style" (544) of his time, whereas Gavarni, in a sense, creates it, leading his public not to see, but to value, its ugliness.[137] If he complements Balzac,[138] this is not in the manner of Daumier, who portrays a *comédie humaine*, an image, distorted, exaggerated, and grotesque, of mankind, but rather in depicting a shared period of history: "Il faudra feuilleter ces oeuvres-là pour comprendre l'histoire des dernières années de la monarchie. La république a un peu effacé Gavarni; loi cruelle, mais naturelle. Il était né avec l'apaisement, il s'éclipse avec la tempête" (560) [One will have to peruse his works to

136. Baudelaire complains of the same thing in his 1861 article, *Les Martyrs ridicules par Léon Cladel* (183, quoted in n. 34), and mocks it mercilessly in the person of Samuel Cramer, who imitates both the heroes and the authors of the works he admires (see my article, "The Function of Literature in Baudelaire's *La Fanfarlo*," 44f.).

137. Gavarni, like Vernet, did drawings for La Mésangère, although for a different publication, the *Costumes de divers pays* (1827–28). Baudelaire is aware of his early career as a creator of fashion plates for Girardin's journal *La Mode*, from 1830 onward.

138. "La véritable gloire et la vraie mission de Gavarni et de Daumier ont été de compléter Balzac, qui d'ailleurs le savait bien, et les estimait comme des auxiliaires et des commentateurs" (560) [The true glory and the true mission of Gavarni and Daumier were to complement Balzac, who, by the way, was well aware of it, and appreciated them both as his auxiliaries and commentators]. Gavarni and Daumier indeed illustrated texts by Balzac. See Passeron, *Daumier*, 118, 137; R. Pierrot, "Balzac et Gavarni," 153f. On the commonly perceived link between Gavarni and Balzac in the nineteenth century, see Stamm, *Gavarni and the Critics*, 14ff.

Fig. 34. Gavarni. *On rend des comptes au gérant. Les Lorettes,* 1841 (photo: Bibliothèque Nationale)

understand the history of the last years of the monarchy. The republic has somewhat eclipsed Gavarni; a cruel law, but a natural one. He was born at the time of appeasement, he vanishes with the storm]. The point is barbed: Gavarni's hypocrisy fits the politics of "apaisement," the moral concessions of the *juste-milieu*. He is a collaborator who exposes the vacuity of an entire age and its political system. This appeasement directly contradicts the moral *engagement* of revolution (however great the failure in 1848), and the violence and furor of the *comique absolu*. In his demise with the passing of his era, Gavarni contrasts directly with Daumier, who created a new form (*caricature de moeurs*) to suit a new age, and thus reformed the art as a whole.

Baudelaire's praise is, at best, tepid, and frequently condescending. His description of the *lorette* has none of the enthusiasm of Gautier's in 1845, to which he directly alludes. Gautier distinguishes her from the kept woman of the Empire and the grisette of the Revolution by her "masculine" freedom, independence, and spirit,[139]—qualities Baudelaire mocks: "La lorette, on l'a déjà dit, n'est pas la fille entretenue, cette chose de l'Empire, condamnée à vivre en tête à tête funèbre avec le cadavre métallique dont elle vivait, général ou banquier. La lorette est une personne libre. Elle va et vient. Elle tient maison ouverte. Elle n'a pas de maître; elle fréquente les artistes et les journalistes. Elle fait ce qu'elle peut pour avoir de l'esprit." (560) [The Lorette, it has already been said, is not the kept woman, that phenomenon of the Empire, condemned to live in funereal intimacy with the metallic corpse, a general or banker, on which she depended. The Lorette is a free agent. She comes and goes. She keeps open house. She has no master; she keeps company with artists and journalists. She does what she can to be witty]. Indeed his ambivalence toward Gavarni stands out among the acclaim of contemporary articles; the qualities which they praise become problematic in his.[140] The skillful literary character that, in his view, weakens the caricatural effect, is elsewhere cited as an unequivocal strength. In a famous article virtually launching Gavarni as an artist in 1830, Balzac praises the *Physionomie de la population de Paris*, the collection of Parisian character sketches, as a literary *comédie de moeurs* notable for their truth

139. Gautier, *Portraits contemporains*, 331f.

140. Only Champfleury follows Baudelaire on Gavarni's manner of indulging his public, teasing rather than attacking. But Champfleury is less aware of the strategy that this represents, and instead sees only an art of the *joli*, superficial and frivolous, "gallantries," "passing amours." See Stamm, *Gavarni and the Critics*, 57ff.

and immediacy, nature captured "in the flesh."[141] Similarly, in a number of articles written from 1845 to 1869,[142] Gautier defends Gavarni as a painter of modern life similar to Baudelaire's hypothetical one in the final chapter of the *Salon de 1845*: "Paris . . . a cependant son charme, et ce qu'il trouve élégant mérite bien d'avoir un peintre" [Paris nevertheless has its charm, and what it finds elegant deserves to have a painter].[143] What Baudelaire considers Gavarni's historical limitations become for others a sign of truth, his ability to capture an entire spirit and manner in just a fashion plate.[144] Gautier takes this further, presenting Gavarni as a *peintre feuilletoniste*, the comic author of the nineteenth century, rather than "merely" a caricaturist.[145] The superiority of the caption is not the sign of an "impotent" image, as Baudelaire holds, but is part of the caricature itself: "a vaudeville, a comedy, a novel of manners in the best sense of the word," a necessary commentary so that the image may endure and be understood.[146] The *philosophe* and *écrivain* constitute Gavarni's original genius, rather than contaminate it.[147]

Gavarni's sensuality is freely acknowledged but is attributed to his realism and his compassion for human frailty. Sainte-Beuve presents him as a "fin railleur" who satirized life not out of misanthropy but because he saw it as it was.[148] Here we have moved a long way from Baudelaire's delightfully corrupt hypocrite: rather, Gavarni is refined and humane, a *littérateur* and *moraliste* who does not moralize overtly, but rather renders with a tinge of

141. *L'Artiste* III (4 March 1832) (in *Etudes balzaciennes* 5–6 [December 1958], 158). See also S. Le Men, "Balzac, Gavarni, Bertall et les *Petites Misères de la vie conjugale*."

142. *La Presse*, 2 June 1845, in *Souvenirs de théâtre*; *L'Artiste* 1857, in *Portraits contemporains* (which incorrectly notes 1855); *Moniteur universel*, 26 November 1866, in *Portraits contemporains*; and various short notices, e.g. in *L'Artiste* (1857) and *L'Illustration* (1869).

143. *Souvenirs de théâtre*, 172. Cf. Baudelaire's *Salon de 1845*: "Celui-là sera le *peintre*, le vrai peintre, qui saura arracher à la vie actuelle son côté épique, et nous faire voir et comprendre, avec de la couleur et du dessin, combien nous sommes grands et poétiques dans nos cravates et nos bottes vernies" (407) [The painter, the true painter, will be he who can wrest from contemporary life its epic side, and make us see and understand, by means of color and drawing, how great and poetic we are in our cravats and our patent-leather boots]. Stamm (*Gavarni and the Critics*, 76) suggests that Gautier had read Baudelaire's *Salon*, published a month previously.

144. Cf. Balzac, *Oeuvres diverses* II, 146. Gavarni had recently become the chief illustrator for *La Mode*, and Balzac presents him as the one capable of fulfilling the journal's radically new conception of the fashion plate as the representation not of an outfit on an immobile model but of an entire spirit and manner.

145. *Souvenirs de théâtre*, 170f.

146. Ibid., 175.

147. *Portraits contemporains*, 337.

148. *Nouveaux Lundis* VI (1866), 147ff.

misanthropy and sadness the vicissitudes of human affairs.[149] And Gautier attributes to the late work a moral sense comparable to Hogarth's, which punishes, rather than encourages, vice: the ravaged faces and tired bodies of the aged *lorettes* reveal the price of past pleasures.[150]

But Baudelaire's insights were uncannily prescient, as the Goncourts' 1872 study of Gavarni would later make clear. The long passages they quote from Gavarni's previously unpublished journals and letters corroborate what Baudelaire perceived in the pictorial oeuvre alone, namely Gavarni's cynicism, hypocrisy, and corruption, his "literary" depravity. Baudelaire discovered this at the level of style, Gavarni's use of reticence and suggestion; he flatters and encourages, not to win favor but to put his public utterly in his power and thus to treat it as he pleases. Indeed, Gavarni's cynicism about love and women in particular, and humanity in general, fits this description well. In a letter to his friend Edouard Loizelay in 1825, he writes: "Je vous dis d'avoir de l'hypocrisie, c'est indispensable . . . [le philosophe] doit prêter complaisamment l'oreille aux caquets des hommes comme à ceux des petites filles, et comme son intérêt n'est pas de leur faire fâcher, puisqu'il a besoin d'eux, il doit flatter leurs erreurs et avoir pour leurs hochets cette comique vénération qu'on a pour ceux d'un enfant" [I tell you that to be hypocritical is indispensable . . . the philosopher must obligingly lend an ear to the prattle of men, as to that of little girls, and as his interest is not to anger them, since he needs them, he must flatter their mistakes and have for their playthings the kind of comical veneration that one has for those of a child].[151] No critic other than Baudelaire had understood this. On the basis of the *inédits*, the Goncourts present a Gavarni interested not in the physical or sentimental pleasures of love, but in the game of flirtation and seduction, the hero of an eighteenth-century novel, a Valmont[152]—the same quality grasped by Baudelaire.

Moreover, in the journals and letters one encounters frequent passages that ring of Baudelaire's own sentiments. The suppressed admiration that one senses in *Quelques caricaturistes français*—admiration colored by dislike—may derive from the perception of a kindred and equal spirit. The parallels are striking: for example, expressing his belief in the sensuality of the child, Gavarni describes the "pleasure so pure, so indescribable, that one

149. Ibid., 163.
150. *Portraits contemporains*, 335. Gautier is discussing *Les Lorettes vieillies* of 1852.
151. Edmond and Jules de Goncourt, *Gavarni, l'homme et l'oeuvre*, 12.
152. Ibid., 11.

feels as a child passing one's fingers through white hair,"[153] as Baudelaire describes the child watching his father dress in *Le Peintre de la vie moderne* (690f.). He has a vehement abhorrence of Progress ("Progress, but I formally deny it, Progress!"), and a hatred of democracy and egalitarianism: he agrees with Töpffer's definition of the follower of the doctrines of February as man, minus his moral sense.[154] He displays a deep cynicism toward women, an evident dandyism, and expresses his sense of the pleasure taken in the crowd—"se renouveler dans la foule . . . Qu'il faut être vide ou usé pour s'ennuyer près d'une agglomération d'hommes" [to renew oneself in the crowd . . . How one must be empty or worn-out to be bored in the company of an agglomeration of men][155]—as Baudelaire himself says of Guys (692) and the poet of "Les Foules" (I, 291). Perhaps Baudelaire could not help recognizing in Gavarni's oeuvre certain tendencies of his own imagination—not least a cynicism corresponding to a new politics of *apaisement*, Second Empire style. The deprecatory familiarity with which he treats Gavarni may signal a self-portrait, or even a self-caricature, the poet's confrontation with his own ethics, aesthetics, and politics.

In 1863 Baudelaire sent Gavarni a copy of his translation of Poe's *Eureka*.[156] Gavarni thanked him for it in a letter forwarded through *Le Figaro*, where the essay on Constantin Guys, whom Gavarni knew well, had just begun to appear. In his response, Baudelaire alludes to *Quelques caricaturistes français*: "J'espère vous envoyer cette année plusieurs livres qui vous intéresseront, et dans l'un d'eux vous verrez ce que j'écrivais autrefois sur vous; mais ce que j'écrivais était bien inférieure à ce que je pense" [I hope to send you this year several books that will interest you, and in one of them you will see what I once wrote about you; but what I wrote was much inferior to what I think].[157] As the volume in question did not materialize, the essay was probably never sent; but his willingness to send it suggests that he felt his words would not wholly displease their subject. Nevertheless, the letter reveals the same ambivalence, the same restraint, as the passage from *Quelques caricaturistes français*. Whether Baudelaire actually thought more highly of Gavarni than is implied by what he wrote is doubtful: the ambiguous final clause suggests equally that he did not express

153. Ibid., 136.
154. Ibid., 176, 191.
155. Ibid., 37.
156. Later he listed him as one who should receive the *Histoires grotesques et sérieuses* and *Les Epaves* (*Corr.* II, 275, 432, 624).
157. Ibid., 346.

his thoughts *adequately.* The literary corruption and hypocrisy belong as much to Baudelaire as to Gavarni. And if Baudelaire's analysis of him is correct, Gavarni would surely have appreciated the joke.

Trimolet and Traviès

Trimolet

Although Baudelaire mentions the "gracious and childlike buffoonery" of Trimolet's etchings, he devotes most of his discussion to the unlucky side of the artist's life, his "destinée mélancolique," the "grave afflictions and . . . violent sorrow [that] assailed his poor existence" (561). His few remarks on Trimolet's *comique* imply a certain relation to the *absolu*: "bouffon- nerie" points to the Italian *comique innocent*, and the etchings have a freedom and movement later attributed to Cruikshank's *grotesque*. But Baudelaire leaves these suggestions hanging and pursues instead the theme of the *guignon*. Accordingly, his sole example is not one of the buoyant graphic works, but a painting, the only example of such in the entire essay:

> Dans une nuit sombre et mouillée, un de ces vieux hommes qui ont l'air d'une ruine ambulante et d'un paquet de guenilles vivantes s'est étendu au pied d'un mur décrépi. Il lève ses yeux reconnaissants vers le ciel sans étoiles, et s'écrie: "Je vous bénis, mon Dieu, qui m'avez donné ce mur pour m'abriter et cette natte pour me couvrir!" Comme tous les déshérités harcelés par la douleur, ce brave homme n'est pas difficile, et il fait volontiers crédit du reste au Tout-Puissant. Quoi qu'en dise la race des optimistes qui, selon Désaugiers, se laissent quelquefois choir après boire, au risque d'écraser *un pauvre homme qui n'a pas dîné*, il y a des génies qui ont passé de ces nuits- là! (561)

> [On a dark, wet night, one of those old men who look like a walking ruin and a living bundle of rags has stretched himself out at the foot of a dilapidated wall. He raises his grateful eyes to the starless sky and exclaims: "I thank you, my God, for giving me this wall to shelter me, and this mat to cover me!" Like all the disinherited

tormented by suffering, this worthy man is not difficult, and he willingly gives the Almighty credit. Whatever may be said by the race of optimists who, according to Désaugiers, sometimes fall down after drinking, at the risk of crushing *a poor man who has had no dinner*, there are geniuses who have spent nights like that!]

The language reflects a sentimentality reserved normally for those unfortunate geniuses seen to exemplify the situation of the artist in the modern world, notably Poe. The opening of *Edgar Poe, sa vie et ses ouvrages* (1852) utters a similarly sensational *cri de coeur*:

> Il y a des destinées fatales; il existe dans la littérature de chaque pays des hommes qui portent le mot *guignon* écrit en caractères mystérieux dans les plis sinueux de leurs fronts. . . . On dirait que l'Ange aveugle de l'expiation s'est emparé de certains hommes, et les fouette à tour de bras pour l'édification des autres. (249)

> [There are fatal destinies; there exist in the literature of each country men who carry the words *bad luck* written in mysterious characters in the sinuous wrinkles of their brow. . . . It is as though the blind angel of expiation has taken hold of certain men, and lashes them with all its might for the edification of others.]

Trimolet is in fact a comic victim, living a caricature of a life, sacrificed for the benefit of others, a "farceur" in the manner of Poe. He is the old man of the work described—misjudged, unappreciated, beaten down by fate: "il est mort au moment où l'aurore éclaircissait son horizon, et où la fortune la plus clémente avait envie de lui sourire" (561) [he died at the very moment when dawn brightened his horizon, and when the kindest fortune felt like smiling upon him].[158] He is as neglected as the beggar in the picture is by the "optimistes"; indeed, a contemporary obituary remarks that few will actually feel his loss, for "who in the world worried about Trimolet?"[159]

Baudelaire thus chooses the work most illustrative of the "comedy" of the

158. Cf. Baudelaire's words on Poe (*Présentation de Bérénice*): "il a quitté la vie, comme Hoffmann et Balzac et tant d'autres, au moment où il commençait à avoir raison de sa redoutable destinée" (289) [he quitted this life, like Hoffmann and Balzac and so many others, at the very moment he began to get the better of his terrible destiny].

159. *Les Beaux-Arts* II, 45, 252.

life. The painting is not *La Prière*, as has been assumed,[160] but an etching entitled *Le Vieux Mendiant* (1841), published in *Les Beaux-Arts* in 1844 (Fig. 35).[161] A comparison of the image with Baudelaire's description brings out the dark comedy of the latter. The old man metonymically embodies the dilapidated wall and pile of rags that surround him: he is a "ruine ambulante" and a "paquet de guenilles vivantes," like the grotesque figures of the city in "Les Sept Vieillards" and "Les Petites Vieilles." And his exorbitant thanks fall ironically amid the signs of the meager blessings bestowed in return; likewise his trust vis-à-vis his abandonment by God.

But this is an irony that, in Flaubert's phrase, does not undermine the pathos, but rather intensifies it.[162] The allusion to the hypocrisy of the social *optimistes*, here actors in a vaudeville show, objects of a cabaret *chanson*, directs the devastating sarcasm toward its true target. Those who would deny the truth of the beggar's comedy become themselves the objects of laughter, stumbling in a repetition of the most standard comic situation. Refusing to acknowledge misery and wretchedness while crushing the poor man, they become the cruel God their social optimism denies. And the viewer who laughs at the beggar's ironic situation unwittingly identifies with them, laughing at the fallen man and later stumbling himself. The "pathetic" image is a caricature, bringing out the dualism of the laugher.

As Baudelaire describes him, Trimolet's central figure resembles the "vieux saltimbanque" in his prose poem of that title (1861), who effects a

160. Crépet, *Curiosités esthétiques*, 507; Mayne, *The Painter of Modern Life*, 184. Thackeray's testimony from the 1841 Salon makes clear that *La Prière* is not the work in question: "There are . . . some few whose humble pictures cause no stir, and remain in quiet nooks, where one finds them, and straightaway acknowledges the simple kindly appeal which they make. Of such an order is the picture entitled "La Prière," by M. Trimolet. A man and his wife are kneeling at an old-fashioned praying desk, and the woman clasps a sickly-looking child in her arms, and all three are praying as earnestly as their simple hearts will let them. The man is a limner, or painter of missals, by trade, as we fancy. One of his works lies upon the praying desk, and it is evident that he can paint no more that day, for the sun is just set behind the old-fashioned roofs of the houses in the narrow street of the old city where he lives. Indeed, I have had a great deal of pleasure in looking at this little quiet painting, and in the course of half-a-dozen visits that I have paid to it, have become perfectly acquainted with all the circumstances of the life of the honest missal illuminator and his wife, here praying at the end of their day's work in the calm summer evening" ("On Men and Pictures, à propos of a Walk in the Louvre," in *The Works of Thackeray* xxx, 259f.). *Le Vieux Mendiant* was reproduced, without comment, in a rare limited edition of *De l'essence du rire* (ed. J. Crépet, Paris, René Kieffer, 1925).

161. *Les Beaux-Arts* ii, 45, p. 241. The exact caption reads: "Mon Dieu, je vous rends grâce de ce qu'il vous a plu me donner ce mur pour m'abriter et cette natte pour me couvrir" [My God, I am thankful that it pleased you to give me this wall to shelter me and this mat to cover me].

162. *Corr.* ii, 172.

Fig. 35. Trimolet. *Le Vieux Mendiant,* 1841 (photo: British Library)

similar knowledge of dualism.[163] In the carnival, pantomime atmosphere of the poem—the clowns and mountebanks cracking jokes, the grotesque, ape-like Hercules, the fairy-like dancers leaping and capering, the deafening din and explosive energy, the screeching, bellowing, and howling, the booming brass and exploding rockets (I, 295)—the old clown constitutes at once a contrast and a caricature:

> Au bout, à l'extrême bout de la rangée de baraques, comme si, honteux, il s'était exilé lui-même de toutes ces splendeurs, je vis un pauvre saltimbanque, voûté, caduc, décrépit, une ruine d'homme, adossé contre un des poteaux de sa cahute. (I, 296)

> [At the end, at the very end of the row of booths, as though, ashamed, he had exiled himself from all these splendors, I saw a poor clown, stooped, worn out, decrepit, a human ruin, leaning against one of the posts of his hut.]

Like Trimolet's walking ruin, the "living bundle of rags" lying at the base of a crumbling wall and unnoticed by the social optimists, this "ruin" with his "comical rags" sits against a post of his miserable hut, forgotten by the crowd. Separate, motionless, silent, impassive, he directs his gaze outward, thus carrying out the *flânerie* that his body does not, sending into the crowd an unforgettable look: "Mais quel regard profond, inoubliable, il promenait sur la foule" (I, 296).

But if he seems to the narrator the mere wreck of a clown, the vestige of a once-brilliant "entertainer," he nevertheless effects, through his gaze, a comic reaction, making the speaker sense in the comic object a grotesque image of himself: "Je sentis ma gorge serrée par la main terrible de l'hystérie" [I felt my throat squeezed by the terrible hand of hysteria]. The narrator feels the fearful malaise of Virginie standing before the caricature, the presence of an image of his own dualism, but fails to understand its implications. Just as Baudelaire turns the irony of the Trimolet image upon the self-deluded social optimists, so he turns the irony of the poem upon the supposedly observant narrator, making him, like them, a comic object. The speaker misinterprets the obsessive sorrow that he feels, his *hystérie*, taking

163. On this poem, see J. Starobinski, *Portrait de l'artiste en saltimbanque*, 92ff.; V. Rubin, "Two Prose Poems by Baudelaire: 'Le Vieux Saltimbanque' and 'Une Mort héroïque' "; McLees, *Baudelaire's "Argot Plastique,"* 84f.

it not as the mark of dualism, but as an affirmation of his own superiority.[164]
He sees the clown as an allegory of the poet in an ungrateful world, a
sentimental image of his own self-pity and vanity:

> Et, m'en retournant, obsédé par cette vision, je cherchai à analyser
> ma soudaine douleur, et je me dis: Je viens de voir l'image du vieil
> homme de lettres qui a survécu à la génération dont il fut le brillant
> amuseur; du vieux poète sans amis, sans famille, sans enfants,
> dégradé par sa misère et par l'ingratitude publique, et dans la baraque
> de qui le monde oublieux ne veut plus entrer! (I, 297)

> [And, turning round, obsessed by that vision, I tried to analyze my
> sudden sorrow, and I told myself: I have just seen an image of the old
> man of letters who has outlived the generation of which he was the
> brilliant entertainer; an image of the old poet without friends,
> without family, without children, degraded by his wretchedness and
> the public's ingratitude, and in a booth that the forgetful world will
> no longer enter!]

This cliché-ridden analysis and the self-justification it expresses make the
speaker, too, an object of laughter.[165] The sentimentality of the language is
the poetic equivalent of the optimists' social clichés in Baudelaire's descrip-
tion of the Trimolet image—a mark of the speaker's self-delusion. The old
clown is thus hardly impotent; on the contrary, he achieves a properly comic
effect, exposing, like a superb comic artist, the speaker's self-ignorance and
confronting us with the possibility of our own.

Traviès

Baudelaire's section on Traviès likewise seems to pass over the most obvious
contribution of this artist to caricature—the hunchback Mayeux—and con-
centrates on something from his life. Baudelaire does not analyze Mayeux,

164. Even his pity—his attempt to offer the clown money—is based on this: in the *Poème
du hachisch*, philanthropy is an example of the sense of superiority and the "esprit satanique"
(I, 433f.).
165. Rubin ("Two Prose Poems by Baudelaire: 'Le Vieux Saltimbanque' and 'Une Mort
héroïque,' " 54f.) sees the irony of the ending as asserting the narrator's difference from the
clown, his refusal to identify with him. But the sentimentality of the language suggests a lack
of self-awareness on the speaker's part.

that emblematically corrupt and lascivious petit-bourgeois opportunist of the July Monarchy, but instead traces the process by which he became a popular type: the transformation of a real "physiognomanic" clown named Leclercq into Mayeux, the self-seeker. Baudelaire's history suggests the close relation between caricature and the popular theater at this time, which the centrality of the English pantomime in his own theory affirms. But more important, it asserts Traviès's role in imagining and creating the type, rather than merely copying a figure from the real world, as Monnier had done: "Traviès le vit; on était encore en plein dans la grande ardeur patriotique de Juillet; une idée lumineuse s'abattit dans son cerveau; Mayeux fut créé, et pendant longtemps le turbulent Mayeux parla, cria, pérora, gesticula dans la mémoire du peuple parisien" (562) [Traviès saw him; it was still during the great patriotic fervor of July; a brilliant idea burst into his brain; Mayeux was created, and for a long while the turbulent Mayeux spoke, shouted, perorated, gesticulated in the memory of the Parisian people]. If Baudelaire does not actually discuss Mayeux, the language itself conveys the evolution of the Parisian clown into the perfect representation of the sociopolitical system: his metamorphosing faces become the corrupt and devious strategies of the new man, his ape-like gestures and voice the emphatic, pretentious demeanor of the bourgeois, his wild gesticulation a caricature of the "grande ardeur patriotique" that had marked 1830. And as usual, the caricature preserves the original and highlights the distortion: Mayeux, like his class, carried out the revolution and betrayed it as well, moving from the punning "pearicide" to the sensualist *arriviste* with top hat and cane, exploiting his new-found authority, respectability, and power for his own pleasure (Figs. 36 and 37).

Stylistically, too, Traviès represents a degradation of the true representative of 1830s revolutionary spirit, Daumier. His works are characterized by a lack of sureness, by "hesitations," "lapses," and "tergiversations"; "il s'amende, il se corrige sans cesse; il se tourne, il se retourne" (561) [he amends himself, corrects himself incessantly; he turns in one direction and back again], lacking the power and force of Daumier's "permanent skirmishing." They suffer from an evident dualism, unlike Daumier's, from which the idea springs directly. If Daumier's comedy is created almost without his trying, Traviès' is precisely the opposite, closer to the wrongheadedness of Grandville, and betraying a self-ignorance incompatible with the comic artist: "Il veut être plaisant et il ne l'est pas"; "il trouve une belle chose et il l'ignore" (561) [He tries to be amusing, and he is not; he finds a good thing and does not recognize it].

FIG. 36. Traviès. *Je suis le poiricide Mayeux, tonnerre de D. . . ! vends-moi ton éventaire que je le f . . . à l'eau!!!* [I am the pearicide Mayeux, by God. . . ! Sell me your tray so I can chuck it into the water!] *Facéties de M. Mayeux,* 1831 (photo: British Museum)

FIG. 37. Traviès. *Dis donc farceuse! tu d'meures bien haut* (photo: Bibliothèque Nationale)

Baudelaire ends the essay with a very brief mention of Jacque, which nevertheless suggests the achievement of this artist in the domain of caricature. Jacque fulfills some of the main conditions of the *comique absolu*: the idea presents itself with immediacy and clarity ("d'emblée," "soudaineté," 563), as in Daumier, recalling the single, sudden impression of the *absolu* (536); he merits the adjectives "grave" and "grotesque," features of the higher *absolu*, the German (538); in the *Salon de 1845* Baudelaire praises his etchings for their boldness and freedom (401), necessary elements of the comic. Here he finds in the series *Militariana* and *Malades et médecins* "the pungency and immediacy of the poet-observer" (563)—qualities associated with the best of this genre, but here further enhanced by that privileged term of his criticism, "poète."

Quelques caricaturistes français, in representing and qualifying the notion of the comic proposed by *De l'essence du rire*, provides by its own varied discourse the example of a broad range of comic techniques. But it also contains the ironies and paradoxes of the comic itself. While it purports to illustrate the *significatif* of the French—imitation, moderation, superiority over one's fellows, reasonableness, evident dualism—it shows many of the artists to be invaded by the *absolu*. It thus brings out the crucial harmony of the two—the *absolu* which contains and preserves an element of *significatif*—characteristic of the best comic art.

Moreover, Baudelaire employs a discourse of the *absolu* to present artists principally of the *significatif*: the biting sarcasm, the brutal understatement, and the ironic banality and platitude of the language applied to some have the same ferocity as the exuberant, carnivalesque quality of the section on Daumier. Confronting at every stage the linguistic *absolu*, in its various voices, with the dominant *significatif* of the subject, the essay places ever before the reader the dual structure of comic art, indeed, carries it to its limit. It provokes and disconcerts, challenging us to seek the distinctive *comique* of each artist and to discover it in ourselves, to overcome the self-ignorance of the comic by discerning comic *dédoublement*, to escape the limitations of the self through an understanding of the alternative forms that image it. The extreme dualism of *Quelques caricaturistes français* might actually put the comic theory to its most severe test, bringing out the *significatif* through the infinitely greater power of the *absolu*.

Quelques caricaturistes étrangers

3

Quelques caricaturistes étrangers proceeds according to the order established in *De l'essence du rire*, following the hierarchy of the comic from *significatif* to *absolu*. *Quelques caricaturistes français* had exhausted the range of the *significatif* at its lower level, the traditional domain of the French; the new essay thus opens with the English, who occupy the next level up, the *comique féroce*. But the continuity and resemblances cease there. *Quelques caricaturistes étrangers* represents a very different enterprise from the previous essay: rather than interpreting specific examples, Baudelaire here chooses to characterize an artist's oeuvre in general terms, and states this at the outset (565). Only for Hogarth, Seymour, and Goya does he analyze individual works. Discussions of each artist are brief except for Goya, and the essay itself is about one-half the length of *Quelques caricaturistes français*, despite the vastly greater range of nationalities and periods covered.

The choice of artists is also incomplete and idiosyncratic. There are important omissions—Gillray and Rowlandson among the English, for example—and some who do not merit the attention given them, such as the Italian Pinelli. He admits including the latter to demonstrate what caricature is not, more than what it is, and this of course has its use; but one wonders why, after extolling Bassano and even the French Callot as true representatives of the Italian *comique*, he did not discuss them instead. The example chosen to represent the supposedly German *absolu* is the Flemish Bruegel. Baudelaire exploits the *quelques* of the title: this is a representative sample

of foreign caricaturists, confirming, and often contradicting, the comic categories set by *De l'essence du rire*.

To some extent this may be explained in terms of Baudelaire's circumstances and tastes, and his ambition to include in the project artists of various nationalities, however inconsistent with their own comic tradition. In some cases he would have been limited by the availability of original work: he did not travel and was thus largely dependent on the library, Parisian dealers, and reproductions in journals.[1] Mayne remarks, for example, that he would have known Bruegel entirely through engravings;[2] for German engravings he frequented a dealer in the rue de Rivoli near the Palais-Royal.[3] English caricatures had crossed the Channel regularly since before the Revolution,[4] and London's main illustrated journals were available in Paris; these he could have seen first-hand.

More important than reasons of availability, however, the eccentricities of *Quelques caricaturistes étrangers* provide Baudelaire with a point of departure for a wide-ranging meditation on the *comique absolu*. The essay greatly extends his comic system into the realm of the grotesque, violent, and fantastic, thus complementing the emphasis on the rational and reasonable in *Quelques caricaturistes français*, and exploring a domain crucial to modern art. The essay moves freely between caricature and the grotesque, and even equates the two, for the conception of caricature stated in *De l'essence du rire*—"l'expression plastique du comique" (537) [the visual manifestation of the comic]—had weakened the traditional boundaries and enlarged its scope: grotesque art is a category of caricature, because the grotesque is a category of the comic.

However brief, abstract, and incomplete, *Quelques caricaturistes étrangers* testifies to an astonishing boldness and clarity of vision. Many of the artists discussed had received little or no prior attention in France; the comparative material that I have uncovered and presented here is on the whole sparse and undistinguished. Goya constitutes an exception: the revival

1. For his reliance on the Bibliothèque Nationale, no less notorious for its closures then than now, see the letter to Ulbach, 11 August 1854: "Cependant, si la bibliothèque était fermée longtemps, je serais obligé, particulièrement dans les Caricaturistes étrangers, de laisser quelques lacunes qui ne seraient comblées que postérieurement" (*Corr.* I, 287f.) [If the library were closed for a long time, however, I would be obliged to leave some gaps, especially in the essay on the foreign caricaturists, which could not be filled in until later].

2. *The Painter of Modern Life*, 196.

3. Letter to Nadar, 16 May 1859 (*Corr.* I, 576).

4. On the popularity of eighteenth-century English prints in France, see Melot, "Caricature and the Revolution: the Situation in France in 1789," 27f.

of interest in Spanish art, inspired by the opening of Louis-Philippe's Musée Espagnol, occasioned a number of studies of his work, especially the *Caprichos*. But one finds little on Hogarth, brief mentions only of Cruikshank, nothing whatever on Seymour; Bruegel did not then enjoy the renown and stature that he does in our time, this having been established only later in the century.[5] Baudelaire generalizes and analyzes, compares and contrasts; his insights are usually apposite and frequently brilliant. For all its peculiarities, *Quelques caricaturistes étrangers* bears witness to extraordinary originality and independence of mind, and remains to this day an astute and perceptive statement on the artists studied, as well as a central text for Baudelaire's aesthetic of the modern.

Hogarth, Seymour, and Cruikshank

Hogarth

Using a common ironic rhetorical tactic, Baudelaire organizes the section on Hogarth around the straw-man authority of hearsay and public opinion: "J'ai souvent entendu dire de Hogarth: 'C'est l'enterrement du comique.'" [I have often heard it said of Hogarth: "He is the death of the comic"]. The irony thus identifies his purpose even before stating it openly: to turn this censure into praise ("éloge"), this "malevolent formula" into "un mérite tout particulier" (564). Indeed, by the end of the section the terms of the phrase have been literally reversed: "Hogarth, l'enterrement du comique! j'aimerais mieux dire que c'est le comique dans l'enterrement" (565) [Hogarth, the death of the comic! I would prefer to say that it is the comic in death!] The joke has a point, for Baudelaire aims to redefine the comic in terms of Hogarth's conception of it: those qualities so antithetical to French notions—cold, astringent, funereal, brutal, violent, and sinister (564f.)— may actually comprise the comic character of another national school. Baudelaire insists on the violence of Hogarth's vision, using the word thrice in the space of a page, and thus recalls the distinctive quality of the *absolu*

5. Gautier, for all his interest in the grotesque, never discusses him, and only Wright treats his work in any detail (*A History of Caricature and Grotesque in Literature and Art*, 291ff.). See Grossmann's bibliographical essay in his *Pieter Bruegel*, 29–50.

as represented by the English pantomime in *De l'essence du rire* (538).[6] But here he insists equally on the moral that the violence is explicitly made to serve: "toujours préoccupé du sens moral de ses compositions, moraliste avant tout, il les charge, comme notre Grandville, de détails allégoriques et allusionnels, dont la fonction, selon lui, est de compléter et d'élucider sa pensée" (564) [always concerned with the moral sense of his compositions, moralist above all else, he loads them, like our Grandville, with allegorical and allusive details whose function, according to him, is to complement and elucidate his thought]. The play on *charge* makes the point: the caricatural *charge* becomes in Hogarth, rather, the "weight" of allegorical and allusive details, his dominant moralizing, which keep him from the higher *absolu* and place him squarely in the *féroce*, the English category *par excellence*.

The comparison with Grandville in fact clarifies Baudelaire's position toward both artists. He attributes to Hogarth the same philosophical effort, that is, translating a primarily literary sensibility by means of the visual arts, and resulting occasionally in the same problems: the allusions can backfire, retarding and confusing understanding rather than facilitating it. This art must be read rather than observed, as the author's deliberately conspicuous self-correction indicates ("Pour le spectateur, j'allais, je crois, dire pour le lecteur" [For the spectator, I think I was about to say for the *reader*]); the manner is described as "écrit" (564). But Hogarth succeeds where Grandville, in Baudelaire's eyes, fails. He gets philosophical art right, if philosophical it must be. Baudelaire criticizes the overwhelming dualism of Grandville's work—thought versus art, literary versus pictorial—and his use of speaking balloons as one of many "bastard means" of projecting his thought into the visual arts (558).[7] He does not even mention Hogarth's more abundant captions, but suggests rather the literary quality of the *pictures*, with their allegorical and allusive accessories; this is dualism too,

6. Cf. Champfleury, who, in a remark reminiscent of the beheading of Pierrot in the pantomime, comically likens English caricature to a thick slab of rare English beefsteak, rich, bloody, and palatable only to the heartier appetites and tougher intestines of that people: "C'est le côté particulier à l'Angleterre, en art comme en cuisine, de se montrer rouge, gros, nutritif et apoplectique. Ne sommes-nous pas des figures pâles en face de nos voisins dont le sang est injecté d'épaisses nourritures, d'apéritifs excitants et de dérivatifs qui veulent des estomacs de bronze?" [It is particular to English art, like English cuisine, to be red, rich, nourishing, and full-blooded. Are we not pale figures compared to our neighbors, whose blood is injected with heavy food, stimulating appetizers, and medicines which require stomachs of bronze?] (*Histoire de la caricature sous la République, l'Empire et la Restauration*, 237).

7. Baudelaire is mistaken on this point. Cf. Benjamin's defense of the "allegorical" scrolls attached to the figures in old paintings (*The Origin of German Tragic Drama*, part 3, 197).

but from within the art itself. One might say that the images themselves narrate; the captions are not part of the composition, but merely translate the moral already stated by it. Hogarth the moralist is an artist and a philosopher, Grandville neither the one nor the other (558).

Baudelaire exceptionally prefers *The Rake's Progress, Gin Lane, The Enrag'd Musician,* and *The Distress'd Poet* to the more celebrated *Marriage à la mode* for their greater freedom, "plus d'aisance et d'abandon"— precisely those qualities he requires for the comic overall. He is right to notice this: such "abandon" had to do, by Hogarth's own admission, with the popular subjects and the audience for which they were intended. Correctness of drawing and fine engraving over an etched outline would have given the print finish but made the price too high, and indeed would have weakened the effect.[8] Instead the result is greater immediacy, a spontaneity and freedom of manner characteristic of etching as a medium, and less of the laboriousness that he criticizes in Grandville.

Baudelaire's example of Hogarth's comic narrative comes from his last major series, *The Four Stages of Cruelty* of 1751. *The Reward of Cruelty* (Fig. 38), the final plate of the four, depicts the just deserts of a criminal after a life of cruelty and brutality toward weaker creatures—animals in the first two plates and a young woman in the third. Here his corpse, fresh from the gallows, has been offered to the Company of Barber-Surgeons for dissection. It lies on a table surrounded by doctors in curled wigs and mortarboards, and a public eager for a sensational spectacle, who observe the operation with interest and evident enjoyment. The chief surgeon points at the specimen with his stick; a pulley rope attached to a stake driven into the skull will soon hoist the skeleton up to a second gallows, to hang with other specimens in public view ever after. One surgeon gouges out the eyes, another cuts at the feet, a third removes the intestine, which dangles on the floor; the serpentine gut, a standard image of evil, the inner essence of the criminal, is expelled from the body in death. The torturer has become a victim, and his victims torturers: a dog, object of the man's first crime (represented in the initial plate) here nibbles at the corpse's heart, which has fallen, like some old ball, onto the floor; the gallows knot around the corpse's neck and the pulley rope extending from its forehead repeat the rope around the dog's neck, which the child is cruelly pulling in the first image; the stake driven into the skeleton's skull and the stick with which the

8. *Autobiographical Notes,* in *The Analysis of Beauty,* 226f. See also Paulson, *Hogarth's Graphic Works* I, 211.

FIG. 38. Hogarth. *The Reward of Cruelty*, 1751 (photo: British Museum)

chief surgeon points to its gut reflect the rod stuck up the dog's behind earlier (Fig. 39).

Such vivid and ironic juxtapositions suggest why Hogarth's comic vision so closely matches Baudelaire's own: the comical in the sinister and violent, like the "incorrigible hilarity" found in the "lamentable spectacle" of human ugliness in *De l'essence du rire*. The difference between Hogarth's grotesquely horrible corpse and Charlet's dangling "dancer" (see page 104) marks the distance between the English and the French, *absolu* and *significatif*. Baudelaire perceives the irony of the picture: the man's life of crime is "rewarded" in death by the grotesque humiliation to which his body is subjected, symbolized by the contrast between the naked corpse with its entrails hanging out and the comically bewigged and curled doctors, the stiffness of the body stretched out flat and their "tall, long, thin, or rotund figures," its ghastly expression and their grave ones.[9] The dog's macabre meal is likewise ironic—it eats lustily as the corpse is pathetically disembow-eled and dismembered, it fills its belly while the criminal's is emptied out. In fact it carries out the inevitable justice of death: the reversal by which the victim (the maltreated dog from the first in the series) is avenged and the torturer punished, and by a means wholly appropriate to the crime.

If Baudelaire misses this particular reversal, however, he signals another, less obvious one: this most corpse-like of corpses ("ce cadavre, cadavérique entre tous") becomes almost an object of pity, and the onlookers ridiculous objects of laughter, "les hautes, longues, maigres ou rotondes figures, grotesquement graves, . . . chargées de monstrueuses perruques à rouleaux" (565) [tall, long, thin, or rotund figures, grotesquely grave, . . . laden with monstrous curled wigs]. *Charges* in their own right, the doctors are impli-cated in the comic pattern from which they feel exempt. Hogarth points the moral beyond the "villain" to the doctors themselves and the system of justice that they represent (Paulson notes that the chief surgeon resembles a magistrate).[10] Ultimately he targets the viewer too, who becomes the agent of yet another "stage of cruelty," enjoying this one, as Paulson remarks, with the onlookers in the picture.[11] *Ridicule pendu, tes douleurs sont les miennes* [Ridiculous hanged man, your sufferings are my own]: like the

9. Baudelaire mistakes a few details—he has the dog picking some human remains out of the cauldron in the left foreground, the pulley attached to the intestines, and the figure a *débauché*—and as a result misses the ultimate moral sense of the work, i.e. the perfect, ironic retribution of death.

10. *Popular and Polite Art in the Age of Hogarth and Fielding*, 8.

11. *Hogarth: His Life, Art, and Times* II, 108.

FIG. 39. Hogarth. *The First Stage of Cruelty,* 1751 (photo: British Museum)

corpse of "Un Voyage à Cythère," whose *intestins pesants lui coulaient sur les cuisses* [intestines hanging out spilled over his thighs], the object of laughter here offers an image of the laugher's inferiority—or grotesque comicality—itself.

Gin Lane (1751) (Fig. 40) provides another example that moves Hogarth into the realm of the grotesque: the misfortunes that beset the gin drinkers are too terrible to amuse the French, and have a grotesque violence associated with the *absolu*. Baudelaire does not describe the picture in any detail or discuss its seemingly moralistic purpose (depicting the harmful effects of the lower classes' addiction to gin), but mentions only the predominance of violent deaths in it. Indeed, Hogarth shows in the foreground a baby falling to its death through a mother's inattention, a ballad-seller sprawling dead from drink at the foot of the steps, another baby impaled on a spit in the middle right, a burial taking place in the background, a man dangling from a noose in an upper story on the right, the undertaker's sign—a coffin—hanging prominently in the center of the picture, parallel to the gin-seller's emblematic tankard, as though in a line of causation. Baudelaire's reticence about the moral, his inclusion of this work as an example of Hogarth's freer conception, and his emphasis on its violence, point to the ambiguity of its message. As Paulson observes, the gin drinkers are less perpetrators of the violence than its victims.[12] The sources of the violence, rather, thrust themselves prominently from the buildings: the gin-sellers' tankards, the undertaker's coffin, the pawnbroker's sign—those who profit from the ruin of others. Once again the "reversible" scheme of the comic operates, implicating those who feel most exempt by their moral and social distance from the subject—notably Hogarth's middle-class viewers.

The controversy over the value of Hogarth's narrative emphasis, the uneasy alliance of literary and pictorial, began in the artist's own time and continues today.[13] He won the praise of Fielding and suffered the ridicule of numerous contemporary artists over this question. In Baudelaire's time his reputation as a *moraliste* and *littérateur* was justly widespread, and marked

12. Paulson notes that the pawnbroker's sign seems a cross atop the church spire in the background, which itself carries a statue of the king, thus suggesting the alliance of pawnbroker, church, and state in the crime (*Popular and Polite Art in the Age of Hogarth and Fielding*, 5ff.).

13. R. Vogler, *Reading Hogarth*, UCLA exhibition catalogue, 14f. Hogarth described the *Progresses* in narrative terms in the *Autobiographical Notes* (*The Analysis of Beauty*, 209, 229), but preferred the metaphor of the drama (*The Analysis of Beauty*, 211f.). On the narrative aspects of his art, see also P. J. de Voogd, *Henry Fielding and William Hogarth. The Correspondences of the Arts*, 50ff.; Paulson, *Hogarth. His Life, Art, and Times*, I, 263ff.; and R. Cowley, *Hogarth's Marriage à la mode*.

FIG. 40. Hogarth. *Gin Lane*, 1751 (photo: British Museum)

the divide between supporters and critics of his work. Baudelaire's comments are striking precisely because he transcends this division, celebrating in Hogarth that which others, on either side of the line, dislike—inverting the standard view as he jokingly does the "studio witticism" about the "death of the comic" at the start. In 1843 Gautier, for example, criticizes Hogarth's moralism as a hindrance to his art, and compares his work to the hackneyed moralistic verses of Pibrac.[14] The details have no pictorial value but are meant only to clarify the main action.[15] But although Baudelaire finds these same faults, with characteristic independence (or eccentricity) he merely mentions them in passing, and instead concentrates on those works that overcome them, works in which the pictorial brilliantly renders the literary, as in the ironies of *The Reward of Cruelty*. One senses in his final remark an ironic allusion to Gautier himself: "de nombreuses appréciations ont déjà été faites du singulier et minutieux moraliste" (565) [numerous evaluations have already been done of this singular and meticulous moralist]. This represents Gautier's image of Hogarth, against which Baudelaire offers his own: a moralism deriving from the "aisance" and "abandon" of the *absolu*, the harmony of a dualistic, literary pictorial art.

Wright, like Baudelaire, values Hogarth's delineation of character and his narrative skill: every aspect of the picture, however trivial, serves a purpose in the narrative. He characterizes the art as comedy rather than caricatures per se, following Hogarth's own claims in his *Anecdotes*, and Fielding's in *Joseph Andrews*.[16] But once again Baudelaire's admiration springs from a different source, the moral that comes from the grotesque itself. Indeed, Wright specifically disapproves of the very works that Baudelaire, by contrast, prefers: *Gin Lane* is disgusting and vulgar, and the *Four Stages of Cruelty* repulsive "by the unveiled horrors of the scenes which are too coarsely depicted"—precisely the violence by which English caricature, in Baudelaire's scheme, raises itself above the French.[17]

14. *La Presse*, 19 December 1843. Pibrac's *Quatrains contenant préceptes et enseignements utiles pour la vie de l'homme* date from 1574.

15. "Il nous semble qu'Hogarth . . . s'est trompé de vocation . . . La plume lui venait mieux que le pinceau; il aurait été un remarquable essayiste, un parfait écrivain de moeurs" (ibid.) [It seems to us that Hogarth . . . followed the wrong vocation. The pen came to him more easily than the brush; he would have been a remarkable essayist, a perfect writer of manners].

16. See page 81.

17. *A History of Caricature and Grotesque in Literature and Art*, 445. Likewise, Wright considered *Marriage à la mode* Hogarth's greatest work, while Baudelaire thought it "hard," "literary," "fussy" (564).

Seymour

Seymour's work, too, represents the violence and excess characteristic of the English and the *comique féroce*. However, the brutality ascribed to Hogarth appears here not in the subject but in the starkness of presentation, the simple, direct, and "ultra-brutal" way of stating the subject (565f.). In his prose, Baudelaire thus follows his subject's lead, launching immediately into an example—Seymour's portrayal of the adventures of bourgeois city-dwellers on sporting outings in the country, a mock-epic to fit the comedy of a middle-class national obsession: "les admirables charges sur la pêche et la chasse, double épopée de maniaques" (565) [the admirable caricatures on fishing and hunting, that twofold epic of maniacs].[18] In a series of 180 prints, the *Sketches* illustrate the fiasco of leisure, the bourgeoisie's ludicrous and failed attempt to reappropriate the lost—or fantasized—idylls of Nature.[19]

Baudelaire's description of one of the best *Sketches*, *The deep, deep sea!* (no. 153) (Fig. 41), in fact reproduces the blunt ironies and direct juxtapositions that constitute Seymour's special brand of humor. Out in his pleasure boat "The Water Nymph," a top-hatted, well-fed townsman, cigar held aloft, wine bottles and ample picnic basket displayed behind him, exclaims ecstatically at the sea which, unbeknownst to him, has swallowed up his lady companion: only two stout legs protruding from the water remain to tell the story. Baudelaire suggests a first irony, the bombast of the caption relative to the mere quarter of a league that separates the boat from the port, with the buildings of London still visible in the distance. To this the language, like the image, adds a further irony: "Il paraît que cette grasse personne s'est laissée choir, la tête la première, dans le liquide élément dont l'aspect enthousiasme cet épais cerveau" (566) [It appears that this stout person has allowed herself to fall head first into that liquid element, the sight of which so enthuses this fathead.]. This sea may be just "deep" enough to drown the fat and inexperienced city-dweller before the unseeing eyes of her thick-headed husband; the boat is not the only "water nymph" in the picture. Perhaps more importantly, Baudelaire translates through the lan-

18. Besides the *Sketches*, see Seymour's illustrations to R. Penn's *Maxims and Hints for an Angler* and *Miseries of Fishing*, 1833.

19. On bourgeois hunting scenes as the image of a class fear and uncertainty—its inability to carry through its own ambitious enterprise—see Klaus Herding, "Le Citadin à la campagne: Daumier critique du comportement bourgeois face à la nature." The *Sketches* were first published in 1834 and 1836, then as a series in 1838.

FIG. 41. Seymour. *The deep, deep sea! Sketches,* 1838 (photo: Cambridge University Library)

guage the exemplariness of the image, its concentration of the themes and manner of the series overall, including its mockery of an entire class: "Tout à l'heure ce puissant *amant de la nature* cherchera *flegmatiquement* sa femme et ne la trouvera plus" (566, my emphasis) [In a little while this formidable lover of nature will phlegmatically look for his wife and will not find her]. The irony points well beyond the image at hand, making fun of those two proverbial English traits that Seymour targets in the *Sketches* as a whole—phlegm and the love of nature. Like the *Sketches*, Baudelaire's irony mocks the bourgeois parody of the bourgeoisie's own values, ideals, and aspirations.

There was little written on Seymour (and nothing in French) before Baudelaire's essay, and despite the originality of his wit and his accomplished artistry, he remains to this day an underrated, under-appreciated caricaturist and illustrator. Baudelaire is concerned to correct this, noting that it would be unfair ("injuste") not to mention him (565), but also implies that he is well known as the source of the famous image of the spider weaving its web between the arm and line of a fisherman. The discrepancy in fact targets the unoriginality of Henri Monnier, who unscrupulously "borrowed" this image and popularized it.[20] (He does not mention another, more serious borrowing of Monnier's from Seymour: the emblematic M. Prudhomme himself, who resembles Seymour's Mr. Pickwick to a remarkable degree [Fig. 42]). Through Baudelaire's own comic act, the "injustice" is subtly but clearly redressed, and Seymour's place reclaimed from the French usurper.

Cruikshank

The section on George Cruikshank concentrates exclusively on the artist's claim to the *absolu*, that is, the inexhaustible wealth of his grotesque (566). *Grotesque* occurs four times in the first paragraph alone; Baudelaire locates it in the theatrical quality with which Cruikshank endows his figures, the violence of gesture and movement, and his explosive expression (566). The vocabulary of the *absolu—verve, violence, mouvement, explosion, fureur, turbulence*—predominates, and Baudelaire makes the connection explicit

20. Baudelaire does not mention Seymour's direct influence on Daumier's series, *La Chasse* (1836–37). Houfe (*Dictionary of British Book Illustrators and Caricaturists*, 80) also cites Seymour's *The Great Joss and His Playthings* (1829), satirizing the Prince Regent's extravagance, as a source for Daumier's *Gargantua* of 1833.

Fig. 42. Seymour. *Mr. Pickwick addresses the club*, 1836 (photo: Cambridge University Library)

by evoking the pantomime to which they originally applied in *De l'essence du rire*: "Tous ses petits personnages miment avec fureur et turbulence comme des acteurs de pantomime. . . . Tout ce monde minuscule se culbute, s'agite et se mêle avec une pétulance indicible" (566f.) [All his little characters mime their part with frenzy and boisterousness, like pantomime actors. . . . All these miniscule people tumble over themselves, move wildly about, and mingle together with indescribable liveliness].

This quality is everywhere apparent in Cruikshank's work: an uproarious commotion, the pandemonium and rough-and-tumble brawling of *St. Patrick's Day*, the skittish, jerky movement and macabre mishaps of *Sees-Unable Weather*, the clown-like gags of *A New Art-if-ice*, where the skaters crash through the artificial ice into the game room below, allowing some of the less scrupulous players to make off with the money (Figs. 43–45). Baudelaire's language is hyperbolic, as though Cruikshank's oeuvre stands at the limits of the human imagination in quantity and spirit: an "inexhaustible" abundance, an "inconceivable," "impossible" verve (566). The prose has the carnivalesque freedom and movement of the pantomime, as a

FIG. 43. George Cruikshank. *St. Patrick's Day. Comic Almanach,* March 1838 (photo: Cambridge University Library)

FIG. 44. George Cruikshank. *Sees-Unable Weather. Comic Almanach,* November 1841 (photo: Cambridge University Library)

catalogue conveys the dizzying profusion of Cruikshank's ongoing production: "une oeuvre immense, collection innombrable de vignettes, longue série d'albums comiques, enfin . . . une telle quantité de personnages, de situations, de physionomies, de tableaux grotesques, que la mémoire de l'observateur s'y perd" (566) [an immense oeuvre, an innumerable collection of vignettes, a long series of comic albums, and . . . such a quantity of grotesque characters, situations, expressions, and scenes that the observer's memory loses its bearings]. In another stab at Monnier, Baudelaire contrasts this ebullience, imagination, and life with the coldness of those "modern French plagiarists" who vainly try to appropriate his subjects and style.[21] Cruikshank's grotesque is all his own, and gives the impression of unity that marks the *absolu*: it is his *natural* manner, "inevitable," his "way" (566), coming as effortlessly from his pen as *rime riche* from the pen of born poets.

But the poet enjoying the flow of *rime riche* may not pay sufficient attention to the rest of the line. Indeed, Baudelaire finds a lack of sureness

21. That Monnier was inspired by Cruikshank, notably the *Scraps and Sketches*, was well known. He knew Cruikshank in London in the 1820s and dedicated his *Distractions* (1832) to him. See the preface to the French translation of Wright's history, *Histoire de la caricature et du grotesque dans la littérature et dans l'art*, xxvi.

FIG. 45. George Cruikshank. *A New Art-if-ice*. *Comic Almanach*, July 1844 (photo: Cambridge University Library)

in Cruikshank's draftsmanship, resulting less from inability than from the inattention consequent upon enthusiasm, the "pleasure" of abandoning himself to his "prodigious verve." He thus lacks the conscientiousness earlier praised in Daumier (553); he is sometimes more of a "sketcher" or scribbler ("crayonneur") than an artist (566). There results a mechanical quality, a lack of credibility, "hypothèses humaines" rather than plausible characters. In their exuberance, his figures forfeit their naturalness:

> l'auteur oublie de douer ses personnages d'une vitalité suffisante. Il dessine un peu trop comme les hommes de lettres qui s'amusent à barbouiller des croquis. Ces prestigieuses petites créatures ne sont pas toujours nées viables. (566f.)

> [the author forgets to endow his characters with sufficient vitality. He draws a bit too much like men of letters who amuse themselves scribbling sketches. These amazing little creatures are not always born to live.]

The joke is apparent: if Cruikshank has the ease of the poet of *rime riche*, his drawing frequently approaches the poet's marginal scribblings and doodles. This draftsmanship translates his wit and verve, but at the price of the truth of movement, the viability, the perfect appropriateness, the "tel nez, tel front, tel oeil, tel pied, telle main" of Daumier (556). This in no way contradicts the basic definition of the grotesque as the perceived superiority of humanity over nature; Baudelaire does not uphold an aesthetic of realism (which would itself be incongruous with caricature). Naturalness here applies not to an outside standard provided by Nature, but to the figure's *own* nature, a naturalness within itself, however grotesque or "unnatural" it may be—an idea for which Baudelaire argues throughout his career.

Baudelaire's assessment of Cruikshank is not typical: he insists on the fantastic and grotesque qualities of an artist more commonly cited, in Wright's words, for his "kindly and genial spirit."[22] Wright portrays him as a true follower of Hogarth in the creation of moral comedies, but who surpassed the master in making each detail of the picture contribute to the "story." Only Thackeray, in his 1840 article, brings out the grotesque, rather than whimsical, quality of Cruikshank's work, his genius for the

22. *A History of Caricature and Grotesque in Literature and Art*, 494.

terrible and ridiculous, and his mixture of real and supernatural, all aspects of Baudelaire's *absolu*.[23] Thackeray likens Cruikshank's illustrations to a pantomime, and describes one print as "writhing and twisting about like the *Kermess* of Rubens."[24] Moreover the viewer experiences the sudden, full laughter of the *comique absolu*: "There must be no smiling with Cruikshank. A man who does not laugh outright is a dullard."[25] But Thackeray finds in Cruikshank's draftsmanship the conscientiousness and attention to form that Baudelaire denies, and discovers only in Daumier.[26] Baudelaire may have known the article and responded to it, emphasizing, to the exclusion of all else, Cruikshank's grotesque and its relation to the *absolu*.[27] Indeed, he presents a more dynamic artist of immense creative energy and imagination, as his wealth of adjectives of abundance attest: *inépuisable, innombrable, inconcevable, immense, extravagante, prodigieuses, riches* (566f.)—an energy unrivalled except perhaps by the prolific invention of Daumier and the violent supernaturalism of Goya.

Goya

"In Spain, an extraordinary man has opened up new horizons in the comic." The opening sentence, placed apart from the rest, states dramatically the centrality of Goya to Baudelaire's notion of comic art. If, like the Spanish *comique* in general, Goya lies between the two main types—neither purely *absolu* nor purely *significatif* (567)—this represents no moderate, middle-of-the-road position, as Baudelaire's terms make clear: *effrayant, contrastes violents, épouvantements de la nature, grotesques horreurs* (568), *hideur,*

23. "An Essay on the Genius of George Cruikshank," in *The Works of Thackeray* XXVI, 428ff., 441, 457f., 469.

24. Ibid., 434, 428.

25. Ibid., 430.

26. Ibid., 471. Indeed Thackeray's tribute to Cruikshank resembles Baudelaire's later tribute to Daumier on a number of specific points: a man of the people, Cruikshank has the same kindness, benevolence, and good faith, has given pleasure to the same myriads of people, and is rewarded with the same ingratitude by a public that considers his work a popular and thus secondary form (ibid., 448, 467, 475ff.).

27. The article appeared in the *Westminster Review* 66 (June 1840); Baudelaire later had a review copy of the 1861 *Fleurs du mal* sent to this review and also to "Thackeray's *Cornhill Magazine*" (*Corr.* II, 126).

saletés morales, vices, cauchemar (569), *monstrueux, monstres, contorsions, grimaces* (570). Indeed, Baudelaire discovered in the art of Goya the extraordinary relation between the comic and the fantastic by which he defines the *comique absolu* in *De l'essence du rire*: the comic taken, like the clowns, to the frontier of the marvelous (541), to the visionary "intoxication" of Hoffmann (542). Goya combines *significatif* and *absolu* in the best tradition of the fantastic, successfully making the fantastic enter the realm of the real and obscuring the line between them. His oeuvre is the nightmare peopled by unknown forms, the "cauchemar plein de choses inconnues" of "Les Phares," and the fantastic a natural quality of his comic vision, rather than a simple effect: "le regard qu'il jette sur les choses est un traducteur naturellement fantastique" (567) [the eye he casts upon things translates them naturally into the fantastic].

Just as, in the case of Hoffmann, the *absolu* was rooted in the *significatif*, the grotesque in the moral, here Goya maintains a perfect balance of opposites and produces an oxymoronic art that constitutes a new form and a new level of achievement in the comic: "Le grand mérite de Goya consiste à créer le monstrueux vraisemblable. Ses monstres sont nés viables, harmoniques. Nul n'a osé plus que lui dans le sens de l'absurde possible. Toutes ces contorsions, ces faces bestiales, ces grimaces diaboliques sont pénétrées d'*humanité*" (569f.) [The great merit of Goya consists in creating a monstrousness which seems likely. His monsters are born viable, harmonious. No one has ventured more than he in the sense of the absurd which seems wholly possible. All these contortions, these bestial faces, these diabolical grimaces, are imbued with *humanity*].[28] Like Hoffmann's, his grotesque maintains its credibility, intelligibility, and power by its contact with the real, or with the illusion of reality. This saves him from the flaw of Cruikshank's *crayonnage*, described in the same terms: Cruikshank's sketchy figures are not "nées viables" (567), Goya's specifically are (570). However monstrous, they remain harmonious within themselves; hence their peculiar verisimilitude, their paradoxical naturalness. They reflect the principles of portraiture applied to the grotesque, like Daumier's caricatures of political personalities. Goya's execution, characterized by *certitude* and originality of conception and technique, allows him to maintain this balance

28. Baudelaire attributes the same ferocity, brutality, and violence to Goya's studies in the *Salon de 1846* (452), and associates these qualities with the comic, but there does not give equal weight to his humanity. In 1859 he described the *Maja desnuda* as "du Bonington ou du Devéria galant et féroce" [a kind of fierce and gallant Bonington or Devéria] (*Corr.* I, 574).

of extremes, to express a "monstrueux vraisemblable," an "absurde possible," a *human* diabolism, an art "at once transcendent and natural" (570). Baudelaire's terms express the indivisible character of Goya's paradoxes, his unity in dualism. As we shall see, this inseparable union of fantastic and real will come to define the art of modernity too, showing the fantastic in the real and the reality of the fantastic in the urban world of Guys.

In insisting throughout the section on this harmony of opposites, Baudelaire makes a statement of remarkable insight, defining an aspect of Goya's art that has not been fully appreciated to this day. Combining fantastic and real, light and dark, joviality and horror, vagueness and certitude, gaiety and *épouvantement*, harsh anticlericalism and a fascination with "witches, sabbaths, *diableries*"(568), Enlightenment reason and an obsession with the supernatural, Goya's art everywhere reflects a fertile and expressive ambiguity. The famous set-piece from the *Caprichos, El sueño de la razón produce monstruos* ("The Sleep of Reason Produces Monsters," no. 43), provides a fine example (Fig. 46). Baudelaire does not discuss this image but clearly understands the interplay of the rational and irrational that it depicts, and their reciprocal value in Goya's oeuvre overall. As the title states, the sleep of reason produces the monsters of superstition, prejudice, ignorance, and oppression; but at the same time, only *through* the sleep of reason are the monsters exposed and the immense power of the irrational brought to light—through the equally monstrous creations of the *Caprichos* themselves.[29] And the dual, equivocal quality that Baudelaire discerned appears in example after example: as Gassier and Wilson point out, the witchcraft scenes could be drawn from life, and the "realist" scenes of social satire have a dreamlike quality.[30] Baudelaire grasped the ambiguity that Goya preserved at the heart of his most "enlightened" works: not only the "residuum of darkness," which remains even in the enlightened mind, as Licht puts it,[31] but, more radically, that "darkness"—the irrational, supernatural, and grotesque—that is part of the process of enlightenment itself. If the inescapable uncanniness of Goya's images calls into question the ability of reason to defeat evil,[32] it may also suggest the *impossibility* of defeating evil other than through the *irrational*, that is, the extraordinary,

29. The term *capricho* suggests not only fantasy and caprice but extravagance and irrationality as well. See E. Sayre, "Introduction to the Prints and Drawings Series," xcviii.

30. *Goya: His Life and Work, with a Catalogue Raisonné of the Paintings, Drawings, and Engravings*, 129.

31. F. Licht, "Goya and David: Conflicting Paths to Enlightenment Morality," lxxx.

32. Ibid., lxxxii.

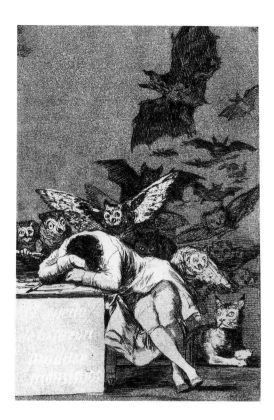

FIG. 46. Goya. *El Sueño de la razón produce monstruos. Caprichos* no. 43, 1799 (photo: British Museum)

extravagant creations of the imagination. *El sueño de la razón produce monstruos*: the *Caprichos* were originally to be called *Sueños*;[33] the "sleep of reason" and the means of enlightenment may be one and the same thing, and the "phénomène de la chute" a "moyen de rachat."[34] As Goya's own inscription on the preparatory drawing for the plate suggests, only the *sueño*, the *capricho*, the irrational and grotesque, will lead to truth: "El autor soñando. Su yntento solo es . . . perpetuar con esta obra de caprichos, el testimonio sólido de la verdad" [The author dreaming. His only intention is . . . to perpetuate with this work of irrational fantasies the firm testimony of truth].

33. Sayre, "Introduction," xcviii.
34. Cf. G. Levitine ("Some Emblematic Sources of Goya," 121ff., 129f.) who reaches a similar conclusion, but sees Goya as thus warning against the dangers of imagination, rather than exposing through its creations the monsters of real life.

Baudelaire also maintains that, while Goya's works allude to historical figures and events, they are intelligible even to viewers unfamiliar with these (568). Once again he conjures up an imaginary observer and makes him react, Virginie-like, to the unknown:

> J'imagine devant *Les Caprices* un homme, un curieux, un amateur, n'ayant aucune notion des faits historiques auxquels plusieurs de ces planches font allusion, un simple esprit d'artiste qui ne sache ce que c'est ni que Godoï, ni le roi Charles, ni la reine; il éprouvera toutefois au fond de son cerveau une commotion vive, à cause de la manière originale, de la plénitude et de la certitude des moyens de l'artiste, et aussi de cette atmosphère fantastique qui baigne tous ses sujets. (567f.)

> [I imagine in front of the *Caprichos* a man, an enthusiast, an art-lover, having no notion of the historical facts to which several of these plates allude, a simple artistic soul who may not know who Godoy is, or King Charles, or the queen; yet he will feel a sharp shock deep within his brain, because of the artist's original manner, the fullness and sureness of his means, and also that fantastic atmosphere which suffuses all his subjects.]

As in the case of Virginie, this "commotion vive" is a subconscious mark of understanding, a sign of the art's effect. Goya's works thus outlive the historical events to which they allude and pass the ultimate test of *caricature artistique*, "toujours durable et vivace, même dans ces oeuvres fugitives, pour ainsi dire suspendues aux événements" (568) [forever enduring and vital, even in these fugitive works, hanging on events, so to speak]. In this they resemble the self-sufficient and enduringly suggestive works of Daumier, wholly comprehensible without their captions, and differ from the political allegories of Bruegel, which are almost wholly unintelligible today (573). For Baudelaire's hypothetical viewer, the fantastic is an aid to understanding, rather than a source of confusion, for Goya transforms the individual and particular into the universal. We recognize in his visions our own, as though the work before us were a product of our own imagination, our own repressed dreams, desires, and anxieties: "Du reste il y a dans les oeuvres issues des profondes individualités quelque chose qui ressemble à ces rêves périodiques ou chroniques qui assiègent régulièrement notre sommeil" (568) [Moreover, in works coming from profoundly individual

minds there is always something that resembles the periodic or chronic dreams that regularly besiege our sleep].

Goya's very modernity consists in the comic—violent contrast, distortion, caricatural forms: "l'amour de l'insaisissable, le sentiment des contrastes violents, des épouvantements de la nature et des physionomies humaines étrangement animalisées par les circonstances" (568) [a love of the ungraspable, a feeling for violent contrasts, for the horrifying aspects of nature and for human physiognomies strangely animalized by circumstance]. This is accordingly presented as an alternative to the Voltairean satire of the Enlightenment, yet no less effective in its criticism of human mores and institutions: "toutes ces blanches et sveltes Espagnoles que de vieilles sempiternelles lavent et préparent soit pour le sabbat, soit pour la prostitution du soir, sabbat de la civilisation!" (568) [all those fair-skinned and slender Spanish girls that ancient hags wash and prepare for the witches' sabbath, or for nighttime prostitution, the witches' sabbath of civilization!] The *Caprichos* (1799) are indeed composed of two main types: on the one hand, satirical caricatures on the follies and vices of humanity—cruelty, extortion, prostitution, manipulation, gluttony, hypocrisy, superstition, political corruption; on the other, the famous scenes of hallucinatory fantasy and witchcraft. But for Baudelaire the latter have moral implications as significant as those of a more evident social satire: prostitution is the witches' sabbath of civilization. Reality can be understood through the fantastic and irrational, the social through the supernatural, and with all the more power: we recognize the political, social, and moral ugliness as part of our own fantasies, coming from within. We thus cannot dissociate ourselves from it through an ostensibly "real" difference of age, class, or situation. The fantastic, in the best tradition of caricature, cannot be resisted, as with the clowns before the magic of the fairy's wand, or Virginie before her caricature.

In keeping with his emphasis on the fantastic aspect of Goya's *comique*, Baudelaire chooses his main examples from the witchcraft group of the *Caprichos*, and within it, two of the strangest and most difficult plates of the set. *Quién lo creyera?* ("Who would believe it?" no. 62) (Fig. 47) resists localization and could belong to the real or imaginary: "Est-ce un coin de Sierra inconnue et infréquentée? un échantillon du chaos?" (569) [Is it some corner of a remote, unknown sierra? a sampling of chaos?] The uncertainty of the image—its refusal of the categories by which time and space are ordered—provides an example of the "amour de l'insaisissable" that defines

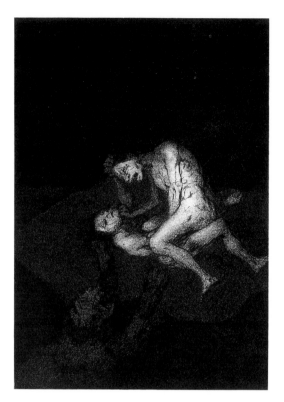

FIG. 47. Goya. *Quién lo creyera? Caprichos* no. 62, 1799 (photo: British Museum)

Goya's modernity.[35] Its central figures, two witches struggling furiously with one another as they ride through the air, combine human and beast. Baudelaire sees in it an image of evil, vice, cruelty, and power:

> Là, au sein de ce théâtre abominable, a lieu une bataille acharnée entre deux sorcières suspendues au milieu des airs. L'une est à cheval sur l'autre; elle la rosse, elle la dompte. Ces deux monstres roulent à travers l'air ténébreux. Toute la hideur, toutes les saletés morales, tous les vices que l'esprit humain peut concevoir sont écrits sur ces deux faces. (569)

35. For F. Licht (*Goya: the Origins of the Modern Temper in Art*, 101ff.), this disruption of our terms of orientation and our normal approaches to the exterior world constitutes the radically new vision of the *Caprichos*.

[There in the midst of that abominable theater, a fierce battle is taking place between two witches suspended in the air. One is astride the other, thrashing and taming her. These two monsters go spinning through the gloomy air. All the hideousness, all the moral filth, all the vices that the human spirit can imagine are written on these two faces.]

Baudelaire does not here mention the leopard-like creatures pouncing on the two central figures, although he does so in his 1858 poem on the subject, "Duellum."[36] These in fact motivate Goya's caption—"Who would believe it?": the witches claw at each other and pull one another's hair, oblivious (and thus prey) to the common menace that looms above and below. Suspended between two dangers they destroy one another, their clutching and clawing as vicious as that of the monstrous animal which lunges at them. In "Duellum," the furious struggle specifically represents that of love, or love mixed with hatred, which leads them into the abyss. Here, however, Baudelaire leaves the question open, suspended like the figures in the air. Such non-specificity invites us to interpret the image in multiple ways, according to our own experience, fantasies, or anxieties, thus illustrating the principle of the fantastic stated above, by which we see in Goya's vision our own. The moral is inseparable from the art, and thus indeterminate, ensuring the power of the image to convey and interpret different aspects of the viewer's reality, or that of different viewers over time. In this lies the enduring power of *caricature artistique*, the ongoing significance of these paradoxically fleeting works "hanging on events" (568).

A similar indeterminacy permeates the second work, *Y aun no se ván* ("And still they do not go away," no. 59) (Fig. 48). The image itself is puzzling and has provoked various, sometimes contradictory, interpretations. A massive, heavy, dark stone slab leans diagonally across the surface of the picture. A naked, skeleton-like figure holds it up, breaking its fall and attempting to push it away. Several grotesque figures, traditionally associated with vampirism,[37] look on: those in the background huddle together; a woman in the center watches fearfully, her hands clasped; a man appears to be caught under the stone at its base. A luminous middle background, as

36. On the relation between Goya's plate and the poem, see D. Scott, *Pictorialist Poetics*, 67f.; D. Festa-McCormick, "Elective Affinities between Goya's *Caprichos* and Baudelaire's *Danse Macabre*," 304f.; and J. Prévost, *Baudelaire*, 121ff.

37. F. J. Sánchez Cantón, *Los Caprichos de Goya y sus dibujos preparatorios*, 94; R. Alcalá Flecha, *Literatura y ideología en el arte de Goya*, 455f.

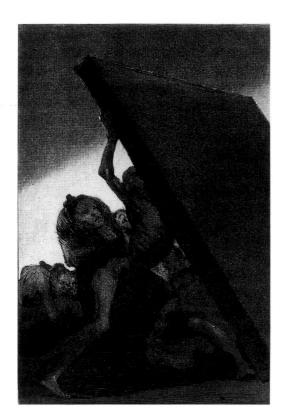

Fig. 48. Goya. *Y aun no se ván. Caprichos* no. 59, 1799 (photo: British Museum)

though a dawning light, contrasts with the darkness of the stone and the shadow that engulfs the figures. Baudelaire takes it as one man's desperate and doomed attempt to escape from the grave while demons and gnomes oppose his effort—an image of the insurmountable finality of death: "Ces gardiens vigilants de la mort se sont coalisés contre l'âme récalcitrante qui se consume dans une lutte impossible" (569) [These vigilant guardians of death have united to oppose the recalcitrant soul wearing himself out in an impossible struggle]. But although this is a common explanation, advanced in a variant form by Gautier,[38] it somewhat misconstrues the image: the

38. Cf. N. Glendinning, *Goya and his Critics*, 314f., n. 27. Gautier, describing the plate in a famous article for *Le Cabinet de l'amateur* in 1842 which Baudelaire mentions, interpreted it as a joint effort, the ghost and his companion phantoms engaged in a tragic and futile battle to escape death.

grotesque figures do not counteract the central one but merely look on, huddling together in fear, as he struggles with the stone. The generally accepted view allies the stone with the light: the massive weight of enlightenment progress, reason, and truth is about to entomb the deathlike forces of darkness, ignorance, and superstition, as represented by the grotesque figures in its path, including the central one.[39] The caption would thus imply that despite the advancing threat of annihilation they still "do not go away."

But such a neat explanation fails to satisfy the ambiguities of Goya's work. Baudelaire's conception of the central figure as a desperate, solitary monad, separate from the others and trying with all his might to escape from his tomb (569), a "recalcitrant soul" fighting off the oppressive weight of death, should not be rejected. Indeed the central figure, placed at the same angle against the stone and at almost the same height, meets the threat powerfully, even heroically; his emaciated figure reveals at the same time an extraordinary musculature, and his effort appears superhuman, straining and distorting every aspect of his body. As Helman notes, he resembles the dead man brought back to life in Goya's fresco for the church of San Antonio de la Florida done around the same time;[40] his *Saint Jerome* also has the same emaciated legs and torso with the ribs showing through.[41] Moreover the stone is dark and opaque, in contrast to the dawning light (so standard an image, at the time, of the forces of enlightenment) that falls on the faces of the hag in the middle and the cowering gnome in the background.

The image might thus represent a lone, perhaps doomed struggle to throw off a weight that keeps the figures in a deathly darkness, prey to the forces of superstition, ignorance, and corruption, and that threatens to crush or bury them altogether. Whether this force of darkness is that of the lamentable reign of Charles IV, the oppressive influence of the Church, or the authority of superstition and unquestioned common beliefs, is immaterial; all are concerns of Goya's in the *Caprichos*. The exclamatory caption would then underline a frustrating irony: the figures do nothing to escape despite the brilliant light and the extraordinary efforts of the central one to create the conditions under which they might free themselves.[42] The image, sus-

39. E. Sayre, *The Changing Image: Prints by F. Goya*, 112; Alcalá Flecha, *Literatura y ideología en el arte de Goya*, 455f.; Camón Aznar, *Francisco de Goya*, III, 91; E. Helman, *Los Caprichos de Goya*, 120f.

40. Ibid., 121. The subject is *The Miracle of Saint Anthony of Padua* (no. 717 in Gassier and Wilson, *Goya: His Life and Work*).

41. No. 716 in Gassier and Wilson, *Goya. His Life and Work*.

42. On the various functions of the caption in the *Caprichos* (although not the one under discussion), see J. Battesti-Pelegrin, "Les Légendes des *Caprices*, ou le texte comme miroir?"

pended where the two planes meet (the stone and the diagonal line separating light and dark), leaves in question whether the stone will be held up long enough for the light to prevail, or whether this shines uselessly, powerless to disperse the engulfing darkness. The commentary on the plate would then deepen the irony: "He who does not reflect on the inconstancy of Fortune sleeps peacefully while surrounded by dangers; he does not know how to avoid the danger which threatens him, and there is no misfortune which does not surprise him."[43] This applies not to the central figure, who meets the misfortune head-on, but to the onlookers. And the irony lies in the fact that they hardly sleep peacefully, oblivious to their danger, once it has struck; this is perfectly represented in the figure lying under the stone, his mouth open in sleep or a groan of agony, his body curled up in slumber or contorted in pain and horror. Their tranquil sleep becomes a nightmare as they watch in a paralysis of fear, incapable of escaping even when the courage and foresight of another make it possible.[44]

Baudelaire also discusses Goya's splendid final series of 1825, the four lithographs of *The Bulls of Bordeaux*.[45] These are "vast pictures in miniature" (569), having the status of canvases, caricatures that attain the highest level of art. Baudelaire remarks upon the extraordinary movement that Goya renders in these images—the surging of crowds, the charging of the bulls, the various scenes of activity splintered over the surface of the picture—and that later generations would regard as a daring and modern use of composition.[46] He insists on this movement and energy in his description of no. 3 (*Diversión de España*), with its tumult and chaos, its "tohu-bohu" (569) (Fig. 49). Significantly, however, he neglects the activity at the center of the work (and occupying most of the picture)—the four kicking bulls have left behind a gored man on the ground. He concentrates

43. "El que no reflexiona sobre la inestabilidad de la fortuna duerme tranquilo rodeado de peligros: ni sabe evitar el daño que amenaza, ni hay desgracia que no le sorprenda." (J. Camón Aznar, *Francisco de Goya*, III, 91) That the commentaries were written by Goya, as the Prado manuscript attests, has been doubted for decades, although they are contemporaneous with the production of the *Caprichos* and may have been intended to accompany the set. See Sayre, "Introduction," ci and n. 24. R. Andioc ("Al margen de los Caprichos: las 'explicaciones' manuscritas," 281) attributes them to Goya's friend, the poet Leandro Fernández de Moratín, as first suggested by Helman (*Los Caprichos de Goya*, 125, 127f.).

44. Klingender (*Goya in the Democratic Tradition*, 99) misses the ambiguity but suggests a possible political interpretation—the Spanish people had not awakened to throwing off their oppressors.

45. Delacroix, awed by the *Bulls of Bordeaux* in 1846, obtained a set from his friend Dauzats in September of that year. Baudelaire may have seen them at his studio.

46. Cf. Glendinning, *Goya and his Critics*, 126f.

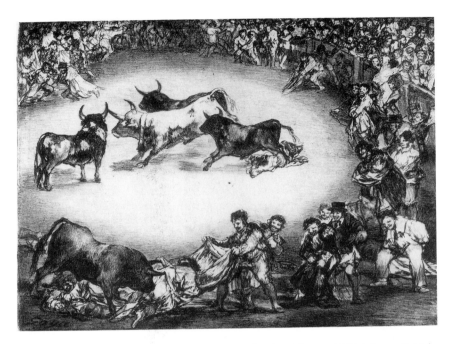

Fig. 49. Goya. *Dibersión de España. The Bulls of Bordeaux,* 1825 (photo: British Museum)

instead on the scene in the foreground, where a bull has captured a man from behind with his horns, forced him to his knees, lifted his shirt and exposed his buttocks to the crowd. This skewed perspective follows that of the work itself: the ring placed off-center to the left makes the eye follow the laughing crowd round to the source of its laughter, the comical scene in the left foreground. For Baudelaire it combines the ludicrous and the horrible, "indecency amid the carnage," a comical obscenity within the general brutality. Goya indeed gives a circus quality to this "Dibersión" amid its images of tragic violence, emphasized by the extraordinarily brilliant ring in which the rushing bulls appear almost to be frolicking, and by the evident merriment of the crowd. He brings out the conjunction of barbarous violence and entertainment, "carnival and carnage" as Gassier and Wilson put it,[47] and thus illustrates the close relation between violence and the comic characteristic of the *absolu.*

47. *Goya: His Life and Work,* 347.

Baudelaire's was one of the early significant discussions of Goya at a time when relatively little of his work was accessible to the French public; he later planned a study of Spanish painting in which Goya would have figured prominently, but this was never written.[48] Interest in Goya and Spanish art in general, as previously mentioned, had increased greatly after the opening of the Musée Espagnol at the Louvre in 1838, that extraordinary, unprecedented collection of Spanish paintings assembled for Louis-Philippe by Baron Taylor.[49] The *Caprichos* were widely known through reproductions;[50] the Cabinet des Estampes owned an original set. A few pages on Goya in the *Revue encyclopédique* in 1831 presented a brief but penetrating account of his work and emphasized many of the same aspects as Baudelaire's: Goya's brilliant exposure of vice, particularly among the clergy, his violent, frightening ridicule, his fantastic imagination that fills the air with demons, his portrayal of the perversion of elegance and the hypocritical consecration of prostitution by religion.[51] But it was Gautier who produced the first major study, in the *Cabinet de l'amateur* (September 1842).[52] Baudelaire calls attention to this article at the beginning of his own, particularly for questions of medium.

Although the articles have some points in common, including two of the same works,[53] Baudelaire radicalizes Gautier's views and takes them to their limits. Where Gautier finds the comic, picaresque spirit of Cervantes, Baudelaire adds the modern spirit of the unknown, the supernatural, and

48. Letter to Nadar, 14 May 1859 (*Corr.* I, 574).

49. Baudelaire knew the collection well and in a footnote to this essay laments its disappearance; it was reclaimed by Louis-Philippe after 1848 and sold in London in 1853 after his death. Of Goya's works it included, among others, the Frick *Blacksmiths*, *The Duchess of Alba*, *Manolas on a Balcony*, *Young Woman Reading a Letter*, and *Burial*. See P. Guinard, "Baudelaire, le Musée Espagnol et Goya"; N. Glendinning, *Goya and his Critics*, chap. 4; I. H. Lipschutz, *Spanish Painting and the French Romantics*, 123ff. and 392 n. 31.

50. In 1824 Delacroix greatly admired the series belonging to Ferdinand Guillemardet, the former French ambassador to Spain who was influential in having the *Caprichos* printed, and dreamt of "doing caricatures in the manner of Goya." He indeed copied from the early ones (Glendinning, *Goya and his Critics*, 14) and seems to have had the set at his studio at one point (*Journal*, 57, 61).

51. Adélaïde de Montgolfié, *Revue encyclopédique* L (May 1831), 328ff.

52. Gautier had already written an article on the Caprichos (*La Presse*, 5 July 1838). The more extensive one of 1842 was later incorporated into his *Voyage en Espagne* of 1845. Baudelaire mistakenly wrote that it had appeared in *Caprices et Zigzags*; perhaps he was thinking of Gautier's article on Hogarth, which he also read, and which was reprinted in this collection. For Gautier's debt to Baron Taylor's *Voyage pittoresque en Espagne* and Louis Viardot's *Notice sur les principaux peintres d'Espagne*, see M. C. Spencer, *The Art Criticism of Théophile Gautier*, 82f.

53. *Capricho* 59 (*Y aun no se ván*) and *Dibersión de España*.

the grotesque. Gautier minimizes the allusions in the political works, while Baudelaire maintains that the works are intelligible in spite of them. More important, he develops into a major aspect of his theory one of Gautier's casual suggestions: "C'est de la caricature dans le genre d'Hoffmann, où la fantaisie se mêle toujours à la critique, et qui va souvent jusqu'au lugubre et au terrible. . . . On se sent transporté dans un monde inouï, impossible, et cependant réel" [This is caricature in the manner of Hoffmann, where fantasy is always mixed with criticism, and which often reaches the lugubrious and the terrible. . . . One feels transported into a world unimaginable, impossible, and yet real].[54] The comparison with Hoffmann fits Baudelaire's scheme well, where Goya represents the same type of *comique*—the fantastic and grotesque of the *absolu* ever in contact with the real and the moral of the *significatif*. Baudelaire made from Gautier's anecdotal and descriptive comment a powerful analysis of Goya's distinctive *comique* and a solid foundation on which to build his own theory of modernity, with the interpenetration of fantastic and real, absurd and true, that it will formulate.

In the *Bulls of Bordeaux* series Gautier had pointed out merely a vigor worthy of the *Caprichos* at a time when the artist had become old, deaf, and nearly blind.[55] Baudelaire seems to respond directly to this by a comment that sounds curiously personal while setting out a universal artistic principle: the superb late lithographs are "preuves nouvelles à l'appui de cette loi singulière qui préside à la destinée des grands artistes, et qui veut que, la vie se gouvernant à l'inverse de l'intelligence, ils gagnent d'un côté ce qu'ils perdent de l'autre, et qu'ils aillent ainsi, suivant une jeunesse progressive, se renforçant, se ragaillardissant, et croissant en audace jusqu'au bord de la tombe" (569) [further proof in support of that singular law which presides over the destinies of great artists, and which wills that, as life and understanding proceed in opposite directions, they gain on one side what they lose on the other; and thus go forward, following a progressive rejuvenation, strengthening and reinvigorating themselves, and increasing in boldness to

54. Gautier, *Voyage en Espagne*, 118f. Cf. his article on Hoffmann (*Chronique de Paris*, 14 August 1836), where he likens the German author to Callot and Goya, "caricaturiste espagnol trop peu connu, dont l'oeuvre à la fois bouffonne et terrible produit les mêmes effets que les récits du conteur allemand. C'est donc à cette réalité dans le fantastique qu'Hoffmann doit la promptitude et la durée de son succès" (*Souvenirs de théâtre*, 45) [that Spanish caricaturist all too little known, whose work, at once farcical and terrible, has the same effect as the narratives of the German storyteller. It is thus to this reality in the fantastic . . . that Hoffmann owes the immediacy and the duration of his success].

55. *Voyage en Espagne*, 124.

the very brink of the grave].[56] One senses in this tribute a more significant principle, however: the same law that governs the progress of civilization in *De l'essence du rire*, the increasing daring and boldness, the "ambition supérieure" (532), the *audace* that moves Virginie to Melmoth, and Melmoth to the pure poet. On the frontier of the real and the fantastic, Goya may also have reached, by the time of the *Bulls of Bordeaux*, deaf, near-blind, and weakened from illness, the frontier of comic art and *poésie pure*.

Leonardo and Pinelli

Baudelaire's discussion of the Italians incorporates the most comical discrepancies of the caricature project as a whole. Although the Italian *comique* defined in *De l'essence du rire* belongs in the domain of the *absolu*, Baudelaire seems unable to find any example that reflects this prestigious status: of the two Italians discussed, neither is (by his own admission) a caricaturist in his sense of the term. The first, Leonardo, is reduced virtually to the level of a copyist; and the second, Pinelli, to that of a stylizing *croqueur*. Baudelaire devotes a disproportionately large amount of space to anecdotes from the latter's biography and appearance, in which he finds the originality and romanticism missing from the art. But he does not pretend to justify such physiognomical criticism (as he does elsewhere)[57] as a rhetorical way of incorporating the artist's life into a discussion of his work. On the contrary, he here establishes an inverse law, demonstrating that the artist's appearance and comportment reflect only *ironically* the nature and quality of the work. The two artists who represent the essence of the Italian comic spirit, Callot and Hoffmann, are not Italians at all, yet Baudelaire offers no explanation for this, nor any defense of his own category. The reader may legitimately ask why he defines the Italian *comique* as he does,

56. Delacroix frequently notes this "contradiction" between the power of the mind which increases with age, and the progressive weakening of the body. See *Journal*, 566, 782.

57. *Edgar Allan Poe, sa vie et ses ouvrages*: "C'est un plaisir très grand et très utile que de comparer les traits d'un grand homme avec ses oeuvres. Les biographies, les notes sur les moeurs, les habitudes, le physique des artistes et des écrivains ont toujours excité une curiosité bien légitime" (267) [It is a very great, and a very useful, pleasure to compare the traits of a great man with his work. Biographies of artists and writers, notes on their habits, practices, and physical appearance have always provoked a very legitimate curiosity].

if it is not so realized in Italian art. Moreover, the tone throughout the section is one of intense dislike, a sourness befitting *Quelques caricaturistes français* more than this essay, where his cosmopolitan admiration of things foreign otherwise guarantees respect and admiration for his subject.

Baudelaire's ideas on the Italian character directly reflect the famous and highly Romantic division of the *Salon de 1846*: the naturalistic, brutal, and positivistic South versus the misty North, "suffering and anxious" (421), the solidity of Raphael versus the dreaminess of Rembrandt, material versus ideal. In the domain of the comic, this "esprit matériel" finds an appropriate environment and produces admirable results, an "intoxication" (570) of gaiety similar to that of the English Clowns. Baudelaire associates Italian humor with the exuberant merriment of Carnival and playfully expresses this in terms of the *grande bouffe* that goes with it: "Cette gaieté regorge de saucissons, de jambons et de macaroni. . . . Matérialiste, . . . leur plaisanterie sent toujours la cuisine et le mauvais lieu" (570f.) [This gaiety is replete with sausages, hams, and macaroni. . . . Their humor is materialist, it reeks of the kitchen and the brothel]. Carnival provides an example of the *comique innocent* in action, erupting once a year on the Corso with the explosive furor of the *absolu* (570). A first solution to the irregularities of this section may thus be found here: the Italian comic character is exemplified less in Italian art than in the living work of art that is Carnival, where "everyone is a wit, *everyone becomes a comic artist*" (570f., my emphasis). Carnival is the English pantomime extended beyond the limits of the Théâtre des Variétés; the Italian artists of Carnival are seized by the intoxicating frenzy of the Italian comic (571), the same *vertige* that takes hold of the English actors, the *comique absolu* (540). Hence the importance of *Die Prinzessin Brambilla*, here evoked as an example: Carnival, that living comic theater, provides in Hoffmann's story the context and the means for curing the characters' dualism by exploiting it and bringing them to self-knowledge.[58]

In pictorial forms of representation, however, the Italians provide no example of their national comic spirit. Baudelaire mentions Leandro Bas-

58. Baudelaire cites Reinhold's definition of the Italian *comique* in chapter 3 of the novel, located in the space between shallow buffoonery, the pure comic (a love of the comic for itself), and obscenity. The Italian *comique* is like a clown's imitation of someone whose speech he does not understand, and must exaggerate because of the enormous effort required to reproduce it; the German *comique* is the original speech itself, which "rings out from the inner self" and determines the gestures naturally. The German deals with the deep reality of the human soul, the Italian with appearances. See Hoffmann, *Sämtliche Werke* III, 813; cf. *La Princesse Brambilla, Contes*, 79f.

sano's paintings of the Venetian Carnival, but gives the real honor to the French Callot.[59] Callot was one of the most oft-named examples of the grotesque, noted for the specifically Italian nature of his comedy; Hugo and Gautier cite him in this context on numerous occasions.[60] Yet Baudelaire's treatment is distinctive, not because he makes a Frenchman represent the Italian comic spirit, but because he gives to Callot's native French qualities a decisive role in this: "Au total, c'est un artiste français, c'est Callot, qui, par la concentration d'esprit et la fermeté de volonté propres à notre pays, a donné à ce genre de comique sa plus belle expression" (571) [All things considered, it is a French artist, Callot, who, by the concentration of mind and the firmness of will proper to our country, has given this type of comic its finest expression]. The explosive furor of the Italian *innocent* can best be realized through the recuperative qualities of the French.

Baudelaire thus generalizes and makes explicit the principle of the harmony of opposites already suggested for individual artists: the best *comique absolu*, from Hoffmann to Goya to Callot, contains an element of the *significatif*. Hoffmann mixes a dose of the *significatif* into the highest *absolu* (542); Goya unites the monstrous and verisimilar, absurd and possible, diabolical and human, fantastic and real, transcendent and natural; in inverse proportion, Daumier's normal *significatif* participates in the *absolu*, reflecting the "réalité fantastique" (554) of the city, the grotesque and *bouffon* enormities of normal everyday life. The freedom and license of the comic are based in the will; the "vaporization" and multiplication of the self depend on concentration. Baudelaire gives Callot only a brief mention, but typically makes this mention suggest one of the most important ideas of the caricature project as a whole—the absolute produced through the very dualism that contradicts it.

Leonardo

Diametrically opposed to the dominant national farce, the *comique bouffon*, is the pedantry of Leonardo and Pinelli, the academic style characteristic of the Italian pictorial manner. Although Baudelaire attributes to both the

59. Baudelaire knew Callot's work well (see *Salon de 1859*, 651). He wrote his "Bohémiens en voyage" after Callot's etchings of the same title of 1621. (On the relation of the poem to the image, see Scott, *Pictorialist Poetics*, 62f.)

60. E.g. Hugo, *Préface de Cromwell*, 200; Gautier, *Voyage en Espagne*, 117, and *Souvenirs de théâtre*, 45. See also Cormenin, "De la caricature," *La Liberté*, 10 February 1850, and A. Houssaye, "Callot, sa vie et son oeuvre," *L'Artiste* 1849, 36–46.

same flaw—copying nature—this manifests itself differently in each. He condemns Leonardo's caricatures, the numerous grotesque heads so frequently reproduced from the seventeenth century onward, for lacking a comic element, and the "expansion" and "abandon" necessary to it (Fig. 50). For Baudelaire, they are actually portraits the artist executed as a "scholar," a "geometrician," a "professor of natural history." Paradoxically, their grotesque is thus naturalistic, lacking the criterion of aesthetic choice: "He was careful not to omit the least wart, the smallest hair" (570). Baudelaire terminates his remarks with the most damning word in his aesthetic vocabulary: "He looked around him for types of eccentric ugliness, and copied them" (570).

This view is consistent with a long critical tradition, both before and after Baudelaire. Gombrich argues that Leonardo's caricatures were not distortions but examples of reality; the artistic "monstrosity" actually represents commonplace ugliness or freakishness.[61] Indeed, they had long been considered physiognomic illustrations of the passions like Lavater's or Lebrun's. In the introduction to Caylus's *Recueil de testes de caractère et de charges dessinées par Léonard de Vinci, florentin* (1730), Mariette argued that Leonardo was following nature and that his object was not raillery, "badinage," but the study of the passions through physiognomy.[62] In an enthusiastic article in *L'Artiste*, Gautier likens Leonardo's caricatures to portraits, specimens of monstrous faces for a course in natural history: "Souvent ces têtes extravagantes, enlaidies à plaisir, ont la vérité féroce des portraits. . . . on les reconnaît, on les a vues cent fois, on les nomment presque. . . . On dirait que l'artiste a voulu faire une espèce de cours de tératologie entendue dans le sens large de Geoffroy Saint-Hilaire, et prouver la beauté par la laideur, la norme par le désordre" [Often these extravagant heads, made gratuitously ugly, have the fierce truth of portraits. . . . you recognize them, you have seen them a hundred times, you can almost give their names. . . . It is as though the artist wished to provide a kind of lesson in teratology, in the broad sense in which Geoffroy Saint-Hilaire understands it, and to prove beauty by ugliness, the norm by the exception].[63] Gautier also recounts the anecdote that Leonardo took regular walks in the Borghetto quarter of

61. E. H. Gombrich, *The Heritage of Apelles*, 58f. Gombrich cites works on Leonardo from 1880 to 1930 interpreting the grotesque heads as studies in physiognomy and anatomy; while he attributes this to the late nineteenth-century emphasis on Leonardo's scientism it actually extends much earlier.

62. *Receuil de testes*, 12.

63. "Les Caricatures de Léonard de Vinci," 12 April 1857.

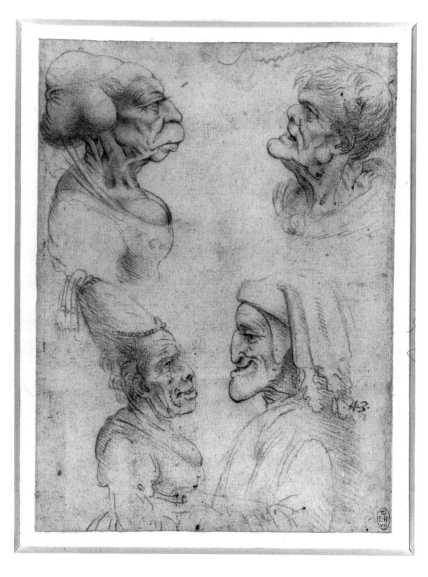

FIG. 50. Melzi, after Leonardo. *Grotesque Heads* (photo: Windsor Castle, Royal
Library. © 1990 Her Majesty Queen Elizabeth II)

Milan to find bizarre faces, grotesque expressions, ugly profiles.[64] But whereas he considers this scientific basis an admirable quality that places Leonardo above other caricaturists, Baudelaire harshly judges him not a caricaturist at all. Moreover, Gautier's "beauté par la laideur" differs greatly from Baudelaire's "beauté dans la laideur." Gautier's phrase denotes a beauty by default, beauty perceived through a contrasting ugliness, while Baudelaire's refers to a beauty in "ugliness" itself.

Baudelaire's low opinion of Leonardo's caricatures thus has two principal causes. First, the absence of a comic element: Leonardo's grotesque depends merely on distorting the ideal lines of the human face, which may guarantee ugliness but not necessarily the comic. "Laideur excentrique" is not equivalent to caricature; this requires the comic, and the comic requires a sense of pleasure, "expansion" and "abandon" (570), like Hogarth's "aisance" and "abandon" (565), however satanic, satirical, or compassionate it may be. Baudelaire's remark that the artist was not enjoying himself as he drew them should be understood in this context. The object of Leonardo's activity was not to develop in the observer the pleasure of superiority, and the consciousness of inferiority, but rather to explore the possibilities of ugliness for the human face. Once again Baudelaire's judgment is incisive: others later saw the grotesque drawings as variations—by negation, inversion, repetition, distortion, and combination—on standard "normal" types;[65] or as permutations of exaggerated anatomical forms that suggest an abstract idea of ugliness.[66] Such art produces an effect not of the comic or grotesque, but of coldness and harshness, a cruelty unrelieved (in contrast to Hogarth's) by fantasy, freedom, or pleasure.

Second, the absence of imagination: Leonardo's caricatures seem not creations but copies of types found in Nature. Baudelaire communicates the distinction through the common Romantic rhetorical opposition of "great artist" and "scholar," "geometrician," "professor of natural history";[67] on

64. The story that Leonardo followed people with strange faces around for days on end, so impressing the images on his mind that he could later draw them as though still before his eyes, goes back to Vasari (*Vite de' più eccelenti pittori* IV, 24). Prévost (*Baudelaire*, 131) holds that Baudelaire would have read the *Lives*.

65. Gombrich, *The Heritage of Apelles*, 62ff.

66. K. Clark, *The Drawings of Leonardo da Vinci*, xlviiif.

67. Cf. Delacroix, *Journal*, 461: "Les savants trouvent dans la nature ce qui y est. La personnalité du savant est absente de son oeuvre; il en est tout autrement de l'artiste. C'est le cachet qu'il imprime à son ouvrage qui en fait une oeuvre d'artiste . . . Le savant découvre les éléments des choses, . . . et l'artiste, avec des éléments sans valeur là où ils sont, compose, invente un tout, crée" [Scholars find in nature what is there. The personality of the scholar is

the Baudelairean ladder of creativity, the scientific and mathematical fall lower than even the philosophical and literary, about which he expresses such vehement reservations in the sections on Grandville and Gavarni. The lack of imagination signals a lack of art in Baudelaire's sense of choice, composition, abstraction: copying ugly types does not constitute a carica-ture any more than copying a natural scene constitutes a painting, or copying a dictionary constitutes a poem in the *Salon de 1859* (661). Paintings, poems, and caricatures too must be composed; Leonardo does not exclude the slightest wart or hair, and thus produces description rather than creation, natural and anatomical science rather than art.[68]

Pinelli

"Si j'avais suivi ma pensée droite, ayant à m'occuper des caricaturistes, je n'aurais pas introduit Charlet dans le catalogue, non plus que Pinelli; mais on m'aurait accusé de commettre des oublis graves" (548f.) [If I had followed my inclination, having to write about caricaturists, I would not have included Charlet in my catalogue, any more than Pinelli; but I would have been accused of grave omissions]. As in the case of Charlet, Baudelaire's disingenuous statement conceals (and, in its irony, reveals) an underlying program, offering this "non-comic" artist not only as an example of what comic art is not, but as an example, rather than creator, of the comic itself— a perfect object of laughter. Baudelaire's sarcasm is less venomous here than in the Charlet section, where the artist's reputation and ideological position put more at stake. But the abundance of italicized terms, clichés, and *idées reçues* makes the irony clear. Indeed Baudelaire brings out the non-comic art of Pinelli through a brilliant comic act of his own, adapting his comedy to the character of the subject. Pinelli is criticized for the formulaic and clichéd nature of his work, through a language itself consisting of ironic clichés, a double voice which turns the artist's non-comic method into a consummately comical one.

Baudelaire insists on the stylized aspects of Pinelli's work, "une préoccu-pation constante de la ligne et des compositions antiques, une aspiration systématique au style. . . . Encore ces sujets, même les plus nationalement

absent from his work; it is completely otherwise with the artist. It is the stamp that he leaves on his work which makes it the work of an artist. . . . The scholar discovers the elements of things, . . . and the artist, taking elements worthless in themselves, composes, invents a whole, creates].

68. Baudelaire makes a similar criticism of Hugo in the *Salon de 1846* (431).

comiques et pittoresques, sont-ils toujours . . . passés au crible, au tamis implacable du goût" (571f.) [a constant preoccupation with line and with old-fashioned composition, a systematic aspiration toward style. . . . And yet these subjects, even the most nationally comic and picturesque of them, are still always put through the sieve, through the implacable filter of taste]. This represents the same pedantry as Leonardo, but from the opposite perspective: idealizing, neoclassical forms, rather than ugly types. The freedom and extravagance of the comic, its capacity to reach beyond its own limits, is here controlled, contained, and repressed through the neutralizing formulas, the "filter" of taste and style. The same effect separates the *peintre de moeurs* from the true artist of modern life in the later essay on Guys: the classical style of the former removes the essence of modernity by smoothing its hard edges and toning down its dazzling brilliance (724). Modernity, like the comic, constantly exceeds the restrictive formulas of style and thus requires a new language altogether.

Pinelli also follows the same muse of copying, although this is the result not of a scientific mind, as with Leonardo, but a lazy imagination: "On voit que Pinelli était de la race des artistes qui se promènent à travers la nature pour qu'elle vienne en aide à la paresse de leur esprit, toujours prêts *à saisir leurs pinceaux*" (572) [One can see that Pinelli belonged to the race of artists who stroll through nature so that it will come to the help of their lazy minds, and are always ready to *seize their brushes*]. Here the negative relation of copying to imagination is established explicitly: "il prétendait . . . trouver dans la nature, et seulement dans la nature, de ces sujets tout faits, qui, pour des artistes plus imaginatifs, n'ont qu'une valeur de notes" [He claimed . . . to find in nature, and only in nature, those ready-made subjects which, for more imaginative artists, are only good for notes]. This is a major concern in the *Salon de 1859*, which describes it in the same language: the poor quality of landscape painting derives from the artists' practice of copying direct from nature, a method perfectly suited to the "laziness of their minds" (665). Like Pinelli, they take a corner of nature for a work of art, taking everything within the frame of the window as a ready-made poem (661). Only Boudin understands the difference between "notes" and "pictures" (665), and offers his atmospheric studies as studies, momentary fantasies that express and celebrate their own transitoriness. Notes run the risk of confusion, unintelligibility, and ultimately *ennui*: Théodore Rousseau, who reveals the same flaw of taking a study for a composition (662), is dazzling but wearying. There is no contradiction between Pinelli's excessive care for *style* and his habit of finding in nature

"ready-made subjects," as a comparison with the French artist Léopold
Robert attests: both combine the doctrines of neoclassicism with pictur-
esque genre subjects drawn from contemporary life—stylized peasants in
rags, as it were.[69] The conservative academic critic Delécluze, writing on
Robert, described this manner as the seriousness of ancient statuary com-
bined with the suddenness and immediacy of nature.[70]

Baudelaire puts across these points through ironies that turn Pinelli's own
methods against him. Underlining the formula in "toujours prêts à *saisir
leurs pinceaux*" distances Pinelli from the likeness that an artist usually
attempts to "catch" (cf. "saisir les traits"), and signals instead the joke:
Pinelli fits an image of the artist as clichéd as his own painting. Baudelaire
ridicules the copyist's practice with a comical anecdote from Pinelli's legend:

> Quelquefois, en rentrant chez lui, il trouvait sa femme et sa fille se
> prenant aux cheveux, les yeux hors de la tête, dans toute l'excitation
> et la furie italiennes. Pinelli trouvait cela superbe: "Arrêtez! leur
> criait-il, —ne bougez pas, restez ainsi!" Et le drame se métamorpho-
> sait en un dessin. (571f.)

> [Sometimes, on coming home, he would find his wife and daughter
> tearing at each other's hair, their eyes bulging out of their heads, in
> all the fury and excitability of the Italians. Pinelli found that superb:
> "Stop!" he would cry, "Don't move, stay like that!" And the drama
> was transformed into a drawing.]

69. Robert's works were well known through engravings and lithographs. Numerous
writings on his life and work were available during Baudelaire's time: he was frequently
discussed in reviews of the Salons of 1822, 1824, 1827, 1831, and 1836; his suicide in 1835
occasioned many articles in the press; Delécluze published his *Notice sur la vie et les ouvrages
de L. Robert* in 1838, and Feuillet de Conches his *Robert, sa vie, ses oeuvres, et sa
correspondance* in 1848. Like Pinelli, he depicts popular genre scenes of the Italian peasantry
at work and leisure; an artist of the *juste milieu*, he aspired to the grand style and to
neoclassical pictorial ideals; he was highly acclaimed in his time, produced an immense oeuvre,
and was awarded the Legion of Honor cross at the 1831 Salon; by Baudelaire's time he had
become, like Pinelli, a "gloire bien diminuée." See A. Boime, *Thomas Couture and the Eclectic
Vision*, 23ff.

70. *Débats*, 8 June 1831. Delécluze later pictures him with his friend the artist Schnetz
strolling through nature, which furnishes them profusely with subjects and models (*L'Artiste*,
10 May 1831, 188). See also Charles Lenormant, "Léopold Robert," *Revue française* VI, 1838,
271.

Pinelli's notion of art derives from the most standard and worn-out of jokes, the emotionalism of the Italian people (cf. Fig. 51).[71] Baudelaire reserves his most mordant irony, however, for Pinelli's dress and behavior, in which he purports to find the originality and romanticism missing from his work: "il fut un des types les plus complets de l'*artiste*, tel que se le figurent les bons bourgeois, c'est-à-dire du désordre classique, de l'inspiration s'exprimant par l'inconduite et les habitudes violentes" (571) [he was one of the most perfect types of the *artist*, as the good bourgeois imagine them, that is, classic disorder, inspiration expressing itself in unseemly behavior and violent habits].[72] But the pejorative allusion to the "bons bourgeois" makes the point clear: Pinelli's romantic originality is just another form of that *style* which so degrades his drawings. It is the stale cliché of the artist,

71. Pinelli did many scenes entitled "lite di donne", e.g. *Raccolta di cinquanta costumi pittoreschi*, 1809, no. 18 [Fig. 51]; a watercolor of 1818 in the Rome Museum, no. 348; *Costumi di Roma*, 1831, no. 1. In a volume published in 1835, Carlo Falconieri (*Memoria intorno alla vita ed alle opere di Bartolomeo Pinelli*, 28) recounts an anecdote comparable to Baudelaire's, where Pinelli interrupts the violent and chaotic scene of a domestic quarrel to fix it on paper: "Un giorno entrato Pinelli in cucina, mentre che la moglie friggeva alcune ova ebbe secolei non so che litigio, onde come di poca pazienza era, diè di piglio al tegame, e senza altri complimenti gliel menò in testa: a tanto bisbigliare accorsero ad assalirla i cani e le gatte, accorse la serva, ed i ragazzi piagnevano. Egli però a questa vista, in un punto si mise a sganasciare dalle risa e tosto dato di mano alla matita, la pose in sulla carta e poscia la incise, come per tutti si è visto" [One day when Pinelli entered the kitchen while his wife was cooking some eggs, she had some argument with him, whereupon as she was a woman of little patience, she took hold of the pan and without further ado threw it at his head: at such a commotion the dogs and cats ran to assail her, the servant-girl came running, and the children wailed. But at this sight, he at once began to roar with laughter, and taking his pencil in hand, put it to paper and afterward made an engraving for all to see]. Baudelaire's scenario has mother and daughter going at one another rather than husband and wife fighting it out with a pan, but the idea is the same.

72. Baudelaire's portrait—the two famous large dogs that followed Pinelli around, his walking stick, the long tresses which framed his face, his dubious companions, the cabaret he frequented, his determination to destroy any work for which he did not receive a satisfactory offer—comes from a number of possible sources, including Pinelli's self-portraits (see the frontispiece to the *Istoria romana* of 1819 and his self-portrait in the *Raccolta di cinquanta costumi pittoreschi* of 1809). The *Magasin pittoresque* (xiv, 37 and 43 [September and October 1846], 289, 339, repr. in *La Presse littéraire* 46, 13 March 1853) mentions his "big black dog," his practice of sketching and reproducing nature as it is, and his dishevelled appearance. A later article in the same journal (xxv, 14 [April 1857]) notes his hair and walking stick, and his habit of frequenting the Gabbioni tavern. In language nearly identical to Baudelaire's, Falconieri (*Memoria intorno alla vita ed alle opere di Bartolomeo Pinelli*, 26ff.) discusses Pinelli's "bizarre life," and likewise mentions the two large dogs, his knotty walking stick, and the locks which frame his face: "due grossi mastini lo seguivatano," "il suo noderoso bastone," "lunghe ciocche di capelli, che sulle tempia gli pendevano." Falconieri also describes the same "misconduct" and "violent habits" as Baudelaire: Pinelli's excitable character, his revelling, and his drinking in bad company.

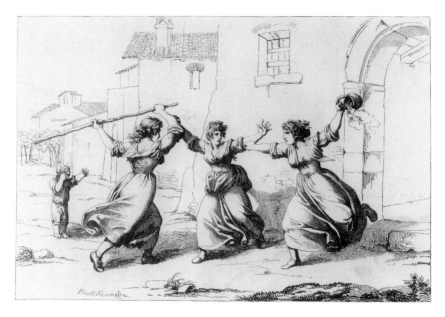

FIG. 51. Pinelli. *Lite di femmine in Roma. Raccolta di cinquanta costumi pittores-chi*, 1809 (photo: British Library)

"charlatanisme" (571), or in pictorial terms, the "*poncif* in manner and conduct" (572), the stereotypical bohemian disorder of the creative artist. Baudelaire had mocked the same trait mercilessly in his own caricatural self-portrait in *La Fanfarlo*: Samuel Cramer, the artist manqué, "dont la poésie brille bien plus dans sa personne que dans ses oeuvres" (I, 553) [whose poetic qualities shine through more brightly in his person than in his works]. Here he perversely points out that the true artist more often leads, on the contrary, an orderly life, displaying "highly developed domestic virtues": "les artistes les plus inventifs, les plus étonnants, les plus excentriques dans leurs conceptions, sont souvent des hommes dont la vie est calme et minutieusement rangée" [the artists who are the most inventive, the most astonishing, the most eccentric in their conceptions, are often men whose life is calm and scrupulously ordered]—a principle exemplified in Delacroix, as his later essay on that artist makes clear (758). In a remarkable reversal, the artist of genius now rejoins, by design, the bourgeois: "N'avez-vous pas remarqué souvent que rien ne ressemble plus au parfait bourgeois que l'artiste de génie concentré?" (572) [Have you not often noticed that nothing is more like the perfect bourgeois than the artist of concentrated genius?]

But in context this remark, too, is replete with irony. It smacks of the *Conseils aux jeunes littérateurs* and preserves an important ambiguity: "parfait bourgeois" is as much a cliché as "artiste inspiré." The rhetorical question remains a question. The genius can resemble the bourgeois, but the image of the bourgeois is itself a commonplace. Baudelaire mocks both categories and thus drives home his main point, a critique of the *poncif* in both art and life. In this way, he comes close to his stated objective of inventing a term to destroy the *poncif* altogether: "Je voudrais que l'on créât un néologisme, que l'on fabriquât un mot destiné à flétrir ce genre de poncif . . . qui s'introduit dans la vie des artistes comme dans leurs oeuvres" (572) [I wish that someone would invent a neologism or manufacture a word designed to blight this kind of *poncif* . . . which creeps into the lives of artists as into their works]. His answer is not to find a new word but to invert and ironize the old ones, thus exposing the *poncif* by his very method. Indeed Pinelli's *poncif*-ridden manner must even take the blame for Baudelaire's scathing critique: "Has Pinelli been slandered? I do not know, but such is his legend" (572). The one so concerned with creating the legend, living a life of Romantic clichés, now suffers the consequences: truth is of no concern.

Bruegel

In Bruegel the Elder, called "the Droll," Baudelaire finds the fantastic, hallucinatory aspect of the comic taken to its furthest extreme, as the dizzying concentration of terms in the space of a mere page and a half attests: "singulières," "excentricité," "bizarre," "étrange," "fantastique," "hallucination," "monstrueusement paradoxales," "baroque," "capharnaüm diabolique et drolatique," "folie," "vertige," "diableries," "merveilles," "effrayantes absurdités," "monstruosités," "diabolique." This is the Bruegel of *Dulle Griet*, *The Triumph of Death*, or *The Fall of the Rebel Angels* (Fig. 52)—a supernatural vision that Baudelaire attributes to a higher power, a force beyond human will comparable to the unconscious in Grandville's late works:

> il est bien certain aussi que cet étrange talent a une origine plus haute qu'une espèce de gageure artistique. . . . Quel artiste pourrait

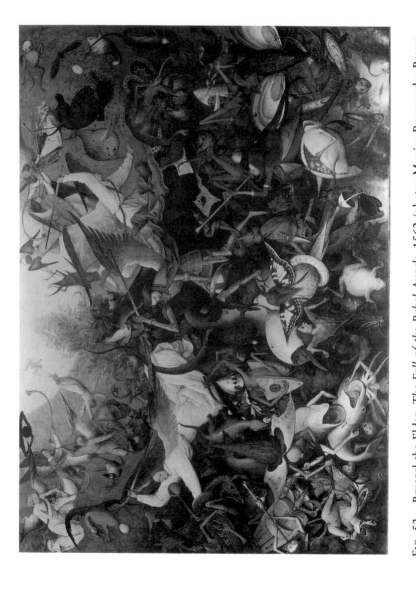

FIG. 52. Bruegel the Elder. *The Fall of the Rebel Angels*, 1562 (photo: Musées Royaux des Beaux-Arts de Belgique)

composer des oeuvres aussi monstrueusement paradoxales, s'il n'y était poussé dès le principe par quelque force inconnue? En art, c'est une chose qui n'est pas assez remarquée, la part laissée à la volonté de l'homme est bien moins grande qu'on ne le croit. (572f.)

[it is also certain that this strange talent has its source in something higher than just a kind of artistic wager. What artist could compose such monstrously paradoxical works, if he had not been driven to it from the outset by some unknown power? In art, something that is not noticed enough is that the share that falls to human will is far less great than one thinks.]

This is an extraordinary statement coming from a man who, in the tradition of Delacroix and Poe, insisted throughout his criticism on the importance, in art, of will, judgment, intelligence, and choice as necessary companions to passion, inspiration, and pleasure (*volupté*). On the one hand, Baudelaire's provocative remark challenges the tradition of excessive intellectualism that he had criticized in Grandville, and that appears in some of Bruegel's political allegories, with their "deliberate eccentricity" and the "methodical" quality of their bizarre (572).[73] On the other hand, it equates this "other side" of art, lying beyond human will, with the phenomenon most proper to mankind, the comic itself. The unknown force that inspires Bruegel's strange and wild creations, the mystery that manifests itself through his frightening visions, is the satanic spirit of the comic:

Celle[s]-ci, que notre siècle, pour qui rien n'est difficile à expliquer, grâce à son double caractère d'incrédulité et d'ignorance, qualifierait simplement de fantaisies et de caprices, contien[nen]t, ce me semble, une espèce de *mystère*. . . . Or, je défie qu'on explique le capharnaüm diabolique et drolatique de Brueghel le Drôle autrement que par une espèce de grâce spéciale et satanique. (573)[74]

73. The political aspect of Bruegel's allegories is still in dispute today. Baudelaire indicates only their obscurity for the modern viewer, the "puzzle" ("logographe") into which nature is transformed (573), their "argot plastique" no longer being comprehensible.

74. Cf. Baudelaire's letter to Flaubert, who had objected to his insistence on the satanism of hashish in the *Paradis artificiels*: "étant descendu très sincèrement dans le souvenir de mes rêveries, je me suis aperçu que de tout temps j'ai été obsédé par l'impossibilité de me rendre compte de certaines actions ou pensées soudaines de l'homme sans l'hypothèse de l'intervention d'une force méchante extérieure à lui. —Voilà un gros aveu dont tout le dix-neuvième siècle conjuré ne me fera pas rougir," (*Corr.* II, 53 [26 June 1860]) [having gone deep into the

[These works, which our century (for which nothing is difficult to explain, thanks to its dual character of incredulity and ignorance) would qualify simply as fantasies and caprices, contain, it seems to me, a kind of *mystery*. . . . Now I defy anyone to explain the diabolical and amusing chaos of Bruegel the Droll otherwise than by a kind of special satanic grace.]

Bruegel's grace is the fairy of the English pantomime; his works are infused with, and impart, the invigorating *vertige* of the *comique absolu* (573, cf. 540).

The theological metaphor of *De l'essence du rire* thus returns with a vengeance ("mystère," "grâce"), affirming the human, "comic" basis of the beyond: the mythical "explanation" preserves the mystery of the inexplicable, the creative dualism that constitutes the comic, and that scientific explanations suppress. Baudelaire calls attention to this by defiantly and scornfully soliciting terms with more scientific overtones: "For the word 'grace,' substitute, if you will, the word 'madness,' or 'hallucination'; the mystery will remain almost as obscure" (573). Indeed, medical and psychological accounts represent a positivism almost as blind as the Voltairean variety, an effort to deny mystery by rationalizing it away. In a reversal of conventional values, positivism becomes a response of ignorance and incredulity, incapable of admitting the existence of mystery, miracle, absurdity, or the intangible and inexplicable (*insaisissable*). In a brilliant tour de force Baudelaire weaves his critique of positivism into a remarkable example of grotesque and murky *mystère*, ending the section, and the essay, with an uncertainty as weird and disquieting as Bruegel's own:

La collection de toutes ces pièces répand une contagion; les cocasseries de Brueghel le Drôle donnent le vertige. Comment une intelligence humaine a-t-elle pu contenir tant de diableries et de merveilles, engendrer et décrire tant d'effrayantes absurdités? Je ne puis le comprendre ni en déterminer positivement la raison; mais souvent nous trouvons dans l'histoire, et même dans plus d'une partie moderne de l'histoire, la preuve de l'immense puissance des contagions,

memory of my daydreams, I realized that I have always been obsessed with the impossibility of accounting for certain unexpected actions or thoughts of man without imagining the intervention of an evil force exterior to him. —That is a great admission about which the whole nineteenth century conspiring together will not make me blush]. On Baudelaire's use of Bruegel's works in his poems, see J. Prévost, *Baudelaire*, 129ff.

de l'empoisonnement par l'atmosphère morale, et je ne puis m'empêcher de remarquer (mais sans affectation, sans pédantisme, sans visée positive, comme de prouver que Brueghel a pu voir le diable en personne) que cette prodigieuse floraison de monstruosités coïncide de la manière la plus singulière avec la fameuse et historique *épidémie des sorciers*. (573f.)[75]

[All these works brought together spread a contagion; the drolleries of Bruegel the Droll make one dizzy. How could a human intelligence contain so many wonders and devilries, how could it beget and describe so many terrifying absurdities? I cannot understand it, nor can I positively determine the reason; but often we find in history, and even in many a chapter of modern history, proof of the immense power of contagion, of poisoning by the moral climate, and I cannot refrain from remarking (but without affectation, without pedantry, without any positive aim, for example, of proving that Bruegel could see the devil in person) that this prodigious flowering of monstrosities coincides in the most singular way with the notorious historical *witchcraft epidemic*.]

Just as Bruegel's works give off a contagion and provoke the dizziness of the *comique absolu*, so they may reflect another diabolical *contagion répandue*, attested in the historical (hence "real"), yet equally inexplicable witchcraft epidemic. Baudelaire's language is sensational, and his point obscured in intriguing shadow, as though he ironically wants to walk the delicate line between real and fantastic, nineteenth-century skepticism and outright medieval superstition—an indeterminacy characteristic of Bruegel's art itself.

But the outrageous suggestion has a satirical point as well; for Baudelaire, the *absolu*, even at its wildest, contains the *significatif*, as we have seen. One recognizes behind these words an unmistakable reference to his own time, where the contagion of realism and positivism, the "poisoning by the moral climate," has produced not a "prodigious flowering" of fascinating and

75. Pichois (1366) proposes section XIII of the introduction to Michelet's *Histoire de France* VII (1855), which Baudelaire read, as the inspiration for this last remark. Baudelaire knew a number of works on witchcraft, as his note to "L'Imprévu" attests (I, 172): Charles Louandre, *La Sorcellerie* (1853) and "Le Diable, sa vie, ses moeurs, et son intervention dans les choses humaines" (1842); Eliphas Lévi, *Dogme et rituel de la haute magie* (1856); and later, Michelet, *La Sorcière* (1862).

powerful creations like Bruegel's, but only a succession of platitudes and mediocrities. The excessive deference paid to positive proof in his inability to provide it ("déterminer positivement la raison," "visée positive"), and the affectation and pedantry associated with it, signal the irony; positivism is a worse contagion in the "partie moderne de l'histoire" than *diablerie* was in Bruegel's, a true poison bringing disease and death. It infects not only the production but also the reception of works of art. The positivist, who, like Voltaire, "did not see any mystery in anything" (134), makes it impossible to appreciate the full power of Bruegel, the *mystère* at work: the nineteenth century "for which nothing is difficult to explain" can explain his works only as "fantaisies" and "caprices," imposture, or psychic aberration (573). Baudelaire's question—"Comment une intelligence humaine a-t-elle pu contenir tant de diableries et de merveilles, engendrer et décrire tant d'effrayantes absurdités?"—has in fact been answered at every point in the theory of the comic. This is the condition of mankind, the satanic spirit, which moves the imagination to reach audaciously beyond its limitations only to encounter greater mystery, to realize its "comic" superiority and inferiority, defining in the very act the *merveilleux* that lies at its boundary.

Pièces retrouvées: Hood and Rethel

> There are new sections on Leonardo da Vinci, Romeyn de Hooge, Jean Steen, Brueghel the Droll, Cruikshank senior, Thomas Hood, Callot, Watteau, Fragonard, Cazotte, Boilly, Debucourt, Langlois du Pont de l'Arche, Raffet, Kaulbach, Alfred Rethel, Töppfer, Bertall, Cham and Nadar. (1343)

Of the twenty artists whom Baudelaire claimed to have added to this project, only three—Leonardo, Callot, and Bruegel—actually find a place in it, and the latter alone a prominent one. Romeyn de Hooge, Jan Steen, Isaac Cruikshank, Fragonard, Boilly, Töppfer, Bertall, Cham, and Nadar nowhere appear in his criticism.[76] Langlois du Pont de l'Arche was the author and engraver of the *Essai historique, philosophique et pittoresque sur les Danses*

76. There is a description of a work by Boilly, the *Cour des messageries* (I, 366f., 374), which may have been intended as the basis for a projected prose poem of that title.

des morts in which Baudelaire found the plate which he commissioned Félix Bracquemond to copy for the frontispiece to the 1861 *Fleurs du mal*; he thus appears repeatedly in the correspondence of 1859–60 (Baudelaire clearly admired his work), but is nowhere treated in detail.[77] Watteau, Cazotte, Debucourt, Raffet, and Kaulbach receive cursory mention in other essays, particularly the *Salon de 1859* (617, 643), *Le Peintre de la vie moderne* (683, 698), and *L'Art philosophique* (599). The remaining two— Thomas Hood and Alfred Rethel—likewise turn up in these works, although to a considerably greater extent. What material Baudelaire may have gathered for his expanded caricature project seems to have been dispersed and reworked into texts of around 1859.

As early as 1935, M. Gilman suggested that this was the case with the English poet Thomas Hood, whom Baudelaire discusses at length in the *Salon de 1859*—significantly, his caricature of Cupid in *Whims and Oddities* (1826).[78] Hood was considered one of the great English humorists of the nineteenth century, in the tradition of Shakespeare, Sterne, Swift, and Lamb, a master of the grotesque who produced his humor, in the words of one contemporary critic, from a brilliant blend of slightly vulgar jokes and the most serious thoughts.[79] His use of exaggeration and coarseness, and his extraordinarily vivid language, make him an appropriate candidate for what Baudelaire sees as the essential English comic tradition: grotesque in method and conveying a moral point.[80] The material for the section on the "comic" art of the German Alfred Rethel has not been noticed, probably because Baudelaire places it in a work remote from the theme of the comic, *L'Art philosophique*. But in fact his discussion of Rethel has much in common with the theory of the comic, enough for it to have been destined for the essays on caricature too.

In the *Salon de 1859*, Baudelaire inserts his discussion of Hood's drawing, *Tell me my heart, can this be love?* (Fig. 53) into his excoriation of the *école*

77. *Corr.* I, 577 and II, 83ff.

78. "Baudelaire and Thomas Hood."

79. See "Poètes et romanciers de la Grande-Bretagne: Thomas Hood," *Revue des deux mondes*, 15 November 1847, 719.

80. Baudelaire later translated Hood's most famous poem, *The Bridge of Sighs* (1844), which Poe quotes in full in *The Poetic Principle*, and took from it the title of his prose poem, "Anywhere out of the World." Poe admired Hood's poem as well as his general *grotesquerie* but intensely disliked his puns. In his article on Hood's *Prose and Verse* (*Broadway Journal*, 9 August 1845) he called them "things of such despicable platitude" and wrote: "to no mind, however debased in taste, is a continuous effort at punning otherwise than unendurable" (*Essays and Reviews*, 274).

FIG. 53. Thomas Hood. *Tell me my heart, can this be love? Whims & Oddities,* 1826 (photo: Cambridge University Library)

des pointus, painters who transfer everyday life to a Greek or Roman setting (637).[81] Hood's satire is evoked to ridicule the predominance of the figure of Eros, "the immortal Cupid of the confectioners," in their art. Indeed, in contrast to the Romantic figure, Hood's Cupid is, in his own words, a "monster of obesity," a "palpable being," a "substantial Sagittarius," a "preposterous effigy" whose unseemliness accounts for the proverbial resistance of maidens to his advances—in short, an elephant and a pig:

> I can believe in his dwelling alone in the heart—seeing that he must occupy it to repletion—in his constancy, because he looks sedentary and not apt to roam. That he is given to melt—from his great pinguitude. That he burneth with a flame, for so all fat burneth— and hath languishings—like other bodies of his tonnage. That he sighs—from his size.
> I dispute not his kneeling at ladies' feet—since it is the posture of elephants—nor his promise that the homage shall remain eternal. I

81. The drawing accompanied the poem "On the Popular Cupid," from *Whims and Oddities.* Baudelaire translates the poem too.

doubt not of his dying—being of a corpulent habit, and a short neck. Of his blindness—with that inflated pig's cheek. But for his lodging in Belinda's blue eye, my whole faith is heretic—*for she hath never a sty in it.*[82]

Baudelaire creates a brilliant caricature to match, describing Hood's squatting Cupid as an insect and a fat duck, "écrasant de sa molle obésité le nuage qui lui sert de coussin" (638) [squashing flat his cloud cushion with his flabby obesity], his fat cheeks crowding out his eyes and nose, and his meat-like flesh, "capitonnée, tubuleuse et soufflée, comme les graisses suspendues aux crochets des bouchers" [stuffed, tubular and blown up, like the pieces of lard hanging on butchers' hooks]. This piece of lard is ironically and incongruously fitted with that stock image of daintiness and lightness, the wings of a butterfly. This is a parodic warrior, his bow a parodic saber, his tightly curled hair like a coachman's wig: a fit leader only for that courtly ("galante") and simpering ("minaudière") republic of contemporary French art (638) and the "natural frivolity" (637) of the French mind. Baudelaire's political metaphor is subtle enough, in the non-republic of the Second Empire, to pass unnoticed, but by 1859 can hardly be innocent. The target is not simply French art, but the aesthetic and moral mentality—and the government—that tried and convicted the *Fleurs du mal* for *their* representation of love.

In his discussion of Rethel in *L'Art philosophique*, Baudelaire establishes a parallel between philosophical and caricatural art through the figure of Hogarth:

> Il faut, dans la traduction des oeuvres d'art philosophiques, apporter une grande minutie et une grande attention; là les lieux, le décor, les meubles, les ustensiles (voir Hogarth), tout est allégorie, allusion, hiéroglyphes, rébus. (600)

> [In interpreting philosophical works of art, one must bring to bear great attention and meticulousness; in them, setting, decor, furnish-

82. *Whims and Oddities*, 21f. Baudelaire misses the pun on *sty*, for while he perceives the sense of pig-sty (he translates it as "étable"), he misses the sense of a growth in the eye, as his footnote, speciously suggesting that he knows the meaning, attests: "one can guess the figurative meaning of the word *sty*" (639). He implies a more obscene meaning to the word (indeed, *sty* figuratively denotes a place of lust and moral degradation), but the essential element of the pun goes unnoticed.

ings, implements (see Hogarth), everything, is allegory, allusion, hieroglyphs, rebuses.]

Pure art, like *comique absolu*, is a dualistic art presenting itself as unified, a suggestive magic containing at once subject and object, the world outside the artist and the artist himself. In contrast, philosophical art has the evident dualism of the *significatif*, or, worse, of Grandville—allusive, allegorical, "a visual art that pretends to replace the book" (598).[83] It suffers from a division between philosophical and artistic, literary and pictorial, cerebral and visual. But Baudelaire suggests that Alfred Rethel turns this to his advantage, using a form that best suits it—allegory—and producing from this an art of vast moral significance and aesthetic interest. Baudelaire calls Rethel's most famous work, *Auch ein Totentanz* (*Another Dance of Death*), an "allégorie épique" and refers to the series repeatedly as a poem, having the "caractère satanique et byronien"of the comic.[84] Rethel approaches pure art from within an art supposedly antithetical to it, much like the work of Hogarth.

But Baudelaire's language is less witty here than in the section on Hogarth, with its many puns and jokes. One senses a seriousness in his remarks, an unqualified respect for Rethel's artistry, technique, and originality of thought. Indeed, *Auch ein Totentanz* is an extraordinary series of six woodcuts depicting the 1848 revolution as Death's ruse to enslave the people.[85] Baudelaire acknowledges its reactionary message—"l'usurpation de tous les pouvoirs et la séduction opérée sur le peuple par la déesse fatale de la mort" [the usurping of all power and the seduction of the people by the fatal goddess of death]—and expresses admiration for the independence of its vision at a time when the revolution was having its greatest effect, indeed, playing the role of Death in the series itself: "Ce que je trouve de vraiment original dans le poème, c'est qu'il se produisit dans un instant où presque toute l'humanité européenne s'était engouée avec bonne foi des sottises de la révolution" (600) [What I find to be truly original in the poem

83. Cf. also the allegorical works of Bruegel, "nearly undecipherable today" (573).

84. Baudelaire explicitly links the dance of death with the grotesque and comic in the *Salon de 1859*: "Les artistes modernes négligent beaucoup trop ces magnifiques allégories du Moyen Age, où l'immortel grotesque s'enlaçait en folâtrant, comme il fait encore, à l'immortel horrible" (652) [Modern artists neglect far too much these magnificent allegories of the Middle Ages, in which the immortal grotesque became merrily intertwined, as it does still, with the immortally horrible]. Cf. *Corr.* I, 535.

85. The work was published in May 1849 and reproduced in *L'Illustration*, 28 July 1849.

is that it was produced at a time when almost the whole of European humanity had become genuinely infatuated with the follies of the revolution]. Rethel's vision was probably less reactionary than was perceived on both sides of the ideological fence, as Paret has argued.[86] But Baudelaire's own stand on the inauthenticity of this revolution, the "bourgeois" egoism and individualism of the republicans who carried it out and led it to failure, made him delight in the perceived irony—almost perversity—of Rethel's brutal images amid the revolutionary furor.

The *danse macabre* is one of the classic examples of the grotesque, with its intermingling of real and fantastic, life and death, human and demonic. Rethel's novel use of this traditional motif matched Baudelaire's own practice. His 1858 poem of that title presents an ironic, mocking, grimacing skeleton leading the whole of humanity in a grotesque, contorted dance of madness. But following the law of comic art, this "caricature" is an image of beauty too:

> Aucuns t'appelleront une caricature,
> Qui ne comprennent pas, amants ivres de chair,
> L'élégance sans nom de l'humaine armature.
> Tu réponds, grand squelette, à mon goût le plus cher! (i, 97)

> [Some will call you a caricature
> Who, lovers drunk on flesh, do not understand
> The indefinable elegance of the human frame.
> You respond, great skeleton, perfectly to my taste!]

This is a caricature in the revised sense of *De l'essence du rire*, exhaling a *vertige* that produces "nausea" and a Virginie-like uneasiness before an unfamiliar image of the self. For the song that Death sings is an "Hypocrite lecteur!" and the skeleton an image of the viewer: "malgré l'art des poudres et du rouge / Vous sentez tous la mort!" [despite the art of powder and rouge / You all reek of death!]

86. P. Paret, *Art as History: Episodes in the Culture and Politics of Nineteenth-Century Germany*, 113ff. For Paret, the series targets not the revolution in general, but a particular aspect of it, lower-class populist movements which resisted the change from an artisanal to an industrial society. He notes that Rethel pictures only this group—artisans and shopkeepers—as the force behind the revolution, and ignores all others. Champfleury wrote an article on Rethel's series, pointing out, like Baudelaire, its reactionary message (*L'Artiste*, 15 September 1849).

Two other works that Baudelaire cites demonstrate one of Rethel's most distinctive qualities, the interpenetration of fantastic and real. As Paret notes, both have an ahistorical quality and at the same time an abundance of carefully drawn detail.[87] As in *Auch ein Totentanz*, Rethel brings together the mythical, the conventionally symbolic, and the topical or specific; as Baudelaire puts it, the allegorical and the fake ("postiche")—his imitations of Dürer, Holbein, and others—brought to bear on an allegedly specific event. The "real" is thus universalized as though by the power of that universal and timeless reality, death itself. In *Der Tod als Erwürger: Erster Auftritt der Cholera auf einem Maskenball in Paris, 1831* (*Death the Slayer, or The Appearance of Cholera at a Masked Ball in Paris, 1831*) (Fig. 54) the irony is evident even in the title, in the contrast between the carnival-like festivities of the Opera ball and the terrible onslaught of the cholera epidemic. Like the revelers at the masked ball in Poe's *Masque of the Red Death* (which Baudelaire translated in 1855), Rethel's cannot keep out the Red Death of cholera, whose power they so outrageously flout. Baudelaire notes the dancers stretched out stiff on the floor, the hideous character of a Pierrette with her toes in the air and her mask undone, and the sinister character of the whole. The musicians flee in the presence of the great fiddler; the masks, with their frozen smiles, slide off to reveal the faces of corpses, like Death emerging from beneath the powder and rouge of the dancers in the lines cited above from "Danse macabre." In the midst of the confusion, the figure of cholera sits "impassive" on a bench, and Death plays calmly on a pair of bones: his flowing robes and almost coquettish posture recall the skeleton dancing to the rhythm of the violin in Baudelaire's poem, and contrast ironically with the heavy, lumpish bodies of the former dancers now strewn lifeless on the floor around him.

The other work, *Der Tod als Freund* (*Death the Friend*), depicts a tranquil end—an old man delivered unto death in his sleep (Fig. 55). The hooded figure of Death tolls the bells, and the sun setting across the fields throws up its last rays over the horizon in an evident symbol of mortality: "it is the end of a fine day," as Baudelaire puts it with comical banality. He notes the room high up in the bell tower where the old man rests in his great chair, the fields spreading across to a vast horizon through the open window, and the pattern of rays cast by the setting sun: this is a perspective from on high, already half-removed from the world, like the sun divided by the horizon, or the earth on the threshold of night and day. The one who rang the hours is

87. Ibid., 116.

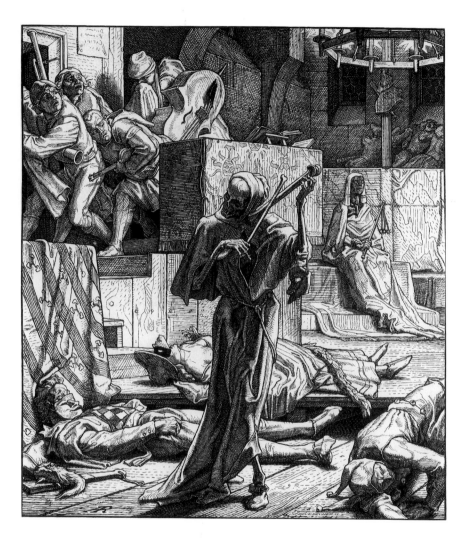

FIG. 54. Rethel. *Der Tod als Erwürger. Erster Auftritt der Cholera auf einem Maskenball in Paris, 1831,* 1851 (photo: Victoria and Albert Museum)

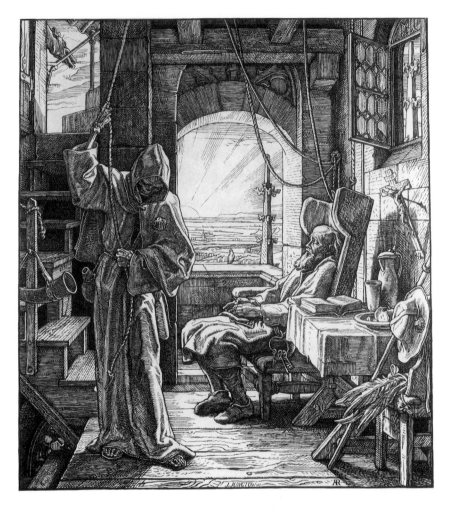

FIG. 55. Rethel. *Der Tod als Freund* (photo: Victoria and Albert Museum)

now outside of time, or reintegrated into the true time, the cycle of nature at its splendid end. Of the bird perching on the sill, Baudelaire asks in closing: "vient-il écouter le violon de la Mort, ou est-ce une allégorie de l'âme prête à s'envoler?" (600) [has it come to hear Death's violin, or is it an allegory of the soul ready to fly off?] This is a *pointe* worthy of his poems, and a fitting end to this chapter too. For as the interrogative suggests,

the two are identical, and the bird the ambiguous image of mankind's relation to death, and to the comic as well: fascinated and lulled by it on the one hand, liberated by it on the other.[88]

88. Baudelaire planned to write a prose poem on the subject of the *Erster Auftritt der Cholera auf einem Maskenball in Paris* (I, 367, 370). T. J. Clark (*The Absolute Bourgeois*, 26) likens his notes for another, entitled "La Guerre civile" (I, 371), to the *Death on the Barricade* plate of Rethel's *Auch ein Totentanz.*

The Comic and Modernity

4

A comparison of *Le Peintre de la vie moderne*[1] with the essays on caricature immediately produces some remarkable parallels on all levels—vocabulary, theme, and example. Indeed, the theory of modernity offered in the work on Constantin Guys has more to do with these essays than with the one to which it is regularly compared, the *Salon de 1846*. Of the ten artists discussed in *Quelques caricaturistes français*, six reappear in *Le Peintre de la vie moderne* (Daumier, Gavarni, Carle Vernet, Trimolet, Traviès, and Charlet), and one of those meant for the expanded version of the caricature project turns up here as well (Debucourt). Caricature and *peinture de moeurs* are clearly related by subject matter (common-life genre subjects) and medium (the graphic arts), and it is often impossible to place an artist securely in one or the other category. Baudelaire himself blurs the distinction between "caricatures" and "sketches of the crowd and street" (544) in *Quelques caricaturistes français*. Still, the extent of the resemblance and repetition here is significant, suggesting the close relation, in his scheme, of an art of modern life to comic art, the *beau moderne* to the *comique*. A *peintre de moeurs* on the level of Gavarni (687),[2] an *artiste mnémonique* like Daumier (698), a better painter of the military than Charlet (709), Guys is throughout discussed in the context of the caricaturists.

1. The essay was written in late 1859 and early 1860, and published in 1863.
2. Cf. Baudelaire's note on Guys attached to a letter to J. Desaux, 10 January 1861, in which he makes Guys the equal of Gavarni and Lami as a *peintre de moeurs* (P. Duflo, "Baudelaire et Constantin Guys: Trois lettres inédites," 601).

The relation is important, for the theory of the comic qualifies or calls into question some of the features of modernity that have been derived from Baudelaire's essay. For example, the emphasis on dualism in the theory of the comic—the laugher's status as an object of laughter—radically revises the concept of the urban *flâneur*, no longer merely a controlling gaze, but at once subject and object, observer and observed. The necessary feature of the comic artist in *De l'essence du rire*—*dédoublement*—returns in Guys's capacity to enter into the character of others while observing them from without, the defining quality of the artist-*flâneur*, cosmopolitanism. The artist of modernity, with an insatiable passion for the varied and ever-changing forms of life and a compulsion to express them in visual images, this "self insatiable for the non-self" (692) who observes the forms exterior to him, absorbs them into himself and in turn becomes one with them, has the same "power to be at once self and other," notably the most *contradictory* other, that characterizes the comic artist (543). The ironic understanding of dualism, the "comic" recognition of superiority and inferiority, makes possible the move out of the self that is *dédoublement,* and that becomes the *flâneur*'s reciprocal and life-creating communion with the crowd.

The aesthetic value of the city, advanced in the Daumier section of *Quelques caricaturistes français*, also comes to prominence here, in a virtual equation of the urban and the modern. The city depicted by Guys, offered as material for an art of modernity, is hardly a "pastoral" image,[3] a spectacle mirroring the glitter of bourgeois prosperity, but rather possesses the satanic quality that defines the comic; the modern city is the Paris of Virginie, fascinatingly demonic, a product and manifestation, like the comic, of a mythical Fall. And as the locus of the comic, it thus encompasses the means not only of corruption but of redemption too, the awareness and exploitation of dualism, the *flâneur*'s interaction with the innumerable forms and beings that meet the eye.

Le Peintre de la vie moderne indeed abounds in the vocabulary of the *comique absolu*: *ivresse* (690, 699, 702), *fureur* (699), *feu* (699), *grotesque* (700), *fantastique* (697), *fantasmagorie* (694), *passion* (691f.), *explosion* (700, 705), *ardeur* (705), *mystérieuse* (695), *magique* (694, 706), *bizarre, violent, excessif* (724). Like the pages of *La Caricature* and Daumier's *Robert Macaire*, Guys's works constitute an archive and an epic (700f.). As in all *comique absolu* their moral springs "naturally" from the art itself, or

3. *Pace* Marshall Berman, *All That Is Solid Melts Into Air: The Experience of Modernity,* 134ff.

rather the art suggests a host of moral considerations (708). They have an immediacy and richness of meaning that defy the attempts of verbal description—temporal, restrictive, and exclusive—to reproduce them. Baudelaire makes the same admission of defeat in his struggle to convey the effect of Guys's works as he had earlier of the English pantomime: "Elles sont grosses de suggestions, mais de suggestions cruelles, âpres, que ma plume, bien qu'accoutumée à lutter contre les représentations plastiques, n'a peut-être traduites qu'insuffisamment" (722) [They are pregnant with suggestions, but harsh suggestions, which my pen, while used to wrestling with the visual arts, has perhaps translated only inadequately].

Like the comic, beauty is dual, composed of two seemingly contradictory elements, and results from the dualism of mankind. Baudelaire extends the satanic—and thus human—nature of comic art to the whole of art; like caricature, the art of modern life testifies to this dualism explicitly, for it embodies the same contradiction between the ephemeral and eternal, phenomenal and ideal, "ugly" and "beautiful," particular and universal. The moral and aesthetic value of comic art thus applies equally well to the art of modern life, which simultaneously realizes and transcends the dualism of which it is born. Like the comic, it discovers the ideal, the mysterious, the *insaisissable*, the enduring, in and through the real, the phenomena of a particular time and culture.

Indeed, this dualism suggests one other parallel: the aesthetic of modernity that Baudelaire repeatedly formulates in *Le Peintre de la vie moderne*—extracting beauty from ugliness, the poetic from the historical, the eternal from the transitory, the fantastic from the real, the epic from the trivial—restates the comic aesthetic of *caricature artistique*: the beauty found in works representing humanity's moral and physical ugliness, the pleasure taken in such a "lamentable spectacle," the enduring power of works "hanging on events," the epic created from the fleeting and prosaic experience of contemporary history, public and private—names, events, and policies otherwise forgotten. And the mixture of fantastic and real by which Baudelaire characterizes Goya, Hoffmann, and Daumier becomes the main quality of Guys's vision and an art of modernity in general: finding the fantastic in the real, and conversely, depicting the reality of the fantastic in contemporary life.

Baudelaire's theory of caricature thus prepares and provides the justification for his aesthetic of modernity. It furnishes a response to the issue raised at the start of *Le Peintre de la vie moderne*: it explains how the *poetae minores* fulfill the same function and operate according to the same princi-

ples as the stock examples (here ironized) of idealist art, Racine and Raphael; and how the "second order" rejoins, and sometimes surpasses, the "first." Perhaps the long and protean history of the caricature project provided Baudelaire with the necessary time in which to explore one of the central concerns of his critical and creative thought, expressed in his earliest writings—an art appropriate to the mid-nineteenth century, a worthy successor to the great tradition of Romanticism (493). In 1846, he could only manage the problem in two ways, without finding a satisfactory solution: on the one hand, to extol Delacroix as the artist who carried on the torch, and on the other, to pose the challenge of an art that would express the epic side of modern life (493). These two approaches persisted concurrently throughout his career: Delacroix remained the most brilliant contemporary "phare," but a solitary one, the Romantic tradition brought to its height; while the search for an artist of modern life, a painterly equivalent to Balzac, continued alongside, in Lami and Gavarni in the *Salon de 1846*, Meryon in the *Salon de 1859*, Guys in *Le Peintre de la vie moderne*, and the etchers of *Peintres et aquafortistes* (1862). The essays on caricature offer a way of reconciling the two, of extending the notion of an art of modernity beyond merely an art of modern subjects to an aesthetic of the modern, drawing lasting beauty from the transient, historically bound, ugly experience of contemporary life. The theory of comic art furnishes the model by which the paradoxical, or dualistic, aesthetic of the modern may operate, the ephemeral endure, the historical enter the eternal, and conversely, the mysterious provoke recognition and knowledge of the real; the practical examples identify such an aesthetic at work in artists past and present, notably Goya and Daumier. The aesthetic of modernity born of the comic locates the "mysterious, enduring, eternal" element not only in the fleeting images of contemporary life, but also in the creations of an equally transitory single imagination from a single historical moment: the oxymoron of comic art and modern art thus applies ultimately to art in general.

The relation of Baudelaire's comic system to his aesthetic of the modern also defines the subtle but powerful moral dimension of art. This does not mean a moralizing, didactic, or philosophical purpose, which he consistently rejected as a heresy,[4] but rather a morality deriving from the art itself, the moral considerations that it inspires in the viewer. Leakey's suggestion that Baudelaire's late moralism lies in bringing the reader into the poem and creating the illusion that he or she, rather than the poet, is the moralist[5] is

4. *L'Art philosophique*, 604.
5. "Baudelaire: The Poet as Moralist," 216.

confirmed by the morality of caricature such as Daumier's and Goya's, which emerges from the art alone; and later by the morality of Guys, which springs naturally from his works in the form of suggestions called up in the observer's mind (722). The essays on caricature integrate the moral and the aesthetic, positing the moral value of all true aesthetic experience, the impression of unity of the dualistic *comique absolu*.

These connections are significant for our understanding both of Baudelaire's thought and of the relation between comic art and modernism in the nineteenth century. The direct line from the essays on caricature to *Le Peintre de la vie moderne* traces not only the link between "popular" and "high" art, but more important, the comic aspect (in the Baudelairean sense) of modernist subjects and aesthetic values—the ugly, transitory, urban, banal, artificial, grotesque, ironic, multiple, and paradoxical. Moreover, the essays on caricature, so openly based on contradiction, offer one of the central contradictions of nineteenth-century aesthetics. In their relation to *Le Peintre de la vie moderne*, they demonstrate how the most radical aesthetic of the time could base itself on the most apparently conservative, indeed reactionary, of metaphysical and moral theories, which in the poet's own words repudiated the positivism of eighteenth-century enlightened philosophy and the social progressive doctrines of his own era in favor of the pervasive myth of original sin—perhaps the most eloquent vindication of the theory itself and the fundamental Baudelairean principle on which it rests: the creative potential of paradox.

The *Salon de 1846*

The relation of *comique* to *beau moderne*, and of caricature to the painting of modern life, can be glimpsed already in Baudelaire's brief discussion of modernity in the *Salon de 1846*, contemporary with the first stage of the caricature project. The *Salon* thus provides a natural point of departure for studying the role of the essays in the evolution of his modern aesthetic. In his edition of the *Salon*, Kelley draws attention to two connections between it and the essays on caricature: the relativism of concepts of beauty and ugliness, and the theme of dualism.[6] Indeed, the first point is fundamental,

6. Kelley, *Salon de 1846*, 31f.

for the paradoxical beauty in ugliness that characterizes comic art is the principle on which Baudelaire bases the heroism of modern life and the *beau moderne* in the famous final chapter of the *Salon*. The experience of everyday life is ugly, trivial, and ordinary but contains a beauty, sublimity, and heroism of its own, deriving from the passions proper to the age.[7] Thus the famous *habit noir*, symbol of the "sorrow" that the "suffering age" carries on its bony shoulders, its folds enveloping the body like snakes around mortified flesh ("ces plis grimaçants, et jouant comme des serpents autour d'une chair mortifiée," 494), has its own beauty, charm, and "mysterious grace" worthy of representation. The powerful comparison, recalling the cadavers of "Un Voyage à Cythère" and "Une Charogne," presents the modern hero in an image of victimization and torment that nevertheless inspires aesthetic pleasure, just as caricature, the image of moral and physical ugliness, provokes laughter. As we have seen, it is accordingly realized in a caricature, Daumier's "Le Dernier Bain," described in identical language in *Quelques caricaturistes français*: the same bony misery and grim torment, "la redingote chétive et grimaçante . . . sous laquelle tous les os font saillie! Et la cravate . . . tortillée comme un serpent" (553) [the miserable frock coat with its grimacing folds . . . with the bones jutting through! And the tie . . . twisted like a snake].

Baudelaire's example from the moral domain behaves likewise, the peculiarly modern heroism recorded daily in the *Moniteur universel* and the *Gazette des Tribunaux*, which goes as unrecognized as the serious art in caricatures did to readers of the morning editions in *Quelques caricaturistes français* (549). The haughty courage of Guizot in a brilliant tour de force before the opposition in the Chambre des Députés, and the fearless, independent defiance of the criminal who, pushing aside the priest and rushing upon the guillotine, reenacts the final performance of that exemplar of the modern criminal, Lacenaire—both represent a caricatural, and modern, heroism in the topical and uneventful business of everyday life.[8] Baudelaire

7. In 1846, Baudelaire's emphasis on the *passions* proper to the age, notably *douleur*, allows for the inclusion of Delacroix among the painters of modernity, although his subjects are not contemporary: "la tristesse sérieuse de son talent convient parfaitement à notre religion, religion profondément triste, religion de la douleur universelle" (436, cf. 440) [the serious sadness of his talent is perfectly suited to our religion, a profoundly sad religion, the religion of universal sorrow].

8. Oehler ("Le Caractère double de l'héroïsme et du beau moderne," 196f., 202f.) rejects Mayne's identification of Baudelaire's heroic criminal as Lacenaire (*Art in Paris*, 119) and proposes instead Pierre-Joseph Poulmann, who had gone to the gallows for murdering a wine merchant, as reported in the *Gazette des Tribunaux* (7 February 1844). But Baudelaire specifies

does not merely illustrate this theory but puts it into action, presenting a seemingly banal modern life metaphorically as an art *tout fait*, a heroic drama from the pen of Byron (495), a "spectacle," a repeat performance, a poem with sublime motifs (493); the black suit is a costume befitting the part played by modern man. In this he accomplishes the purpose stated at the outset of the chapter (493): to create a new "great tradition" consistent with the aims and practices of the old, but proper to the age, accomplishing for the modern world the "idealization" that history painting does for the past. "La vie ancienne *représentait* beaucoup" [Life in antiquity was very much a spectacle]; the artistic metaphors imply that modern life does likewise. Painters have only to open their eyes and watch the drama unfolding everywhere around them, in public and private, high and low life; and then submit it to an arrangement or "idealization" that translates the interpretation of their temperament.

The second point of contact, dualism, informs both the scheme and the content of the *Salon*: the principal division of line versus color, Ingres versus Delacroix, the *dessin physionomique* with its "dual method" (458) of outlining forms and then filling in the spaces, versus the *dessin imaginatif* with its more simple and unified "method . . . analogous to nature," that is, drawing by the very use of color.[9] The *dessin physionomique* harbors an incessant duality counterproductive to the effort to create a harmonious *ensemble*, and leaves the viewer dissatisfied: "Cette méthode double . . . donne à toutes leurs productions je ne sais quoi d'amer, de pénible et de contentieux" (458) [This dual method . . . gives to all their works something bitter, painful, and contentious]. The *dessin imaginatif*, on the other hand, presents an immediate unity of conception: such artists draw *because* they use color (458), just as the moral springs directly from the art in the *comique absolu*. Like the *comique significatif*, the *dessin physionomique* is primarily an imitation, and the *dessin imaginatif*, like the *absolu*, primarily a creation.

that the criminal's cry of defiance ("Leave me my courage!") "*fait allusion* à la funèbre fanfaronnade d'un criminel, d'un grand protestant, bien portant, bien organisé, et dont la féroce vaillance n'a pas baissé la tête devant la suprême machine" [*alludes* to the funereal boasting of a criminal, a great protester, sound in mind and body, whose fierce bravery did not bow its head before the supreme machine]. The earlier criminal to whom "Poulmann" alludes is surely Lacenaire, whose impenitence and defiance at his execution were legendary: he too refused the last consolation of the Abbé Montès's services, pushing him away with an "Ah bah!" (*Gazette des Tribunaux*, 10 January 1836), and proclaiming, according to Canler, chief of the security forces, "I am not afraid! go away! I am not afraid!" (*Mémoires de Lacenaire*, 206).

9. Kelley (*Salon de 1846*, 32) compares this to the *significatif-absolu* distinction.

The essential dualism of *both* types of *comique* applies to the two types of *dessin* as well. *De l'essence du rire* makes clear that *comique absolu* is not absolute at all, but only so in relation to a fallen humanity: it presents itself as unified but is actually dual, and represents the human equivalent of a posited absolute. The *dessin imaginatif* likewise comes closest to divine creation but remains in the thoroughly human realm of representation. It thus reflects the same paradox as *comique absolu: dessin* is a product of human analysis, nature artificially broken down into a dual system of color and line, as the comic is a product of consciousness; *imaginatif*, like *absolu*, belongs to the ideal.

The *Salon de 1846* also introduces the dual structure of beauty that later grounds *Le Peintre de la vie moderne*. But this has an important affinity with the dual structure of the comic as well:

> Toutes les beautés contiennent, comme tous les phénomènes possi-
> bles, quelque chose d'éternel et quelque chose de transitoire,—
> d'absolu et de particulier. La beauté absolue et éternelle n'existe pas,
> ou plutôt elle n'est qu'une abstraction écrémée à la surface générale
> des beautés diverses. L'élément particulier de chaque beauté vient des
> passions, et comme nous avons nos passions particulières, nous avons
> notre beauté. (493)

> [All forms of beauty, like all possible phenomena, have within them
> something eternal and something transitory—something absolute
> and something particular. Absolute beauty does not exist, or rather
> it is only an abstraction skimmed from the general surface of diverse
> types of beauty. The particular element of each form of beauty comes
> from the passions, and as we have our special passions, we have our
> own form of beauty.]

Absolute beauty exists only as an abstraction; each individual example consists of an eternal, absolute element (that qualifies the whole as beauty) and a transitory, particular one that conveys and expresses the first. This directly reflects the structure of the comic, particularly at its highest level, which likewise consists of a transitory element and an enduring one, while presenting itself as unified. The relativism of the *comique absolu* applies to beauty too, which Baudelaire here considers wholly in human terms, bound to the transient phenomenal world: "comme tous les phénomènes possi-bles." He does not elaborate on this here, but the essays on caricature

formulate the system implied: like the comic, beauty—dual, relative, phenomenal—is born of human consciousness and created from a human perspective. The essays on caricature thus work the *Salon*'s aesthetic concepts into a moral and metaphysical scheme, and account for the extraordinary and otherwise unexplained statement of *Le Peintre de la vie moderne*: "La dualité de l'art est une conséquence fatale de la dualité de l'homme" (685f.) [The dualism of art is an inevitable consequence of the dualism of man].

Indeed, in the *Salon de 1846* aesthetic dualism is presented in the moral vocabulary central to *De l'essence du rire—unité, dualité,* and *contradiction*:

> Quoique le principe universel soit un, la nature ne donne rien d'absolu, ni même de complet; je ne vois que des individus. Tout animal, dans une espèce semblable, diffère en quelque chose de son voisin, et parmi les milliers de fruits que peut donner un même arbre, il est impossible d'en trouver deux identiques, car ils seraient le même; et la dualité, qui est la contradiction de l'unité, en est aussi la conséquence. . . . Je dis la contradiction, et non pas le contraire; car la contradiction est une invention humaine. (455f.)

> [Although the universal principle is one, nature provides nothing absolute, or even complete; I see only individuals. Every animal within the same species differs in some way from the next, and among the thousands of fruits that the same tree produces, it is impossible to find two that are identical, for they would be one and the same; and duality, which is the contradiction of unity, is also the consequence of it. . . . I say the contradiction, and not the opposite; for contradiction is a human invention.]

As Kelley has noted, Baudelaire defines unity throughout the *Salon* as an abstraction of variety, as absolute beauty is an abstraction of individual ones (493).[10] The complementary contrast of tones constitutes the color harmony of a natural scene ("une infinité de tons, dont l'harmonie fait l'unité," 455); the unity of nature itself consists in its variety of individual phenomena; and a species is an abstraction of particulars, each one necessarily different from the others. Duality is the contradiction of unity—it

10. *Salon de 1846*, 10ff.

negates it and is incompatible with it—but also its consequence, because necessarily implied by it: considered as an abstraction, unity demands particulars and variety, the principle of differentiation, without which things would be not unified or harmonious, but merely identical. Baudelaire makes no distinction between duality and multiplicity; the latter is merely an extension of the former. As we shall see, this has considerable significance for the late works, for it suggests the continuity, rather than the opposition, between *dédoublement* and self-multiplication, irony and a play of voices.[11]

Baudelaire specifies that duality is a contradiction of unity and not its opposite: as with color and line, rational analysis has separated the two, but the distinction does not exist in reality. As this passage suggests, unity in fact consists in duality, variety, and difference; the contradiction lies, like all contradiction, in the human perception of the two. The world is in this sense a "vast system of contradictions" (I, 546), a "unified" network of contradictory, interrelated elements. This also informs the context in which he uses these terms in *De l'essence du rire*: Melmoth's "double nature contradictoire" is so defined by the two tendencies within him, but this division is a product of consciousness, the awareness of his position as superior to fellow humanity and inferior to the divine. The ignorant Virginie with her innocent "âme . . . primitive" (528) has no such contradictory nature and accordingly knows no laughter. Moral dualism, like contradiction, is a human invention, falsely separated from the idea of unity which it implies. The latter remains an abstraction and an illusion, representing the impossible passage of human to divine. Thus in the absolute realm which the hashish smoker momentarily seems to attain in the *Paradis artificiels*, "toute contradiction est devenue unité. L'homme est *passé* dieu" (I, 394) [all contradiction has become unity. Man has become a god.].

If moral unity is theoretically impossible by reason of the essentially *human* nature of contradiction and the essentially contradictory nature of humanity, it must be redefined and understood, like *comique absolu*, in relative terms. The source of moral unity lies in duality itself: self-knowledge, the awareness of the self as other, and the manifestation of this in comic *dédoublement*. Like the *absolu*, this unity is essentially comic, that is, dual, self-conscious, and imperfect, a human absolute. The conscious exploitation of dualism in the sacrifice of the artist leads others to an awareness of their own dualism, indicates the "system of contradictions" that they are. As we shall see, this defines the Baudelairean absolute too: the

11. *Pace* Lang (*Irony/Humor*, 115).

transcendent experience of *surnaturalisme*, that paradisiacal, beatific experience open only to those capable of observing themselves from without and preserving the memory, the mysterious intoxication that the solitary person draws from a communion with the crowd.

The Dualism of Art

The famous dualistic theory of the beautiful formulated in the first chapter of *Le Peintre de la vie moderne* elaborates on that of the earlier *Salon*.

> C'est ici une belle occasion, en vérité, pour établir une théorie rationnelle et historique du beau, en opposition avec la théorie du beau unique et absolu; pour montrer que le beau est toujours, inévitablement, d'une composition double, bien que l'impression qu'il produit soit une; car la difficulté de discerner les éléments variables du beau dans l'unité de l'impression n'infirme en rien la nécessité de la variété dans sa composition. Le beau est fait d'un élément éternel, invariable, dont la quantité est excessivement difficile à déterminer, et d'un élément relatif, circonstanciel, qui sera, si l'on veut, tour à tour ou tout ensemble, l'époque, la mode, la morale, la passion. Sans ce second élément, qui est comme l'enveloppe amusante, titillante, apéritive du divin gâteau, le premier élément serait indigestible, inappréciable, non adapté et non approprié à la nature humaine. Je défie qu'on découvre un échantillon quelconque de beauté qui ne contienne pas ces deux éléments. (685)

> [This is in fact an excellent opportunity to establish a rational and historical theory of beauty, in contrast to the theory of a unique and absolute beauty; to show that beauty is always, inevitably, of a dual composition, even though the impression it produces is single; for the difficulty of discerning the variable elements of beauty in the single impression it gives off in no way invalidates the necessity of variety in its composition. Beauty consists of an eternal, invariable element, the amount of which is exceedingly difficult to determine, and a relative, circumstantial element, which will be, if you like, one by one or all together, the age, fashion, morals, passion. Without this

second element, which is like the amusing, enticing, appetizing icing
on the divine cake, the first element would be indigestible, unappre-
ciable, unadapted and unsuited to human nature. I defy anyone to
find any sample of beauty whatsoever that does not contain these
two elements.]

As before, Baudelaire here implies the inadequacy of the traditional neoclas-
sical or idealist theory: absolute beauty does not exist, for all beauty is dual,
composed of two contradictory elements. He retains the equivalency of
variety and duality, and although he does not revive the 1846 idea that
absolute beauty is an abstraction of particular ones, such is implied: variety
in composition makes for a unity of impression as, in 1846, variety made
up the unity of nature, complementary tones the harmony of natural color,
duality the identity of a species, and so on.[12]

However, this "historical" theory differs from the earlier one in two ways.
First, it stresses the *reciprocal* importance of one element of beauty to the
other, following the structure of the comic. The relative (transitory, circum-
stantial, particular, contingent) element expresses the eternal, invariable
one, which would be unintelligible and inaccessible without it. The playful
alimentary metaphor is made to carry, in good comic fashion, a major
point. While one associates icing on the cake with the trivial and inessential,
Baudelaire here endows it with capital importance, and the comparison is
apt: he converts the "trivial" aspect of a work (the contemporary) into an
essential one, and a trivial kind of work (*peinture de moeurs*, caricature)
into one of value. Indeed, the icing on this cake makes it fit for human
consumption; it stimulates appetite ("amusante," "titillante," "apéritive"),
but also renders the cake itself palatable, edible, digestible. The eternal
element of beauty has no meaning without the relative element by which it
is transmitted and, from the viewer's perspective, perceived, "consumed,"
and understood.

Nor does Baudelaire neglect the eternal element. In the "Modernité"
section he argues that while the eternal can be grasped only through the
transitory, the transitory can endure only if the eternal quality of its
"mysterious beauty" is extracted from it: "pour que toute *modernité* soit

12. Later in the essay he explicitly describes unity as an abstraction of variety: "Dans l'unité
qui s'appelle nation, les professions, les castes, les siècles introduisent la variété" (696) [Into
that unity which we call a nation, the various professions, castes, and centuries introduce
variety].

digne de devenir antiquité, il faut que la beauté mystérieuse que la vie humaine y met involontairement en ait été extraite" (695) [for any *modernity* to be worthy of becoming antiquity, the mysterious beauty that human life involuntarily puts into it must be extracted from it]. This eternal element, essential for the work to be art, is clarified by the parallel passage from *De l'essence du rire*: there it is not only eternal, invariable, and mysterious, but also intangible, ungraspable ("insaisissable") and profound (526). The eternal element guarantees, paradoxically, a necessary indeterminacy, the space in which poetry is a "human aspiration toward a superior beauty," and the beautiful a Stendhalian *promesse du bonheur* (686). It is the same mystery characteristic of beauty in *Fusées* (I, 657), "quelque chose d'un peu vague, laissant carrière à la conjecture" [something rather vague, giving free scope to conjecture], the elusive, unknowable aspect which ensures that "le Beau est toujours étonnant" (578, 616) [Beauty is always surprising].[13] As *De l'essence du rire* suggests, this element is eternal and enduring precisely because it cannot be fully grasped. It therefore preserves its power of suggestion, its capacity to inspire thought and to realize fully its function as a *mnémotechnie du beau*, the aesthetic enterprise par excellence.[14] Retaining the eternal element in a modernist aesthetic in this way is not to defeat its radicalism, as Bersani charges,[15] but rather to affirm an extreme modernism: the most fleeting aspect of beauty may come not from the transitory images of modern life but from the "eternal" aspect itself, which forever eludes and thus keeps one searching to represent it.[16] Baudelaire subverts neoclassical aesthetics from within, finding the eternal in the transitory, and making the transitory an aspect of the eternal itself.

The second difference between the theories of the *Salon de 1846* and *Le Peintre de la vie moderne* is that the latter insists on the contradictory relation between unity and duality in the definition of beauty itself, as the paradoxical rhetorical structures ("bien que," "n'infirme en rien") of the first sentence suggest. Baudelaire thus emphasizes the aesthetic paradox first brought out clearly in the discussion of *caricature artistique* and *comique*

13. MacInnes (*The Comical as Textual Practice in Les Fleurs du mal*, 121) reaches a similar conclusion, defining poetry as comical because impure, "tracing the gap between desire and fulfillment." For Baudelaire, of course, "comical" in this sense applies to all art, as representation; with the gap bridged, art would cease to exist.

14. Cf. *L'Oeuvre et la vie d'Eugène Delacroix* (745).

15. *Baudelaire and Freud*, 20f.

16. As R. Chambers shows for the poems ("Baudelaire's Street Poetry," 248f.), the eternal element becomes a matter of chaos, disorder, and tempest—the "ouragan" in the eye of the *passante*.

absolu—the "unity" in dualism. The eternal element of beauty present in works meant to represent our moral and physical ugliness, and the hilarity inspired by such a "lamentable spectacle" (526), the enduring, artistic quality of the most fleeting and circumstantial of forms—this provides the formula for an art of modernity. The transitory and the ugly fall into the same category, in keeping with the values of nineteenth-century aesthetics. The system of the essays on caricature, and the contradiction that it formulates and works out, directly reflect Baudelaire's aesthetic of the modern: *la beauté dans la laideur, le poétique dans l'historique* (694), *la beauté dans la modernité* (718), *l'éternel du transitoire* (694), *la beauté particulière du mal, le beau dans l'horrible* (722) [beauty in ugliness, the poetic in the historical, beauty in modernity, the eternal from the transitory, the singular beauty of evil, the beautiful in the horrible]. Beauty follows the same pattern as *comique absolu*, which is dual and contradictory (depending on a relation of inferiority and superiority) but presents itself as unified (536), like the "impression . . . une" here—absolute only in relation to fallen humanity. Like the comic, it is essentially human, suggesting, and in this way defining, the absolute.

The point is crucial. In discovering the ideal in and through the real, caricature asserts the radical modernism of Baudelaire's "comic" aesthetic; the fallenness of art, the human nature of beauty, the paradoxical reality of the ideal. The sensationalism of this idea and of the theological metaphor used to present it in a secular and scientific age, as Baudelaire saw it, would have been fully understood by the author. "Toute littérature dérive du péché.—Je parle très sérieusement" [All literature derives from sin. I am speaking very seriously]:[17] the qualification indicates to what extent he recognized the extravagance of the statement and used it for his own unorthodox purposes. For, as we have seen, the aesthetic he derives from this is not nostalgic. The notion of an absolute beauty existing in some prelapsarian paradise is undermined by the senseless and stupid experience of joy, the burgeoning and growth of a plant, in contrast to the life-giving *vertige* of the *comique absolu*. It is unequivocally discredited by a simile in *Le Peintre de la vie moderne*: "Cet élément transitoire, fugitif . . . vous n'avez pas le droit de le mépriser ou de vous en passer. En le supprimant, vous tombez forcément dans le vide d'une beauté abstraite et indéfinissable,

17. Letter to Poulet-Malassis, August 1860 (*Corr.* II, 85). Baudelaire is discussing the sixteenth-century image of the Fall, taken from Langlois' book, which he wished to use for the frontispiece to the *Fleurs du mal*.

comme celle de l'unique femme avant le premier péché" (695) [This fleeting, transitory element . . . you do not have the right to scorn it or dispense with it. In suppressing it, you necessarily fall into the void of an abstract and nondescript beauty, like that of the only woman before the first sin].[18] The beauty of Eve is abstract, nondescript, unintelligible; beauty is born, like the comic, after the first sin.

Indeed, ideal beauty cannot be appreciated: "Ce qui n'est pas légèrement difforme a l'air insensible—d'où il suit que l'irrégularité, c'est-à-dire l'inattendu, la surprise, l'étonnement sont une partie essentielle et la caractéristique de la beauté" (I, 656) [What is not slightly deformed seems imperceptible—whence it follows that irregularity, surprise, the unexpected, wonder, are an essential part and a main characteristic of beauty]. In *Le Peintre de la vie moderne* beauty testifies not only to the dualism and contradiction of the comic, but also to the convulsive clash or "choc" that results from this and is realized in laughter: the aesthetic experience of the modern, cosmopolitan, "convalescent" painter before the fleeting, multiple forms of life involves a shock or jolt to the nerves ("une secousse nerveuse," 690) that resounds deep within him, and is channeled into expression.[19]

Baudelaire's attitude toward a prelapsarian paradise is reflected in his consistently negative attitude toward utopia, as he describes it in the *Exposition universelle de 1855*—a prescribed system of rules conceived in the tiny enclave of the classroom and falsely imposed upon the diversity of life (579). Any aesthetic prescription is a "lamentable daughter of utopia" (577) that threatens the existence of art. The idealist's system of a *beau absolu*, to be achieved according to an unchanging formula, signifies the death of art itself. On the other hand, the historical element does not suffice to ensure the aesthetic value of a work, the mystery that attracts but forever eludes and thus retains its hold on the imagination; as with Charlet, the pure circumstantial inhibits genius.[20] Guys's art of modernity, like the caricatural art of Daumier and Goya, integrates the two in a reciprocal relation, expressing the eternal aspect of the transitory, the absolute quality of the relative and particular, the beauty of evil and ugliness, "the painter of circumstance and all that it suggests of the eternal" (687).

18. Ideal beauty is *indéfinissable* but not *mystérieuse*: mystery exists only in an imperfect, human world.

19. "Solid nerves" (690) enable such an artist to receive the "jolt" and translate it, through an ordering "analytical spirit," into formal expression.

20. *Quelques caricaturistes français* (546): "an artist of circumstance and an exclusive patriot, two hindrances to genius." Cf. the article on Auguste Barbier (143), whose verses he finds "marked with the sorry character of circumstance and fashion."

Baudelaire's dualism also applies to the value of a work: its historical interest consists in its ability to re-create and preserve a moment in time, its artistic interest in its technical achievement in rendering this. He takes as his example precisely the same "caricatural" fashion plates of the Revolutionary period discussed in the Carle Vernet section of *Quelques caricaturistes français*.[21] As in the earlier passage, the images inspire laughter in those who do not understand the period (or lack the cosmopolitan power to enter into it), and represent an era in which people resembled their conception of beauty: "L'homme finit par ressembler à ce qu'il voudrait être" (684) [Man ends up looking like what he would like to be]. But a comparison of the two reveals a shift in emphasis from the artistic value of Vernet's plates—the "truthfulness" of the representation, the appropriateness of each part within the whole—to the historical value of these, the morality and aesthetic of the time imprinted in every detail:

> Ce n'est pas seulement pour avoir gardé profondément l'empreinte sculpturale et la prétention au style de cette époque, ce n'est pas seulement, dis-je, au point de vue historique que les caricatures de Carle Vernet ont une grande valeur, elles ont aussi un prix artistique certain. (*Quelques caricaturistes français*, 544)

> [It is not only for having thoroughly preserved the sculptural imprint and the pretention to style of that era, it is not only, I mean, from the historical point of view that Carle Vernet's caricatures have great value, they also have a definite artistic worth.]

> Le passé est intéressant non seulement par la beauté qu'ont su en extraire les artistes pour qui il était le présent, mais aussi comme passé, pour sa valeur historique. Il en est de même du présent. . . . [Ces costumes] sont très souvent beaux et spirituellement dessinés; mais ce qui m'importe au moins autant, et ce que je suis heureux de retrouver dans tous . . . c'est la morale et l'esthétique du temps. (*Le Peintre de la vie moderne*, 684)

> [The past is interesting not only by reason of the beauty that artists for whom it was the present could extract from it, but also as the

21. T. H. Parke ("Baudelaire et La Mésangère," 254ff.) identifies Baudelaire's source as the *Journal des dames et des modes* published by Pierre de La Mésangère, but does not make the connection with Vernet; many of the plates were done after drawings of Vernet.

past, for its historical value. It is the same with the present. . . . These outfits are very often beautiful and wittily drawn; but what matters at least as much to me . . . is the moral attitude and the aesthetic of the time.]

The propositions have been rhetorically inverted. In privileging the historical value, Baudelaire supports his immediate argument for the transitory: the depiction of the historical sheds light on the aesthetic of the period, the way in which people tried to satisfy their "immortal appetite for the beautiful," and thus contains within itself an image of the enduring, mysterious element. One has the impression that Baudelaire is aware of the potentially greater historical interest of such images even in the earlier essay, but lacks the precise terms by which to justify it, and thus adds a rather vaguely defined category of "artistic value." *Le Peintre de la vie moderne* more willingly and openly affirms the value of the historical element *in*, rather than in spite of, itself.

In this essay, Baudelaire also attributes to the *peintre de moeurs* the dualistic *génie mixte* of the novelist, the moralist, and the caricaturist, exemplified in Daumier, Grandville, Gavarni, and Hogarth: artist and philosopher, pictorial and literary. Guys's works accordingly present a narrative that may be read: "j'ai pu *lire* ainsi un compte rendu minutieux et journalier de la campagne de Crimée, bien préférable à tout autre" (689) [thus I could *read* a detailed daily account of the Crimean campaign, much preferable to any other]. In Grandville, the insufficient integration of the two qualities had left the viewer with the disquieting and dissatisfying impression of dualism. In Gavarni, the balance tips toward the literary: with his great talent for observation, he is a complement (like Daumier) to Balzac; his works translate a particular historical moment; his literary imagination makes him invent as much as he sees. In the essay at hand, Baudelaire transfers all these qualities to the *peintre de moeurs*: he completes Balzac, has an imagination at once pictorial and literary, resembles the novelist and moralist, is an "observateur, flâneur, philosophe" (687), chronicles a historical moment (689), produces an archive. But whereas Gavarni's historical aspect ultimately restricts his appeal with the passage of time, the true painter of modern life touches on the eternal. Baudelaire usually sets the philosopher/moralist against the artist, the successive and analytic against the synthetic, the *significatif* against the *absolu* (616; cf. 124). But the best in this genre—Balzac, Daumier, Hoffmann, Goya, and now Guys— manage to combine the two, observing and classifying experience but also

suggesting its mysterious significance—visionary realists, to use the phrase applied to Balzac, passionate observers, pictorial philosophers, *moralistes pittoresques* (691).

The Dualism of Man

"The dualism of art is an inevitable consequence of the dualism of man" (685f.). Despite the importance of the dualistic theory of beauty in *Le Peintre de la vie moderne*, this is the only sentence openly to name its cause. Baudelaire merely acknowledges the phenomenon and dispenses with the explanations, as though it were a truth obvious to all, or as though he wished, in an essay taking so modern a position, to deemphasize, if not suppress, its mythical foundation. He admits only to the former motive, with a rather coy allusion to his other writings—"I have more than once explained these things already" (686); dualism had indeed informed his criticism since the *Salon de 1846*, especially the essays on the comic. It is true that his emphasis on the "positive" and "real" aspect of his topic (686) fits his current purpose, valorizing the historical. Also, reminding the reader of a metaphysical realm allows him to take yet another sarcastic stab at the positivist, utilitarian character of the French mind, ever resistant to and impatient with theoretical abstractions: "je sais que les lecteurs français, pour la plupart, ne s'y complaisent guère" (686) [I know that French readers, for the most part, take little pleasure in them]. But he need not have introduced the theme of human dualism at all. The maxim-like statement, this new *Le Sage ne rit*, gains in prominence through the show made of suppressing it; it remains teasingly in the reader's mind, like some monumental secret dropped with strategic nonchalance. Moreover, it recurs even in the "positive and real" part of the essay: as we shall see, original sin dominates the "Eloge du maquillage" section, and the satanic origins of female beauty are emphasized in the section on "Les Femmes et les filles." The moral dualism of the essays on caricature is of fundamental importance to the theory of modernity.

The solitary statement is actually prepared by a weighty "inévitablement" in the definition of beauty ("le beau est toujours, inévitablement, d'une composition double," 685), and reinforced by a direct comparison of the dualism of art to the traditional soul-body dualism of man—the eternal

element the "soul" of art and the variable element its "body" (686). The analogy, however, does not merely provide a mythical model for the structure of beauty; it attributes a moral significance and dimension to art, corresponding to the moral situation of mankind. Here the importance of the essays on caricature becomes apparent: the dualism of art follows the same moral-theological pattern as the comic, making the products of the Fall the means of redemption, ensuring from its fallen perspective the means of its own transcendence. Far from undermining his injunction against confusing the beautiful with commonplace notions of the good, or committing the "heresy" of making art subservient to a moral purpose, Baudelaire instead attributes to art the achievement of mankind's highest moral goal— the "unification" of the divided self—and makes this a function of the dualism that seems to contradict it, that is, irony and comic *dédoublement*.[22] In irony the self recognizes its capacity to be other, and its identity as a reciprocal relation *to* others, a unity from duality.

This relation between the value of comic art and that of art in general is worked out fully in one of the most problematic of Baudelaire's writings, the set of prose pieces on hashish from the *Paradis artificiels*. *Du Vin et du hachisch* (1851) and the more elaborate *Poème du hachisch* (1858) deal with the moral implications of a state *simulating* aesthetic experience. Significantly, the discussion is carried out wholly in the discourse of the comic, which, in bringing together the moral and the aesthetic, the dualism of art and the dualism of mankind, provides the criteria for distinguishing false aesthetic experience from true.

Baudelaire establishes the connection between the comic and hashish from within the *Paradis artificiels* themselves: "l'homme qui a pris du hachisch est, dans la première phase, doué d'une merveilleuse intelligence du comique" (I, 391) [the man who has taken hashish is, in the first stage, gifted with a wonderful sense of the comic]. The comic dominates the first stage of intoxication, which he accordingly describes as a rollicking, grotesque comedy, a mad carnival, a caricatural *charge*, a *scène grotesque* (I, 412) having a noxious atmosphere akin to Virginie's Paris. The *hachischin* is seized with "an absurd, irresistible hilarity" (I, 411), an irrepressible gaiety, *folâtrerie* (I, 412), the unmotivated, uncontrollable, explosive laughter of the possessed or the insane. As in *De l'essence du rire*, these bursts of laughter cannot be restrained, the demon cannot be resisted: there they are

22. Other works of around 1860 share this concern. Cf. the essays on Wagner and on Asselineau's collection, *La Double Vie*.

compared to a sneeze (530), here to a tickle so insistent as to cause pain (I, 411). Hashish inspires the dizzying "violent gaiety" (I, 395) and "vertiginous intoxication" (I, 394) of the English pantomime, with "dancing, leaping, a stamping of feet, and bursts of laughter" (I, 395) like the rollicking antics of the clowns. The smokers have caricaturally distorted faces (I, 412), and produce an unending succession of puns, jokes, and incongruous and bizarre associations (I, 411). Baudelaire calls the feeling inspired by the drug a "childlike gaiety" (I, 416), a "joy" (I, 391, 412), recalling the joy of the *comique absolu*, which "comes close . . . to a childlike state." Like the comic, it is infectious, contagious, and self-generating, having the freedom and excess of the *absolu*: "Des ressemblances et des rapprochements incongrus, . . . des jeux de mots interminables, des ébauches de comique, jaillissent continuellement de votre cerveau" (I, 411) [Incongruous likenesses and associations, . . . interminable puns, rough sketches of the comic spring continually from your brain].

This hilarity directly follows the model proposed in *De l'essence du rire*, that is, superiority with its necessary correlate, inferiority—the fool laughs at the sage. Indeed Baudelaire insists on the inversion of roles: the *hachischins* take the wisdom, good sense, and sang-froid of the sober witness, who looks on with bewildered restraint, for foolishness and dementia, pity him, feel themselves superior to him. As in the case of the comic, the *hachischin*'s pleasure increases relative to his sense of superiority and the perceived ignorance of those over whom he feels it: "Ce qui ajoutait à mon abominable jouissance était la certitude que tous les assistants ignoraient ma nature et quelle supériorité j'avais sur eux" (I, 417) [What increased my abominable pleasure was the certainty that all those in attendance were unaware of my nature and of how superior I was to them]. But this sense of superiority is equally a mark of inferiority, as Baudelaire sends the comic rebounding back upon the hashish smokers themselves and gives the sage the last laugh: "N'est-ce pas une situation mystérieusement comique que celle d'un homme qui jouit d'une gaieté incompréhensible pour qui ne s'est pas placé dans le même milieu que lui?" (I, 412) [Is it not strangely comical to see a man delighting in a mirth that is incomprehensible for whoever has not been in the same situation?] The laugher becomes an object of laughter, an unwitting player in a comedy, superior and unconsciously inferior.

Indeed, this paradise is the product of a *lost* freedom in which one is obliged to feel superior without recognizing one's inferiority, and thus to remain ridiculous, even contemptible—an object, rather than creator, of the comic. Baudelaire underlines the hashish smoker's impotence at the very

height of his egoistic self-assertion: he is constrained ("contraint") to admire himself (I, 434). His pride and egoism are the signs not of power but of the most absolute and humiliating *esclavage*: his sense of superiority, like that of the one who laughs, indicates equally his inferiority. Unaware of dualism, the laugher is all the more a victim of it, like the chronic dualism of Giglio as opposed to the self-conscious irony of Celionati in *Die Prinzessin Brambilla*. Hashish thus lacks the *sine qua non* condition of comic art, the means of avoiding the comic trap. It provokes an unbounded sense of superiority but not the recognition of inferiority. In fact, superiority stands behind even an expression of fellowship toward others, who seem, to the *hachischin*, unable to appreciate the "immense love" that he feels for them (I, 394).

By increasing his sense of superiority out of all proportion (I, 391), hashish develops the Melmothian imbalance between our faculties and our milieu, our image of ourselves and the reality in which we live, our soul and body:

> Souvenons-nous de Melmoth, cet admirable emblème. Son épouvantable souffrance gît dans la disproportion entre ses merveilleuses facultés, acquises instantanément par un pacte satanique, et le milieu où, comme créature de Dieu, il est condamné à vivre. Et aucun de ceux qu'il veut séduire ne consent à lui acheter, aux mêmes conditions, son terrible privilège. En effet, tout homme qui n'accepte pas les conditions de la vie, vend son âme. . . . L'homme a voulu être Dieu, et bientôt le voilà . . . tombé plus bas que sa nature réelle. (I, 438)

> [Let us remember Melmoth, that admirable example. His frightful suffering lies in the disproportion between his marvelous faculties, acquired instantaneously through a satanic pact, and the milieu in which he, as God's creature, is condemned to live. And none of those whom he tries to seduce agrees to buy his terrible privilege, with the same conditions attached, from him. Indeed, any man who does not accept the conditions of life, sells his soul. . . . Man wished to be God, and soon we see him . . . fallen lower than his real nature.]

Asserting his freedom and will in a forbidden game (I, 437), the *hachischin* actually delivers himself into slavery and damnation (I, 404), gives over his freedom (I, 420), annihilates his will (I, 397). Like Melmoth, he loses his

freedom and abdicates his will in the very effort to exercise them, thus condemning himself to a frustration more debilitating than the human weakness from which he originally sought to escape: *"il a voulu faire l'ange; il est devenu une bête"* (I, 409) [he wanted to be an angel; he became a beast]. In fact this source of pleasure has the effect of the most devastating ennui, dissipating the will as Satan vaporizes the "rich metal of our will" in "Au Lecteur," leaving one prey to the monster of Ennui. Without the will, the *hachischin* becomes "subjugated," as much the victim of an excess of sensibility as the beneficiary of its *voluptés* (I, 409). Baudelaire implies that the *hachischin* bears the responsibility for this damnation, for in his egoism he misjudges his own fallibility and inferiority relative to another: "Il oublie, dans son infatuation, qu'il se joue à un plus fin et plus fort que lui, et que l'Esprit du Mal, même quand on ne lui livre qu'un cheveu, ne tarde pas à emporter la tête" (I, 403) [In his infatuation, he forgets that he is pitted against one shrewder and stronger than himself, and that the Spirit of Evil, even when one gives him only a hair, does not take long to carry off the whole head]. With heavy irony he thus ridicules a deterministic view of human destiny: "You willed it; long live fatality!" (I, 410).

The satanism of hashish is a dominant theme of the work, and the same metaphors that characterize the comic thus recur here: hashish is an "evil" (I, 390), a "temptation" (I, 427), a fall ("déchéance," I, 427), a "demon" (I, 411, 428) that invades and possesses the soul, "one of the surest and most terrible means that the Spirit of Darkness possesses to enlist and enslave wretched humanity" (I, 428f.), an "infernal drug" (I, 433), a "perfect satanic instrument" (I, 434), a "forbidden game" (I, 437), a form of "debauchery" (I, 410), "witchcraft" (I, 439), "swindling," a kind of "sorcery" (I, 410) that challenges divine authority. The hashish smoker has the satanic qualities of pride and egoism that humanity exhibited at the Fall. Section 4 of *Le Poème du hachisch*, "L'Homme-Dieu," examines the extreme manifestation of this egoism, our belief in our own divinity and our self-glorification as center of the universe (I, 436). Under the influence of hashish, we see ourselves as God and the rest of creation as existing for our own pleasure.

The satanic sense of superiority carried to its extreme in this way perverts even the normal weapon against it, remorse. Remorse provides the *hachischin* with yet another occasion to indulge his obsession with himself, and furnishes him another motive for self-glorification and self-congratulation. Remorse is admirable and so is he for feeling it: "Cette action ridicule, lâche ou vile . . . est en complète contradiction avec ma vraie nature, ma nature

actuelle, et l'énergie même avec laquelle je la condamne, le soin inquisitorial avec lequel je l'analyse et je la juge, prouvent mes hautes et divines aptitudes pour la vertu" (I, 435) [This ridiculous, cowardly or base action . . . is in complete contradiction to my true nature, my current nature, and the very energy with which I condemn it, the inquisitorial care with which I analyze and judge it, are proof of my great and divine aptitude for virtue]. The most serious perversion, however, derives from his egotistical self-deception, the "sophism" of hashish (I, 432), which permits him, indeed forces him, to confuse desire with reality, or the virtue *projected* in remorse with virtue itself:

> . . . son imagination s'échauffant de plus en plus devant le spectacle enchanteur de sa propre nature corrigée et idéalisée, substituant cette image fascinatrice de lui-même à son réel individu, si pauvre en volonté, si riche en vanité, il finit par décréter son apothéose en ces termes nets et simples, qui contiennent pour lui tout un monde d'abominables jouissances: *"Je suis le plus vertueux de tous les hommes!"* (I, 436)

> [as his imagination gets more and more excited at the enchanting sight of his own nature corrected and idealized, he substitutes this fascinating image of himself for his real self, so meager in will, so rich in vanity, and ends by proclaiming his apotheosis in these plain and simple terms, which contain for him a whole world of abominable delights: "I am the most virtuous of all men!"]

Baudelaire's irony is no exaggerated reaction to a hypothetical *hachischin*, however. He gives as a parallel example that pride of the French Romantic tradition, Rousseau:

> Cela ne vous fait-il pas souvenir de Jean-Jacques, qui, lui aussi, après s'être confessé à l'univers, non sans une certaine volupté, a osé pousser le même cri de triomphe . . . avec la même sincérité et la même conviction? . . . Jean-Jacques s'était enivré sans hachisch. (I, 436)

> [Does that not remind you of Jean-Jacques, who, he too, having confided in the whole universe, and not without a certain delight, dared to utter the same triumphant cry . . . with the same sincerity

and conviction? . . . Jean-Jacques became intoxicated without hash-ish.]

Baudelaire alludes to this same Rousseau syndrome, the egotistical confusion of desire with reality, in the *Journaux intimes*—"Parce que je comprends une existence glorieuse, je me crois capable de la réaliser. O Jean-Jacques!" (I, 672) [Because I can conceive of a glorious existence, I believe myself capable of realizing it. O Jean-Jacques!]. He mocks it mercilessly in his own self-portrait, the comical hero of *La Fanfarlo*, Samuel Cramer.[23] Its cause lies in Rousseau's denial of original sin: Baudelaire likewise blames the "blindness" of the eighteenth century generally on its refusal to acknowledge original sin in *Le Peintre de la vie moderne* (715). This is the satanic legacy par excellence, as he here reminds us in a reenactment of the battle of the angels: "Si par hasard un vague souvenir se glisse dans l'âme de ce déplorable bienheureux: N'y aurait-il pas un autre Dieu? croyez qu'il se redressera devant *celui-là*, qu'il discutera ses volontés et qu'il l'affrontera sans terreur" (I, 437) [If by chance a vague memory slips quietly into the mind of this lamentable happy one—Would there not be another God?—have no doubt, but that he will rise up before *that one*, put forward his own wishes, and confront him fearlessly]. The *hachischin*'s will exists only as an instrument of self-delusion, blinding him to his dualism rather than making him aware of it—precisely the opposite of the comic.

The consequences of this gesture are devastating from an aesthetic point of view as well. First, whereas hashish promises paradise in a teaspoon, "un pays prodigieux, un vaste théâtre de prestidigitation et d'escamotage où tout est miraculeux et imprévu" [a wonderful land, a vast theater of magic tricks and sleight of hand where everything is miraculous and unexpected], the supernatural side of life, a "hieroglyphic dream" speaking the messages of another world, divine or unconscious, in a symbolic language (I, 408f.), it actually delivers only the ordinary world aggrandized to excess, a "natural dream" limited to the experiences and preoccupations of the dreamer: "Le cerveau et l'organisme sur lesquels opère le hachisch ne donneront que leurs phénomènes ordinaires, individuels, augmentés, il est vrai, quant au nombre et à l'énergie, mais toujours fidèles à leur origine" (I, 409)·[The brain and the whole organism on which hashish operates will produce only the individual phenomena ordinary to them, augmented, it is true, in number and energy, but always faithful to their origins]. It is not creative but

23. See my article, "The Function of Literature in Baudelaire's *La Fanfarlo*."

imitative, providing only an enlarging mirror for the *hachischin*'s normal impressions: "un miroir grossissant, mais un pur miroir" (I, 409). It forces him to admire only himself and thus makes him nothing more than a Narcissus, his pool an infernal abyss into which he falls: "le précipitant jour à jour vers le gouffre lumineux où il admire sa face de Narcisse" (I, 440). This is the mirror of Monnier, reflecting only the mystified self; the *hachischin* resembles the bourgeois, admiring like Narcissus his trivial image on the photographic plate (617). It lacks the "élément insaisissable" of comic art, reflecting back to the viewer aspects of the self unrecognized or unacknowledged, a reminder of the self's otherness.

Second, the loss of will that the hashish smoker suffers in return for sensual pleasure leaves him like a wreck battered by the waves, at the mercy of ceaseless sensations, thoughts, and ideas, without the normal defense of intelligence to confront them, sort them out, admit some and exclude others (I, 428). He is buffeted and swept up by one current of ideas after another: "Mais un autre courant d'idées vous emporte; il vous roulera une minute encore dans son tourbillon vivant" (I, 420) [But another current of ideas carries you off; it will roll you about for another minute in its lively whirlpool]. The one who had eagerly set sail on a free adventure without knowing where he was going (I, 410) here encounters the consequences: this solipsistic *volupté* casts him not onto the cradling, caressing, regular sea of "La Chevelure," nor even the stormy sea on which his soul ironically "dances" in "Les Sept Vieillards," but onto one whose *bercement* swells to turbulence and drowns him. And hashish has the ironic last word. The increased imagination, without a corresponding will, is doomed to frustration: dualism is not exploited, as in the *comique absolu*, but suppressed. The creative tension is destroyed, and no laughter, nor pleasure, can result.

Baudelaire ensures that the opposition between hashish and aesthetic experience, the "artificial" and "real" paradises, will emerge from within the work itself; he draws a portrait of the authentic aesthetic state at the very beginning and concludes, as we shall see, with a hymn to the poet. What has not been noticed, however, is the comic status of this aesthetic state and the art that represents it. If the *paradis artificiel* is an object of the comic, the true paradise is a product and example of it, with the dualism and ironic *dédoublement* characteristic of comic art. It is not coincidental that the model of poetic *surnaturalisme* cited in the first sentence of the *Paradis artificiels* is also Baudelaire's supreme example of the comic artist in *De l'essence du rire*, E. T. A. Hoffmann. The point is crucial, as it accounts for many of the ambiguities of the *Poème du hachisch*, particularly the senten-

tiousness of the ending, and provides a solid link between the moral significance of comic art and that of art in general.

The genuine, as opposed to artificial, paradise consists in those "beautiful seasons of the mind" known to all those who, like Hoffmann, follow the fluctuations of their own temperament, in which one's experience of the world (both physical and moral) is heightened, intensified, and understood in new ways: "le monde extérieur s'offre . . . avec un relief puissant, une netteté de contours, une richesse de couleurs admirables. Le monde moral ouvre ses vastes perspectives, pleines de clartés nouvelles" (I, 401) [the outside world presents itself . . . in powerful relief, with a sharpness of contour and a wealth of wonderful color. The moral world opens up its vast perspectives, full of new splendors]. This is precisely the state of aesthetic *surnaturalisme* elsewhere marked by the perception of *correspondances*, "ces admirables heures, véritables fêtes du cerveau, où les sens les plus attentifs perçoivent des sensations plus retentissantes, où le ciel d'un azur plus transparent s'enfonce comme un abîme plus infini, où les sons tintent musicalement, où les couleurs parlent, où les parfums racontent des mondes d'idées" [those wonderful moments, veritable festivals of the mind, when the keenest senses perceive the most resounding sensations, when the sky of a more transparent blue deepens into a more infinite abyss, when sounds ring musically, when colors speak, and scents tell of whole worlds of ideas], so perfectly translated by the painting of Delacroix in the *Exposition universelle de 1855* (596), and the music of Wagner (*Richard Wagner et Tannhäuser à Paris*, 784).[24] In both states—*surnaturalisme* and the intoxication of hashish—nature presents itself more sharply defined, more richly colored, speaking a synaesthetic language, with sounds having a kind of color, and colors possessing a kind of music (I, 419).

But here lies the first of numerous important distinctions. The *hachischin*'s loss of will and his consequent belief that desire is actually a reality make him confuse himself with the objects of nature (I, 419), falsely believe himself to be them. He lacks the *dédoublement* of the poet, the self-observation that produces the Hoffmannian *état surnaturel*:

> Votre oeil se fixe sur un arbre harmonieux courbé par le vent; dans quelques secondes, ce qui ne serait dans le cerveau d'un poète qu'une comparaison fort naturelle deviendra dans le vôtre une réalité. Vous

24. Baudelaire there compares this aesthetic state to the opium trance in Poe's *Tale of the Rugged Mountain*.

prêtez d'abord à l'arbre vos passions, votre désir ou votre mélancolie; ses gémissements et ses oscillations deviennent les vôtres, et bientôt vous êtes l'arbre. De même, l'oiseau qui plane au fond de l'azur *représente* d'abord l'immortelle envie de planer au-dessus des choses humaines; mais déjà vous êtes l'oiseau lui-même. (I, 419f.)

[Your eye settles on a well-proportioned tree bent by the wind; in a few seconds, what in the mind of a poet would be only a very natural comparison becomes in yours a reality. First you attribute to the tree your passions, your desire or your melancholy; its groaning and swaying become your own, and soon you are the tree. Likewise, the bird which soars in the heights of the firmament at first *represents* the eternal desire to soar above the things of this world; but already you have become the bird itself.]

The hashish smoker projects himself everywhere onto nature, converts nature into an image of himself, but is ultimately overcome by the uncontrollable multiplication of the images themselves. His escape from the confines of the self only imprisons him the more within it. As M. Jeanneret observes, he exhibits the standard dual movement of narcissism—concentration and multiplication, contraction and dilatation: a "centripetal" retreat into the self with a sense of his own superiority and self-sufficiency, and a "centrifugal" expansion, a projection of the self onto the phenomena of the exterior world to the point of confusing himself with them. The *hachischin*, like Narcissus, is fascinated by his own self-proliferation and threatened by dissolution.[25] In contrast the poet, while going beyond the limits of the self, nevertheless preserves a relation between himself and nature, the "comparaison" to which Baudelaire alludes above, the consciousness of representation which he here italicizes, a "comic" consciousness of dualism. The poet's harmony with nature follows the laws of nature's harmony itself: universal analogy and metaphor. It fulfills the creative imperative of expanding and escaping the self, but retains the self's capacity for concentration and recuperation, qualities equally necessary to creative expression.

Second, while in *surnaturalisme* the hieroglyphic language of nature becomes intelligible, no such disclosure occurs in the intoxication of hashish. Things are enlarged and distorted but not revealed or explained: "ces analogies revêtent alors une vivacité inaccoutumée; elles pénètrent, elles

25. Jeanneret, "Baudelaire et le théâtre d'ombres," 128ff.

envahissent, elles accablent l'esprit de leur caractère despotique" (I, 419) [these analogies then assume an unusual vivacity; they penetrate, invade, and overwhelm the mind with their despotic character]. This not only prevents the *hachischin* from attaining the "paradise" to which he aspires, but more seriously overwhelms him, presenting him with a tyrannical riot of images and sensations (I, 420) comparable to the furious, anarchic "riot of details" that assails the non-mnemonic artist and inhibits the observer's understanding in *Le Peintre de la vie moderne* (698f.). The hashish smoker is swept into a whirlpool of perceptions and engulfed (I, 420).

Third, Baudelaire describes authentic *surnaturalisme* as a distorting mirror, "un miroir magique où l'homme est invité à se voir en beau, c'est-à-dire tel qu'il devrait et pourrait être; une espèce d'excitation angélique, un rappel à l'ordre sous une forme complimenteuse" (I, 402) [a magical mirror in which man is invited to see himself "beautified," that is, as he should and could be; a kind of angelic stimulation, a call to order in a complimentary form]. As we have seen, hashish is a distorting mirror too, exaggerating the individual's perceptions but reflecting only himself: "un miroir grossissant, mais un pur miroir" (I, 409). The mirror of art is a comic mirror, allowing for no self-love; its "excitation" reminds the viewers of what they could be *if they set their will to it*. It corresponds to the trembling of the Sage or the uneasiness of the laugher, a reminder of the self's dualism and otherness. This call to order contains the formula for securing a more permanent knowledge of the ideal: "C'est une espèce de hantise . . . dont nous devrions tirer, si nous étions sages, la certitude d'une existence meilleure et l'espérance d'y atteindre par l'exercice journalier de notre volonté" (I, 402) [It is a kind of obsession . . . from which we would deduce, if we were wise, the certainty of a higher existence and the hope of attaining it by the daily exercise of our will]. The mirror of hashish is a false substitute because it reveals to man nothing but man himself (I, 440): not his place in the immensity of the universe, but a false sense of himself as center of the universe; not the certainty of a higher existence to which he can aspire, but the illusion of having attained it; not the world outside the self, but the world as a creation of the self; not dualism, but a false sense of unity.

For the same reason, Baudelaire compares the experience of hashish to a shadow show (part 3, "Le Théâtre de Séraphin"), in which the action takes place behind a screen and appears to the audience as shadows. The *hachischin*/spectator turns a real show into a shadow show playing in his mind (I, 418); exterior reality becomes the projection of one's fantasies, the vain

contemplation of oneself.[26] Further, the metaphor of the shadow theater specifically condemns the self-deception of the *hachischin* by evoking the quintessential image of illusion and ignorance, the Platonic allegory of the cave. Hashish offers shadows for truth, keeps one in the darkness of the cave, and tricks one into a complacency that prohibits any movement toward the light.

It is specifically the dualism of comic art that ensures the authenticity of *surnaturalisme* as opposed to the artificiality of the experience of hashish. Like hashish, the comic mirror deforms and exaggerates, presents the grotesque and the caricatural, and shows us what we should and could be. But it does not allow this to be a source of pride, or the desire to be falsely transformed into the real (I, 432). In the comic, our vision of our own ugliness cannot be converted into admiration of our ability to recognize it, or to be otherwise, precisely because of its essentially dual nature: as with Melmoth, the laughter that supports our feeling of superiority also *burns our lips* (531). Unlike hashish, comic art keeps egoism ever in check. Its reflection *en laid* differs from an idealizing reflection *en beau* only in manner, for ugliness derives from the same *goût de l'infini* as beauty: the grace that motivates the visionary art of Bruegel is a satanic one (573). The art that vulgarizes has the same effect as the art that idealizes, provoking an aspiration toward the beautiful; *surnaturalisme* has the abnormality (I, 402) of caricature itself.

The difference between the artificial and genuine paradises consists in the same factor that distinguishes an object of the comic from a creator of it, and the dualism of the comic from its transcendence: the will manifested in *dédoublement*. The condition of the *hachischin* resembles the *comique absolu*, but does not go far enough: he does not exploit dualism, but becomes a victim of it, trapped within the self rather than liberated from it. The *état surnaturel*, rather, is comparable to the convalescence that metaphorically defines the artist in *Le Peintre de la vie moderne* (690) and the essay on Wagner, the pleasurable and passionate interest in things outside the self, the ardent, excessive embracing of life that follows upon great moral or physical crises (807). Hashish reflects the thirst for this but removes the means of quenching it; comic art demonstrates precisely this means. The irresistible "jolt to the nerves" that accompanies the sublime in *Le Peintre de la vie moderne* matches not the painful tickle to which the effects of hashish are compared (I, 411) but the "choc" of the comic artist's

26. Cf. ibid., 125.

laughter, at once withstood and channeled into expression by the will. The true artist like Balzac considers that "there is no greater source of shame, no keener source of pain for man than abdicating the will" (I, 438); the *hachischin*, foolishly believing in the power to "win paradise at one stroke" (I, 402), is a Pinelli-like *caricature* of the artist, "l'homme sensible moderne, . . . la *forme banale de l'originalité* . . . poussée à l'outrance" (I, 429f.) [the sensitive modern man, . . . the banal form of originality . . . exaggerated to the extreme]. The intoxication of the comic resembles not that of hashish, which saps the will and isolates the self, but that of wine, which exalts the will, makes one sociable, and enriches the blood (I, 397), as the vertiginous *comique absolu* fills the English Clowns with life, resolves their differences, and renews the blood in the veins. It has the social quality of *dédoublement*, the willful embracing of those outside the self.[27] This is likewise the "intoxication" of Guys (699, 702), produced by the heady concentration of the "wine of Life" in the final image of *Le Peintre de la vie moderne* (724).

The 1861 essay on Wagner describes the listener's experience of the music in the same terms as the experiences of hashish and *surnaturalisme*: a perception of universal analogy (sounds, colors, scents, ideas), of intense light and immense space, of a spiritual beatitude. The listener's desire to hear more is described as a compulsion, like the *hachischin*'s addiction to the drug; it leads him to accept even the lowest company in the most vulgar establishments in order to satisfy his craving, a "comic spectacle" (786) on the order of the comic scenes in the *Paradis artificiels*. But the "drug" of music, inspiring like hashish an intense pleasure, also inspires knowledge ("une extase *faite de volupté et de connaissance*," 785), and the listener's desire to express and analyze it, "transformer ma volupté en connaissance" (786). Passion in this sense becomes the agent of understanding and the means of producing it: "par cette passion il comprend tout et fait tout comprendre" (807). Art is the product of concentrating *volonté* and explosive desire (807), the one inseparable from the other, like the single impression of the *comique absolu*, or the welding of moral and art that it represents. And it develops in the observer the will and the sensibility, both components of the imagination, as the comic pantomime inspires not only vertiginous hilarity but also understanding—the theory of the comic itself.

If the artificial and real paradises, hashish and *surnaturalisme*, may be differentiated with reference to the comic—the illusion of superiority alone versus the ironic knowledge of superiority and inferiority, and the *dédouble-*

27. See Handwerk on the socializing aspect of irony (*Irony and Ethics in Narrative*, 53).

ment that manifests this—the language of the *Paradis artificiels* is nevertheless shot through with ambiguity. The wry "si nous étions sages" that qualifies the moral injunction casts the whole theory into doubt: only "if we were wise" would we infer from the experience of the *surnaturel* the certainty of a higher existence and the hope of reaching it through exercising the will (I, 402). After such a moralistic opening, Baudelaire says unequivocally that the *surnaturel* is not a product of "good hygiene" or a "wise man's regime." Nor is it "the reward of diligent prayer and spiritual fervor" (I, 401) but, rather, frequently occurs after moments of spiritual or physical abandon, "après une période où [l'homme] a fait abus de ses facultés physiques . . . après de coupables orgies de l'imagination, après un abus sophistique de la raison" (I, 401f.) [after a period in which man has abused his physical faculties . . . after sinful orgies of the imagination, after a sophistical abuse of reason]—a binge suspiciously like the orgies of hashish smoking described in the work itself. The *surnaturel* is unforeseeable and intermittent (I, 402); we cannot will it to occur. Baudelaire seems to undermine the morality of the work in the very act of affirming it.

The problem is especially evident in the final lines of the *Poème du hachisch*, where Baudelaire creates an allegory of the difference between the intoxication of hashish and poetic *ivresse*. A figure watches from the heights of a spiritual Olympus the torments of the *hachischins* in the slime below:

> Mais l'homme n'est pas si abandonné, si privé de moyens honnêtes pour gagner le ciel. . . . Qu'est-ce qu'un paradis qu'on achète au prix de son salut éternel? Je me figure un homme (dirai-je un brahmane, un poète, ou un philosophe chrétien?) placé sur l'Olympe ardu de la spiritualité; autour de lui, les Muses de Raphaël et de Mantegna, pour le consoler de ses longs jeûnes et de ses prières assidues, combinent les danses les plus nobles, le regardent avec leur plus doux yeux et leurs sourires les plus éclatants; le divin Apollon, ce maître en tout savoir (celui de Francavilla, d'Albert Dürer, de Goltzius ou de tout autre, qu'importe? N'y a-t-il pas un Apollon, pour tout homme qui le mérite?), caresse de son archet ses cordes les plus vibrantes. Au-dessous de lui, au pied de la montagne, dans les ronces et dans la boue, la troupe des humains, la bande des ilotes, simule les grimaces de la jouissance et pousse des hurlements que lui arrache la morsure du poison; et le poète attristé se dit: "Ces infortunés qui n'ont ni jeûné, ni prié, qui ont refusé la rédemption par le travail, demandent à la noire magie les moyens de s'élever, d'un seul coup, à

l'existence surnaturelle. La magie les dupe et elle allume pour eux un faux bonheur et une fausse lumière; tandis que nous, poètes et philosophes, nous avons régénéré notre âme par le travail successif et la contemplation; par l'exercice assidu de la volonté et la noblesse permanente de l'intention, nous avons créé à notre usage un jardin de vraie beauté. (I, 441)

[But man is not so abandoned, so deprived of honest means of reaching heaven. . . . What is a paradise that one purchases at the cost of one's eternal salvation? I imagine a man (shall I say a Brahmin, a poet, or a Christian philosopher?) atop the arduous Olympus of spirituality; around him, to console him for his long fasts and his fervent prayers, the Muses of Raphael and Mantegna contrive the most noble dances, observe him with their sweetest gazes and their most dazzling smiles; the divine Apollo, that master of all learning (the Apollo of Francavilla, Albrecht Dürer, Goltzius, what does it matter? Is there not an Apollo for each man who deserves one?) caresses with his bow his most resonant lyric strings. Below him, at the foot of the mountain, in the brambles and mud, the troop of human beings, the band of helots, simulate the grimaces of pleasure and utter the howling cries that the bite of the poison tears from them; and the saddened poet says to himself: "These unfortunate ones who have not fasted or prayed, and have refused redemption through work, ask of black magic the means to rise, at a stroke, to a supernatural existence. Magic dupes them and kindles for them a false happiness and a false light; whereas we, poets and philosophers, we have regenerated our souls by steady work and by contemplation; by the assiduous exercise of the will, and a permanent nobility of intention, we have created for our use a garden of true beauty.]

As Jeanneret points out,[28] the passage openly condemns the wizardry, magic, and sorcery that produce *paradis artificiels*, in favor of "jeûne," "prière," "travail," "contemplation," and "volonté," but this is couched in a suspect language of sententiousness and cliché; the classical models put forward seem abstract and false after the powerful comical images that have preceded, and contrast sharply with Baudelaire's stated preferences elsewhere. Indeed, this "subversive voice," to use Jeanneret's term, seems to undercut

28. "Baudelaire et le théâtre d'ombres," 133f.

the final vision and to affirm the attraction of the artificial paradise, the infinitely richer creative possibilities of the *jeu défendu* of hashish; the work is, after all, a "poème du hachisch," a song of the artificial paradise rather than the authentic one preached here.[29] One can hardly accept the essay's moralism at face value once it has been undermined from within; nor is it likely to be a mere send-up, given its prevalence in the work overall.[30]

In fact the *Poème du hachisch* here follows the same procedure as the essays on caricature. The presence in this passage of the hypothetical Christian philosopher imported from *De l'essence du rire* should make the connection clear: Baudelaire again uses an extended, exaggerated theological metaphor to present aesthetic experience. The supposed spokesman for conventional Christian theology, the "perfectly orthodox pen" (526) that ironically formulated the radical principle of the comic theory—the duality of the comic expressed by *Le Sage ne rit*, and the transformation of the *phénomène de la chute* into a *moyen de rachat*—plays a similar role here. The conventional doctrine, here rendered ironic, states a main principle of the essay: the role of the will, and thus *dédoublement*, in the experience of *surnaturalisme*.[31] The conspicuous parenthetical uncertainty of the figure's identity—"dirai-je un Brahmane, un poète, ou un philosophe chrétien?"—implies the equality and interchangeability of the three. It thus states the metaphorical relation between art and theology, the aesthetic and the moral, and establishes the principle by which to interpret the passage (and the essay) as a whole: the moral and theological metaphor understood in aesthetic terms. The irony signals not the falsity of the passage but its metaphoricity, just as in the essay on the comic.

More important, ironizing the metaphor makes the ending—and the work itself—an example of comic art in the best sense. In employing the language

29. Jeanneret sees Baudelaire's allusion to poetry as a possible solution to this ambiguity, calling into question the overt condemnation of hashish, but remaining a mere suggestion between the lines, nearly lost in the moralistic discourse that dominates (ibid., 134).

30. *Pace* C. Lang (*Irony/Humor*, 113f.).

31. The same terms are used to describe the artistic will in *Les Martyrs ridicules par Léon Cladel* (183): "De son absolue confiance dans le génie et l'inspiration, [la jeunesse réaliste] tire le droit de ne se soumettre à aucune gymnastique. Elle ignore que le génie . . . doit, comme le saltimbanque apprenti, risquer de se rompre mille fois les os en secret avant de danser devant le public; que l'inspiration, en un mot, n'est que la récompense de l'exercice quotidien" [From its total confidence in genius and inspiration, [young realists] claim the right not to subject themselves to any exercise. They do not realize that the genius . . . must, like the apprentice clown, risk breaking his bones a thousand times in secret before dancing before the audience; and that inspiration, in a word, is only the reward of daily exercise]. Burton too locates the distinction between artificial and real paradises in the will (*Baudelaire in 1859*, 173f.).

of clichéd religious morality, Baudelaire follows an essentially comic proce-
dure, recommended at the very beginning of the work—jokingly charging a
banal religious commonplace with a central idea: "On pourrait prendre
dans un sens métaphorique le vulgaire proverbe: *Tout chemin mène à Rome*,
et l'appliquer au monde moral; tout mène à la récompense ou au châtiment,
deux formes de l'éternité" (I, 402f.) [One could take in a metaphorical sense
the common proverb: *All roads lead to Rome*, and apply it to the moral
domain; everything leads to reward or punishment, two forms of eternity].
The allegory of the ending thus bears out his remark about the great virtues
of this devalued rhetorical form, one of the most "primitive" and "natural"
forms of poetry (I, 430). The principle of his comic theory—finding the
beautiful in the ugly, the essential in the trivial—is here put to work; the
"common proverb," the "trivial locution" (I, 403), and the disdained
allegorical form ironically state a main point. The *hachischin*'s road down
through the mud and brambles to hell theoretically leads to Rome too, since
this thirst, however degraded, for eternity is also the sign of his original
grandeur (I, 441).

 Baudelaire injects into the beatific vision of the poet itself an unequivocal
dose of the comic. The supposedly classical, absolute, "divine" image of
Apollo consists of an unlimited variety of particular ones, including the
most grotesque, as the relativistic parenthetical aside rather flippantly at-
tests.[32] Indeed, the figures in the *Poème du hachisch* who most closely match
the mythological poet of the final vision are the least classical, but most in
possession of their will: the accomplished "caricaturists" Hoffmann and
Balzac, the comic and the modern artist. The ideal, the true paradise, is
comical, varied, and multiple, a product of the self's capacity to see—and
represent—itself simultaneously as other, to speak two voices, to express
the caricatural through the image of Raphael, and vice versa. In contrast the
hachischins are false artists, lacking *volonté*, the ironic understanding of
dédoublement, the comic exploitation of dualism.

 But comic *dédoublement* the author of the text before us has throughout
performed to perfection. *Surnaturalisme* here follows an "absurd law" (I,
402), a comic law, perversely deriving not from prayer but from the
"abusive" extravagance to which it seems opposed. The comedy of hashish

32. For reproductions, see R. de Francqueville, ed., *Pierre de Francqueville, Sculpteur des
Médicis et du roi Henri IV, 1548–1615*, plates VII and XIV; W. Strauss, ed., *Hendrik Goltzius
1558–1617. The Complete Engravings and Woodcuts*, no. 263, and *The Intaglio Prints of
Albrecht Dürer. Engravings, Etchings and Drypoints*, no. 38. Baudelaire's "L'Amour et le
crâne" is based on Goltzius's engraving *Quis evadet?*

ultimately leads to the *surnaturel,* in the true fashion of comic art, through the *volonté* that produces the "poem." *Surnaturalisme* is reached not through the experience of hashish, but through the poem about it; not through the bite (I, 441) of the drug, but through that of a plate—an etching, an engraving, a caricature. The *Poème du hachisch* resembles the Carnival of Celionati, a creation of the comic poet, a stage for the comic artist's act. It demonstrates what hashish alone cannot do, the "assiduous exercise of the will," in the comic mode, that produces a genuine paradise from the artificial one—a *caricature artistique.* Aesthetic and moral dualism are not simply analogous, but equivalent: the *dédoublement* of the comic artist constitutes the moral and aesthetic ideal proposed in the final lines of the work.

In *Le Peintre de la vie moderne* human dualism explicitly informs the famous "Eloge du maquillage" section, where the same paradoxical and reversible comic scheme operates: beauty in artifice follows the pattern of beauty in ugliness and the transitory that governs caricature and the painting of modern life. But the consequences of this parallel are significant, for the comic artificer here is in traditional terms the most paradoxical example, a woman.

Baudelaire attacks the eighteenth-century association of artifice with evil and ugliness, and instead makes artifice a vehicle of beauty in the face of the monstrosities and abominations—the real ugliness—of nature. Far from ensuring beauty and virtue, nature guarantees evil, barbarity, and crime. As in the *Salon de 1846,* Baudelaire cites the *Gazette des Tribunaux* for its examples of man's cruelty toward his fellows when artifice (here the rule of law) is absent. Nature inspires the instinct for self-preservation and self-interest, a desire for power and pleasure at the expense of others: "C'est cette infaillible nature qui a créé le parricide et l'anthropophagie, et mille autres abominations que la pudeur et la délicatesse nous empêchent de nommer" (715) [It is this supposedly infallible Nature that has created parricide and cannibalism, and a thousand other abominations that modesty and decency prevent us from naming]. Nature is fallen and marked by original sin:[33] "Le crime, dont l'animal humain a puisé le goût dans le ventre de sa mère, est originellement naturel" (715) [Crime, for which the human animal acquired its taste in his mother's womb, is natural in origin]. Virtue, rather, is instilled by artifice, the deliberate exercise of intellect over instinct: "Le mal se fait sans effort, *naturellement,* par fatalité; le bien est

33. Cf. *Salon de 1859* (650).

toujours le produit d'un art" (715) [Evil is committed effortlessly, *naturally*, by necessity; good is always the product of an art]. The refusal to acknowledge dualism and fallenness is blamed not only for the customary vilification of artifice, but more generally for most of the errors regarding beauty (715). A modern conception of the beautiful depends, like the comic, on the dualism of mankind.

In the aesthetic sphere, beauty thus depends on the seeming ugliness of artifice, art, construction, and *calcul* (715), applied to the crudeness, disorder, and true ugliness of nature. Inspired by Delacroix and nourished by Poe,[34] this idea appears throughout Baudelaire's criticism, notably in the *Salon de 1859*: nature is ugly (620), riotously confusing and indiscriminate, and must be refined and explained by the imagination (660). And in the "Eloge du maquillage" the imagination specifically belongs to women. As in the Vernet section of *Quelques caricaturistes français*, fashion, the "unnatural," reflects a taste for the ideal, an ongoing attempt to deform and reform nature, "une approximation quelconque d'un idéal dont le désir titille sans cesse l'esprit humain non satisfait" (716) [some approximation of an ideal, the desire for which constantly teases the restless human spirit]. *Maquillage* similarly applies the artist's materials to imperfect nature: facial powder aims at "une unité dans le grain et la couleur de la peau, laquelle unité . . . rapproche immédiatement l'être humain de la statue, c'est-à-dire d'un être divin et supérieur" [a unity in the texture and color of the skin, that . . . brings the human being close to a statue, that is, a superior, divine being]; dark liner deepens the eye and makes it seem a window onto the infinite; rouge adds the mysterious passion of the priestess, man's access to the *vie surnaturelle* (717). Like the modern artist, women attempt, by means of fashion and makeup, to draw the eternal from the transitory, "to consolidate and 'divinize' . . . their fragile beauty" (717). A woman's art is demonic and tyrannical, to subjugate the hearts of men—a comic art, ensuring that she will be as "irresistible" as that image of evil, the caricature, was to Virginie.[35] The beauty of artifice is satanic but, by the law of the comic, no less ideal, like the beauty in ugliness that defines comic art.

Such artifice belongs not only to the *comique* but to the specifically caricatural. Baudelaire insists that it should make itself obvious, display itself candidly, proclaim its artificiality, like the garish makeup of the English

34. Delacroix, *Journal*, 366, 414, and *Oeuvres littéraires* I, 58, 114f.; Poe, *The Philosophy of Composition*, in *Essay and Reviews*, 13–25.
35. Cf. the tyranny of Beauty in "Hymne à la beauté."

Clowns: the woman becomes a kind of mannequin or statue (717). Of course caricature deforms toward the ugly while makeup performs a "déformation *sublime*" (716) toward the beautiful; but in terms of the eighteenth-century valuation of the natural, which Baudelaire attempts to discredit, the *flaunted* artifice of *maquillage* belongs to the ugly and borders on the grotesque. It thus follows the pattern of caricature and comic art in general, approaching beauty through "ugliness," the ideal through the caricatural, offering in a deformed image of ourselves the means by which we recognize ourselves. The "vie surnaturelle" is itself "excessive" (717), having the extravagance and license of the comic.

Perhaps most important, the caricature that is the made-up woman not only inspires in the (male) viewer a sense of superiority, but also represents to him his "inferiority," presents him with an image of what he does not know about himself. Like the comic artist of *De l'essence du rire*, the made-up woman is sacrificial, confronting the male viewer with his own mythology of the feminine. The techniques of *maquillage* translate man's fantasy of the divinity of woman, her status as an idol, an object mediating between him and the ideal, a priestess, a medium for a force beyond nature, a window onto the infinite (713, 717). The irresistible, demonic attraction of the made-up, "caricatural" woman, like that of the comic, leads man as much to an understanding of his unacknowledged ideals: not "woman herself" (714) but the image of woman, a phantasm, incorporating—and exposing—the viewer's illusions as Robert Macaire does for the bourgeois. In the most "comic" reversal of all, the mannequin-woman, that image of the victim, becomes a comic artist of the highest order, and the painter of the face the painter of modern life—herself.

In *De l'essence du rire*, Baudelaire opposes the purity of primitive peoples to the depravity of civilized ones.[36] In *Le Peintre de la vie moderne*, similarly,

36. "Primitive" rather than "natural": "primitive" means characterized by faith and belief, like Virginie. In contrast the natural is associated in *Le Peintre de la vie moderne* with the fallen and, paradoxically, a certain degree of civilization: "*sitôt que nous sortons de l'ordre des nécessités et des besoins pour entrer dans celui du luxe et des plaisirs,* nous voyons que la nature ne peut conseiller que le crime" (715, my emphasis) [as soon as we leave the order of needs and necessities to enter that of luxuries and pleasures, we see that nature counsels nothing but crime]. Humanity in the state of nature *or* in society is marked by moral degradation, as *Fusées* XIV implies: "Que l'homme enlace sa dupe sur le Boulevard, ou perce sa proie dans des forêts inconnues, n'est-il pas l'homme éternel, c'est-à-dire l'animal de proie le plus parfait?" (I, 663) [Whether man catches his dupe on the Boulevard, or spears his prey in the depths of unknown forests, is he not nevertheless eternally man, that is, the most perfect predator?]

the taste of primitives and children for adornment reflects the "immateriality" and "primitive nobility" of their soul (716). For them artifice has no connotations of ugliness, but rather a high spirituality; "civilized" peoples, in contrast, revere the natural. For Baudelaire, the *naïveté* of primitives and the caricatural tastes of the *ultra*-civilized thus come together, both demonstrating a spark of the sacred fire (718), an aspiration toward an ideal beyond nature: "La mode doit donc être considérée comme un symptôme du goût de l'idéal surnageant dans le cerveau humain au-dessus de tout ce que la vie naturelle y accumule de grossier, de terrestre et d'immonde" (716) [Fashion must thus be considered as a symptom of the taste for the ideal surviving in the human brain, above everything coarse, earthly, and unclean that natural life piles up in it]. Those who think otherwise succumb to the lure of laughter without recognizing their own comicality, like the *professeurs-jurés* and the *hachischin*: "Je permets volontiers à ceux-là que leur lourde gravité empêche de chercher le beau jusque dans ses plus minutieuses manifestations, de rire de mes réflexions" (717f.) [I shall happily allow those whose ponderous gravity prevents them from looking for beauty in its most minute manifestations to laugh at these reflections of mine]. Laughing while not seeing the dualism that it represents, they enter the pattern of the comic and become objects of laughter. Laughing at the primitives, they become laughable themselves: "Les races que notre civilisation, confuse et pervertie, traite volontiers de sauvages, avec un orgueil et une fatuité tout à fait *risibles*, comprennent . . . la haute spiritualité de la toilette" (716, my emphasis) [Those races that our civilization, confused and perverted, quite happily treats as savage, with a pride and fatuousness that are wholly *laughable*, understand . . . the high spirituality of dress]. If the dualism of art is a consequence of the dualism of mankind, one might also say that the ironic understanding of dualism is a condition for the perception of modern, as of comic, art.

Cosmopolitanism and *Dédoublement*

Le Peintre de la vie moderne presents one of the dominant myths of nineteenth-century modernism, the cosmopolitan *artiste-flâneur*, the *homme du monde* who moves through the crowd, imaginatively becoming the persons and objects he encounters. But the concept has proved difficult to

define coherently and has received various interpretations. Notably it has
led to a view of modernity as unequivocally masculine-gendered, a creation
of the *flâneur*'s fantasies. But the comic, as we have seen from the preceding
discussion of the "Eloge du maquillage," calls this idea into question. A
closer look at Baudelaire's notion of cosmopolitanism will do likewise,
extending the dualism and reflexivity of the comic to one of the quintessen-
tial experiences of modernity.

For Richard Burton cosmopolitanism involves a loss of individual iden-
tity: the *flâneur* seeking to escape the limitations of the self in a pantheistic
fusion with the crowd achieves not knowledge of the other but only an
ontological void, which paradoxically leaves him with all the greater a sense
of isolation.[37] The cosmopolitan poet's privilege of being at will himself and
another, as Baudelaire puts it in "Les Foules," actually constitutes a curse:
his passion for knowledge leads to self-dissolution, the truth or reality of
his being becomes a series of counterfeit selves and disguises. For Burton
the *flâneur*'s activity—imaginatively occupying the being of each passer-by
in the crowd, each object encountered—is a literal self-projection: the
Baudelairean self in search of the other encounters only itself, everywhere;
in trying to escape the self it becomes all the more a prisoner of the self; its
dream of *jouissance* becomes a nightmare.[38] But as the preceding section
argues, this describes rather the condition of the *hachischin*, who in a world
aggrandized to excess sees only himself, who projects himself everywhere,
and whose hallucinations bring not revelation but only more of the same.[39]
It is not the condition of the *flâneur*, who escapes the boundaries of the self
and observes it from without, and whose most terrifying and unforeseen
experiences (as in "Les Sept Vieillards") nevertheless allow, through the
artistic will, for the "recuperation" of the poem, if not that of the self within
the poem. The cosmopolitan experience approaches the *état surnaturel* of
the Hoffmannian artist of the *Poème du hachisch,* not the shadow show of
the *hachischin.*

37. "The Unseen Seer, or Proteus in the City: Aspects of a Nineteenth-Century Parisian
Myth." By relating the *flâneur* to other key nineteenth-century protean figures without a fixed
self, who see but are not seen and can take on the character of another at will—the criminal,
the police inspector, the capitalist, and the novelist—Burton convincingly explains a central
myth of the period, the modern *deus absconditus*, as a sign of the "apprehension of powerless-
ness before the growing abstraction of the modern metropolis" (64), a crisis of identity brought
on by modernization and urbanization.
38. Ibid., 60f., 65f.
39. On this distinction, see also Nicole Ward Jouve, *Baudelaire: A Fire to Conquer
Darkness*, 237.

Leo Bersani sees the cosmopolitan's activity as psychic fragmentation, ontological floating, imaginative mobility, the manifestation of desire in its vain search for satisfaction, which produces now pleasure (as in "Les Foules"), now anxiety ("Le Confiteor de l'artiste"), and which irony negates and paralyzes.[40] However, Bersani distinguishes between a process of self-recognition or self-identification (in the *Petits Poèmes en prose* and the *Tableaux parisiens*) and a more reciprocal one (in *Le Peintre de la vie moderne*), involving both possession of and openness to the multiple forms of external reality.[41]

In fact Baudelaire emphasizes reciprocity and reflexivity in his definition of cosmopolitanism; but far from negating and paralyzing it, irony is its necessary condition. The self-generation and openness of the cosmopolitan *artiste-flâneur* are inseparable from the self-mirroring and ironic doubling of the comic artist:[42]

> Pour le parfait flâneur, pour l'observateur passionné, c'est une immense jouissance que d'élire domicile dans le nombre, dans l'ondoyant, dans le mouvement, dans le fugitif et l'infini. Etre hors de chez soi, et pourtant se sentir partout chez soi; voir le monde, être au centre du monde et rester caché au monde. . . . L'observateur est un *prince* qui jouit partout de son incognito. . . . Ainsi l'amoureux de la vie universelle entre dans la foule comme dans un immense réservoir d'éléctricité. On peut aussi le comparer, lui, à un miroir aussi immense que cette foule; à un kaléidoscope doué de conscience, qui, à chacun de ses mouvements, représente la vie multiple et la grâce mouvante de tous les éléments de la vie. C'est un *moi* insatiable du

40. *Baudelaire and Freud*, 9, 90.

41. Ibid., 106f.

42. Only K. Stierle ("Baudelaires 'Tableaux parisiens' und die Tradition des *tableau de Paris*" and D. Aynesworth ("A Face in the Crowd: A Baudelairean Vision of the Eternal Feminine") make any connection between the experience of the *flâneur* and the structure of the comic. Both take Benjamin's "shock experience" as a point of departure and link it to the convulsion of laughter caused by the clash of the two "infinis" in mankind. For Aynesworth the *flâneur*'s violent perception of beauty in "A une passante" has a comic effect, making him an "extravagant" object of laughter. Stierle (314f.) points to Baudelaire's admission, in *De l'essence du rire*, of the inadequacy of language to reproduce the *comique absolu*: the successive nature of language precludes the simultaneity on which the *comique absolu* depends; and the distance between language and its object precludes the presence necessary for the "choc." For Stierle, Baudelaire's answer to the problem of creating a *verbal* caricature comes in the *Tableaux parisiens*, in which the "choc" is the point of departure of the poem, rather than its result.

non-moi, qui, à chaque instant, le rend et l'exprime en images plus vivantes que la vie elle-même, toujours instable et fugitive. (691f.)

[For the perfect *flâneur*, for the passionate observer, it is an immense pleasure to take up residence within the multitude, in the ebb and flow, in movement, in the fleeting and the infinite. To be away from home and yet feel oneself everywhere at home; to see the world, to be at the center of the world and stay hidden from the world. . . . The observer is a *prince* who delights in his incognito. . . . Thus the lover of universal life enters the crowd as though it were an immense reservoir of electrical energy. He can also be compared to a mirror as vast as the crowd itself; or to a kaleidoscope gifted with consciousness, which, at each of its movements, represents the multiplicity of life and the shifting grace of all the elements of life. He is a self insatiable for the non-self, who, at each moment, renders and expresses this in images more lifelike than life itself, ever unstable and fleeting.]

The experience of the *flâneur* here reflects the principle of *dédoublement*, the simultaneous doubling that characterizes the comic artist. This is not a paralyzing, narcissistic self-consciousness; rather, it includes the self-awareness necessary for suppressing the self and adopting another. *Observateur passionné* sets the tone for the paradoxes that the passage repeatedly asserts, for in the Baudelairean lexicon it is oxymoronic: *observateur* implies self-containment and distance from the object, the impassivity of the dandy; *passionné* implies the identification of self and other, the escape from the self. In an earlier passage Baudelaire brings out the same contradiction in radically distinguishing Guys from the dandy by his insatiable passion (691). Moreover the figure to which he alludes in representing the cosmopolitan artist's *amabam amare*, his passionate love of passion (691), is at the same time the very model of the willful control, indeed denial, of passion, Saint Augustine. The only other artist to whom Baudelaire applies this phrase is Delacroix, and there the role of will is apparent: "Delacroix était passionnément amoureux de la passion, et froidement déterminé à chercher les moyens d'exprimer la passion de la manière la plus visible. Dans ce double caractère, nous trouvons . . . les deux signes qui marquent les plus solides génies. . . . Une passion immense, doublée d'une volonté formidable" [Delacroix was passionately in love with passion, and coldly determined to find ways of expressing passion in the most visible manner.

In this dual character we find . . . the two signs that mark the most solid geniuses. . . . An immense passion, coupled with a formidable will].[43]

The paradox of the *observateur passionné*, self and non-self, is maintained in the experience of the artist-*flâneur* in the crowd: the pleasure of being outside the self belongs to the self, feeling itself everywhere *chez soi*; the pleasure of being unrecognized, hidden from the view of others—lacking a self—belongs to the self who feels at the very center of things, to the prince aware of his status while others are ignorant of it. The *jouissance* of escaping the self depends on the consciousness of simultaneously possessing one: cosmopolitanism is a form of *dédoublement*. As Baudelaire describes him, the man of the world takes pleasure in the crowd as a great store of electrical energy, like the "bathing in the multitude" of "Les Foules," an endless, revitalizing source of other selves to adopt. But this successive cosmopolitan doubling allows, indeed requires of him the same self-exploration as the comic *dédoublement* of *De l'essence du rire*, "observing as a disinterested spectator the phenomena of his *self*" (532). Becoming another, he sees himself as others might see him, and the image may be caricatural.[44] Cosmopolitanism is thus necessarily reflexive like the comic, making the *flâneur* not only a controlling and creative self, but the object of another's gaze too.

In the *Exposition universelle de 1855*, Baudelaire likewise develops the metaphor of cosmopolitanism to suggest the dual knowledge—of self and other—that characterizes the ethnographic experience. The man carried to a distant land discovers, through the disorienting experience of having new and strange forms, colors, smells, and movements enter his consciousness, nothing less than a *monde surnaturel* of correspondences of which he was not previously aware, and finds himself greatly enriched or radically altered by it: "ces fruits dont le goût trompe et déplace les sens, et révèle au palais des idées qui appartiennent à l'odorat, tout ce monde d'harmonies nouvelles entrera lentement en lui" (577) [those fruits whose taste deceives and disconcerts the senses and reveals to the palate ideas that belong to the sense

43. *L'Oeuvre et la vie d'Eugène Delacroix*, 746.

44. Similarly, for Stierle ("Baudelaires 'Tableaux parisiens' und die Tradition des *tableau de Paris*," 308) the *flâneur* becomes as eccentric to others as the eccentric figures he sees. For Aynesworth ("A Face in the Crowd. A Baudelairean Vision of the Eternal Feminine," 336) the *flâneur's* act of "becoming" the *passante* allows him to see himself as a caricature and to recognize the monstrosity of his existence. Cf. M. Blanchard, *In Search of the City: Engels, Baudelaire, Rimbaud*, 78f., who describes a theatrical process in which subject and object play one another's roles.

of smell, this whole world of new harmonies will slowly enter into him]. This experience involves a necessary reciprocity: the forms exterior to him cannot penetrate his thought and senses if, through his "sympathy" (576), he does not give himself over to the experience itself. In contrast, the uncosmopolitan "Winckelmann moderne," blinded by the "scholastic veil" of his system, misses it altogether. In "Les Foules" the cosmopolitan self suppresses the self to take on another, as an actor changes roles[45]—the same metaphor expressing the *dédoublement* of the comic artist in *De l'essence du rire*, who deliberately suppresses his knowing self to play a part of ignorance for the benefit of others, the audience. The cosmopolitanism or doubling of the actor is clearly stated in the 1855 article on Philibert Rouvière: dressed in the costume of his role, the actor gazes into the mirror, studies this "new personality" and learns its essence from the process—"the miracle of objectivity is accomplished" (65). The metaphor of the actor adopting a variety of roles recurs in "Les Foules": the cosmopolitan artist has a "taste for disguise and masquerade," a soul that delights in taking on different characters (I, 291) and being thus a spectacle, an object of the audience's eye. Like the comic artist, he exploits his ability to be self and other, at will and at once. Based on the ambiguity of comic doubling, Baudelaire's cosmopolitanism thus undermines the later notion of the experience of modernity whereby the *flâneur* defines experience according to his desire. This would be, rather, the strategy of the "modern Winckelmann" so scathingly ridiculed above. Rather, he must recognize himself as an object for others too.

Indeed the willful emptying of the self permits the cosmopolitan artist to become a mirror to the world, a kaleidoscope with reflecting surfaces rendering the shifting forms of modern life, the innumerable combinations of form, color, and movement that meet the eye. But this is not the passive mirror of Monnier: Baudelaire specifies "doué de conscience," a mirror that thinks. To bring back the theatrical metaphor, the cosmopolitan artist reflects exterior reality as a drama does, or as an actor interprets a role, thus invigorating reality for the spectators and allowing them to see themselves as another interprets them. Nor is it the narcissistic mirror of the *hachischin*. The cosmopolitan artist reflects the crowd in which he partici-

45. Chambers too notes the connection between the actor and the *flâneur* but argues that the *flâneur* is only a *regardant*, while the actor is at once *regardant* and *regardé*, an object of the audience's pleasure ("L'Art sublime du comédien," 237). But the poems and *Le Peintre de la vie moderne* suggest that the *flâneur*, like the actor, makes himself through *dédoublement* an object of perception, for himself and for the crowd.

pates, sends back to it sharpened images of itself ("images plus vivantes que la vie elle-même"), presents life in multiple configurations arranged to form an infinite variety of extraordinary and beautiful patterns. In this he again resembles the comic artist, who likewise holds a distorting mirror up to the crowd and represents to it its moral and physical "ugliness" through an image of irresistible power. By *dédoublement* he offers himself as an object of laughter, makes himself into an image in which the spectators can see themselves; the artist-*flâneur*, taking on the objects of his perception, likewise makes himself an object of perception, an image of and for the crowd. Baudelaire's answer to the social and psychological divisions of modern urban life lies less in the overtly political solution proposed by Berman—confronting modern life in collective political action and mass movements[46]—than in cosmopolitanism, "embracing" the crowd in a reciprocal relation of equals.

In moral terms the delight of cosmopolitanism seems to derive from a Melmothian sense of superiority and power: the satisfaction of seeing all but remaining unseen, of knowing oneself a prince but going unnoticed by others. Indeed, the consciousness of cosmopolitanism provokes a feeling of superiority over those who are not, and the standard reactions attendant on it: Guys vehemently scorns them (692), and the solitary travellers of "Les Foules" "doivent rire quelquefois de ceux qui les plaignent pour leur fortune si agitée et pour leur vie si chaste" (I, 292) [must sometimes laugh at those who pity them for their fortunes so troubled and their lives so chaste]. But this *deus absconditus*, to use Burton's term,[47] is not the egotistical, self-deceived *homme-dieu* of Le Poème du hachisch. Melmoth's sense of superiority, like the comic artist's, is counterbalanced by a sense of inferiority, and so it is here too. The cosmopolitan's feeling of superiority over the egoism of others is matched by a sense of something still greater than himself, beyond his own existence and understanding: "le fleuve de la vitalité, si majestueux et si brillant . . . l'éternelle beauté et l'étonnante harmonie de la vie dans les capitales, harmonie si providentiellement maintenue dans le tumulte de la liberté humaine" [the river of vitality, so majestic and dazzling . . . the eternal beauty and the astonishing harmony of life in the capital, a harmony so providentially maintained within the tumult of human freedom] that so captivates Guys; and for the travellers of "Les Foules," the very mystery of their intoxicating communion (I, 292).

46. *All That Is Solid Melts Into Air: The Experience of Modernity*, 163f.
47. See note 37.

Guys is in fact "*directed* by nature, *tyrannized* by circumstance" (697, my emphasis). Their sense of superiority, thus radically qualified and undercut, is put to the same use as the comic artist's, bringing others to self-knowledge, to a recognition of their own dualism, to an understanding of their place within a system beyond themselves—precisely the opposite of egoism. Thus the object of the cosmopolitan poet of "Les Foules" is "d'apprendre . . . aux heureux de ce monde, ne fût-ce que pour humilier un instant leur sot orgueil, qu'il est des bonheurs supérieurs au leur, plus vastes et plus raffinés" (I, 291) [to teach . . . the fortunate ones of this world, even if only to humble for an instant their foolish pride, that there are forms of happiness superior to theirs, more immense and more refined].[48]

In "Les Foules," the comic artist's sacrifice of self—making himself by *dédoublement* an object of laughter—is accomplished by the cosmopolitan (and, following the sections on women in *Le Peintre de la vie moderne*, the female) gesture of "prostitution," giving oneself "toute entière, poésie et charité, à l'imprévu qui se montre, à l'inconnu qui passe" (I, 291) [totally, poetry and charity, to the unexpected that presents itself, to the unknown passer-by], embracing and allowing oneself to be possessed by a multitude of other selves. The cosmopolitan artist too is invaded and "possessed" by the circumstantial forms of life: "Le tableau de la vie extérieure le pénétrait déjà de respect et s'emparait de son cerveau. Déjà la forme l'obsédait et le possédait" (691); likewise the "despotic" invasion of the traveller by the colors and forms of the foreign land in the *Exposition universelle de 1855* (577). Baudelaire insists on the ambiguity or reciprocity—the "comic" duality—of the experience: the artist occupies the forms he encounters and gives himself to be possessed. And the *Journaux intimes* suggest a reason. Possession without the reciprocal action perverts the process; such a "taste for property" (I, 649) undermines the generosity of prostitution, the "charité" of "Les Foules."

The sacrifice is pleasurable (the "ivresse," "jouissance," "orgie," and "bonheur" of "Les Foules," the "jouissance" and "plaisir" of *Le Peintre de la vie moderne*, 691f.) but has a purpose other than pleasure,[49] namely, the creation of a modern art by which to see the mysterious, enduring beauty of an ostensibly trivial, ugly, fleeting, and tangible experience, an art that

48. The sense of superiority may also occasion a sense of fellowship, as in "Les Petites Vieilles": the narrator, watching the old women while remaining unseen, sharing, unnoticed, their intimate experiences, sees in the "family" he has created for himself not only his position as "father" (as in "Les Foules") but also their collective downfall.

49. *Pace* Bersani (*Baudelaire and Freud*, 11).

formalizes the transcendent movement of *dédoublement*: "cet homme, . . .
ce solitaire doué d'une imagination active, toujours voyageant à travers le
grand désert d'hommes, a un but plus élevé que celui d'un pur flâneur, un
but plus général, autre que le plaisir fugitif de la circonstance. . . . Il s'agit,
pour lui, de dégager de la mode ce qu'elle peut contenir de poétique dans
l'historique, de tirer l'éternel du transitoire" (694) [this man, . . . this
solitary one gifted with an active imagination, ever journeying across the
great desert of humanity, has a purpose higher than that of a mere *flâneur*,
a purpose more general, other than the fleeting pleasure of circumstance.
. . . It is a question of extracting from fashion whatever it may contain of
the poetic within the historical, of drawing the eternal from the transitory].
Baudelaire underlines the allusion and thus calls attention to the intertextual
relation it signals. The modern artist, this new René, this successor to the
Romantic voyager in search of tranquillity, seeks in the crowd not pleasure
or consolation but the ineffable essence of modern life itself, that "indefin-
able something" called modernity (694). And he thus finds, in contrast to
René, not the barrenness of the desert but a wealth of metaphorical forms,
not the loneliness of the self but an exchange of selves, not the *mal du siècle*
but the material for an art of the century.[50]

Cosmopolitanism is thus neither a "loss" of self, nor a free multiplication
of the self, nor yet the unchecked movement of desire (characteristics, rather,
of the *hachischin*). On the contrary, it reveals the same presence of will as
does comic *dédoublement*. And Baudelaire brings out the importance of the
one to the other, desire and the will, through a play on *vouloir*. The *homme
du monde* is dominated by a will, or desire, to know ("il veut savoir,
comprendre, apprécier," 689), curiosity (689f.), a *deliberate* effort to re-
cover the imaginative openness of the child ("l'enfance retrouvé à volonté,"
690). His lack of control over the content of his experience ("the sum of
materials involuntarily amassed," 690) is balanced by the will that interprets
and expresses it, creating sharper images of it. The reciprocity of the
cosmopolitan experience is illustrated by Baudelaire's example of Guys in
action. He is at once an analysing self and an empty vessel that the object,
broken down into multiple forms, fills; and through this process he becomes
a part of the newly reconstructed object (see Fig. 56):

50. Cf. Chateaubriand, *René* (205, 208): "Je trouvai d'abord assez de plaisir dans cette vie
obscure et indépendante. Inconnu, je me mêlais à la foule: vaste désert d'hommes. . . . Cette
vie, qui m'avait d'abord enchanté, ne tarda pas à me devenir insupportable" [At first I found a
certain pleasure in that obscure life of independence. Unknown, I mingled with the crowd: that
vast desert of men. . . . That life, which had at first delighted me, did not take long to become
unendurable to me].

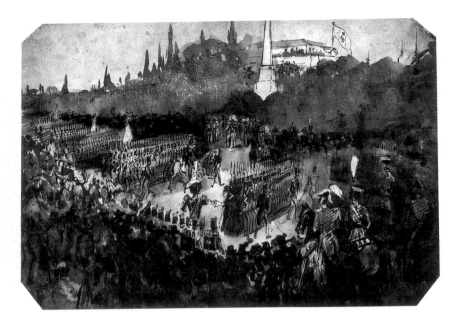

FIG. 56. Constantin Guys. *Review at Madrid* (photo: British Museum)

Un régiment passe . . . ; et voilà que l'oeil de M. G. a déjà vu, inspecté, analysé les armes, l'allure et la physionomie de cette troupe. Harnachements, scintillements, musique, regards décidés, moustaches lourdes et sérieuses, tout cela entre pêle-mêle en lui; et dans quelques minutes, le poème qui en résulte sera virtuellement composé. Et voilà que son âme vit avec l'âme de ce régiment qui marche comme un seul animal, fière image de la joie dans l'obéissance. (693)

[A regiment passes . . . ; and already the eye of M. G. has seen, inspected, and analyzed the weapons, the bearing, and the physiognomy of this troop. Trappings, glitter, music, determined looks, heavy, solemn mustaches, all that enters into him pell-mell; and in a few minutes the poem that results from it will be virtually composed. And thus his soul lives with the soul of that regiment marching like a single animal, a proud image of joy in obedience.]

The experience of escaping the self thus requires an act of will. The comic artist exploits his self-consciousness and capacity for doubling to the point of denying and undermining it, but this self-fragmentation is nevertheless

grounded in a "stabilizing" will: a fairy controls the infinite metamorphoses of Pierrot.

Baudelaire implies likewise in the *Exposition universelle de 1855*. The cosmopolitan imagination, faced with a work from an alien culture or period, enters into its milieu: "il faut . . . que le critique, le spectateur opère en lui-même une transformation qui tient du mystère, et que, par un phénomène de la volonté agissant sur l'imagination, il apprenne de lui-même à participer au milieu qui a donné naissance à cette floraison insolite" (576) [The critic, the viewer, must bring about within himself a transformation that is something of a mystery, and by a phenomenon of the will acting on the imagination, learn from within to participate in the milieu that gave birth to this unusual flowering]. The cosmopolitan artist does not merely suppress the self or passively "escape" it through self-expansion, but in an act of willful doubling draws from himself the necessary understanding by which to enter into the work, read it from within, or, as in the Guys example above, analyze and reconstruct it: the very process of decomposition and re-creation that defines the imagination in the *Salon de 1859*.[51]

It is significant, however, that in Guys the process of emptying the self and filling it with the random and chaotic forms of modern life produces an interior *poem*; the object of which the artist becomes a part becomes an image bridging external and internal, physical and spiritual, self and non-self, form and sense. "Jouir de la foule est un art" [To take pleasure in the crowd is an art]: the statement might be taken literally, and cosmopolitanism ("jouir de la foule") reflect the process of artistic creation, the fertile contest between self and non-self, "the faculty of seeing" and "the power of expression" (693). In *Le Peintre de la vie moderne* the cosmopolitan artist thus engages in a duel with his pen, and with himself, a fencing match to win new life for those images which fill his memory: "s'escrimant avec son crayon, sa plume, son pinceau, . . . pressé, violent, actif, comme s'il craignait que les images ne lui échappent" (693). He is double and single at once ("quarreling, but alone"), and the *dédoublement* is productive, bringing forth the objects renewed and revitalized: "naturelles et plus que naturelles, belles et plus que belles, singulières et douées d'une vie enthousiaste comme l'âme de l'auteur. La fantasmagorie a été extraite de la nature" (693f.)

51. "Elle décompose toute la création, et, avec les matériaux amassés et disposés suivant des règles dont on ne peut trouver l'origine que dans le plus profond de l'âme, elle crée un monde nouveau, elle produit la sensation du neuf" (621) [It decomposes the whole of creation, and with its materials amassed and ordered according to rules whose origin can be found only in the deepest recesses of the soul, it creates a new world, it produces the sensation of the new].

[natural and more than natural, beautiful and more than beautiful, curious and endowed with enthusiastic life like the soul of their creator. The phantasmagoria has been extracted from nature]. The illusory singleness of nature is exploded into a phantasmagoria of shifting forms, at once real and surreal, natural and supernatural. This is not the shadow show within the *hachischin*'s mind, but the phantasmagoria within nature itself, a kaleidoscopic integration of exterior and interior.[52] It reflects the *surnaturalisme* by which Baudelaire describes the experience of the beautiful, the paradisiacal state known precisely by those capable of *dédoublement*, "those who observe themselves," like Hoffmann in the *Poème du hachisch* and the essay on laughter; the visionary truth of Daumier, Goya, and Bruegel produced from the dualistic art of caricature.

In a famous note, Baudelaire relates the vertiginous experience of cosmopolitanism to the city: "Le vertige senti dans les grandes villes est analogue au vertige éprouvé au sein de la nature— . . . Sensations d'un homme sensible en visitant une grande ville inconnue" (607) [The giddiness felt in great cities is analogous to that felt in the midst of nature. . . . The sensations of a sensitive man visiting a big city he does not know]. In another note, he writes: "Ivresse religieuse des grandes villes.—Panthéisme. Moi, c'est tous; Tous, c'est moi" (I, 651) [Religious intoxication of big cities.—Pantheism. I am all; all are me]. The modern, cosmopolitan artist-*flâneur* is an essentially urban phenomenon, like the aspects of modernity—circumstance, contingency, fashion—he takes as his subject. If the comic model for Baudelaire's aesthetic of the modern is to apply fully, it must account for the theme of the city central to this. Indeed, with the exception of the general call for an urban art at the end of the *Salon de 1846*, the nature and importance of the city in *Le Peintre de la vie moderne* has a single precedent: the relation of the city to the comic and caricature in *De l'essence du rire*, and its representation in the art of Daumier.

An Art of the City

"Feuilletez son oeuvre, et vous verrez défiler devant vos yeux, dans sa réalité fantastique et saisissante, tout ce qu'une grande ville contient de vivantes

52. *Pace* Benjamin, who concentrates, following Marx, on the illusory character of phantasmagoria (see Buck-Morss, *The Dialectics of Seeing: Walter Benjamin and the Arcades Project*, 81). For Baudelaire, in contrast, it is the multiple vision behind the apparent unity of nature.

monstruosités. Tout ce qu'elle renferme de trésors effrayants, grotesques, sinistres et bouffons, Daumier le connaît" (554) [Look through his work, and you will see parade before your eyes, in their fantastic and gripping reality, all that a great city contains of living monstrosities. All the frightening, grotesque, sinister, and farcical treasures that it holds, Daumier knows them all]. With these words from *Quelques caricaturistes français* Baudelaire offers *avant la lettre* his prescription for an art of modern life. The city is clearly the space of modernity, its moving crowds, chance occurrences, and fleeting encounters the very realization of the *transitoire, fugitif,* and *contingent* by which he defines *modernité* (695). But the city is also, as the passage above makes clear, the space of the comic and caricatural—the monstrous, grotesque, terrifying, sinister, farcical, and fantastic. Like the comic, the Baudelairean city is satanic, demonic, infernal, the product and mark of a Fall, the degradation of an eternal paradise into a place of filth, stench, and noise, caught in the incessant movement of time. It is the demonic Paris of Virginie from *De l'essence du rire,* the serpent that corrupts, presenting to her naive and simple view an image of dualism and complication, that quintessential urban product, the caricature, an image of violence and lewdness that both fascinates and terrifies her.[53] Paris ultimately offers her the traditional gift of the serpent—knowledge, "science" (529), the very condition of laughter. The city represents civilization as a whole, the world into which humanity is thrown as an exile from a mythical paradise, like Virginie from her primitive tropical homeland; cast into chaos, disorder, and unintelligibility, as she is into the middle of a "turbulent, overflowing, mephitic civilization" (528); and subjected to frightening and irresistibly compelling random encounters like her fatal meeting, "by chance" (529), with the caricature in the shop window near the Palais Royal.

This is indeed the city of Baudelaire's poems as well—fantastic, demonic, paradoxical, a place of disorder, disintegration, and incongruity, subject to endless flux. Paris is a caricatural image of degradation, the "énorme catin" of "Epilogue," a prostitute producing, as Burton remarks, a freakish and monstrous offspring.[54] It is inhabited wholly by eccentric, grotesque figures—prostitutes and whores, gamblers and swindlers, ragpickers, beggars,

53. French caricature was related historically to the city as the arena of political and social activity and the center of graphic production. It is likely that Baudelaire chose Virginie as his hypothetical modern-day innocent rather than the comparable figure from *Melmoth,* Immalee, precisely because the original Virginie is sent to Paris.

54. *Baudelaire in 1859,* 108.

and thieves, all monstrous and caricatural:[55] the "cortège infernal" of "Les Sept Vieillards," the "spectres baroques" representing the speaker's terror before the anonymity of the *fourmillante cité*, which turns multiplicity into self-multiplication, diversity into proliferating sameness, and where everyone is a "Phénix, fils et père de lui-même" [Phoenix, son and father to himself]; the "monstres disloqués . . . brisés, bossus ou tordus" [monsters out of joint . . . broken, hunchbacked or twisted] of "Les Petites Vieilles," puppets on a string, players in a comedy; the frightful, ridiculous "mannequins" of "Les Aveugles;" the grotesque, death-like figures of "Le Jeu"; the clown of "Le Vieux Saltimbanque" with his "comical rags"; even the fashionable woman of "A une passante," who, tall, slim, statuesque and majestic, recalls the tall, thin skeleton so proud of its "noble carriage" in "Danse macabre."

To the city are the fallen exiled in these poems: Andromache, the swan, humanity itself, ever reminded of what can never be recovered or regained; the old women, their names formerly cited by all, now fallen into oblivion and subjected to insults and pranks ("Les Petites Vieilles"); blind men staring upward, sightless, at the heavens ("Les Aveugles"). It has the slime and din of hell—the mire and mud of "Le Cygne," "Les Sept Vieillards," and "Le Crépuscule du soir," the deafening, howling street of "A une passante," the bestial roar of "Le Crépuscule du soir." It follows the disturbing order of the chance occurrence, a "méchant hasard" ("Les Sept Vieillards") lurking round the corner of every serpentine, sinuous street ("Les Petites Vieilles"), which threatens the self with disintegration, death, or madness but may also occasion rebirth and renewal ("A une passante," "Epilogue"). A "chaos," a "fourmillant tableau" ("Les Petites Vieilles"), the modern city has a tempest always on the horizon—in the eye of the *passante*, in the disarming proliferation of old men, in the "riot" of "Paysage." It is a hell possessing an "infernal charm" ("Epilogue"), where death mocks mankind ("Les Sept Vieillards," "Danse macabre"). Paris itself mocks mankind as it does the blind of "Les Aveugles," who live in silence and darkness ("tu chantes, ris et beugles, / Eprise du plaisir jusqu'à l'atrocité" [you sing, laugh, and bellow / Smitten with pleasure to the point of atrociousness]). It is a place of comedy, "absurdité" ("Les Sept Vieillards"), fantasies and phantasms—"enchantements" ("Les Petites Vieilles"), "mystères" ("Les Sept Vieillards"), "rêves" ("Les Sept Vieillards," "Le

55. On the interest in the city's "queerness" as an aspect of early modernist painting, see T. J. Clark, *The Painting of Modern Life*, 78.

Jeu"), Goya-esque demons in the atmosphere ("Le Crépuscule du soir"), phantoms, specters, and monsters, images distorted and exaggerated by mist, fog, and twilight. Like the comic it is composed of paradox and contradiction—isolation and communion with the crowd; *jouissance* and anxiety; monstrous, shoreless sea and electrifying bath; unintelligibility and "mythe," where the poet thrashes and stumbles in search of expression ("Le Soleil") or where "tout pour moi devient allégorie" [everything becomes allegory for me] ("Le Cygne"). If, as Burton suggests, Paris presents a *monde à l'envers* subverting rational categories,[56] it is also, more specifically, a caricature, presenting the *flâneur* not with an image under his control, but with an image of "inferiority," of his status as an object, of the otherness on which the self is dependent. And accordingly, before the caricatural spectacle of the Baudelairean city *le Sage ne rit qu'en tremblant*:

> Que celui-là qui *rit de mon inquiétude,*
> Et qui n'est pas saisi d'un *frisson fraternel,*
> Songe bien que malgré tant de décrépitude,
> Ces sept monstres hideux avaient l'air éternel!
> ("Les Sept Vieillards," my emphasis)

> [Let whoever laughs at my uneasiness,
> And who is not gripped with a brotherly shudder
> Bear in mind that despite so much decrepitude,
> These seven monsters had a look of eternity!]

But is this also the city of Guys? Few would find much resemblance between his images of Paris and Daumier's. Daumier concentrates on the bourgeois, as Baudelaire acknowledges, Guys the fashionable high life and the tawdry demi-monde, "*la pompe de la vie* telle qu'elle s'offre dans les capitales du monde civilisé, la pompe de la vie militaire, de la vie élégante, de la vie galante" (707) [the pomp and circumstance of life such as it is displayed in the capitals of the civilized world, the pageantry of military life, of high life, of gallantry]. But Baudelaire emphasizes the "comic" aspects of Guys's work, which he describes in the language of caricature: not charming, elegant, or witty, but "bizarre, violent, excessive" (724). The city of *Le Peintre de la vie moderne* has the diabolical character of Virginie's and the grotesque quality of Daumier's, particularly in the later chapters: the

56. *Baudelaire in 1859*, 109f.

"infernal light" that serves as a background (719), the courtesan whose beauty "comes from Evil" (720), the prostitutes like "macabre nymphs" (721), the harpy-like barmaid ("mégère") whose kerchief throws a satanic shadow onto the wall in a comical reminder that "tout ce qui est voué au Mal est condamné à porter des cornes" (721) ["everything devoted to Evil is condemned to wear horns]. Guys portrays corruption and depravity, "le vice inévitable . . . le regard du démon-embusqué dans les ténèbres, ou l'épaule de Messaline miroitant sous le gaz" (722) [inevitable vice . . . the look of the demon ambushed in the darkness, or a Messalina's shoulder gleaming under the gaslight]; in short, "the peculiar beauty of Evil, the beautiful in the horrible" (722)—precisely the formula for caricature, the aesthetic of the *fleur du mal*, the gold made from the mud of Paris, beauty in ugliness (Figs. 57 and 58). Guys is the artist of civilization in the sense used in *De l'essence du rire*, the place of knowledge, superiority, and fallenness. He extracts the phantasmagoria behind the appearances of the city, absorbs and expresses the "fantastique réel de la vie" (697), as Daumier does its "réalité fantastique." To find the fantastic and phantasmagorical in the seemingly trivial circumstances of urban life, and to represent and expose this as such, defines his conception of the work of both artists.

Indeed, for Baudelaire the one frequently rejoins the other. Daumier's thought is "serious" (554), and he produces a tragic and pitiful image ("lamentable," 553). Guys can express the "grotesque" aspect of things (700) and reaches the caricatural: the staff officer who "vu de dos, fait penser aux insectes les plus sveltes et les plus élégants" (708) [seen from behind, is reminiscent of some slender and elegant insect], the Cruikshank-ian and Hoffmannian "petits personnages, dont chacun est bien à sa place" (705) [little figures, each in its proper place], extravagant uniforms, bizarre physiognomies (706), the "weird attitudes" and "contorted faces" of the corpses at Inkermann (702), the Turkish functionaries, "veritable carica-tures of decadence" (704), the male dancers with their heavy clown-like makeup and their "hysterical, convulsive gestures" (704), or the prostitutes "mornes, stupides, extravagantes, avec des . . . fronts bombés par l'entête-ment" (721) [gloomy, their minds dulled, eccentric, with their . . . brows bulging from obstinacy] (Figs. 59 and 60).[57]

57. Baudelaire links Guys with Daumier on a number of points, although openly only once: both work from memory, not directly from the model (save to take notes or mark the main outline). Daumier's memory is described as "marvelous and quasi-divine" (556), Guys's similarly as "resurrecting, evocative . . . a 'Lazarus, arise' " (699). Baudelaire does not signal the other points in common but they are numerous. Both produce epics of their respective

FIG. 57. Constantin Guys. *Intérieur d'un cabaret estaminet* (photo: Victoria and Albert Museum)

FIG. 58. Constantin Guys. *Femmes du sultan dans un carrosse* (photo: Musée des Arts Décoratifs, Paris/Sully-Jaulmes)

FIG. 59. Constantin Guys. *Sultan allant à la mosquée* (photo: Musée des Arts Décoratifs, Paris/Sully-Jaulmes)

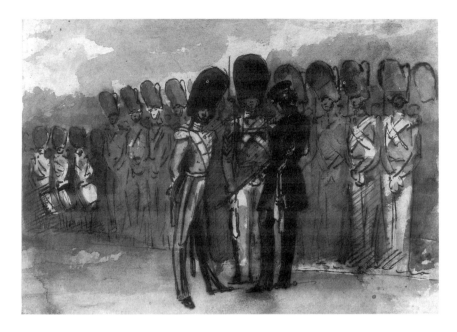

FIG. 60. Constantin Guys. *Standing Soldiers* (photo: British Museum)

It is precisely the *comic* status of the city that justifies an urban poetics of modernity. With the city the *phénomène de la chute* becomes a *moyen du rachat*: the multiplicity of its forms constitutes the peculiar harmony of modern life, which the poet or painter can discern, interpret, and translate, "draw the eternal from the transitory," "extract from it its mysterious beauty" (694f.). And it is the caricaturist, Daumier, who provides the example, drawing the tragic from the trivial, the eccentric from the banal, a true image from a distorted one, making caricature a "high" art.[58] Formally the *Tableaux parisiens* and the *Petits Poèmes en prose* accomplish the same transformation of a "trivial" form bound to the historical moment—the

subjects (555, 701). A work of Daumier's is an "improvisation suivie" (556), finished; Guys's is a similarly paradoxical "perfect study" that "looks sufficiently finished" (700). In Daumier, the idea is communicated instantly (556), in Guys despotically (698). The draftsmanship of both is characterized by certitude (556, 705) with figures solidly posed "d'aplomb" (556, 709) in an art by nature fleeting and transient. Both are singled out for their conversation (611, 689) and their talent for obsèrvation (556, 693).

58. T. J. Clark suggests likewise regarding Daumier's influence on Baudelaire's city poems (*The Absolute Bourgeois*, 161ff.).

tableau de Paris—as does caricature, "hanging on events."[59] The mystery, unintelligibility, and estrangement of the city fulfill the aesthetic criteria of *étonnement, bizarrerie,* or *mystère,* the unattainable and indescribable aspect that challenges the cosmopolitan imagination to a rival creation. Like the comic, the *beau moderne* of an urban art is a beauty in the ugly, horrible, violent, and transitory.

The art of modernity, the art of the city, will not recuperate a lost unity but, like caricature, keep dualism ever present to our minds: the romantic horn-call of memory at the end of "Le Cygne" does not recover the past, but only the past as an allegory of exile and loss. The painting of modern life, like comic art, incorporates dualism, contradiction, paradox, and irony because these are the essence, matter, and purpose of art. One might apply Baudelaire's words on laughter—"laughter is satanic, it is thus profoundly human" (532)—to the city and its art as well. The art of the city is a succession of individual images—those that "parade before our eyes" (549) when we leaf through the "epic" oeuvre of Daumier and Guys, the series of "fragments" that each constitutes a whole in the *Petits Poèmes en prose*— whose harmony in multiplicity is a source of wonder and a reminder of the unknown: "l'étonnante harmonie de la vie dans les capitales, harmonie si providentiellement maintenue dans le tumulte de la liberté humaine" (692) [the astonishing harmony of life in the capital, a harmony so providentially maintained within the tumult of human freedom]. Modern art, like comic art, presents an image of dualism and exile, and the possibilities of transcendence through *dédoublement,* the cosmopolitanism of the artist-*flâneur*.[60] It encompasses, indeed flaunts, its dualism as an image of beauty itself: the mysterious, fantastical, enduring beauty of the fleeting images of Paris— monstrous, alienating, infernal, miserable, comical, sinister, melancholy, depraved—where "every enormity blooms like a flower" ("Epilogue"). The art of modern life, poetic or pictorial, is necessarily caricatural, an urban *fleur du mal.*

59. On Baudelaire's revision of this popular *genre feuilleton,* see Stierle, "Baudelaires 'Tableaux parisiens' und die Tradition des *tableau de Paris.*"

60. In poetic terms, as Chambers suggests, Baudelaire's urban art incorporates the noise and the hurricane within a poetic structure, suggests the chaos at the basis of a vision of order and intelligibility ("Baudelaire's Street Poetry," 253, 257).

Conclusion

The relation between comic art and modern art that Baudelaire's essays establish became a fundamental principle of aesthetic theory and practice in the following century. Caricature, so much a product, at least in France, of the age of revolution, became in the post-revolutionary modern world a model for artistic expression in general. It clearly provided a means for realizing the objectives of modernist movements, undermining the authority of neoclassical standards and values. From the radically caricatural methods of Courbet, Manet, and Degas—abbreviated and exaggerated forms, strong outline, summary backgrounds, sketch-like drawing, bold coloring, effects of improvisation, immediacy, and spontaneity, even the progressive flattening of the picture characteristic of pictorial modernism—to the Cubist play with representation, and the distortion, irreverent humor, uncanniness, and license characteristic of twentieth-century forms, modern art has been dominated by the comic, the grotesque, and the caricatural.[1] Yet the comic provided not only a means of overthrowing standards but also of establishing them, finding the rule of the norm more clearly expressed in the distortion. From Freud's work on jokes to Bakhtin's studies of Rabelais and Dostoyevsky, the comic has furnished models of individual, social, and cultural behavior. Aesthetic theory too has sought in comic forms general principles of art and interpretation, as in the works of Gombrich and W. Hofmann, the Russian Formalists' use of parody as a paradigm for literature overall, and the postmodern emphasis on the ironic, parodic, and paradoxical.

1. In 1863 Paul Mantz described Manet's paintings as "the caricature of color and not color itself," and likened him, by the brutality and violence of his manner, to Goya (*Gazette des Beaux-Arts* XIV, 383). On the relation of caricature to Impressionism and Cubism, see R. Herbert, *Impressionism: Art, Leisure, and Parisian Society*, 38ff.; J. Isaacson, "Impressionism and Journalistic Illustration"; B. Farwell, *The Cult of Images: Baudelaire and the Nineteenth-Century Media Explosion*; Adam Gopnik, "High and Low: Caricature, Primitivism and the Cubist Portrait."

It is perhaps this aspect of Baudelaire's thought and art that accounts for his ongoing "modernity" and his prominent position in the history of the modern era. The comic, grotesque, and caricatural methods evident every-where in his work, as the oxymoronic titles alone suggest (*Fleurs du mal, Petits Poèmes en prose, Morale du joujou, Paradis artificiels,* and so on), have permeated the domains of high art and cultural inquiry in the major movements since his time—a development prefigured in his own aesthetic and formally justified by the essays on caricature. "En matière d'art, j'avoue que je ne hais pas l'outrance; la modération ne m'a jamais semblé le signe d'une nature artistique vigoureuse" (807) [In artistic matters I confess that I do not hate extravagance; moderation has never seemed to me the sign of a vigorous artistic nature].[2] Yet as this sentence demonstrates—its conspic-uous understatement in ironic contradiction to its stated message—Baude-lairean *outrance*, the comic and caricatural, lies not only in exaggeration but also in irony, in the outrageous space where things are other than they seem, where the self is at once itself and another, where truth derives from contradiction and the creative play of appearances, unity from duality, transcendence from the tensions of the real.

In arguing for the essentially comic and caricatural nature of the Baude-lairean aesthetic of the modern, I have attempted not only to show the relation between the two but also to bring out the contribution of the essays on caricature to our understanding of that aesthetic, and of the concept of modernity that derived from it. First, the comic structure by which dualism is exploited to surpass its own limits makes possible the paradoxical art of modernity: dualism becomes *dédoublement*, through which the product of the Fall becomes the means of redemption, and the historical, contingent, fleeting, vulgar, and ugly become the source and matter of the poetic, absolute, eternal, and beautiful. Thus dualism is transformed from the coexistence of separate entities, blind to one another (like Giglio's irrecon-cilable chronic dualism or Grandville's unharmonized idea versus art) into an indivisible, though multiple and relative, "wholeness," the impression of oneness in an art by nature divided and dual, as in the *comique absolu*, the art of Goya, Hoffmann, and Daumier, and the sacrificial *dédoublement* of the comic artist, that image of the self's transcendence of its own limitations and its interaction with others. Moreover the essays on caricature, with their emphasis on aggression, irritation, and *choc*, go far in explaining Baude-laire's own poetic and critical methods, which relentlessly challenge the

2. Cf. his preference for exaggeration in drama, like that of the ancient theater (I, 682).

reader to a radical self-questioning. If they enact the very comic structures that they expose, this has a purpose central to the theory itself: not only to demonstrate the inseparability of the critical and creative faculties of the artist, but to make the reader experience theory and practice as a single phenomenon, coexistent and indivisible, like the moral that springs naturally and simultaneously from the non-moralizing *comique absolu*. The "unity" of the essays reflects that of comic art, and modern art as well, a dualism experienced as one.

Dualism in the Baudelairean scheme cannot, must not, disappear: the comic and the beautiful belong to the fallen, and the ideal does not exist without this. The Baudelairean ideal is thus expressed through a corresponding rhetorical dualism, in oxymoronic terms like *comique absolu, caricature artistique, art moderne, prose poétique*. As the theory of the comic makes clear, *comique absolu* is absolute only insofar as it is dual, integrating the *significatif* into itself: a "pure fantastic, molded from nature," as, using a contradiction in terms, he says of Hoffmann; and the *monstrueux vraisemblable* of Goya, the *réalité fantastique* of Daumier, the *fantastique réel* of Guys, the absolute Italian *comique* of Callot attained only by virtue of the quintessentially *significatif* qualities of the French. This principle of Baudelaire's comic aesthetic governs his aesthetic of modernity too, and explains why, even in the late works with their conception of a freer aesthetic of the fragmentary, he continues to insist on the dualism of art. The two aspects— moral and artistic, *volonté* and *volupté*, concentration and vaporization, *ironie* and *surnaturalisme*, transitory and eternal, particular and universal, ugly and beautiful—contend with one another but therein work in tandem toward an aesthetic end: if, for example, concentration controls vaporization, this is not out of an arbitrary ideal of self-control but rather the aesthetic ends of intelligibility and memorability. In Baudelaire's scheme only an image that is memorable remains alive in the imagination and is capable of suggesting meanings beyond the immediate circumstances of what it depicts; only a memorable image will have significance for the viewer, and different viewers. The contradiction involves a reciprocity that ensures the aesthetic status of the work; as *Le Peintre de la vie moderne* states, the eternal can be grasped only through the transitory, and the transitory can endure only if the eternal quality of its beauty is extracted from it.

The dualism of the comic, the implication of the laugher in laughter, establishes the ambiguity of the experience of modernity, the *flâneur*'s status as subject and object. It thus calls into question the notion of modernity as

it came to be defined, that is, as the *flâneur*'s creation and control of urban experience. In Baudelaire such experience is far more problematic, involving a self-awareness and a necessary reciprocity, the *flâneur*'s appropriation of and *by* the crowd. It derives from the comic concept of *dédoublement*, the artist as actor and spectacle, grounded in a will that abandons itself to others and leads them to do the same. It thus opens up a space for the mystery and "insaisissable" that characterize both beauty and the *comique absolu*.

The emphasis on *dédoublement*, in both the content of the essay and its method, points to a conception of self-knowledge which includes action. The comic artist's doubling, like the modern artist's cosmopolitanism, involves not simply the awareness of inferiority and superiority, or of self and other, but the action of making oneself another for the benefit of another, making oneself an object of laughter for the benefit of the laugher's enlightenment, taking on the figures in the crowd as an image for the crowd. And the action involves a sacrifice; the potentially self-centered and comfortable position of mere self-consciousness disappears with the requirements of praxis. Here too Baudelaire insists on reciprocity: the sacrifice cannot take place without the audience, the crowd, those for whom it is enacted. The transcendence of dualism depends on otherness, both within the self and beyond it. This is a unity defined through difference, like the contrasting colors in the *Salon de 1846*, and the harmony of the chaotic forms of the city in *Le Peintre de la vie moderne*. The comic artist, like the modern one, is closely integrated into the world, a position consistent with the artistic project itself: to draw the beautiful from the fleeting, common, "real" material of everyday life.

Indeed the essays on caricature and their role in his aesthetic of modernity bring to the fore this crucial and radical principle of Baudelaire's aesthetic thought: concepts of transcendence, unity, the ideal, the divine, the absolute, the eternal, the infinite, and the beautiful, all depend on the real, the human, the relative, the temporal, the finite, and the fallen that posit them. Dualism does not signify a nostalgia for a lost unity but is productive of that unity itself; beauty is dual, and the ideal coexistent with the real; degradation posits the standard by which it defines itself; the "product of the Fall" *is* the "means of redemption." And it is the comic that represents this process, the creative dualistic tension between superiority and inferiority, self-ignorance and self-knowledge, with its explosive power to liberate the laugher from the confines of the self (through *dédoublement* and self-multiplication) and from the limitations of the real, and to lead, as in the English pantomime,

Conclusion 313

to the frontier of the marvelous. The limited, temporal, finite, real comic creates those conditions by which we define the ideal: freedom, infinite variety, metamorphosis, simultaneity. Hoffmann, Goya, Daumier, Callot, Guys—in each the *absolu* is linked firmly and necessarily to the *significatif*, without which it would not exist. Hence the centrality of the comic itself, which in celebrating dualism, multiplicity, temporality, and fallenness celebrates the very matter, source, and condition of the ideal. *Surnaturalisme* is one with *ironie*; the absolute is a human absolute. Even the hypothetical "pure poetry" is a product of a strikingly "comical," "fallen," or "satanic" boldness, the human effort to surpass the limits of humanity. The Baudelairean ideal is born precisely of the aspiration toward it; his aesthetic represents not a longing for a lost plenitude, but the human capacity, and need, to create its own ideals, to produce from the most evident marks of the limits of understanding the very means of transcending them, to create in and from fallen nature the *surnaturel*; to transform the punishment of dualism into the power and privilege of *dédoublement*, the means of escaping dualism; to make the uncontrollable grimace of laughter the agent of freedom and pleasure; to create within a dualist art the indivisibility and simultaneity of wholeness. Perhaps the most radical contribution of Baudelaire's notion of the comic to his aesthetic consists in this, its affirmation of the reality of the ideal, the ideality of the real, thus suggesting a crucial aspect of the history and theory of modernism.

In the terms of the comic, the aesthetic of the fragmentary that governs Baudelaire's most deliberately "modernist" work, the *Petits Poèmes en prose*, may be interpreted afresh, not as opposed to unity but as constitutive of it. Indeed the "Dédicace" presents the work in the conspicuous vocabulary of the comic:

> Mon cher ami, je vous envoie un petit ouvrage dont on ne pourrait pas dire, sans injustice, qu'il n'a ni queue ni tête, puisque tout, au contraire, y est à la fois tête et queue, alternativement et réciproquement. . . . Nous pouvons couper où nous voulons, moi ma rêverie, vous le manuscrit, le lecteur sa lecture; . . . Enlevez une vertèbre, et les deux morceaux de cette tortueuse fantaisie se rejoindront sans peine. Hachez-la en nombreux fragments, et vous verrez que chacun peut exister à part. Dans l'espérance que quelques-uns de ces tronçons seront assez vivants pour vous plaire et vous amuser, j'ose vous dédier le serpent entier.
>
> .

Quel est celui de nous qui n'a pas, dans ses jours d'ambition, rêvé le miracle d'une prose poétique, musicale sans rythme et sans rime, assez souple et assez heurtée pour s'adapter aux mouvements lyriques de l'âme, aux ondulations de la rêverie, aux soubresauts de la conscience?

C'est surtout de la fréquentation des villes énormes, c'est du croisement de leurs innombrables rapports que naît cet idéal obsédant.

. .

Mais, pour dire vrai, je crains que ma jalousie ne m'ait pas porté bonheur. Sitôt que j'eus commencé le travail, je m'aperçus que non seulement je restais bien loin de mon mystérieux et brillant modèle, mais encore que je faisais quelque chose (si cela peut s'appeler *quelque chose*) de singulièrement différent, accident dont tout autre que moi s'enorgueillirait sans doute, mais qui ne peut qu'humilier profondément un esprit qui regarde comme le plus grand honneur du poète d'accomplir *juste* ce qu'il a projeté de faire. (I, 275f.)

[My dear friend, I send you a little work of which it cannot be said, without being unfair, that it has neither head nor tail, as everything in it, on the contrary, is at once head and tail, alternately and reciprocally. . . . We can cut wherever we like, I my reverie, you the manuscript, the reader his reading; . . . Remove one vertebra, and the two pieces of this tortuous fantasy will join up effortlessly. Chop it up into numerous fragments, and you will see that each portion can exist separately. In the hope that some of these pieces will be lively enough to please and amuse you, I dare to dedicate to you the entire serpent.

. .

Who among us has not, in his ambitious moments, dreamt of the miracle of a poetic prose, musical without rhythm or rhyme, both supple and jerky enough to fit the lyrical movements of the soul, the undulations of reverie, the fits and starts of consciousness?

It is especially from the experience of great cities, from the intersecting of the innumerable relations in them, that this obsessive ideal is born.

. .

But, to speak truly, I fear that my jealousy may not have brought me luck. No sooner had I begun the work, than I realized not only

that I remained very far from from my mysterious and brilliant model, but even more, that I was doing something (if that can be called *something*) singularly different, an accident of which anyone other than myself would no doubt be proud, but which can only profoundly humble a soul that considers it the poet's greatest honor to accomplish *just* what he planned to do.]

The work is a serpent, a "tortueuse fantaisie," a monstrous and caricatural creation; a literal deception of expectations, an "accident" contrary to the poet's intentions and ideal; a source of pride that becomes a reminder of "inferiority," however ironic; parodic in its distance from its alleged "brillant modèle"; caricatural in its distance from the balanced, measured, and seemly, suggested by the ironically italicized *juste* of the final line; and contradictory in its *prose poétique*, its *prose lyrique*, its rhythm-less music, and its ideal born of the day-to-day experience of the city (I, 275f.).

The aesthetic of the fragmentary that the "Dédicace" advances may thus be understood according to the comic model of unity in dualism and the relativity of the absolute. The *Petits Poèmes en prose* do not abolish unity but propose a new conception of it, a unity dependent on fragmentation, an ideal literally born of the fragmented but interconnecting ("croisement," "rapports") and kaleidoscopic experiences, the *correspondances* of the modern city. Baudelaire's figure of the truncated serpent puts forward a new *ars poetica*: the Horatian monstrosity, where neither head nor foot can be assigned to any one shape ("ut nec pes nec caput uni reddatur formae," lines 8f.), where excessive variety and freedom prevent unity, which resembles the images of feverish dreams ("velut aegri somnia," line 7), and which causes laughter ("risum teneatis, amici?" line 5),[3] becomes the model for a

3. Horace, *Ars poetica,* 1–13: Humano capiti cervicem pictor equinam / iungere si velit, et varias inducere plumas / undique collatis membris, ut turpiter atrum / desinat in piscem mulier formosa superne, / spectatum admissi risum teneatis, amici? / credite, Pisones, isti tabulae fore librum / persimilem, cuius, velut aegri somnia, vanae / fingentur species, ut nec pes nec caput uni / reddatur formae. "pictoribus atque poetis / quidlibet audendi semper fuit aequa potestas." / scimus, et hanc veniam petimusque damusque vicissim; / sed non ut placidis coeant immitia, non ut / serpentes avibus geminentur, tigribus agni. ["If a painter chose to join a human head to the neck of a horse, and to put multi-colored feathers on limbs gathered from here and there, so that what at the top is a lovely woman ends below in a black and ugly fish, could you, my friends, keep from laughing at the sight? Believe me, dear Pisos, a book would be just like this picture, whose fanciful features shall be modeled like a sick man's dreams, so that neither head nor foot can be assigned to a single shape. "Painters and poets," you may say, "have always had an equal right to hazard anything." We know it: we claim this license and in turn we grant it; but not so far that wild beasts should mate with tame, nor serpents pair with birds, lambs with tigers"] (Horace, *Ars Poetica,* lines 1–13).

new conception of unity *based* on variety, the irregular movements of the human imagination, and the laughter-causing methods of the comic and grotesque. Horace's caricature becomes the model for an aesthetic of caricature, his monster a model for an aesthetic of the monstrous, as Baudelaire's ironic, italicized emphasis on his own "accidental," unspeakable creation ("si cela peut s'appeler *quelque chose*") suggests.

Baudelaire specifies that his work is not "without head nor tail," lacking in unity, its parts not making a whole, but rather that everything in it is "at once head and tail, alternately and reciprocally," each part a whole consisting of parts ("tête et queue") and a part within a whole. This is the beheaded, truncated Pierrot of the pantomime, his head and torso taking on their own life—the Pierrot who did not replace the head but became, headless, yet another comic role in the parody of Saint Denis. Such unity, like the *comique absolu*, is protean, relative, and variable: "Enlevez une vertèbre, et les deux morceaux de cette tortueuse fantaisie se rejoindront sans peine. Hachez-la en nombreux fragments, et vous verrez que chacun peut exister à part." In either of these ways, the peculiarly modern unity of the work is itself caricatural, a *tronçon* or a monstrous *serpent*, a unity appropriate to the equally caricatural "mouvements lyriques"—both supple and jerky, "ondulations" and "soubresauts"—of the modern urban soul.

Selected Bibliography

Note: Unless otherwise indicated, page references in the text are to volume II of Baudelaire's *Oeuvres complètes*, ed. Claude Pichois (Paris: Gallimard, 1975–76). Those preceded by Roman I are to volume I of the same edition.

Abé, Yoshio. "La Nouvelle Esthétique du rire: Baudelaire et Champfleury." *Annales de la Faculté des lettres* (Tokyo: Université Chuo) 34 (March 1964), 18–30.

Accaputo, Nino. *L'Estetica di Baudelaire e le sue fonti germaniche.* Turin: Bottega d'Erasmo, 1961.

Adhémar, Jean. "L'Education artistique de Baudelaire faite par son père." *Gazette des Beaux-Arts* XCIII, 1322 (March 1979), 125–34.

———. *Honoré Daumier,* Paris: Pierre Tisné, 1954.

Agulhon, Maurice. *Marianne au combat: L'Imagerie et la symbolique républicaines de 1789 à 1880.* Paris: Flammarion, 1979.

Ahearn, Edward. "Confrontation with the City: Social Criticism, Apocalypse, and the Reader's Responsibility in City Poems by Blake, Hugo, and Baudelaire." *Hebrew University Studies in Literature* X, 1 (Spring 1982), 1–22.

Alcalá Flecha, Roberto. *Literatura y ideología en el arte de Goya.* Zaragoza: Disputación general de Aragón, 1988.

Alexandre, Arsène. *L'Art du rire et de la caricature.* Paris: Librairies-Imprimeries Réunies, 1892.

Amiot, Anne-Marie. *Baudelaire et l'illuminisme.* Paris: Nizet, 1982.

Andioc, René. "Al margen de los *Caprichos*: Las 'explicaciones' manuscritas." *Nueva Revista de filología hispánica* 33, 1 (1984), 257–83.

Anes, Gonzalo. "Freedom in Goya's Age: Ideas and Aspirations." In *Goya and the Spirit of Enlightenment,* exh. cat., Museum of Fine Arts, Boston, 1989, xxvi–xlix.

Antal, Frederick. *Hogarth and his Place in European Art.* London: Routledge and Kegan Paul, 1962.

Appelbaum, Stanley, ed. *Bizarreries and Fantasies of Grandville.* New York: Dover, 1974.

Art Journal 43, 4 (Winter 1983), ed. Judith Wechsler (special issue on caricature).

Athanassoglou-Kallmyer, Nina. "Sad Cincinnatus: *Le Soldat laboureur* as an Image of the Napoleonic Veteran After the Empire." *Arts Magazine* 60, 9 (1986), 65–75.

Atherton, Herbert M. *Political Prints in the Age of Hogarth: A Study of the Ideographic Representation of Politics.* Oxford: Clarendon Press, 1974.

Aynesworth, Donald. "A Face in the Crowd: A Baudelairean Vision of the Eternal Feminine." *Stanford French Review* V (1981), 327–39.

Bakhtin, Mikhail. *Rabelais and His World,* trans. Helene Iswolsky. Bloomington: Indiana University Press, 1984.

Balzac, Honoré de. *Correspondance,* ed. R. Pierrot. Paris: Garnier, 1966.

———. *Oeuvres diverses* I and II. In *Oeuvres complètes,* ed. M. Bouteron and H. Longnon, 40 vols. Paris: Conard, 1935–38.

Balzer, W. *Der junge Daumier und seine Kampfgefährten: Politische Karikatur in Frankreich 1830–1835.* Dresden: Verlag der Kunst, 1965.

Barasch, Frances K. *The Grotesque: A Study in Meanings.* The Hague: Mouton, 1971.

Barrère, J.-B. "Victor Hugo's Interest in the Grotesque in his Poetry and Drawings." In *French Nineteenth-Century Painting and Literature,* ed. Ulrich Finke. Manchester: Manchester University Press, 1972.

Baschet, Robert. *E. J. Delécluze, témoin de son temps 1781–1863.* Paris: Boivin, 1942.

Baticle, Jeannine. "Goya and the Link with France at the End of the Old Regime." In *Goya and the Spirit of Enlightenment,* exh. cat., Museum of Fine Arts, Boston, 1989, l–lxiii.

Battesti-Pelegrin, J. "Les Légendes des *Caprices,* ou le texte comme miroir?" In *Goya: Regards et lectures.* Actes du colloque d'Aix-en-Provence, Université de Provence, 1982, 33–56.

Baudelaire, Charles. *Correspondance,* ed. C. Pichois, 2 vols. Paris: Gallimard, 1973.

———. *Curiosités esthétiques.* In *Oeuvres complètes de Charles Baudelaire,* ed. J. Crépet, 19 vols. Paris: Conard, 1923.

———. *Lettres à Charles Baudelaire,* ed. C. Pichois. Neuchâtel: La Baconnière, 1973.

———. *Oeuvres complètes,* ed. C. Pichois, 2 vols. Paris: Gallimard, 1975–76.

Beaumont, Cyril. *The History of Harlequin.* London: C. W. Beaumont, 1926.

Bechtel, Edwin. *Freedom of the Press: Philipon vs. Louis-Philippe.* New York: Grolier Club, 1952.

Bénard, Christian. "La Théorie du comique dans l'esthétique allemande." *Revue philosophique* X (1880), 241–63, and XII (1881), 251–76.

Benjamin, Walter. *Charles Baudelaire: A Lyric Poet in the Era of High Capitalism,* trans. H. Zohn. London: NLB, 1973.

———. *Gesammelte Schriften,* ed. Rolf Tiedemann, 7 vols. Frankfurt am Main: Suhrkamp, 1974–85.

———. *The Origin of German Tragic Drama,* trans. John Osborne. London: NLB, 1977.

Béraldi, Henri. *Les Graveurs du XIXᵉ siècle.* Repr. Nogent-le-Roi: J. Laget, 1981.

Berman, Marshall. *All That Is Solid Melts Into Air: The Experience of Modernity.* New York: Simon and Schuster, 1982.

Bersani, Leo. *Baudelaire and Freud.* Berkeley and Los Angeles: University of California Press, 1977.

Berthoud, Dorette. *La Vie du peintre Léopold Robert.* Neuchâtel: La Baconnière, 1934.

Bertrand, Alexis: "Le Rire d'après un vieux médecin." *La Nouvelle Revue* LII (May–June 1888), 434–52.

Bibliothèque Nationale. *Le Dessin d'humour du XVᵉ siècle à nos jours,* exh. cat. Paris, 1971.

———. *La Révolution de 1848,* exh. cat. Paris, 1948.

Biermann, Karlheinrich. *Literarisch-politische Avantgarde in Frankreich 1830–*

1870: Hugo, Sand, Baudelaire und andere. Stuttgart: W. Kohnhammer, 1982.

Bindman, David. *Hogarth.* London: Thames and Hudson, 1981.

Blanc, Charles. *Histoire des peintres de toutes les écoles: Ecole française,* 3 vols. Paris: Renouard, 1865.

Blanchard, Marc. *In Search of the City: Engels, Baudelaire, Rimbaud.* Stanford French and Italian Studies, Saratoga, Calif.: Anma Libri, 1985.

Blin, Georges. *Le Sadisme de Baudelaire.* Paris: José Corti, 1948.

Blum, André. *La Caricature politique sous la monarchie de juillet.* Paris: Gazette des Beaux-Arts, 1920.

———. *L'Estampe satirique et la caricature en France au XVIIIᵉ siècle.* Paris: Gazette des Beaux-Arts, 1910.

Boime, Albert. "Jacques-Louis David, Scatological Discourse in the French Revolution and the Art of Caricature." In *French Caricature and the French Revolution,* UCLA exh. cat. (q.v.), 67–82.

———. *Thomas Couture and the Eclectic Vision.* New Haven: Yale University Press, 1980.

Bonfantini, Mario. "Baudelaire et Stendhal." *Actes du colloque de Nice.* Paris: Minard, 1968.

Booth, Michael. *English Plays of the Nineteenth Century* v: *Pantomimes, Extravaganzas, Burlesques.* Oxford: Clarendon Press, 1976.

Bossuet, Jacques Bénigne. *Maximes et réflexions sur la comédie.* In *L'Eglise et le théâtre,* ed. Charles Urbain and E. Levesque. Paris: Bernard Grasset, 1930.

Bourdaloue, Louis. *Oeuvres complètes,* 6 vols. Paris: Gabriel Beauchesne, 1905.

———. *Oeuvres complètes,* ed. E. Griselle, 2 vols. Paris: Bloud et Gay, 1919.

Bouteiller, Henri. *Histoire des milices bourgeoises et de la Garde Nationale de Rouen.* Rouen: Charles Houlard, 1850.

British Museum, Department of Prints and Drawings. *Catalogue of Prints and Drawings in the British Museum: Political and Personal Satires,* ed. F. G. Stephens and M. Dorothy George, 11 vols. London: Trustees of the British Museum, 1870–1954.

Buck-Morss, Susan. *The Dialectics of Seeing: Walter Benjamin and the Arcades Project.* Cambridge: MIT Press, 1989.

Bugliani, Ivanna. "Baudelaire tra Fourier e Proudhon," *Critica storica* x, n.s. 4 (December 1973), 591–679.

Burke, Joseph. "A Classical Aspect of Hogarth's Theory of Art." *Journal of the Warburg and Courtauld Institutes* vi (1943), 151–53.

Burnell, Devin. "The Good, the True, and the Comical: Problems Occasioned by Hogarth's *The Bench.*" *Art Quarterly* 2 (1978), 16–46.

Burton, Richard D. E. *Baudelaire in 1859: A Study in the Sources of Poetic Creativity.* Cambridge: Cambridge University Press, 1988.

———. "The Unseen Seer, or Proteus in the City: Aspects of a Nineteenth-Century Parisian Myth." *French Studies* XLII, 1 (January 1988), 50–68.

Burty, Philippe. "Gavarni." *Chronique des arts,* 2 December 1866, 275–76.

Buvik, Per. "Paris, lieu poétique, lieu érotique. Quelques Remarques à propos de W. Benjamin et de Baudelaire." *Revue romane* (Copenhagen) xx (1985), 231–42.

Camón Aznar, José. *Francisco de Goya,* 4 vols. Zaragoza: Instituto Camón Aznar, 1980–82.

Carofiglio, Vito. "Théorie du rire et anthropologie comparée du comique chez

Stendhal et Baudelaire." in *Stendhal et le romantisme*, ed. V. Del Litto and K. Ringger, Coll. stendhalienne no. 25. Aran: Editions du Grand Chêne, 1984, 279–85.

Carrive, Paulette. "Le Sublime dans l'esthétique de Kant." *Revue d'histoire littéraire de la France* LXXXVI (1986), 71–85.

Caylus, Anne Claude Philippe, Comte de. *Recueil de testes de caractère et de charges dessinées par Léonard de Vinci florentin*. Paris: Mariette, 1730.

Chadefaux, M.-C. "Le Salon caricatural de 1846 et les autres salons caricaturaux." *Gazette des Beaux-Arts* LXXI, 1190 (March 1968), 161–76.

Chambers, Ross. "L'Art sublime du comédien, ou le regardant regardé." *Saggi e Ricerche di letteratura francese* XI (1971), 189–260.

———. "Baudelaire's Street Poetry." *Nineteenth-Century French Studies* XIII, 4 (1984–85), 244–59.

Champfleury. *Henry Monnier, sa vie, son oeuvre*. Paris: Dentu, 1879.

———. *Histoire de la caricature antique*. Paris: Dentu, 1865.

———. *Histoire de la caricature moderne*. Paris: Dentu, 1865.

———. *Histoire de la caricature sous la République, l'Empire et la Restauration*, 2d ed. Paris: Dentu, 1877.

———. *Musée secret de la caricature*. Paris: Dentu, 1888.

———. *Souvenirs des Funambules*. Paris: Michel Lévy, 1859.

Charvet, P.E., trans. *Baudelaire: Selected Writings on Art and Artists*. Cambridge: Cambridge University Press, 1981.

Chateaubriand, François René de. *René*, ed. F. Letessier. Paris: Garnier, 1962.

Cherpin, Jean. *L'Homme Daumier. Un Visage qui sort de l'ombre*. Marseilles: Arts et Livres de Provence 87, 1973.

Chollet, R. *Balzac journaliste: Le Tournant de 1830*. Paris: Klincksieck, 1983.

Citron, Pierre. *La Poésie de Paris dans la littérature française de Rousseau à Baudelaire*. Paris: Editions du Minuit, 1961.

Clapton, G. T. "Balzac, Baudelaire and Maturin." *French Quarterly* (June 1930), 66–84 (September 1930), 97–114.

———. "Lavater, Gall et Baudelaire." *Revue de littérature comparée* (1933), 259–98 and 429–56.

Clark, Kenneth, ed. *The Drawings of Leonardo da Vinci in the Collection of Her Majesty the Queen at Windsor Castle*, 3 vols., 2d ed. London: Phaidon, 1968.

Clark, T. J. *The Absolute Bourgeois: Artists and Politics in France 1848–1851*. London: Thames and Hudson, 1973.

———. *Image of the People: Gustave Courbet and the Revolution of 1848*. London: Thames and Hudson, 1973.

———. *The Painting of Modern Life: Paris in the Art of Manet and his Followers*. London: Thames and Hudson, 1985.

Cleveland Museum of Art. *Constantin Guys: Crimean War Drawings 1854–1856*, exh. cat., ed. Karen W. Smith, 1978.

Clubbe, John. *Victorian Forerunner: The Later Career of Thomas Hood*. Durham: Duke University Press, 1968.

Coleridge, Samuel Taylor. "On the Distinction of the Witty, the Droll, the Odd, and the Humorous." In *Notes and Lectures upon Shakespeare*, 2 vols. London: William Pickering, 1849.

Colin, Paul. *Catalogue analytique de l'oeuvre de Carle Vernet*. Brussels: Editions de la Galerie Giroux, 1923.

Costa de Beauregard, Raphaella. "Eccentricity and Hogarth's Ogee Line." In *L'Excentricité en Grande Bretagne*. Lille: Presses Universitaires de Lille, 1976, 183–87.

Cowley, Robert L. S. *Hogarth's Marriage à la mode*. Ithaca: Cornell University Press, 1983.

Courdaveaux, V. *Etudes sur le comique. Le Rire dans la vie et dans l'art*. Paris: Didier, 1875.

Cuno, James. "Introduction." In *French Caricature and the French Revolution*, UCLA exh. cat. (q.v.), 13–24.

D'Almeras, Henri. *Marie-Antoinette et les pamphlets royalistes et révolutionnaires*. Paris: Albin Michel, 1921.

Dayot, Armand. *Carle Vernet: Etude sur l'artiste suivie d'un catalogue de l'oeuvre gravé et lithographié, et du catalogue de l'exposition rétrospective de 1925*. Paris: Le Goupy, 1925.

———. *Les Maîtres de la caricature française au XIXᵉ siècle*. Paris: Quantin, 1888.

———. *Journées révolutionnaires 1830–48, d'après des peintures, sculptures, dessins, lithographies, médailles, autographes, et objets du temps*. Paris: E. Flammarion, 1897.

De Baecque, Antoine. *La Caricature révolutionnaire*. Paris: Presses du CNRS, 1988.

Deberdt, R. *La Caricature et l'humour français au XIXᵉ siècle*. Paris: Larousse, 1898.

Delacroix, Eugène. "Charlet." *Revue des deux mondes* XXXVII (1 January 1862), 234–42.

———. *Correspondance*, ed. A. Joubin, 5 vols. Paris: Plon, 1936–38.

———. *Journal*, ed. A. Joubin, rev. R. Labourdette. Paris: Plon, 1981.

———. *Oeuvres littéraires*, 2 vols. Paris: Crès, 1923.

Delécluze, E. J. *Notice sur la vie et les ouvrages de L. Robert*. Paris: Rittner et Goupil, 1838.

Delmay, B., and Lori, M. C. *Baudelaire. Dallo Specchio alla scena: uno stadio ripetitivo*. Florence: Franco Cesati Editore, 1983.

Delteil, Loÿs. *Le Peintre-graveur illustré*, 30 vols. Paris: 1906–25.

De Man, Paul. "The Rhetoric of Temporality." In *Blindness and Insight: Essays in the Rhetoric of Contemporary Criticism*. Minneapolis: University of Minnesota Press, 1983, 187–228.

Demoris, R. "Hiérarchie et dualisme dans la critique picturale de Baudelaire." *Nottingham French Studies* VIII, 2 (1969), 69–82.

Dictionary of National Biography, ed. S. Lee. London: Smith, Elder & Co., 1894.

Dictionnaire de la conversation et de la lecture. Paris: Belin-Mander, 1836.

Diderot, Denis. *Oeuvres esthétiques*, ed. P. Vernière. Paris: Garnier, 1968.

———. *Salons*, ed. Jean Seznec, 4 vols. Oxford: Clarendon Press, 1979.

Disher, M. Willson. *Clowns and Pantomimes*. London: Constable, 1925.

Döhmer, Klaus. "Louis-Philippe als Birne: zur Karikatur und ihrer Herkunft aus der Physiognomik." *Pantheon* XXXVIII, 3 (July–September 1980), 248–54.

Drost, Wolfgang. "Baudelaire between Marz, Sade and Satan." In *Baudelaire, Mallarmé, Valéry: New Essays in Honour of Lloyd Austin*, ed. M. Bowie, A. Fairlie, and A. Finch. Cambridge: Cambridge University Press, 1982, 38–57.

———. "De la critique d'art baudelairienne." *Actes du colloque de Nice*. Paris: Minard, 1968, 79–88.

———. "L'Inspiration plastique chez Baudelaire." *Gazette des Beaux-Arts* 49 (May–June 1957), 321–26.

Duché, Jean. *Deux Siècles d'histoire de France par la caricature*. Paris: Editions du Pont-Royal, 1961.

Duflo, P. "Baudelaire et Guys: Trois Lettres inédites." *Revue d'histoire littéraire de la France* 83 (1983), 599–603.

———. *Constantin Guys: Fou de dessin, grand reporter 1802–92*. Paris: A. Seydoux, 1988.

Dumas, Alexandre (père). *Mes Mémoires*, 5 vols., ed. Pierre Josserand. Paris: Gallimard, 1967.

Dumont, Léon. *Des causes du rire*. Paris: Durand, 1862.

Eco, Umberto. "The Comic and the Rule." In *Travels in Hyperreality*, trans. W. Weaver. New York: Harcourt Brace Jovanovich, 1986, 269–78.

Ecole des Beaux-Arts, Paris. *Exposition des peintures, aquarelles, dessins et lithographies des maîtres français de la caricature et de la peinture de moeurs au XIXᵉ siècle*, exh. cat., 1888.

Escholier, Raymond. *Daumier et son monde*. Paris: Berger-Levrault, 1965.

Esnault, Gaston. *Dictionnaire historique des argots français*. Paris: Larousse, 1965.

Evans, James E. *Comedy: An Annotated Bibliography of Theory and Criticism*. London: Scarecrow, 1987.

Erhard, E. "Das traditionelle Denkmal in der Karikatur." *Du* 10 (1982), 37–47.

Fairlie, Alison. "Aspects of Expression in Baudelaire's Art Criticism." In *Imagination and Language*. Cambridge: Cambridge University Press, 1981, 176–215.

Falconieri, Carlo. *Memoria intorno alla vita ed alle opere di Bartolomeo Pinelli*. Naples: Tipografia all' Insegna del Gravina, 1835.

Farwell, Beatrice, ed. *The Cult of Images: Baudelaire and the Nineteenth-Century Media Explosion*, exh. cat., University of California, Santa Barbara, 1977.

———. *French Popular Lithographic Imagery 1815–1870*. Chicago: University of Chicago Press, 1981.

Fauque, Jacques, ed. *Goya y Burdeos 1824–1828*, exh. cat., Zaragoza, Ediciones Oroel, 1982.

Ferment, C. "Le Caricaturiste Traviès. La Vie et l'oeuvre d'un 'Prince du Guignon,' " *Gazette des Beaux-Arts*, ser. 6, 99 (February 1982), 63–78.

Festa-McCormick, Diane. "Elective Affinities between Goya's *Caprichos* and Baudelaire's *Danse Macabre*." *Symposium* XXXIV, 4 (Winter 1980–81), 293–311.

Fingesten, P. "Delimiting the Concept of the Grotesque." *Journal of Aesthetics and Art Criticism* 42 (Summer 1984), 419–26.

Flögel, Karl Friedrich. *Geschichte der komischen Litteratur*, 4 vols. Leipzig: Siegert, 1784.

———. *Geschichte des Grotesk-Komischen. Ein Beitrag zur Geschichte der Menschheit*. Leipzig: Siegert, 1788.

Francqueville, Robert de. *Pierre de Francqueville, sculpteur des Médicis et du roi Henri IV 1548–1615*. Paris: Picard, 1968.

Fried, Michael. "Painting Memories." *Critical Inquiry* CI, 10 (March 1984), 510–42.

Froidevaux, Gérald. *Baudelaire: Représentation et modernité*. Paris: José Corti, 1989.

Fuchs, E. *Die Karikatur der europäischen Völker vom Altertum bis zur Neuzeit*. Berlin: A. Hofmann, 1901.

Gans, E. L. *Essais d'esthétique paradoxale*. Paris: Gallimard, 1977.

Garcin, Laure. *J. J. Grandville. Révolutionnaire et précurseur de l'art du mouve-ment*. Paris: Eric Losfeld, 1970.

Gardey, F. J. Adhémar, and J. Lethève. *Bibliothèque Nationale, Département des Estampes: Inventaire du fond français après 1800*. Paris: 1930.

Garnier, Adolphe. *Traité des facultés de l'âme*, 2d ed., 3 vols., Paris: Hachette, 1865.

Gassier, Pierre, and Juliet Wilson. *Goya: His Life and Work, with a Catalogue Raisonné of the Paintings, Drawings, and Engravings*. London: Thames and Hudson, 1971.

Gaudibert, P. "Delacroix et le romantisme révolutionnaire." *Europe* XLI, 408 (April 1963), 4–21.

Gautier, Théophile. *Histoire de l'art dramatique en France depuis 25 ans*, 6 vols. Leipzig, 1858–59, repr. Geneva: Slatkine, 1968.

———. *Portraits contemporains*. Paris: Charpentier, 1874.

———. *Souvenirs de théâtre, d'art et de critique*. Paris: Charpentier, 1904.

———. *Voyage en Espagne*. Paris: Charpentier, 1883.

George, M. Dorothy. *English Political Caricature*. Oxford: Oxford University Press, 1959.

———. *Hogarth to Cruikshank: Social Change in Graphic Satire*. London: Penguin Press, 1967.

Getty, Clive. "Grandville: Opposition Caricature and Political Harassment." *Print Collector's Newsletter* XIV, 6 (January 1984), 197–201.

Gibson, W. *Bruegel*. London: Thames and Hudson, 1977.

Gilman, Margaret. "Baudelaire and Thomas Hood." *Romanic Review* XXVI (1935), 240–44.

———. *Baudelaire the Critic*. New York: Columbia University Press, 1943.

———. "Le Cosmopolitisme de Baudelaire et l'Espagne." *Revue de littérature comparée* XVI, 1 (January–March 1936), 91–97.

Girard, René. "Perilous Balance: A Comic Hypothesis." In *To Double Business Bound: Essays on Literature, Mimesis, and Anthropology*. Baltimore: The Johns Hopkins University Press, 1978, 121–35.

Glendinning, Nigel. "Art and Enlightenment in Goya's Circle." In *Goya and the Spirit of Enlightenment*, exh. cat., Museum of Fine Arts, Boston, 1989, lxiv–lxxvi.

———. *Goya and His Critics*. New Haven: Yale University Press, 1977.

Goldstein, Robert Justin. *Censorship of Political Caricature in Nineteenth-Century France*. Kent, Ohio: The Kent State University Press, 1989.

Gombrich, E. H. *Art and Illusion: A Study in the Psychology of Pictorial Represen-tation*. Princeton: Princeton University Press, 1972, 330–58.

———. *The Heritage of Apelles*. Ithaca: Cornell University Press, 1976.

Goncourt, Edmond and Jules de. *Gavarni, l'homme et l'oeuvre*. Paris: Eugène Fasquelle, 1925.

Gopnik, Adam. "High and Low: Caricature, Primitivism, and the Cubist Portrait." *Art Journal* 43 (q.v.), 371–76.

Gould, Ann. *Masters of Caricature*. New York: Knopf, 1981.

Gowing, Lawrence. *Hogarth*, exh. cat., London, Tate Gallery, 1971.

Grand-Carteret, John. *Les Moeurs et la caricature en France*. Paris: Librairie Illustrée, 1888.

Grant, Mary A. *The Ancient Rhetorical Theories of the Laughable*. University of Wisconsin Studies in Language and Literature, no. 21. Madison: University of Wisconsin Press, 1924.

Grose, Francis. *Rules for Drawing Caricaturas, with an Essay on Comic Painting.* London: Bagster, 1791.

Grossman, F. *Pieter Bruegel: Complete Edition of the Paintings,* 3d ed. London: Phaidon, 1973.

Gudiol Ricart, José. *Goya: Biography, Analytical Study and Catalogue of his Paintings,* 4 vols., trans. K. Lyons, Barcelona: Ediciones Polígrafa, 1971.

Guillerm, Jean-Pierre. "Matières et musiques: La peinture ancienne et le texte critique à la fin du dix-neuvième siècle." In Philippe Bonnefis and Pierre Reboul, eds., *Des mots et des couleurs: Études sur le rapport de la littérature et de la peinture aux dix-neuvième et vingtième siècles.* Lille: Publications de l'Université de Lille, 1979, 1–47.

Guinard, P. "Baudelaire, le musée espagnol et Goya." *Revue d'histoire littéraire de la France* LXVII (April–June 1967), 310–28.

Haberland, Paul. *The Development of Comic Theory in Germany during the Eighteenth Century.* Göppingen: Alfred Kümmerle, 1971.

Handwerk, Gary. *Irony and Ethics in Narrative: From Schlegel to Lacan.* New Haven: Yale University Press, 1985.

Hannoosh, Michele. "The Function of Literature in Baudelaire's *La Fanfarlo.*" *L'Esprit créateur* XXVIII, 1 (1988), 42–55.

———. "Painting as Translation in Baudelaire's Art Criticism." *Forum for Modern Language Studies* XXII, 1 (1986), 22–33.

Harpham, Geoffrey. *On the Grotesque: Strategies of Contradiction in Art and Literature.* Princeton: Princeton University Press, 1982.

Harris, Tomás, ed. *Goya, Engravings and Lithographs,* 2 vols. Oxford: Oxford University Press, 1964.

Heine, Heinrich. "The Salon of 1833." In *The Works of Heinrich Heine* IV, London: William Heinemann, 1893.

Helman, Edith. *Los Caprichos de Goya.* N.p.: Salvat Editores, 1971.

Herbert, Robert. *Impressionism: Art, Leisure, and Parisian Society.* New Haven: Yale University Press, 1988.

Herding, Klaus. "Die Kritik der Moderne im Gewand der Antike: Daumiers *Histoire ancienne.*" *Hephaistos* 9 (1988), 111–41. (See also *Gazette des Beaux-Arts,* ser. 6, vol. 113 [January 1989], 29–44.)

———. "Le Citadin à la campagne: Daumier critique du comportement bourgeois face à la nature." *Nouvelles de l'estampe* 46–7 (July–October 1979), 28–40.

———. "Visual Codes in the Graphic Art of the French Revolution." In *French Caricature and the French Revolution,* UCLA exh. cat. (q.v.), 83–100.

Hiddleston, J. A. *Baudelaire and Le Spleen de Paris.* Oxford: Oxford University Press, 1987.

Histoire et critique des arts 13–14 (1980): "Daumier et les débuts du dessin de presse" (special issue).

Hobbes, Thomas. *The English Works,* ed. W. Molesworth, 11 vols. London: John Bohn, 1840.

Hoffmann, E. T. A. *Contes,* trans. T. Toussenel. Paris: Pougin, 1838.

———. *Sämtliche Werke,* ed. Hartmut Steinecke. Frankfurt am Main: Deutscher Klassiker Verlag, 1985.

Hofmann, W. "Ambiguity in Daumier." *Art Journal* 43 (q.v.), 361–64.

———. "Baudelaire et la caricature." *Preuves* 207 (May 1968), 38–43.

———. *Caricature from Leonardo to Picasso.* New York: Crown, 1957.

———, et al. "Les Ecrivains-dessinateurs." *Revue de l'art* 44 (1979), 4–102.

Hogarth, W. *The Analysis of Beauty, with the Rejected Passages from the Manuscript Drafts and Autobiographical Notes*, ed. J. Burke. Oxford: Clarendon Press, 1955.

———. *Anecdotes of William Hogarth*, ed. J. B. Nichols. London: J. B. Nichols and Son, 1833.

Holland, Eugene. "On Narcissism from Baudelaire to Sartre: Ego-Psychology and Literary History." In *Narcissism and the Text: Studies in Literature and the Psychology of Self*, ed. Lynne Layton and Barbara Ann Schapiro. New York: New York University Press, 1986, 149–69.

Holme, Charles. *Daumier and Gavarni*. London: The Studio, 1904.

Honoré Daumier und die ungelösten Probleme der bürgerlichen Gesellschaft. Berlin: Neue Gesellschaft für bildende Kunst, 1974.

Hood, Thomas. *Whims and Oddities*. London: Lupton Relfe, 1828.

Horner, Lucy. *Baudelaire, critique de Delacroix*. Geneva: Droz, 1956.

Houfe, Simon. *The Dictionary of British Book Illustrators and Caricaturists 1800–1914*, rev. ed. Woodbridge, Suffolk: Antique Collector's Club, 1981.

Hugo, Victor. *Préface de Cromwell*, ed. M. Souriau. Paris: Société française de l'imprimerie et de la librairie, 1953.

Hunt, Lynn. "The Political Psychology of Revolutionary Caricatures." In *French Caricature and the French Revolution*, UCLA exh. cat. (q.v.), 33–40.

Hyslop, Lois Boe, and Francis K. "Baudelaire and Meryon: Painters of the Urban Landscape." *Symposium* 38 (1984), 196–220.

Iknayan, Marguerite. *The Concave Mirror: From Imitation to Expression in French Aesthetic Theory 1800–1830*. Stanford French and Italian Studies. Saratoga, Calif.: Anma Libri, 1983.

Inoué, Teruo. *Une Poétique de l'ivresse chez Charles Baudelaire: Essai d'analyse d'après les Paradis artificiels et les Fleurs du mal*. Tokyo: France Tosho, 1977.

Isaacson, Joel. "Impressionism and Journalistic Illustration." *Arts Magazine* 56, 10 (June 1982), 95–115.

Jaime, Ernest, ed. *Musée de la caricature, ou recueil des caricatures les plus remarquables publiées en France depuis le XIV^e siècle jusqu'à nos jours*, 2 vols. Paris: Delloye, 1838.

Jal, Augustin. *Souvenirs d'un homme de lettres 1795–1873*. Paris: Techener, 1877.

James, Henry. *The Painter's Eye: Notes and Essays on the Pictorial Arts*, ed. J. Sweeney. London: Rupert Hart-Davis, 1956.

Janko, Richard. *Aristotle on Comedy: Towards a Reconstruction of Poetics* II. Berkeley and Los Angeles: University of California Press, 1984.

Jeanneret, Michel. "Baudelaire et le théâtre d'ombres." In *Le Lieu et la formule: Hommage à Marc Eigeldinger*. Neuchâtel: La Baconnière, 1978, 121–36.

Jennings, Lee Byron. *The Ludicrous Demon: Aspects of the Grotesque in German Post-Romantic Prose*. University of California Publications in Modern Philology 71. Berkeley and Los Angeles: University of California Press, 1963.

Jennings, Michael. *Dialectical Images: Walter Benjamin's Theory of Literary Criticism*. Ithaca: Cornell University Press, 1987.

Johnson, Barbara. *Défigurations du langage poétique: La Seconde Révolution baudelairienne*. Paris: Flammarion, 1979.

Journées illustrées: La Révolution de 1848. Paris: L'Illustration, n.d.

Jouve, Michel. *L'Age d'or de la caricature anglaise*. Paris: Presses de la Fondation Nationale des Sciences Politiques, 1983.

Jouve, Nicole Ward. *Baudelaire: A Fire to Conquer Darkness*. London: Macmillan, 1980.

Kaenel, P. "Le Buffon de l'humanité: La Zoologie politique de J.-J. Grandville." *Revue de l'art* 74 (1986), 21–28.

Kant, Immanuel. *Critique of Judgement*, trans. J. C. Meredith. Oxford: Oxford University Press, 1952.

Kayser, Wolfgang. *The Grotesque in Art and Literature*, trans. U. Weisstein. Bloomington: Indiana University Press, 1963.

Kelley, D. "Delacroix, Ingres et Poe: Valeurs picturales et valeurs littéraires dans l'oeuvre critique de Baudelaire." *Revue d'histoire littéraire de la France* LXXI (July–August 1971), 606–14.

———. "*Modernité* in Baudelaire's Art Criticism." In *The Artist and the Writer in France*, ed. F. Haskell. Oxford: Clarendon Press, 1974, 138–52.

———, ed. *Baudelaire: Salon de 1846*. Oxford: Oxford University Press, 1976.

Klingender, F. D. *Goya in the Democratic Tradition*, 2d ed. London: Sidgwick and Jackson, 1968.

Köhler, Ingeborg. *Baudelaire et Hoffmann*. Uppsala: Acta Universitatis Upsaliensis, Studia Romanica Upsaliensia 27.

Kris, Ernst, and Gombrich, E. H. "Principles of Caricature." In *Psychoanalytic Explorations in Art*. New York: Schocken, 1952.

Kunzle, David. "Cham, the Popular Caricaturist: Cham and Daumier–Two Careers, Two Reputations, Two Audiences." *Gazette des Beaux-Arts* 96 (December 1980), 213–24.

Lacenaire, *Mémoires de Lacenaire, avec ses poëmes et ses lettres*, ed. Monique Lebailly. Paris: Albin Michel, 1968.

La Combe, Joseph-Félix Le Blanc de. *Charlet, sa vie, ses lettres, suivi d'une description raisonnée de son oeuvre lithographique*. Paris: Paulin et Le Chevalier, 1856.

Lafuente Ferrari, Enrico. *Los Caprichos de Goya*, facsimile ed. Barcelona: Gili, 1977.

Lamennais, F. *Esquisse d'une philosophie*, 4 vols. Paris: Pagnerre, 1840.

Lang, Candace. *Irony/Humor*. Baltimore: The Johns Hopkins University Press, 1988.

Langlois, Claude. *La Caricature contre-révolutionnaire*. Paris: Presses du CNRS, 1988.

———. "Counterrevolutionary Iconography." In *French Caricature and the French Revolution*, UCLA exh. cat. (q.v.), 41–54.

Larkin, Oliver. *Daumier: Man of his Time*. London: Weidenfeld and Nicolson, 1967.

La Sizeranne, Robert de. *Le Miroir de la vie: Essai sur l'évolution esthétique*. Paris: Hachette, 1912.

Lavalleye, Jacques. *Pieter Bruegel the Elder and Lucas van Leyden: The Complete Engravings, Etchings and Woodcuts*. London: Thames and Hudson, 1967.

Lavater, J. C. *L'Art de connaître les hommes par la physionomie*. Paris: Depélafol, 1820.

Leacock, Stephen. *Humor, its Theory and Technique*. London: John Lane, 1935.

Leakey, Felix. *Baudelaire and Nature*. Manchester: Manchester University Press, 1969.

———. "Baudelaire. The Poet as Moralist." In *Studies in Modern French Literature in Honor of P. Mansell Jones*. Manchester: Manchester University Press, 1961.

Le Men, Ségolène. "Balzac, Gavarni, Bertall et les *Petites Misères de la vie conjugale*." *Romantisme* 43 (1984), 29–44.

Lemoisne, P. A. *Gavarni peintre et lithographe*. Paris: Floury, 1924–28.

Lethève, Jacques. *La Caricature et la presse sous la troisième république*. Paris: Armand Colin, 1961.

Levitine, George. "Some Emblematic Sources of Goya." *Journal of the Warburg and Courtauld Institutes* 22 (1959), 106–31.

Lhomme, F. *Charlet*. Paris: Librairie de l'Art, 1892.

Licht, Fred. "Goya and David: Conflicting Paths to Enlightenment Morality." In *Goya and the Spirit of Enlightenment*, exh. cat., Museum of Fine Arts, Boston, 1989, lxxvii–lxxxiv.

———. *Goya: The Origins of the Modern Temper in Art*. London: John Murray, 1980.

Lindsay, Jack. *Hogarth: His Art and his World*. London: Hart-Davis MacGibbon, 1977.

Lipschutz, Ilse Hempel. *Spanish Painting and the French Romantics*. Cambridge: Harvard University Press, 1972.

Lloyd, Rosemary. *Baudelaire et Hoffmann: Affinités et influences*. Cambridge: Cambridge University Press, 1979.

———. *Baudelaire's Literary Criticism*. Cambridge: Cambridge University Press, 1981.

———. "Melmoth the Wanderer: The Code of Romanticism." In *Baudelaire, Mallarmé and Valéry. New Essays in Honor of Lloyd Austin*, ed. M. Bowie, A. Fairlie, and A. Finch. Cambridge: Cambridge University Press, 1982, 80–94.

López-Rey, José. *Goya's Caprichos: Beauty, Reason and Caricature*. Princeton: Princeton University Press, 1953.

López Vazquez, José. *Los Caprichos de Goya y su interpretación*. Monografías de la Universidad de Santiago de Compostella 71, 1982.

Lorenzo de Márquez, Teresa. "Carnival Tradition in Goya's Iconic Language." In *Goya and the Spirit of Enlightenment*, exh. cat., Museum of Fine Arts, Boston, 1989, lxxxv–xciv.

Los Angeles County Museum of Art. *Daumier in Retrospect, 1808–1879*, exh. cat., ed. Elizabeth Mongan, 1979.

Lucie-Smith, Edward. *The Art of Caricature*. Ithaca: Cornell University Press, 1981.

Lüdi-Knecht, Karin E. "La Dialectique du nombre chez Baudelaire." Thesis, University of Zurich: Juris Druck, 1974.

Lynch, John. *A History of Caricature*. Detroit: Gale Research Co., 1974.

Macchia, Giovanni. *Baudelaire critico*. Florence: Sansoni, 1939.

McDermott, William. *The Ape in Antiquity*. Baltimore: The Johns Hopkins University Press, 1938.

McFadden, George. *Discovering the Comic*. Princeton: Princeton University Press, 1982.

McIntosh, M. E. "Baudelaire's Caricature Essays." *MLN* vii, 71 (1956), 503–7.

MacInnes, John. *The Comical as Textual Practice in Les Fleurs du mal*. Gainesville: University of Florida Press, 1988.

Maclean, Marie. *Narrative as Performance: The Baudelairean Experiment*. London: Routledge, 1988.

McLees, Ainslie A. *Baudelaire's "Argot Plastique": Poetic Caricature and Modernism*. Athens: University of Georgia Press, 1989.

Mader, Michael. *Das Problem des Lachens und der Komödie bei Platon*. Stuttgart: W. Kohlhammer, 1977.

Maison de la Culture, Reims. *Caricature, humour et satire au XIX^e siècle*, exh. cat., 1974.

Maison, K. E. *Honoré Daumier: Catalogue Raisonné of the Paintings, Watercolors and Drawings*, 2 vols. New York: Thames and Hudson, 1968.

Marash, J. G. *Henry Monnier, Chronicler of the Bourgeoisie*. London: Harrap, 1951.

Maréchal, Christian. *Lamennais et Victor Hugo*. Paris: Savaète, 1906.

Marrinan, Michael. *Painting Politics for Louis-Philippe: Art and Ideology in Orleanist France 1830–1848*. New Haven: Yale University Press, 1988.

Mathéron, Laurent. *Goya*. Paris: Thuillier, 1858.

Maturin, Charles. *Bertram*, ed. M. Ruff. Paris: José Corti, 1956.

———. *Melmoth the Wanderer*. Harmondsworth: Penguin, 1984.

Maurice, A. B. and F. T. Cooper. *The History of the Nineteenth Century in Caricature*. London: Grant Richards, 1904.

Mauron, Charles. "Le Rire baudelairien," *Europe* 456 (April–May 1967), 54–61.

Mayer, David. *Harlequin in His Element. The English Pantomime, 1806–36*. Cambridge: Harvard University Press, 1969.

———. "The Pantomime Olio and Other Pantomime Variants." *Theatre Notebook* XIX, 1 (Autumn 1964), 22–28.

———. "The Sexuality of Pantomime." *Theatre Quarterly* IV, 13 (February–April 1974), 55–66.

Mayne, J., trans. *Art in Paris 1845–1862*. London: Phaidon, 1965.

———. *The Painter of Modern Life*. London: Phaidon, 1964.

Melançon, Joseph. *Le Spiritualisme de Baudelaire*. Montreal and Paris: Fides, 1967.

Melcher, Edith. *The Life and Times of Henry Monnier 1799–1877*. Cambridge: Harvard University Press, 1950.

Melot, Michel. "Caricature and the Revolution: The Situation in France in 1789." In *French Caricature and the French Revolution*, UCLA exh. cat. (q.v.), 25–32.

———. *L'Oeil qui rit. Le Pouvoir comique des images*. Fribourg: Office du livre, 1975.

Meltzer, Françoise. *Salome and the Dance of Writing: Portraits of Mimesis in Literature*. Chicago: University of Chicago Press, 1987.

Ménard, Maurice. *Balzac et le comique dans La Comédie humaine*. Paris: Presses Universitaires de France, 1983.

Mercer, Colin. "Baudelaire and the City: 1848 and the Inscription of Hegemony." In *Literature, Politics and Theory: Papers from the Essex Conference 1976–84*, ed. F. Barker, P. Hulme, M. Iverson, and D. Loxley. London: Methuen, 1986, 17–34.

Mickel, Emmanuel. "Baudelaire's Peintre de la vie moderne." *Symposium* 38 (1984), 234–43.

Milner, Max. *Le Diable dans la littérature française de Cazotte à Baudelaire 1772–1861*, 2 vols. Paris: José Corti, 1960.

Mirecourt, Eugène de. *Gavarni*. Paris: Harvard, 1867.

Mitchell, W. T. "Metamorphoses of the Vortex: Hogarth, Turner and Blake." In *Articulate Images: The Sister Arts from Hogarth to Tennyson*, ed. R. Wendorf. Minneapolis: University of Minnesota Press, 1983, 125–68.

Monda, Maurice. *Un Siècle de la caricature française*. Paris: Editions de l'Eucalyptine LeBrun, 1937.

Möser, Justus. *Harlekin, oder der Verteidigung des Grotesk-Komischen*. Hanover, 1761.

Moss, Armand. *Baudelaire et Delacroix*. Paris: Nizet, 1973.

Mouquet, Jules, and W. T. Bandy. *Baudelaire en 1848: La Tribune Nationale*. Paris: Emile-Paul, 1946.

Musée des Beaux-Arts, Nancy. *Grandville, dessins originaux*, exh. cat., ed. C. Getty, 1987.

Museum of Fine Arts, Boston. *The Changing Image: Prints by Francisco Goya*, exh. cat., ed. E. Sayre, 1974.

——. *Goya and the Spirit of Enlightenment*, exh. cat., 1989.

Musset, Alfred de. *Oeuvres complètes en prose*, ed. M. Allem and Paul Courant. Paris: Gallimard, 1960.

Nash, Suzanne. "Transfiguring Disfiguration in *L'Homme qui rit*: A Study of Hugo's Use of the Grotesque." In *Pretext, Text, Context*, ed. R. Mitchell. Columbus: Ohio State University Press, 1980, 3–14.

Nouvelles de l'estampe 46–47 (July–October 1979) (special issue on Daumier).

Oehler, Dolf. "Le Caractère double de l'héroïsme et du beau modernes." *Etudes baudelairiennes* VIII, 187–216.

——. *Pariser Bilder I (1830–1848): Antibourgeoise Aesthetik bei Baudelaire, Daumier und Heine*. Frankfurt am Main: Suhrkamp, 1979.

Osiakovski, Stanislav. "The History of Robert Macaire and Daumier's Place In It." *Burlington Magazine* 100, 668 (November 1958), 388–92.

Pachet, Pierre. "Baudelaire et le sacrifice." *Poétique* 20 (1974), 437–51.

——. *Le Premier Venu: Essai sur la politique baudelairienne*. Paris: Denoël, 1976.

Paret, Peter. *Art as History: Episodes in the Culture and Politics of Nineteenth-Century Germany*. Princeton: Princeton University Press, 1989.

Parke, T. H. "Baudelaire et La Mésangère." *Revue d'histoire littéraire de la France* LXXXVI, 2 (1986), 248–57.

Passeron, Roger. *Daumier*, trans. Helga Harrison. Secaucus, N.J.: Poplar Books, 1981.

Patty, James S. "Baudelaire and Bossuet on Laughter." *PMLA* LXXX, 4 (September 1965), 459–61.

Paulson, Ronald. *Hogarth: His Life, Art, and Times*, 2 vols. New Haven: Mellon Centre for Studies in British Art, 1971.

——. *Hogarth's Graphic Works*, rev. ed., 2 vols. New Haven: Yale University Press, 1970.

——. *Popular and Polite Art in the Age of Hogarth and Fielding*. Notre Dame: University of Notre Dame Press, 1979.

——. *Representations of Revolution 1789–1820*. New Haven: Yale University Press, 1983.

——. "The Severed Head: The Impact of French Revolutionary Caricatures on England." In *French Caricature and the French Revolution*, UCLA exh. cat. (q.v.), 55–66.

Pérez Sánchez, Alfonso E. "Introduction." In *Goya and the Spirit of Enlightenment*, exh. cat., Museum of Fine Arts, Boston, 1989, xviii–xxv.

Perkins, David N. "Caricature and Recognition." *Studies in the Anthropology of Visual Communication* (Spring 1975).

——, and Margaret A. Hagan. "Convention, Context, and Caricature." In *Perceptions of Pictures*, ed. M. Hagen. New York: Academic Press, 1980, I, 257–86.

Pernoud, E. "Baudelaire, Guys et le kaléidoscope." *Gazette des Beaux-Arts*, ser. 6, CIV, 1388 (September 1984), 73–77.

Petit Palais, Paris. *Baudelaire*, exh. cat., 1968.

Philibert, Louis. *Le Rire, essai littéraire, moral et psychologique*. Paris, 1883.

Pichois, Claude. "Baudelaire en 1847." *Revue des sciences humaines* (January–March 1958), 121–38.

———. "La Date de l'essai de Baudelaire sur le rire et les caricaturistes." *Les Lettres romanes* XIX (1965), 203–16; repr. in *Baudelaire, Etudes et témoignages*. Neuchâtel: La Baconnière, 1967, 80–94.

———. *L'Image de Jean-Paul Richter dans les lettres françaises*. Paris: José Corti, 1963.

———, and J. Ziegler. *Baudelaire*. Paris: Julliard, 1987.

Pierrot, Roger. "Balzac et Gavarni." *Etudes balzaciennes* 5–6 (December 1958), 153–57.

Poe, Edgar Allan. *Essays and Reviews*, ed. G. R. Thompson. New York: The Library of America, 1984.

Pommier, J. "Baudelaire et Hoffmann." In *Mélanges de philologie, d'histoire et de littérature offerts à J. Vianey*. Paris: Les Presses Françaises, 1934, 459–77.

———. *Dans les chemins de Baudelaire*. Paris: José Corti, 1945.

Praz, Mario. "Two Masters of the Absurd: Grandville and Carroll." In *The Artist and the Writer in France: Essays in Honour of Jean Seznec*, ed. F. Haskell, A. Levi, and R. Shackleton. Oxford: Clarendon Press, 1974, 134–37.

Preisendanz, W., and R. Warning, eds. *Das Komische*. Munich: Wilhelm Fink, 1976.

Prendergast, Christopher. "Blurred Identities. The Painting of Modern Life." *French Studies* XL, 4 (October 1986), 401–12.

Prévost, Jean. *Baudelaire: Essai sur l'inspiration et la création poétiques*. Paris: Mercure de France, 1964 (originally published in 1953).

Print Review 11 (1980). "Honoré Daumier: A Centenary Tribute," ed. Andrew Stasik.

Print Review 19 (1984). "The Art of Satire: Painters as Caricaturists and Cartoonists from Delacroix to Picasso," ed. R. Shikes and S. Heller.

Radiguer. *Tables sommaires des périodiques parus de 1848 à 1865*, MS 1036C. Paris: Bibliothèque d'Art et d'Archéologie.

Ragon, M. *Les Maîtres du dessin satirique en France de 1830 à nos jours*. Paris: P. Horay, 1972.

———. *Le Dessin d'humour: Histoire de la caricature et du dessin humoristique en France*. Paris: Fayard, 1960.

Reynolds, Joshua. *Discourses on Art*, ed. Robert Wark. San Marino, Calif.: Huntington Library, 1959.

Rhode Island School of Design and Brown University. *Caricature and Its Role in Graphic Satire*, exh. cat., Providence, 1971.

Richter, Jean-Paul. *Vorschule der Asthetik*. In *Werke* v, Munich: Carl Hanser, 1963.

Roberts, Keith. *Bruegel*, rev. ed. Oxford: Phaidon, 1982.

Roberts-Jones, Philippe. *Beyond Time and Place: Non-Realist Painting in the Nineteenth Century*. Oxford: Oxford University Press, 1978.

———. "La Liberté de la caricature en France au XIXᵉ siècle," *Synthèses* 165 (February 1960), 1–11.

———. *La Presse satirique illustrée entre 1860 et 1890*. Institut Français de Presse, 1956.

Rollins, Yvonne. *Baudelaire et le grotesque*. Washington, D.C.: University Press of America, 1978.

Rome, Palazzo Braschi. *Bartolomeo Pinelli*, exh. cat., ed. Giovanni Incisa della Rocchetta, 1956.

Rousseau, Jean-Jacques. *Lettre à M. d'Alembert sur les spectacles*, ed. M. Fuchs. Geneva: Droz, 1948.

Roy, Claude. *Daumier, étude biographique et critique*. Geneva: Skira, 1971.

Rubin, Vivien. "Two Prose Poems by Baudelaire: 'Le Vieux Saltimbanque' and 'Une Mort héroïque.' " *Nineteenth-Century French Studies* xiv (1985–86), 51–60.

Ruff, Marcel. *L'Esprit du mal et l'esthétique baudelairienne*. Paris: Armand Colin, 1955.

———. "La Pensée politique et sociale de Baudelaire." In *Littérature et société: Recueil d'études en l'honneur de Bernard Guyon*. Paris: Desclée de Brouwier, 1973, 65–75.

Sainte-Beuve, C. A. *Nouveaux Lundis* vi. Paris: M. Lévy, 1866.

Saint-Guilhem, F., and K. Schrenk, eds. *Daumier: L'Oeuvre lithographique*, 2 vols. Paris: Arthur Hubschmid, 1978.

Sánchez Cantón, F. J. *Los Caprichos de Goya y sus dibujos preparatorios*. Barcelona: Instituto Amatller de Arte Hispánico, 1949.

Sand, Maurice. *Masques et bouffons*. Paris: A. Levy, 1862.

Sangiglio, Cristino Giovanni. "Caricatura e caricaturisti in Baudelaire." *Cynthia*, n.s. 1–2 (January–February 1963), 7–9.

Saviotti, G. *Charles Baudelaire critico e la questione dell'umorismo*. Caserta: E. Marino, 1919.

Sayre, Eleanor. *The Changing Image: Prints by Francisco Goya*, exh. cat., Museum of Fine Arts, Boston, 1974.

———. "Introduction to the Prints and Drawings Series." In *Goya and the Spirit of Enlightenment*, exh. cat., Museum of Fine Arts, Boston, 1989, xcv–cxxvii.

Schofer, Peter. "Une Mort héroïque: Baudelaire's Social Theater of Cruelty." *French Literature Series* xv (1988), 50–57.

Scott, David. *Pictorialist Poetics: Painting and the Visual Arts in Nineteenth-Century France*. Cambridge: Cambridge University Press, 1988.

Scudo, Paul. *La Philosophie du rire*. Paris: Poirée, 1840.

Searle, Ronald, and Bernard Bornemann. *La Caricature: Art et manifeste du XVI^e siècle à nos jours*. Geneva: Skira, 1974.

Sello, G. *Grandville. Das Gesamte Werk*, 2 vols. Munich: Pawlak, 1969.

Shiff, Richard. *Cézanne and the End of Impressionism*. Chicago: University of Chicago Press, 1984.

———. "Remembering Impressions." *Critical Inquiry* ci, 12 (Winter 1986), 439–48.

Shikes, Ralph E. *The Indignant Eye: The Artist as Social Critic in Prints and Drawings from the Fifteenth Century to Picasso*. Boston: Beacon Press, 1969.

Siebers, Tobin. *The Romantic Fantastic*. Ithaca: Cornell University Press, 1984.

Silk, Michael. "The Autonomy of Comedy." *Comparative Criticism* x, ed. E. S. Shaffer. Cambridge: Cambridge University Press, 1988, 3–37.

Simon, Richard. *The Labyrinth of the Comic: Theory and Practice from Fielding to Freud*. Tallahassee: Florida State University Press, 1985.

Spencer, M. C. *The Art Criticism of Théophile Gautier*. Geneva: Droz, 1969.

Spies, Werner. "Der verzweifelte Systematiker: Hinweis auf Grandvilles Beschäftigung mit der reproduzierten Welt." In *Kunst um 1800 und die Folgen: Werner Hofmann zu Ehren*, ed. Christian Beutler. Munich: Prestel, 1988, 281–96.

Stamm, Therese Dolan. *Gavarni and the Critics*. Studies in the Fine Arts: Criticism 12. Ann Arbor: UMI Research Press, 1981.

Starobinski, Jean. *Portrait de l'artiste en saltimbanque*. Geneva: Albert Skira, 1970.

———. "Sur quelques répondants allégoriques du poète." *Revue d'histoire littéraire de la France* 67, 2 (1967), 402–12.

Stendhal. *Molière, Shakespeare. La Comédie et le rire*, ed. H. Martineau. Paris: Le Divan, 1930.

———. *Oeuvres complètes*, ed. V. Del Litto and E. Abravanel, 49 vols. Geneva: Edito-Service, Cercle du Bibliophile, 1969.

———. *Racine et Shakespeare*, ed. H. Martineau. Paris: Le Divan, 1928.

Stenzel, Hartmut. *Der historische Ort Baudelaires: Untersuchungen zur Entwicklung der französischen Literatur um die Mitte des 19. Jahrhunderts*, Freiburger Schriften zur Romanischen Philologie 38. Munich: Wilhelm Fink, 1980.

Stierle, Karlheinz. "Baudelaires 'Tableaux parisiens' und die Tradition des *tableau de Paris*." *Poetica* 6 (1974), 285–322.

Stoll, André. "Die Barbarei der Moderne. Zur ästhetischen Figuration des Grauens durch Goya und Daumier." In A. Stoll, ed., *Die Ruckkehr der Barbaren. Europäer und "Wilde" in der Karikaturen Honoré Daumiers*. Hamburg: Christians, 1985.

Storey, Robert. *Pierrots on the Stage of Desire: Nineteenth-Century Artists and the Comic Pantomime*. Princeton: Princeton University Press, 1985.

Strauss, Walter, ed. *Hendrik Goltzius 1558–1617: The Complete Engravings and Woodcuts*. New York: Abaris Books, 1977.

———. *The Intaglio Prints of A. Dürer: Engravings, Etchings and Drypoints*. New York: Kennedy Galleries and Abaris Books, 1976.

Sully, James. *An Essay on Laughter, its Forms, its Causes, its Development and its Value*. New York: Longmans, Green and Co., 1902.

Terdiman, Richard. *Discourse/Counter-Discourse: The Theory and Practice of Symbolic Resistance in Nineteenth-Century France*. Ithaca: Cornell University Press, 1985.

Thackeray, W. M. *The Works of Thackeray*, 32 vols. New York: Scribner's, 1904.

Thomson, Philip. *The Grotesque*. London: Methuen, 1972.

Todorov, Tzvetan. *Introduction à la littérature fantastique*. Paris: Seuil, 1970.

University of California, Los Angeles. *French Caricature and the French Revolution 1789–1799*, exh. cat., Grunwald Center for the Graphic Arts, 1988.

———. *Reading Hogarth*, exh. cat., intro. R. Vogler, Grunwald Center for the Graphic Arts, 1988.

Van Slyke, Gretchen. "Dans l'intertexte de Baudelaire et de Proudhon: Pourquoi faut-il assommer les pauvres?" *Romantisme* 45 (1984), 57–77.

Vasari, Giorgio. *Le Vite de' più eccelenti pittori, scultori e architettori*, ed. R. Bettarini, 6 vols. Florence: Sansoni, 1976.

Viardot, Louis. *Notices sur les principaux peintres d'Espagne*. Paris: Gavard, 1839.

Victoria and Albert Museum, London. *English Caricature 1620 to the Present*, exh. cat., intro. R. Godfrey, 1984.

Villa, Nicole. *Collection de Vinck. Inventaire analytique* VI and VII. Paris: Bibliothèque Nationale, Département des Estampes, 1979 and 1955.

Vincent, Howard P. *Daumier and His World*. Evanston, Ill.: Northwestern University Press, 1968.

Voogd, Peter Jan de. *Henry Fielding and William Hogarth: The Correspondences of the Arts*. Amsterdam: Rodopi, 1981.

Vouga, Daniel. *Baudelaire et Joseph de Maistre*. Paris: José Corti, 1957.

Vovelle, Michel. *La Révolution française. Images et récit*, 5 vols. Paris: Messidor, 1986.

Wardroper, John. *The Caricatures of George Cruikshank*. London: Gordon Fraser, 1977.

Wechsler, Judith. *A Human Comedy: Physiognomy and Caricature in Nineteenth-Century Paris*. London: Thames and Hudson, 1982.

Weiskel, Thomas. *The Romantic Sublime. Studies in the Structure and Psychology of Transcendence*. Baltimore: The Johns Hopkins University Press, 1976.

Wieland, Christoph Martin. *Unterredungen zwischen W*** und dem Pfarrer zu ***, Werke* III. Munich: Carl Hanser, 1967.

Williams, Gwyn A. *Goya and the Impossible Revolution*. New York: Pantheon, 1976.

Wilson, A. E. *Pantomime Pageant*. London: Stanley Paul, n.d.

Wood, Theodore. *The Word "Sublime" and its Context 1650–1760*. The Hague: Mouton, 1972.

Worth, Sol. "Seeing Metaphor as Caricature." *New Literary History* VI, 1 (1974), 195–209.

Wright, Thomas. *England under the House of Hanover, Illustrated from the Caricatures and Satires of the Day*, 2 vols. London: R. Bentley, 1848.

———. *Histoire de la caricature et du grotesque dans la littérature et dans l'art*, ed. A. Pichot. Paris: Au Bureau de la Revue britannique, 1867.

———. *A History of Caricature and Grotesque in Literature and Art*. London: Virtue Brothers, 1865.

Ziegler, J. "François Baudelaire, peintre et amateur d'art." *Gazette des Beaux-Arts* XCIII, 1322 (March 1979), 109–24.

Index

Ruff, Marcel, 16, 129
Russian Formalism, 309

Sainte-Beuve, Charles Augustin, 178
Saint-Hilaire, Geoffroy, 227
Sainte Pélagie prison, 124
Salon de 1846, 7, 27, 44, 78, 79, 97, 101,
 147, 225, 251, 285
 and artist of modernity, 117, 148, 254
 beauty in ugliness in, 255–57
 and the city, 299
 "crosser un républicain" episode, 131–34
 definition of art in, 148
 dualism in, 255–64, 268, 312
 on Gavarni, 254
 on Lami, 254
 and the modern hero, 140, 146, 256–57
 relation to essays on caricature, 255–61
 on Horace Vernet, 97–98
Salon de 1859, 62, 77, 99, 144, 158, 254
 on Boudin, 136, 231
 on copying, 230, 231
 on Hood, 241–43
 and the imagination, 286, 298
 on photography, 86, 155
satire, 8, 28, 42, 52, 117, 215
Scaramouche, 81
Schiller, Friedrich von, 43
Schlegel, Friedrich, 5
Second Empire, 243
Seneca, L. Annaeus, 35
Senefelder, Aloys, 89
Seymour, Robert, 5, 191, 193, 202–4, 205
Shakespeare, William, 7, 47, 63, 241
Siebers, Tobin, 2
Société républicaine centrale, 124
Soult, Nicolas Jean de Dieu, 120
Spanish comic art, 46, 210
Starobinski, Jean, 72
Steen, Jan, 240
Stendhal (Henri Beyle), 15, 27–28, 263
Sterne, Laurence, 42, 241
Stierle, Karlheinz, 290 n. 42, 292 n. 44
Stoll, André, 137
Storey, Robert, 2
sublime, the, 37, 42–43
suicide, 140–41
superiority,
 and the comic, 11–12, 32–35, 42, 72,
 229, 252, 270, 294, 295 n. 48, 312
 theory of, 11, 26–32

See also comique absolu, comique
 significatif
surnaturalisme, 37, 261, 275–85
 comic nature of, 275, 279, 284–85, 287
 and correspondences, 276, 280, 292
 distinct from hashish, 276–85
 and doubling, 276, 280, 283, 299
 dualism of, 278–85
 and Hoffmann, 275, 299
 and phantasmagoria, 299
 and Wagner, 276
 and the will, 279–80, 283
Swift, Jonathan, 42, 241

Talleyrand (Charles Maurice de Talleyrand-
 Périgord), 120
Tannhäuser, 21. See also Wagner, Richard
Taylor, Isidore Justin Séverin, baron, 222
Terdiman, Richard, 6 n. 13, 137 n. 85
Thackeray, William Makepeace, 12 n. 5, 83,
 118, 150–51, 183 n. 160, 209–10
théâtre des Variétés, 58–59, 225
Thersites, 37
Thiers, Louis Adolphe, 120
Titian (Tiziano Vecellio), 125
Töppfer, Rodolphe, 240
translation, 92, 103 and n. 37, 155
Traviès de Villers, Charles Joseph, 5, 84,
 186–89, 251
 and Daumier, 187
 Dis donc farceuse!, 189
 Une Exécution sous Louis XI, 120 and n.
 58, 123
 Je suis le poiricide Mayeux, 188
 La Tribune des peuples, 151
Trimolet, Louis Joseph, 84, 181–86, 251
 La Prière, 183
 Le Vieux Mendiant, 183, 184–86

unity,
 as abstraction, 260
 and dualism, 73, 259–60, 262, 269, 312–
 16
 universal analogy, 38, 73. See also
 correspondences
utopia, 265

Valmont, 173, 179
Van Slyke, Gretchen, 134
Vernet, Carle, 84–91, 104, 155, 251, 286
 Costume paré, 175

348 Index